Guide to Basic Information Sources in
THE VISUAL ARTS

by
Gerd Muehsam
Queens College of The City University
of New York

JEFFREY NORTON PUBLISHERS/ABC-CLIO, INC
Santa Barbara, Calif. Oxford, England

Library of Congress Cataloging in Publication Data

Muehsam, Gerd, 1913-
 Guide to basic information sources in ·the visual
arts.

 Bibliography: p.
 Includes index.
 1. Art--Sources. I. Title.
N7425.M88 700'.7 77-17430
ISBN 0-87436-278-4

Cc

Distributed by ABC-Clio, Inc., P.O. Box 4397, Santa Barbara, California 93103;
European distribution, Clio Press, Ltd., Hinksey Hill, Oxford OX1 5BE England.

Preface

This handbook is intended to guide students and researchers to basic information sources in the visual arts. Although it is designed primarily for art students and art history majors, the wide range of material offered should also, I hope, prove useful to graduate art history students, to students in graduate library science curricula, and to librarians and others concerned with the visual arts.

The text combines what is essentially a bibliographic essay with an introduction to college-level research in art. My aim has been to advise the information-seeker of basic search strategies applicable to the visual arts; to acquaint him or her with the essential reference and research tools; and to indicate authoritative sources dealing with the principal periods in art, as well as sources on art forms and techniques and national schools of art.

Correspondingly, the material has been organized in four broad sections. The first section, containing the core materials, outlines innovative yet eminently practical approaches to art research. It explains the characteristics of the special art research tools — the exhibition catalog, museum publication, *catalogue raisonné,* and *corpus* — and discusses the principal art bibliographies, encyclopedias, histories, primary sources, and other reference materials. The second section, on periods of Western art, is comparable to the first in length and importance. The briefer third and fourth sections, on art forms and on national schools of art, serve largely to enrich and supplement the material introduced earlier in the book.

A guide of this nature must of necessity be selective. To be useful to the broadest segment of readers, the material is with few exceptions limited to sources available in English. Even so, only a few significant titles from the mass of published material could be cited for each of the many subjects covered. In selecting these titles I have sought to balance authoritative writings suitable for beginners with more specialized, advanced studies and the essential works of the grandmasters of art history. The importance of bibliographies is stressed throughout. Since the information needs in the

visual arts are often pictorial as well as verbal, sources with superior illustrations are mentioned whenever possible, in addition to those offering authoritative texts. Only books published before 1977 could be considered.

While the traditional printed information sources are emphasized, the so-called nonprint media — slides, photographs, audio- and videotapes, films — are discussed to the extent that they offer college-level material in the visual arts. The resources of museum collections, research organizations, and libraries are identified in the appropriate chapters.

On the other hand, reasons of space necessitated the exclusion of several subject areas, especially the decorative or applied arts; teacher education in art; some national schools of art; and related fields such as aesthetics and the psychology of art.

This book grew out of twenty-five years of developing art library collections and providing reference guidance to students and researchers in academic, museum, and public art libraries, as well as giving bibliographic instruction to both undergraduate and graduate students. The book could not have been written without the intellectual curiosity and responsiveness of the many bright students who have taught me how to teach them.

I am greatly indebted to several of my colleagues and friends for their generous advice and help: above all to Dr. Wolfgang Freitag, Fine Arts Librarian of Harvard University, whose thoughtful comments and constructive criticism contributed immeasurably to the strengthening of the text; to Professor Stanley T. Lewis of the Queens College Graduate Department of Library Science, who read the initial chapters and was the first to give me encouragement; to Professors Ellen N. Davis and William C. Clark of the Queens College Art Department, who read the chapters on ancient and medieval art respectively and suggested important improvements; and to Professor Peter Fitzgerald of the University of Reading, England, Art Department, who recommended changes and additions, principally to the chapter on modern art. To them, and to the library colleagues of several institutions who most willingly tracked down information whenever needed, I would like to express my sincere gratitude. I also wish to thank Sara Monajem for her enthusiastic help with the index. A special word of thanks goes to Jeffrey Norton, whose unflagging concern and unfailing wisdom were instrumental in finally seeing this book through to publication.

October, 1977 **Gerd Muehsam**
 Art Bibliographer and
 Associate Professor in Library
 Queens College
 of The City University of New York

Contents

Preface, v

A Note for the User, x

I. Core Materials

1. How to Get Information about Artists, 1

Books Showing an Artist's Works. Books about Artists. The Catalog Card:
What It Tells about a Book. When the Artist's Name Is Not Listed in the
Card Catalog. Information on Living Artists. Exhibitions by Living Artists.
Exhibition Reviews. Exhibition Catalogs. The Most Comprehensive
Artists' Dictionaries.

2. How to Research a Work of Art, 11

The *Catalogue raisonné* and *Oeuvre* Catalog. Museum Publications.
Exhibition Catalogs of Historical Material. The *Corpus.* Stylistic Analysis.
Iconography: Saints; Symbolism and Allegory; Visual Sources;
Research Resources.

3. Primary Sources, 27

Collections and Series. Modern Art. Special Source Collections.
"Complete and Unabridged": Artists' Writings. Poets and Critics on Art.

4. Reference Sources and Resources, 36

Bibliographies. General Trade Bibliographies: Current. Art Bibliographies.
Serial Art Bibliographies, Indexes, Abstracts. National Library Catalogs.
Art Library Catalogs. Art Encyclopedias and Dictionaries. Directories.
Topographical Guides. Museology. Art Auction Catalogs. Audiovisual
or Nonprint Materials: Bibliographic Control; Art Sources; Art Slides;
Pictures, Photographs.

5. Art Histories and Introductions, 55

Art Histories in Series.

6. Periodicals, 60

General Art Journals. Scholarly Art Journals. Museum Bulletins. Periodical
Indexes and Abstracts Once More.

II. Periods of Western Art

7. **Prehistoric Art, 65**

How to Locate Books on Prehistoric Art in the Library.

8. **Ancient Art, 69**

Background Study. General Surveys. The Ancient Near East. Egypt. The Aegean and Greece: Sculpture; Painting; Architecture. Ancient Italy: Etruria and Rome. Primary Sources. Periodicals.

9. **Medieval Art, 81**

Early Christian and Byzantine. Early Medieval. Romanesque and Gothic: Architecture; Chartres Cathedral; Sculpture; Painting. Illuminated Manuscripts. Illuminated Manuscripts – Facsimile Editions. Mosaics. Stained Glass. Primary Sources. Periodicals.

10. **The Renaissance and Mannerism, 96**

General Surveys and the Italian Renaissance. Painting. Sculpture. Architecture. Theory. Primary Sources. Northern Renaissance: The Netherlands; France and Germany; Primary Sources. Artists' Monographs. Mannerism.

11. **Baroque and Rococo Art, 109**

Artists' Monographs.

12. **Modern Art: Nineteenth and Twentieth Centuries, 114**

Neoclassicism, Romanticism, Realism. Impressionism, Post-Impressionism, Symbolism. The Twentieth Century: Art Nouveau, Art Deco; Fauvism and Expressionism; Cubism and Abstract Art; Dada and Surrealism; Abstract Expressionism; The 1960s and 1970s: Art and Technology.

III. Art Forms and Techniques

13. **Architecture, 128**

Dictionaries, Reference Works. Architectural Histories. Modern Architecture. Architects: Dictionaries and Directories. Architects: Monographs and Series. Architects and Architecture: Primary Sources. Architects on Architecture: The Twentieth Century. Periodicals.

14. **Sculpture, 138**

Reference Works. Techniques. Histories. Periodicals.

15. **Painting Techniques, 142**

Primary Sources. Color.

16. **Drawing, 145**

Collections. Periodicals. Techniques: Anatomy and Perspective.

17. **Prints, 150**

Definitions, Reference Sources. Introductory Works and Historical Surveys. Printmaking Techniques. Print Catalogs. Periodicals. Print Collections.

18. **Photography, 157**

Manuals. Photography as an Art Form. Pictorial Volumes. Reference and Research. Periodicals and Yearbooks.

19. **Commercial Art, 163**

Periodicals and Annuals. Special Subjects. Techniques. Typography. Lettering.

IV. National Schools of Art

20. **The Americas, 170**

United States. Canada. Latin America.

21. **Europe, 177**

France. Germany. Great Britain and Ireland. Italy. The Low Countries. Russia. Spain and Portugal.

22. **Oriental Art, 184**

Periodicals. Islamic Art. India and Southeast Asia. China. Korea. Japan.

23. **Primitive Art, Tribal Art, 194**

Africa. North American Indian. Oceania.

Bibliography, 199

Index, 249

A NOTE FOR THE USER

The works discussed in the text are usually cited in short form without subtitles. The date of publication, preceded by the edition number unless it is the first edition, is given in parentheses following the title. The bibliography gives full citations, indicating also reprints and paperback editions whenever possible. Some works are mentioned in more than one chapter. The bracketed page references in the bibliography refer to the pages of this volume in which the particular source is cited.

Part I. Core Materials

How to Get Information about Artists

Anyone studying art or taking art history courses needs information about artists — painters, sculptures, architects, printmakers — and their works. Such information, whether it is visual or verbal, may be gathered from a multitude of printed sources: encyclopedias and dictionaries; biographical and critical studies; magazine articles; art histories of a given country, period, or movement; catalogs of museum collections or temporary exhibitions. Slides, audio and videotapes, and other nonprint sources may be available in some libraries; sometimes it may be necessary to write to galleries or museums for specific information.

The most appropriate source of information about a particular artist depends on the following four points:

1. The amount of information needed
2. The importance of the artist
3. The art form, medium, or style in which the artist worked
4. The period, country, or movement in which he or she was active

Whenever a great deal of information is needed it is best to go to the library and look in the card catalog under the artist's name for books about him. If the artist's name appears in the card catalog, there are likely to be two types of books under his name: those which contain primarily the artist's work in the form of reproductions or listings of his paintings, sculptures, buildings, and so forth, and those which consist primarily of text about him. The latter are usually illustrated as well.

Books Showing an Artist's Works

Books reproducing or listing an artist's work are of two basic kinds.* First there is the pictorial volume emphasizing illustrations. Good picture books offer well-selected, high-quality reproductions of the artist's major works, with the necessary data on these works and informative introductory matter. Bad ones have a random selection of plates which are either murky or overly bright, and have minimal data, sloppy editing, and indifferent introductory texts.

Michelangelo: Paintings, Sculptures, Architecture (5th ed. 1975), edited by Ludwig Goldscheider,† is essentially a pictorial volume. Its objective is to bring together good reproductions of Michelangelo's paintings, sculptures, and architecture. Books of this type are extremely useful if one wants to study an artist's work. As a matter of fact, in the United States the only way to see Michelangelo's work is through reproductions, for none of his paintings or sculptures are in this country.

Secondly, there is the so-called *oeuvre* catalog (catalog of works) and the *catalogue raisonné* (critical catalog). These are scholarly publications where the emphasis is on completeness and accuracy of the catalog. All known works of an artist (or all his known works in one medium) are brought together, critically examined, documented, and, whenever possible, reproduced. This type of book is particularly important when an individual work – a painting, sculpture, drawing, or print – is to be researched.

Art students are faced with a situation which is not shared by other students of the humanities. There is rarely an opportunity to see more than a few works by an artist – if any – in the original. Most of the great masterpieces of art are in far away places. We must therefore depend largely on reproductions, good or bad, to study these works of art and to form an idea of an artist's output and artistic development. By contrast, the student of English poetry, for example, can get any edition of a poem, and the text in front of him – even though it is printed – is usually exactly as the poet conceived and created it.

Books about Artists

Most library users know that books *about* an artist are indicated in the card catalog by having the artist's name typed in red or in black capitals across the tops of the cards above the name of the *author,* the person who

*In many libraries such books are found in the card catalog under the *artist's* name as the main, or author, entry.

†This title and all others mentioned hereafter are listed in the bibliography at the end of this book. See bibliography for further explanation.

wrote the book. These books may be biographies in the strict sense of the word, or they may be critical studies about the artist's works, or they may be combinations of both, discussing the life and work of an artist. Studies dealing with a single artist are called *monographs;* artists' monographs are the backbone of the art library. Works on individual artists, especially painters, usually represent the library's largest contingent of art books. Two monographs on the Dutch painter Rembrandt, cited below, show different treatments of the same subject. *The World of Rembrandt* (1968), by Robert Wallace, is a competent general treatment of the artist. It is a volume in the Time-Life Library of Art series, well illustrated and not difficult to read. *Rembrandt: Life and Work* (3d ed. 1968), by Jacob Rosenberg, is a more scholarly volume. The subtitle *Life and Work* indicates that the author aims at comprehensiveness. Evidence of the more scholarly nature of this book are the notes which follow the text. They lead to additional sources and allow a glimpse into the scholar's workshop and his way of writing and documenting his statements. This book has a more extensive bibliography and better indexes than the Time-Life volume as well as more detailed data on the illustrations, giving size, date, and medium of the originals, in addition to location. Books with a "scholarly apparatus" — that is, detailed information on the illustrations, notes or footnotes in the text, and extensive bibliographies — are the preferred sources for an in-depth study of an artist.

The Catalog Card: What It Tells about a Book

Although many students are familiar with the information provided on the catalog card, others may benefit from a review of its content.

Above all, the forms of artists' names on the cards differ considerably. The volumes on Rembrandt use the artist's first name, "Rembrandt" (Rembrandt Hermanszoon van Rijn), as the form of entry, whereas the previously mentioned book of Michelangelo's work was entered under "Buonarroti, Michel Angelo," and *not* under "Michelangelo" as everyone calls him. This is an exception to the rule that many artists of the Italian Renaissance are listed by their first names. For example, Leonardo da Vinci is found under "Leonardo," and Titian is found under "Tiziano Vecellio."

There are other ways in which artists' names appear on catalog cards. Vincent van Gogh, for example, is listed under "Gogh, Vincent van," although he is usually referred to as Van Gogh. Likewise, nicknames or assumed names are not used in library catalogs; thus El Greco is really "Theodocopoulos, Domenicos," and Claude Lorrain is found under "Gelée, Claude."

Besides author and title, a catalog card can give useful information

about the book itself. It can tell whether a book is old or new, in what language, where, by whom, and when it was published.

The catalog card also tells whether a book is long or short — it gives the number of pages or volumes, and often even the size, measured in centimeters. It tells whether or not the book is illustrated and whether the illustrations are in color. In addition, it tells whether the book is one of a series. This information can be quite helpful. Books that are volumes in a series are usually uniform in format and outward appearance. They are sometimes published under the direction of one or several general editors who are responsible for establishing and maintaining certain standards. The difficulty of the text and the quality of the illustrations are often, but not always, similar. Several important series are discussed in Chapter 5.

The catalog card always tells if the book has a bibliography — that is, a listing of sources and other materials for further reference and study. It often gives such data as information about editions and translations.

To sum it up — it is worthwhile to read the catalog card all the way through before deciding which book to consult.

When the Artist's Name Is Not Listed in the Card Catalog

When there is no reference to the literature on a particular artist in the library's card catalog, other information sources can be used. Taking the Italian Renaissance painter Titian (Tiziano Vecellio) as an example, we have the following options:

1. *To consult an art encyclopedia or art dictionary.* The most important art encyclopedia in the English language is the *Encyclopedia of World Art* (1959-68). This fifteen-volume set has excellent, scholarly, signed articles on all major artists, plus illustrations, including a long one on our artist, Titian. The term "major" artist is used here advisedly, for this encyclopedia is highly selective and omits quite a few well-known names that are not considered "major" by the editors. Each article has a comprehensive bibliography, including also references from journals and foreign-language sources. The excellence of the bibliographies is a special feature of this encyclopedia. It should be noted that the bibliographies are arranged by date, with the earliest sources listed first.

Easier to read but also authoritative are the *McGraw-Hill Dictionary of Art* (1969. 5 vols.) and the *Praeger Encyclopedia of Art* (1971. 5 vols.). Both have good-length articles on artists and include selected references of English-language material whenever possible. An informative one-volume art dictionary with concise — although not always unbiased — biographical entries for quick reference is *A Dictionary of Art and Artists,* by Peter and

Linda Murray. The hard-cover edition (1966) has a long bibliography in the back, but the paperback edition (3d ed. 1972) does not.

2. *To search art histories for chapters on artists.* Pertinent art histories are highly suitable sources of information on individual artists. Art histories other than general surveys are of several basic types: they may deal with the art of a country – such as Italy, or of a period – such as the Renaissance, or with a particular art medium – such as painting in a given country and/or period. There are also art histories dealing with styles, movements, and many specialized themes.

To find good chapters on artists in art history books it is always advisable to begin by looking for the most *specific* subject that seems appropriate. To continue with our example, Titian, we should look for books on Italian Renaissance painting. One's first impulse is probably to look in the card catalog under "Italian" or "Italy" or "Renaissance," since books on English literature are listed under "English Literature" and books on French poetry are listed under "French Poetry." However, in art the subject headings are different: the word order of most art subjects is *reversed.* Thus, books on Italian painting are listed in most card catalogs under "Painting, Italian" and books on Renaissance art are found under "Art, Renaissance."

This is a fairly universal practice in American libraries, but there is no absolute uniformity in the way libraries put subject headings in their card catalogs.

One of the most useful books on the subject is *Italian Painting: 1200-1600* (1961), by E. T. Dewald. It has sound information on Italian Renaissance painters and substantial analyses of their principal works.

If the most specific subject heading yields too few books or if the library has only few books on art, more general headings such as "Painting – History," or "Art, Italian," or "Art, Renaissance" should be considered. Books discussing our painter, Titian, can be located under any of these headings, but the amount of space devoted to him in these more general works may be limited.

3. *To search for an artist in histories of styles or movements.* This is still another approach to finding information in art histories about artists – of the nineteenth and twentieth centuries especially – who worked in a particular style or were associated with a particular movement. Let us take, for example, the French impressionist painter Claude Monet. Following the procedure outlined earlier one may consult:

• Monographs on Monet
• Art encyclopedias or dictionaries for good articles about Monet

• Chapters on Monet in books on French painting, listed in the library's card catalog under "Painting, French," or the like

But the subject "Impressionism (Art)" should also be checked. One of the books most likely to be listed under that heading is John Rewald's *History of Impressionism* (4th ed. 1973), the most comprehensive and most painstakingly documented history of this movement. Rewald's book, which is also outstanding for its well-organized critical bibliography, is perhaps less useful for analyses and critiques of the Impressionists and their paintings than for the accumulation of all ascertainable facts. If critiques are needed one might turn to *Impressionism* (1955. 2 vols.) by Jean Leymarie, a survey in the Taste of the Time series published by the famous Swiss publishing house of Albert Skira. These volumes are less well documented than Rewald's but have well-formulated characterizations of the art of the impressionists, including Monet.

By the same token good information on artists can be found under styles, such as "Mannerism (Art)" or "Neoclassicism," or under art movements, such as "Romanticism in Art," "Cubism," "Futurism," or "Surrealism," to name but a few.

It is also worthwhile to check whether the library has an artists' file. Such a file often proves to be a mine of information.

Periodical indexes and abstracts provide many references to artists, but, generally speaking, journal articles on major artists tend to deal only with highly specialized topics.

Information on Living Artists

A search for books on a living artist may well result in the information that no monograph has as yet been written about him. This means that his name is probably not listed in the library's card catalog.

If the artist is an American and only the briefest biographical information is needed, the volume to consult is *Who's Who in American Art.* This directory, which is updated every few years, gives information about the artist's birth date, training, exhibitions, and preferred medium, and lists the museums which own his works. His address is also usually given. In other words, *Who's Who in American Art* is like other *Who's Who*s that may be found in the library's general reference section. Beginning with the 1976 edition, however, bibliographical references appear in some of the entries. Paul Cummings' *Dictionary of Contemporary American Artists* (3d ed. 1977) is comparable to *Who's Who in American Art*, with the important distinction that it gives reference sources for many of the

artists and includes a few important artists (Jackson Pollock, for example) who are no longer alive.

There is also a British *Who's Who in Art,* published biennially, which lists primarily British artists. It is far from being balanced in its coverage, however, and hence of dubious value.

If the artist does not appear in any of these works or if the information provided is unsatisfactory, a totally different approach may produce better results. First, however, it should be determined whether the artist is known or active primarily in his own local community or is known nationally or internationally. Then the alternatives outlined below may be considered.

If the artist is nationally or internationally known. An artist becomes nationally known if he has exhibited in New York City or in one of the other major art centers of the country and if his shows have attracted the attention of critics and collectors. His work is then reviewed in the art magazines, articles begin to appear about him, and information in print can be found, as will be seen below.

If the artist is known chiefly in his own community. If the artist is known primarily locally, it is unlikely that much material about him has appeared in print, except perhaps for some criticism in the local newspaper. This may be adequate, unless examples of his work need to be studied. In that case, the local museum or historical society should be contacted. Chances are that one or both collect information on local artists and have files with illustrations of their work. An alternative is to get in touch with the art associations and art societies in the community. A local artist is likely to be a member of at least one of them. Through these organizations — and with proper guidance from an instructor or other knowledgeable person — it may even be possible to get in touch with the artist and to see slides or photographs of his or her work or arrange for a visit in the studio. Artists may turn out to be quite cooperative in furnishing information about themselves.

But regardless of a living artist's claim to fame, it is apparent that the chief source of information about him or her must be the *exhibitions* in which he or she has taken part.

Exhibitions by Living Artists

There are two basic types of exhibitions in which living artists participate — the one-man show and the group show. Either is what the name implies: the one-man show exhibits the work of a single artist; the group show exhibits the work of several artists together. Group shows may be

all of one medium, such as painting or sculpture, or may combine works in several media. Group shows of printmakers usually include various types of prints, such as woodcuts, etchings, lithographs, and the like.

The most common type of one-man show is an exhibit of an artist's current works in a commercial art gallery; these works are usually for sale. A comprehensive exhibition of a living or a recent artist's work is called a *retrospective*. Such a retrospective brings together works from different periods of the artist's career. These works may be lent by museums or private collectors expressly for the exhibition and hence may not be for sale. Retrospectives are usually put on by museums and occasionally by some of the prestigious commercial art galleries which can afford to mount exhibitions without having to sell the works. An artist who has been honored with a retrospective in a major museum has really "arrived."

Exhibition Reviews

Exhibitions in a given town or city are usually reviewed in the local news-paper. Exhibitions in New York City and other major art centers are regularly reviewed in the art magazines, especially *Art News, Arts Magazine, Artforum, Art in America,* and *Art International.*

Exhibition reviews and articles published in these and other art journals can be located through *Art Index* and *ARTbibliographies Modern.* The scope of these two basic tools is described in Chapter 4. At present, however, we are concerned only with information about artists — especially living artists — which can be obtained from *Art Index* and *ARTbibliographies Modern.* All material on an individual artist is entered under the artist's name. Exact reference to the magazine, volume, year, issue, and pages is always given, as are indications of illustrations, if any. *ARTbibliographies Modern* has the advantage over *Art Index* that it gives an abstract of most of the material indexed. The abstract not only helps in determining the usefulness of a particular reference, but sometimes provides the information sought without one's having to consult the source itself.

The *New York Times Index* is another important tool for exhibition reviews of living or recent artists. This index, which goes back to 1851, is published semimonthly with annual cumulations. It is available in most college libraries, as is the microfilm edition of *The New York Times.*

The *New York Times Index* divides exhibition reviews into group shows and one-man shows, the one-man shows being the more important of the two. One-man shows are listed alphabetically, by the name of the exhibiting artist, under the heading "Art. Shows — One-man." For major

shows, the reviewer's name and a brief abstract are given. In addition to
New York City exhibitions there are also reviews of major exhibitions else-
where in the country and sometimes even abroad. Group shows are
indexed under the heading "Art. Shows – Group." They are listed first by
date and then by the caption of the review article.

Obituaries sometimes offer good summaries of an artist's life and
achievements. *The New York Times Index* list all obituaries – regardless
of the person's profession or vocation – in a single alphabet under "Deaths."

Exhibition Catalogs

An exhibition catalog is the printed record of a temporary exhibition held
in a museum, a commercial art gallery, or another public or private organi-
zation. The catalog's immediate purpose is to guide the visitor through the
exhibition. After the exhibition is over it remains the permanent record of
the objects shown. Exhibition catalogs are invaluable sources of informa-
tion. Those showing the works of living artists, with which we are con-
cerned here, are often the only printed documentation available on a
particular artist.

Exhibition catalogs come in all formats and sizes. They vary from a
modest leaflet with the briefest listing of the items exhibited to an
elaborately produced research tool with thorough documentation and
profuse illustrations. The most carefully researched and produced
exhibition catalogs are generally those issued by museums. The catalogs
of the great artists' retrospectives – shown, for example, at the museum of
Modern Art or the Solomon R. Guggenheim Museum in New York City – are
authoritative summations of the artists' achievements. They include
biographical information, critical evaluations, chronologies of previous
exhibitions, and ample bibliographical references.

The student who needs information on a living artist should therefore
also look for exhibition catalogs. Most art libraries and many large general
libraries collect these catalogs. In some libraries they are treated like books
and kept on the regular shelves together with the monographs on artists.
In other libraries they are housed in a separate section and listed in a
special file.

The Most Comprehensive Artists' Dictionaries

The question is sometimes asked whether there is a dictionary that lists all
the artists that ever lived. The answer is No, there is no such book. No
artists' dictionary can ever be "complete," but there are a few that are

extraordinarily comprehensive. The only trouble is that they are not in English and will never be translated. Yet it is indispensable to have at least a passing acquaintance with them.

The most comprehensive and most authoritative artists' dictionary ever published is *Allgemeines Lexikon der bildenden Künstler* . . . ("Universal Encyclopedia of Visual Artists"), by Ulrich Thieme and Felix Becker, and, accordingly, commonly called "Thieme-Becker" (pronounced Teema-Becker). Published in thirty-seven volumes (1907-50), it is a research tool of the first magnitude. It contains an exceptional number of names and is extremely rich in bibliographic and other documentation. In addition to painters and sculptors it includes architects, printmakers, and craftsmen of all kinds and all periods. It is supplemented by *Allgemeines Lexikon der bildenden Künstler des XX. Jahrhunderts* ("Universal Encyclopedia of Visual Artists of the 20th Century"), by Hans Vollmer, published in six volumes (1953-62).

If the library does not own Thieme-Becker and Vollmer, chances are that it will have Bénézit, which is in French. The new ten-volume edition, titled *Dictionnaire critique et documentaire des peintres, sculpteurs, dessinateurs et graveurs,* by E. Bénézit, (1975), is still not as comprehensive as Thieme-Becker — it excludes architects and craftsmen and has few bibliographic references — but it may well exceed Thieme-Becker in the total number of entries for painters, sculptors, and printmakers, and unquestionably surpasses all English-language dictionaries in coverage.

How to Research a Work of Art

Information on an individual painting, sculpture, or other work of art is often needed for reports, term papers, and the like. If it is merely a question of finding a brief description and illustration of a universally known work, such as the *Mona Lisa* by Leonardo da Vinci, it is usually sufficient to check the monographs on the particular artist or to search the general art histories — for example, *Gardner's Art through the Ages,* by Helen Gardner; *The Story of Art,* by Ernst H. Gombrich; or the *History of Art,* by H. W. Janson — and the appropriate art historical surveys.

But in this chapter we are concerned with information in depth for works which may be less familiar or even downright obscure. The questions discussed here are:

1. How does one find the bibliography — or published literature — on a given work of art?
2. What aids are available for a stylistic analysis if no such bibliography can be found?
3. What are the principal sources for an iconographic analysis?

Before starting out, however, the possibility of a full-length study on the work to be researched should be investigated. An example of such a study is *Picasso's Guernica: The Genesis of a Painting* (1962), by Rudolph Arnheim, which contains, besides an excellent text, the full visual documentation on the creation of what is probably the best known of all twentieth-century paintings.

There are at least two series devoted to in-depth studies of individual works of art: the Norton Critical Studies in Art History and the Art in Context series. Each volume in the Norton series is devoted to a great and complex monument and contains a scholarly selection of source writings, modern critiques, and iconographical analyses. Included in this series are,

among others, *Giotto: The Arena Chapel Frescoes* (1969), edited by
James H. Stubblebine, and *Michelangelo: The Sistine Chapel Ceiling*
(1972), edited by Charles Seymour.

The Art in Context series, which discusses, in the words of the series
editors John Fleming and Hugh Honour, "a famous painting or sculpture
as both image and idea in its context — whether stylistic, technical, literary,
religious, social or political," includes such diverse works as *Piero della
Francesca: The Flagellation* (1972), by Marilyn A. Lavin; *Goya: The Third
of May 1808* (1973), by Hugh Thomas; and *Manet: Olympia* (1976), by
Theodore Reff. But these volumes are exceptions; usually a search must be
made for the published literature.

Assuming the most common situation, that the work to be researched is
a painting by a known artist and is owned by a museum, there are two
basic approaches for locating a bibliography. The first is to find a publica-
tion on the *artist* that contains bibliographies on individual paintings — in
other words an *oeuvre* catalog, or *catalogue raisonné*. The second is to find
material on the painting that is issued by the *museum* which owns the work.

The *Catalogue Raisonné* and *Oeuvre* Catalog

Of all monographs and studies on a given artist a *catalogue raisonné* or an
oeuvre catalog are the most important reference sources for studying a
work by that artist.

A *catalogue raisonné* is a systematic, descriptive, and critical listing or
catalog of all known, or documented, authentic works by a particular
artist — or of all his known works in one medium. Each entry aims at
providing all ascertainable data on the work in question: (1) title, date,
and signature if any, as well as size and medium; (2) present location or
owner and provenance (previous recorded owners and history of the work);
(3) description, comments, analysis, or literary documentation; (4) biblio-
graphical references to books and periodicals; (5) listings of exhibitions
and reproductions. Usually there is also an illustration. The entries are
numbered consecutively. These catalog numbers are often referred to in
the scholarly literature about the artist and permanently identify a
particular work.

The arrangement of such a catalog may be chronological — that is,
according to the date, or supposed date, of each work (but very often the
chronology of an artist's output is itself full of controversy) or topical — that
is, according to subject. An example of a chronologically arranged *catalogue
raisonné* is *Chardin* (1969), by Georges Wildenstein, revised edition by
Daniel Wildenstein. An example of a topical arrangement is *The Paintings*

of Titian (1970-75. 3 vols.), by Harold E. Wethey. Volume 1 contains all the religious paintings, arranged by date within each subject group, and brings together, for example, all of Titian's paintings of the Madonna and Child in chronological order. Volume 2 contains the portraits, arranged alphabetically by the name of the sitter. Volume 3 contains the mythological and historical paintings.

Catalogues raisonnés often include other useful features. The catalog itself is often preceded by an illuminating text as, for example, *Annibale Carracci* (1971. 2 vols.), by Donald Posner. There is usually an extensive general bibliography in addition to the bibliographical references given in each entry. This general bibliography may be in chronological rather than alphabetical order, in which case the earliest bibliographical citations are given first. An example of a chronological bibliography in a *catalogue raisonné* is in *The Paintings of Nicolas Poussin: A Critical Catalogue* (1966), by Anthony Blunt.

The *catalogue raisonné* occasionally includes contemporary sources relating to the artist or his works and almost always contains an index of the works by geographic location. The latter enables the user to see at a glance which cities or museums own works by the artist in question.

An *oeuvre* catalog is comparable to the *catalogue raisonné* in its complete critical listing and reproduction of an artist's work, but it often omits the extensive bibliographical documentation and the provenance for each work. An example of an *oeuvre* catalog is *Rembrandt: The Complete Edition of the Paintings,* by Abraham Bredius, of which the third edition (1969) was revised by Horst Gerson.

Both the *catalogue raisonné* and the *oeuvre* catalog are essential tools for the study of art and art history. Because of the completeness of the illustrative material they are of value also for the studio artist. Their importance for the study of art history lies in the fact that it is impossible to establish the total *oeuvre* of an artist with absolute certainty. Even the authorship of world-famous masterpieces is sometimes a matter of controversy.* Works of art are subject to loss, damage, or poor restoration; there may be replicas, copies, imitations, or outright forgeries. The compiler of a *catalogue raisonné* or *oeuvre* catalog critically sifts all available evidence, and on the basis of this evidence accepts some of the works traditionally given to an artist as authentic and rejects others.

*An example is the *Ghent Altarpiece,* traditionally thought to have been painted by Hubert and Jan van Eyck. Lotte B. Philip, in *The Ghent Altarpiece and the Art of Jan van Eyck* (1971), concludes that Hubert van Eyck was actually the sculptor of the painting's elaborately carved framework – now lost.

Museum Publications

In researching a museum-owned object, a so-called collection catalog of the museum should always be the principal museum source to be looked for. The term "collection catalog" means a catalog of objects in the museum's permanent collection. If such a catalog exists, the entries are apt to be as detailed and extensive as those in a *catalogue raisonné*. In researching, for example, the painting *Third-Class Carriage* by the French painter Honoré Daumier in the Metropolitan Museum of Art, compare the entry on this painting, volume 2 of *French Paintings: A Catalogue of the Collections of the Metropolitan Museum of Art* (1966), by Charles Sterling and Margaretta Salinger, with that in *Honoré Daumier: Catalogue raisonné of the Paintings, Watercolours, and Drawings* (1968. 2 vols.), by Karl E. Maison.

Unfortunately, few museums are in the position to publish fully documented catalogs of all the works they own, and even partial catalogs are not too numerous. But even if there is no collection catalog, other types of museum publications may offer helpful information. The most important of these are bulletins and annuals, which usually contain lengthy articles on individual works in the collection. The contents of the major bulletins and annuals is indexed in the *Art Index* (for example, the bulletins of the museums at Baltimore, Boston, Cleveland, Detroit, Los Angeles, Minneapolis, New York, Philadelphia, Toledo, and others). The accessibility of this information makes the *Art Index* a major finding tool for articles on single works of art. The usefulness of museum handbooks, guidebooks, or picture books is more limited, since the information on single works in this type of publication is usually quite brief and includes no bibliographical references.

It may sound elementary, but the student about to research a museum object should make every effort to study the original first (assuming the museum is within reach) and should, right then and there, jot down everything he or she can discover about the work including the information on the label which is on or next to the object. The reason is obvious: an original work of art in its actual dimensions, shape, and color can be experienced in a way no reproduction on a sheet of paper can approximate. The information on the label, especially the accession number, which usually indicates the year the object was acquired by the museum, often helps to narrow down the hunt for published sources. For example, a work which entered a museum in 1965 is more likely to be written up or "published" by the museum around that time than it is ten years before or after. If the work to be studied is in the local museum, one should also be on the lookout for museum brochures, taped tours, and other gallery

information. Some museums permit local college students to consult the museum file on a particular work being researched.

Exhibition Catalogs of Historical Material

We have already (Chapter 1) discussed exhibition catalogs as being the indispensable research tool for information on living or recent artists. Equally important, if for other reasons, are the catalogs of historically oriented exhibitions.

The great national or international loan exhibitions in which several museums — or even national governments — participate have a very special function. They bring together related works that are ordinarily hundreds or thousands of miles apart in museums and localities all over the globe. Such exhibitions give the viewer a unique opportunity to examine and compare works that normally can never be seen side by side. In the great commemorative exhibitions of single artists, which are usually held in conjunction with an anniversary, more originals by one artist can be seen in one place than is otherwise possible. This stimulates the discussion of an artist's *oeuvre* and often leads to reevaluations, reattributions, or changes in the presumed chronology of his works. Examples are the great Rembrandt exhibitions of 1969 on the occasion of the 300th anniversary of Rembrandt's death, and the great Dürer exhibitions of 1971 in commemoration of the 500th anniversary of Dürer's birth.

International exhibitions exploring special themes or key periods in art often reveal unexpected art historical interconnections enabling the viewer to see works of art in a new light. Examples are the fourteen great exhibitions sponsored by the Council of Europe, which began in 1954 with "Humanist Europe,"* shown in Brussels, and have probably come to an end with the "Age of Neo-classicism," shown in London in 1972. They were art historical events of the first order. The illustrated catalogs of these and other major exhibitions are carefully researched, scholarly documents of permanent value and importance. The information provided on each work exhibited is, as a rule, fully up to date and a rich source of critical and bibliographical material.

The *Corpus*

The *corpus* (from the Latin word for "body") is a very special, highly important type of scholarly catalog, comparable to the *catalogue raisonné*

The Age of Humanism (1964), by André Chastel, was published in the wake of the exhibition.

in form and bibliographical detail but much more comprehensive in scope. Because of the enormous amount of research involved in producing a *corpus,* such a work is usually the result of international cooperative scholarship and is published over a long period of time. In contrast to the *catalogue raisonné* which — as has been said — attempts to assemble, sift, classify, and document all known authentic works (or works in one medium) by a *single artist,* the *corpus* attempts to do the same thing for all surviving monuments of a special *kind* or *category.** To assure similarity of treatment, a typology of the monuments and a classification of the supporting documentary material is usually established before work on a *corpus* gets under way. Complete coverage of all monuments to be cataloged, as well as complete description and documentation for each monument, is the aim here. As a rule, a *corpus* is made up of many volumes, or parts, often called "fascicles." To give some examples: The important *corpus* of early Netherlandish painting (title: *Les Primitifs flamands*), in progress since 1951, has as its aim to catalog all extant Flemish paintings of the fifteenth century. The arrangement is topographical and by locality: museum by museum, region by region. By contrast, *A Critical and Historical Corpus of Florentine Painting,* begun in 1930 by Richard Offner, is arranged according to Master or workshop.

There are also important *corpora* of works of art other than paintings. The oldest and best-known is the *Corpus Vasorum Antiquorum* ("Corpus of Ancient Vases"), begun in 1922 and still continuing. This, too, is broken down by countries and, within each country, by city and museum.

The scholarship and the extent of documentation provided for a single work of art in these great international compilations make the *corpus* an unsurpassed reference source. Consider, for example, the information given in *Les Primitifs flamands* for the famous Arnolfini Marriage Group (official title: *The Marriage of Giovanni Arnolfini and Giovanna Cenami),* by Jan van Eyck, in the National Gallery, London. This painting is the first item in volume 2 of the three volumes on the National Gallery, London, written by Martin Davies (1954). In addition to the identifying references and data on the painting, its physical characteristics and condition, there is a full description and iconography with bibliographical references up to the date of publication, an account of the painting's origin and subsequent history (factual evidence and opinions of critics, including chronological records of ownership, dating back to 1516), comparative materials — that

*The term *corpus* is also applicable to a multivolume *catalogue raisonné* by several contributing scholars, as for example *Corpus Rubenianum Ludwig Burchard,* in progress since 1968.

is, related paintings — comments by the author, a bibliography arranged by date, transcription of documents and literary sources (in the original languages), and lastly, a full set of illustrations including many details, infrared photographs, and even a photograph of the reverse of the painting.

Stylistic Analysis

In spite of all the sources mentioned in the foregoing pages, even the most diligent efforts do not always turn up published or usable information on a monument to be researched. This is not necessarily because appropriate museum publications are unavailable — after all, many works of art are not in museums but are in churches, palaces, private collections, or elsewhere. Nor is it just for the lack of an English-language *catalogue raisonné* of an artist's works, for quite often works by unknown artists are to be researched — for example, a Byzantine mosaic or an African mask. Even if an entry is found in a catalog, this does not automatically guarantee a bibliography on the work. Many works by well-known artists simply have no bibliography to speak of.

A student confronted with the problem of having to deal with an "unpublished" painting usually needs to undertake either a stylistic (or form) analysis or an iconographical analysis.

A good introduction to stylistic analysis and the problems of style in general is *Styles in Painting* (1963), by Paul Zucker. The author compares paintings that represent the same theme but are painted in different styles and periods. Themes include, among many others, Adam and Eve, as painted by Jan van Eyck, Masaccio, Dürer, Michelangelo, and so on; self-portraits, by Titian, Rembrandt, Goya, Van Gogh, and others; still life paintings, by Caravaggio, Chardin, Cézanne, Matisse, Picasso, and so forth. An introductory essay, "Art and Style," explains the factors governing style, and a concluding chapter, "A History of Styles in Painting," provides the "historical vantage point" from which stylistic or form analyses can be made.*

The master of form analysis was Heinrich Wölfflin. His *Classic Art* (1953) abounds with brilliant analyses of Italian Renaissance masterpieces. *Looking at Pictures* (1960), by Kenneth Clark, has evocative analyses of a select group of well-known paintings and demonstrates what a stylistic analysis can do.

*The advanced student may wish to refer to two important essays, "Style" (1935), by Meyer Schapiro, and "Meditations on a Hobby Horse, or the Roots of Artistic Form" (1951), by Ernst H. Gombrich, both reprinted in *Aesthetics Today*, edited by Morris Philipson (1961), pp. 81-113, 114-128.

A stylistic analysis of a painting may well be approached by searching for *related* information which can be *applied* to the work in question. This may include

1. Information about the genre of the painting
2. Definitions and characteristics of the pertinent art historical style of the work or the movement in which the artist was active
3. Information about the artist's characteristic personal style
4. Authoritative analyses of *comparable* paintings by the same artist

Two practical examples will illustrate these points.

An analysis of a still life painting by Paul Cézanne may be approached by consulting the articles on "Still Life Painting" in the *McGraw-Hill Dictionary of Art,* the *Praeger Encyclopedia of Art,* or the *Encyclopedia of World Art;* by consulting the appropriate chapters in a history of still life painting, such as *Still Life Painting from Antiquity to the Present Time* (rev. ed. 1959), by Charles Sterling; by searching for apt characterizations of Cézanne's art and for authoritative analyses of comparable still lifes in one of the principal monographs on Cézanne, such as *Cézanne* (3d ed. 1965), by Meyer Schapiro, with its excellent comments on individual paintings, or *The Art of Cézanne* (1939), by Albert C. Barnes and Violette De Mazia, which is particularly rich in detailed analyses.

A comparison between an impressionist landscape by Claude Monet and a post-impressionist landscape by Vincent van Gogh may be similarly researched. General information on "Landscape Painting," especially during the second half of the nineteenth century, may be gathered from the art encyclopedias mentioned above or from a history of landscape painting, such as *Landscape into Art* (rev. ed. 1976), by Kenneth Clark. Definitions of styles — here "Impressionism" and "Post-impressionism" — may be found in the same art dictionaries or encyclopedias, in general art histories, or in histories of modern art which go back to the mid-nineteenth century. Libraries have, furthermore, entire books on these styles; they are entered in the library card catalog under the headings "Impressionism (Art)" and "Post-impressionism," respectively. Analyses of comparable landscapes may be found in monographs such as *Claude Monet* (1960), by William C. Seitz, and *Vincent van Gogh* (1950), by Meyer Schapiro.

Works in media other than painting or works by unknown artists may be researched similarly, but with appropriate variations. For example, applicable information on a Byzantine mosaic may include information on the characteristics of the "Byzantine" style. The characteristics of the medium "mosaic" and its significance in Byzantine art may be researched in art encyclopedias, art histories, and histories of medieval art, as well

as in specialized works found in the library's card catalog under the heading "Mosaics."

An African mask could be researched first for the general characteristics of "African Art" or "African Sculpture" in the art encyclopedias, or in surveys on African art ("Art, African" in the library's card catalog). The functions and characteristics of masks in tribal or traditional art could be explored in works listed under the heading of "Masks (Sculpture)." Sound information is often found in specialized critical anthologies and similar essay collections. In our case, *The Many Faces of Primitive Art* (1966), compiled by Douglas Fraser, contains a penetrating essay, "Masks as Agents of Social Control," by Roy Sieber. If the mask in question originates from a specific region or ethnic group, as for example from Benin in West Africa, information on the special characteristics of Benin art would provide additional leads.

Iconography

It is possible to analyze a work of art entirely in terms of its form, style, or technique without taking subject matter into account. For example, a painting of a young woman holding a baby in her arms may be studied for its composition, gestures and expression, spatial relationships, use of light and color, and so forth, irrespective of the fact that this painting may represent the Virgin Mary and the Christ Child. Likewise, in a painting of a reclining nude the formal characteristics or rendering of skin tones may be examined whether or not this nude is supposed to be the goddess Venus or an artist's model from next door.

However, for the full understanding of a work of art, its purpose, and the artist's intention, a thorough knowledge of subject matter is essential. The pictorial elements, figures, and objects found in medieval, Renaissance, and baroque works in particular may seem familiar, but their true meaning, which was obvious to the viewer in those times, often escapes us today. Investigating the iconography of a work enables us to decipher these often complex meanings.

The word *iconography* comes from the Greek: *icon* means "image" and *graphein* means "to describe, write." Iconography is thus, literally, the description of images. In a lucid essay called "Iconography and Iconology: An Introduction to the Study of Renaissance Art," the eminent Erwin Panofsky* (a name that should be familiar to anyone involved in the study of art and art history) defines iconography as "that branch of the history

*Erwin Panofsky; *Meaning in the Visual Arts* (1955), pp. 26-54.

of art which concerns itself with the *subject matter* or *meaning* or works of art, as opposed to their *form*" (italics added). Panofsky goes on to say that "familiarity with specific themes and concepts as transmitted through literary sources" is fundamental to iconographic analysis.

The principal literary sources important in Western art are

1. Greek and Roman mythology, especially as transmitted by Ovid and other Roman poets
2. The Bible (Old and New Testament as well as the apocryphal writings)
3. The lives of the saints and other Christian writings
4. Histories, chiefly of antiquity

To become acquainted with an unfamiliar subject in painting, the *Encyclopedia of Themes and Subjects in Painting* (1971), by Howard Daniel, may well be consulted as an initial source. This handy volume describes briefly, in alphabetical order, each of the most frequently represented scenes, events, and figures within the subject limitations cited above. The literary source or authority and an illustration, usually of a well-known painting, are placed beside the entry.

While the *Encyclopedia of Themes and Subjects in Painting* is good for identifying the subject at hand — whether it is the Fall of Icarus (entered under "Icarus"), or the Rape of the Sabine Women (entered under "Sabine Women"), or the Supper at Emmaus (entered under "Emmaus") — a deeper probing into the literary sources is usually necessary for an iconographical analysis.

A subject from Greek or Roman mythology may be looked up in a modern mythological handbook, such as Herbert J. Rose's *Handbook of Greek Mythology* (6th ed. 1954), or in any other work on classical mythology. However, the Renaissance or baroque artist was probably familar with the *Metamorphoses* by the Latin poet Ovid, or he may have known Vergil's *Aeneid*, or even Homer's *Illiad* and *Odyssey*. A reading of the original literary sources often clears up otherwise incomprehensible pictorial elements in a painting.

For a biblical subject the particular Old or New Testament passage should be referred to. The appropriate Bible version should be consulted whenever possible. There is, incidently, a *Bible for Students of Literature and Art* (1964), by G. B. Harrison, which consists of extracts of Bible passages important in literature and the visual arts.

The legends connected with the Virgin Mary, which for the most part are not included in the New Testament, are retold in *Legends of the Madonna* (1890), by Anna B. Jameson, which also describes paintings depicting scenes from the life of the Virgin.

The manner of representing biblical subjects, especially those related to Jesus Christ and the Virgin Mary, has undergone enormous changes since the Early Christian period. The first to document and interpret this development were French and German scholars, whose writings have only in part been translated into English. An excellent introduction to the study of iconography in the context of art history is *Religious Art: From the Twelfth to the Eighteenth Century* (1958), by Émile Mâle, the eminent French art historian who made Christian iconography his life work. This book is a selection, by Mâle himself, of the most significant passages from his seminal work, *L'Art religieux* — a four-volume study which deals with the subject of Christian art from its monastic beginnings at Cluny through the Counter-Reformation and the baroque — which was never translated in full.* Here Mâle traces the iconographical development of Jesus Christ, the Virgin Mary, and certain saints, and explains the derivations of motifs and symbols, relating them to the principal sources, literary and otherwise. His *The Gothic Image: Religious Art in France of the Thirteenth Century* (1958) is a translation of the second volume of *L'Art religieux,* which concentrates on the programs and contents of French cathedral sculpture and its sources.

One of the best recent German iconographical works, now being published in an English translation, is *Iconography of Christian Art* (1971-72), by Gertrud Schiller. Volume 1 covers the life of Christ from the Annunciation and the Nativity up to the Miracles; volume 2 continues with the Passion and ends with the Resurrection. The copious illustrations show, principally, examples of medieval and Renaissance art.

Saints

Saints represent a special chapter in iconography. They are frequently shown in paintings and sculptures because they once played a very important role in people's lives. They still do for many Catholics.

Questions about saints in art usually fall into one of two categories. One type of question concerns the identification of an unnamed saint from the attribute or symbol with which he is represented. The other type of question concerns the identification of a scene or episode from the life of a saint whose name is known from the title of the painting or sculpture.

To identify an episode from a saint's life, it is often desirable to consider the literary source the medieval or Renaissance artist might have had at his disposal at the time. This was usually the so-called *Golden Legend,*

*A complete translation of this work is in preparation.

by Jacobus de Varagine (sometimes spelled Voragine), a thirteenth-century hagiographer — or writer of sacred biography — from Genoa, Italy. *The Golden Legend,* originally written in Latin, was the most widely known literary source for the lives of saints in earlier centuries. It is available in a modern translation by Granger Ryan and Helmut Ripperger (1941. 2 vols.). The stories of the saints' lives (which are all quite brief) are arranged in the order of the calendar, that is, by the days on which their feast days occur, beginning with Advent, the season before the birth of Christ on Christmas Day. In addition to the lives of the saints, the stories of the sacred events connected with the life of Christ and the Virgin Mary — Advent, Christmas, Epiphany, Annunciation, Ascension, and so on — are told at the appropriate dates.

If it is not possible to refer to *The Golden Legend,* or if the saint on whom information is needed was sainted after *The Golden Legend* was written, it is feasible to consult some of the numerous modern works dealing with saints. The most authoritative sources are *The Catholic Encyclopedia,* and *The New Catholic Encyclopedia,* where saints are listed in alphabetical order, along with descriptions of how they are represented in art—often with illustrations. These encyclopedias are also the best sources for liturgical or other questions that may arise in researching Christian monuments or works of art.

A useful book for the identification of saints by their symbols or attributes is *Saints and Their Attributes* (1955), by Helen Roeder. In contrast to most books on saints, which are arranged alphabetically by the name of the saint, the main body of Roeder's book consists of an alphabetical listing of the *attributes,* which may be an animal, plant, or manmade object. Thus, for example, such saints as St. Mark and St. Jerome are listed under "Lion," St. Peter is listed under "Keys," and St. Barbara is listed under "Tower."

The two great compilations by George Kaftal, *Iconography of the Saints in Tuscan Painting* (1952) and *Iconography of the Saints in Central and South Italian Schools of Painting* (1965), are, in effect, pictorial dictionaries of several hundred saints represented on panel paintings and fresco cycles by Italian artists from the regions mentioned. All the paintings are reproduced, and there are extensive references to art historical writings, literary sources, and hagiographical writings. The value of these volumes is enhanced by five indexes: Index of Attributes, Distinctive Signs and Scenes; Index of Painters; Topographical Index of Paintings; Bibliographical Index of Works Mentioned in the Text; and, last, Index of Saints and Blessed.

In many libraries religious encyclopedias and books on saints are found either in the religion or in the general reference section.

Symbolism and Allegory

The use of visual symbols for the identification of saints is indicative of the importance of symbols and symbolism in art. Objects, animals, plants or fruit, architectural and landscape elements, frequently occur in paintings for symbolic rather than strictly pictorial reasons. In other words, birds or lions, rocks or trees, are not necessarily in a painting because the artist thought it would be nice to enliven the scene with these features but because of their symbolic or allegorical significance.

A popular source on symbols is *Signs and Symbols in Christian Art* (1954), by George W. Ferguson, which explains in simple language the symbols of Jesus Christ, the Virgin Mary, the Evangelists, and the principal saints. The illustrations all reproduce paintings in the Kress Collection, and there are line drawings of the symbolic objects in the margins of each page. The *Dictionary of Subjects and Symbols in Art* (1974), by James Hall, is broader in coverage and more scholarly, including also allegory and a fairly wide range of subjects from mythology, legend, and history. References to primary sources are given in most entries and there is a general bibliography of the iconographic literature.

The principal secular allegories common in baroque painting can be traced to a famous work, *Iconologia,* by Cesare Ripa, the first illustrated edition of which was published in 1603 with an Italian text and woodcut illustrations. This major source is available in an English edition under the title *Baroque and Rococo Pictorial Imagery: The 1758-60 Hertel Edition of Ripa's 'Iconologia'* (1971), and combines the texts of several editions. The illustrations, however, rather than reproducing the simple woodcuts of the 1603 edition, consist of elaborate engravings in the rococo style. The introduction, by the translator Edward A. Maser, is helpful in placing this work in the proper art historical context and in explaining the special features of this important source.

Visual Sources

It goes without saying that artists depended not only on literary sources for their works but on visual sources as well. As a matter of fact, artists of the past quite freely copied or adapted the creations of other artists. The yearning for originality, which characterizes modern art, was unknown in earlier centuries. Thus iconographic analysis often calls for

comparisons of different works with similar subject matter, either by the same artist, or by different artists of the same school, or by artists of other schools and periods.

An elementary finding list for subjects in painting is *Index to Reproductions of European Paintings* (1956), by Isabel S. Monro and K. M. Monro. This book indexes the paintings reproduced in about 300 "general books available in most art libraries" under the name of the artist, title of the painting, and subject, all in a single alphabet; location of the original and source of the illustration are also given. In example, the listing under "Jesus Christ" gives dozens of representations of the Nativity, Crucifixion, and other scenes painted by a great variety of artists.

Although the books indexed in Monro and Monro may no longer be available over twenty years after publication, the index has not lost its usefulness as a subject guide to paintings. With so many new and better illustrated art histories and artists' monographs now available in libraries, it is most likely that a better reproduction of the desired painting can readily be found in a book other than the one originally indexed.

An important German compilation, which unfortunately was never translated, provides broader, more scholarly coverage. It is *Barockthemen* ("Themes of the baroque"), by A. Pigler (2d ed. 1974. 3 vols.). In translation, the subtitle reads: "Selected Listings on the Iconography of the Seventeenth and Eighteenth Century." This book lists, indeed, the themes and subjects represented in seventeenth- and eighteenth-century paintings, but it frequently includes the antecedents and is therefore useful even for Renaissance treatments of various subjects. The Old and New Testaments, mythology, history, allegory, and genre subjects are covered. A section called "Special Subjects" includes such assorted oddities as flea catchers, bird concerts, dentists, and wedding nights. For every subject the exact literary source is given, and there is a bibliographical source for a reproduction of the painting. There is no real text, but unfortunately all subjects, titles of paintings, and so on are, of course, in German. However, since the painter's name presents no linguistic problem, the difficulties of translating titles and subjects with the aid of a dictionary are not insurmountable. Regrettably, the bibliographical citations refer for the most part to older European books and periodicals not commonly found in American libraries, except in the very largest ones. Thus the search for an illustration can be quite tedious.

The great pictorial compilations also serve as useful tools for iconographic research. Of particular value for Italian Renaissance paintings are the seven volumes of illustrations to Bernard Berenson's *Italian*

Pictures of the Renaissance: two volumes each on the Florentine School (1963) and Venetian School (1957), and three volumes on the Central Italian and North Italian schools (1968). *Early Netherlandish Painting* (1967-76. 14 vols.), by Max J. Friedländer, contains about 2,000 illustrations, which makes it a very rich pictorial source for fifteenth- and sixteenth-century Dutch and Flemish painting.

It should also be noted that the *Art Index* is an important general tool for finding illustrations of specific paintings, sculptures, and other works reproduced in periodicals. References to these reproductions are handled in two ways. If they appear as illustrations in an article, they are listed immediately after the citation for that article, preceded by the word "il:" (for illustration). Works of art produced *without any accompanying text* are listed under the artist's name after the subhead "Reproductions." However, since titles of works are always given in the language and form in which they appear in the magazine source, the references listed are sometimes difficult to identify.

Research Resources

A special tool for advanced iconographical research is the *Index of Christian Art,* which was begun at Princeton in 1917 on the initiative of Charles R. Morey, then the leading American medievalist. His aim was "to catalogue by subject and 'picture type' all the known (published) monuments of Christian art dated before the year 1400. . ." This *Index,* of which complete copies are at Princeton University, Dumbarton Oaks, and the University of California, Los Angeles, consists of a photograph file of art objects arranged by medium, and four separate card files supplying the documentation for the objects reproduced: a bibliographic file listing the sources of the photographs or illustrations; a file of manuscript titles; a location file of the objects, by name of city; and finally, a subject file. The history and objectives of this vast undertaking are explained in *The Index of Christian Art at Princeton University* (1942), by Helen Woodruff, from which the earlier quotation was taken.

The Warburg Institute of the University of London must finally be mentioned as an institute concerned with iconographical investigation. Its principal interest is the "study of the survival and revival of classical antiquity in the thought, literature, art and institutions of European civilization." The Warburg Institute has published several important studies, in particular *A Bibliography of the Survival of the Classics* (1934-38. 2 vols.) and a series, Studies of the Warburg Institute, of which one volume is *The Codex Huygens and Leonardo da Vinci's Art Theory*

(1940), by Erwin Panofsky. The *Journal of the Warburg and Courtauld Institutes* is valuable for its scholarly contributions to iconographical research.

CHAPTER 3

Primary Sources

Students of art history often find it desirable to consult primary sources — that is, documents or other written information dating from the artist's own time or from the period in which a particular work of art was produced.

There are several distinct types of primary literary source materials. First, there are writings left by the artists themselves: letters; notebooks; diaries, journals, and other autobiographical statements; theoretical, technical, or critical writings; poetry and other literary works; and statements of artistic philosophy. Related to these are oral statements by artists, recorded interviews and conversations, audio- and videotapes, and comparable material.

Second, there is archival material relating to art and artists. This includes registers, inventories and similar listings of works of art, contracts, and other legal or factual records relating to works of art.

Thirdly, there are accounts by contemporaries, such as reports, letters, biographies, critiques, travelogues, and so forth, not by the artists themselves but by their friends (or enemies), family, patrons, critics, or other observers.

Primary sources are also the earliest available literary documents relating to art and artists, if no actual contemporary records exist. This is true particularly of ancient art.

Literary sources relating to iconography have been discussed in the preceding chapter.

Collections and Series

During the last few years an enormous amount of primary source material has become available in English, most of it in the form of highly selected

documents or extracts therefrom, to be used in conjunction with college courses. The common objective of these collections is to make such sources easily accessible to the student and to enable him or her to gain a better perspective of the period or artist to be studied.

The trend setter, so to speak, was *Artists on Art* (1945), compiled and edited by Robert Goldwater and M. Treves. This is still a useful anthology of brief statements of artists from the Renaissance to the recent past. *Modern Artists on Art* (1964), edited by Robert L. Herbert, comprises ten important unabridged essays by twentieth-century artists, among them Albert Gleizes' and Jean Metzinger's seminal essay on cubism.

Combinations of all types of primary sources in excerpts are found in the basic *Documentary History of Art* (1957-58. 2 vols.), compiled by Elizabeth G. Holt, which covers the arts from the Middle Ages to the eighteenth century. Renaissance documents in this set include excerpts from Leone Battista Alberti's treatise *On Painting,* from Piero della Francesca's treatise on perspective – the only English-language source for this important work – and the contracts for Michelangelo's 1498 *Pietà* and his *David.*

Holt's *Documentary History of Art* has a sequel, *From the Classicists to the Impressionists* (1966), which deals with primary sources on art and architecture in the nineteenth-century. This last-named volume, although it contains important documents, is perhaps too condensed to do justice to the diverse trends and movements within so limited a space. More extensive coverage of primary nineteenth century source material is found in the following: *Neoclassicism and Romanticism,* (1970. 2 vols.), edited by Lorenz Eitner; *Realism and Tradition in Art* (1966), edited by Linda Nochlin; and *Impressionism and Post-Impressionism* (1966), also edited by Linda Nochlin. Each of these works contains critiques on art and artists by the leading artists and the literary personalities of the time.

These four volumes form part of the fundamental Sources and Documents in the History of Art series, published by Prentice-Hall under the general editorship of H. W. Janson. Each of the volumes deals with a specific period or area and is edited by an expert in the particular field. There are comments, introductions, and footnotes for each selection, which help to put the excerpts into their proper historical context. The material presented is broad enough to permit fairly intensive study of a particular area.

Examples of other volumes in this series are *The Art of Greece* (1965) and *The Art of Rome* (1966), both edited by J. J. Pollitt; *American Art* (1965), edited by John W. McCoubrey; and *The Art of the Byzantine Empire* (1972), edited by Cyril Mango.

Modern Art

The basic collection of sources in excerpts for modern art is *Theories of Modern Art* (1968), edited by Herschel B. Chipp. This indispensable volume begins with selections from the letters of Cézanne and Van Gogh and writings by symbolist painters and authors. It then takes up the twentieth-century art movements, one by one, introducing important documents. Each section is prefaced with an essay on the salient points of the movement. Fauvism, expressionism, cubism, futurism, constructivism, dadaism, surrealism, are all included, as well as a useful chapter titled "Art and Politics" which includes many artists' statements, and one on contemporary art which features interviews with — and documents by — recent or living personalities in art. The excellent bibliography lists the principal source writings up to 1967/68, with general comments and brief annotations on the items cited.

Since the publication of this volume several new series and collections of sources on the twentieth century have been issued. The most important is Documents of 20th-Century Art, published since 1971 under the general editorship of Robert Motherwell and Bernard Karpel. This series comprises writings and oral statements by artists and critics from Europe and the United States and also some early twentieth-century sources which have never before been available in English. Examples are *Apollinaire on Art* (1972), edited by LeRoy C. Breunig, and *Art-as-Art: The Selected Writings of Ad Reinhardt* (1975), edited by Barbara Rose.

Special Source Collections

There is a host of specialized source books for periods or styles in art. Special mention should be made of *The Elder Pliny's Chapters on the History of Art* (1896), by Pliny, or Plinius Secundus, the Roman scholar of the first century A.D. This source is remarkable, for it is the earliest account of Greek and Roman art, buried though it is in the chapter on minerals and metals in Pliny's *Natural History*.

Another important specialized volume is *The Gothic* (1960), by Paul Frankl. The author, who devoted his life work to the study of Gothic art, has explored what has been written about the phenomenon of the Gothic from its very beginning — the writings of the Abbot Suger — to the twentieth century. In his text he has thoroughly and critically examined and evaluated these sources and has substantiated his analyses with long quotations from the original writings translated into English.

A different type of souce book is *French Painters and Paintings from the Fourteenth Century to Post-Impressionism* (1970), by Gerd Muehsam.

This is a collection of about one thousand contemporary and later criticisms of French painters and individual paintings which is, in effect, a documentary history of French painting, with a very full bibliography.

"Complete and Unabridged": Artist's Writings

While the usefulness of the collections cited in the preceding pages is unquestioned, there is much to be gained from seeking out — at least occasionally — some of these sources, especially those available in English, in their complete and unabridged form. They truly add another dimension to the understanding of art and of the great artistic personalities and their works.

The writings of the two towering figures of the Renaissance, Leonardo da Vinci and Michelangelo, are discussed in Chapter 10 on the Renaissance. These writings, which are among the earliest literary documents left by any artist, are readily available in English and can be appreciated without too specialized a knowledge of Renaissance art theory. Leonardo's writings — to be consulted in the Jean P. Richter edition, *The Literary Works of Leonardo da Vinci* (3d ed. 1970. 2 vols.), of which the paperback edition has the title *The Notebooks of Leonardo da Vinci* all but dazzle the reader with their depth, vision, and keen observation, reflecting the genius of this universal mind. Michelangelo's revealing poems will touch anyone with a feeling for poetry.

Artists of the seventeenth and eighteenth centuries have composed many theoretical treatises. However, most of these have never been translated in full and are more or less in the domain of the specialist.

Two major theoretical works from eigtheenth-century England, however, have the great advantage that they can be read in the original, although they require a good foundation in academic art theory. *The Analysis of Beauty* (1753), by William Hogarth, derives its concepts mostly from Italian theorists. It gives no clues at all to Hogarth's paintings, such as the well-known satirical picture cycles, *Rake's Progress* and *Marriage à la Mode.* The famous *Discourses on Art*, by the portrait painter Joshua Reynolds, date from 1769 to 1790 when Reynolds was at the height of his fame. The *Discourses* reflect the prevailing academic training and values in art but also reveal a certain amount of independent thinking — for example, Reynolds' preference for Rembrandt and Titian over the academic painters in vogue at the time.

The nineteenth century is particularly rich and rewarding in artists' writings. To remain in England, there are the *Memoirs of the Life of John Constable, Composed Chiefly of His Letters,* by C. R. Leslie, first

published in 1845, only a few years after the death of the great English landscapist in 1837. The enlightening appendix of 1836, "Notes of Six Lectures on Landscape Painting," shows the unorthodox ways of Constable's teaching and his seemingly impromptu characterizations of painters and paintings he liked or disliked. This volume has lost some of its value since the publication of *John Constable's Correspondence* (1962-68. 6 vols.) and his *Discourses* (1970), both compiled and edited by R. B. Beckett, which — together with *Further Documents and Correspondence* (1975) — are as complete as present research would have it.

The Pre-Raphaelites, who emerged in England after 1848, were painters as well as poets. William Holman Hunt, who, together with Dante Gabriel Rossetti and John Everett Millais, founded the PRB (Pre-Raphaelite Brotherhood), wrote *Pre-Raphaelitism and the Pre-Raphaelite Brotherhood* (1905. 2 vols.), essentially an autobiographical work but also the authentic source for the movement, written by one of its leading participants.

In the last quarter of the century stands the American-born painter James Whistler, who lived in London most of his life. Whistler, whose art was sharply attacked by the British critic John Ruskin, sued Ruskin for libel and won, but this victory did not help to make Whistler more acceptable to the British public of his day. *The Gentle Art of Making Enemies* (2d ed. 1892) was his witty and sarcastic defense against the verbal attacks of his critics. It remains a provocative declaration of the artist's right to express himself as he sees fit.

The Journal of Eugène Delacroix (1948), in the competent abridged translation by Walter Pach, is probably the major artistic. literary document from the first half of the nineteenth century. The wide range of Delacroix's artistic and literary interests, his brilliant circle of friends, which included the composer Frédéric Chopin and the novelist George Sand, are manifest here. His "Notes for an Intended Dictionary of Painting," which are scattered throughout the latter part of the journals, are important statements on technique. The only English-language source for the writings on art by Ingres, Delacroix's great opponent, appears in Walter Pach's *Ingres* (1939), of which part 2 contains his recorded words, notes and letters.

One of the great human and artistic documents of all time is *The Complete Letters of Vincent van Gogh* (1958. 3 vols.).* Few readers will fail to be touched by Van Gogh's intensity, passion, and deep commitment to art, and his extraordinary sensitivity to nature and its colors. The third

*An unauthentic collection of Van Gogh's letters, edited by I. Stone and published under the title *Dear Theo,* should be avoided.

volume particularly reveals Van Gogh's anguished mind, his tragic encounter and rupture with Gauguin in Arles, his final months in the asylum at Saint Remy and with Dr. Gachet at Auvers, where he commited suicide in 1890. Most of the letters are addressed to Van Gogh's brother, Theo. The third volume, though, also contains his important letters to Émile Bernard, which deal more with technical matters. The complete edition is enhanced by fine facsimile reproductions of the many sketches included in the original letters.

The writings of Paul Gauguin form, so to speak, a counterpoint to those of Van Gogh, although Gauguin experienced his own kind of agonies. Gauguin was a brilliant writer whose epigrammatic style seems very modern. His *Intimate Journals* (1936) are an abridged translation of *Avant et après* ("Before and After;" 1903). They contain extraordinary reflections on life and art and also tell Gauguin's side of the tragic relationship with Van Gogh. In his *Letters to His Wife and Friends* (1949) Gauguin articulates the meaning of some of his key pictures in a most remarkable way. His *Noa Noa: Voyage to Tahiti* (1961), while not really on art, is a piece of accomplished writing on his escape to the pure and primitive life on the South Sea Islands. Two versions exist: the one edited for publication by his friend Charles Morice, who toned down Gauguin's unconventional prose, and the unedited version, which has become available in English only recently and is especially worthwhile because of Gauguin's fine illustrations.

A lively and authentic picture of the Parisian art scene and the impressionists' struggles during the 1880s and 1890s emerges from the *Letters to His Son Lucien* (3d ed. 1972), by Camille Pissarro, edited by Lucien Pissarro and John Rewald. These letters, documenting also Pissarro's own work and his unflagging social concerns, still fascinate because of Pissarro's judgments of his fellow artists Cézanne, Renoir, Degas, Claude Monet, and Gauguin. Paul Cézanne's *Letters,* edited by John Rewald, which should be read in the expanded 1976 edition, reveal this master's withdrawn, almost misanthropic personality; they contain important clues to Cézanne's ideas about art and his own artistic objectives. The much quoted paragraph from a Cézanne letter of 1904 to Émile Bernard, "Treat nature by the sphere, the cylinder, the cone . . ." which was to become the point of departure for cubist aesthetics, is an example.

Two seminal essays by early twentieth-century artists provide a verbal justification for abstract art: *Concerning the Spiritual in Art* (1912), by Wassily Kandinsky, and *Plastic Art and Pure Plastic Art* (1937), by Piet Mondrian, both published by George Wittenborn in the Documents of Modern Art series.

Paul Klee's brief treatise *On Modern Art* (1924) has been called by the English critic Sir Herbert Read "the most profound and illuminating statement of the aesthetic basis of the modern movement in art ever made by a practising artist." In order to explain art, Klee "tells us what happens inside the mind of the artist in the act of composition — for what purposes he uses his materials, for what particular effects (he) gives to them particular definitions and dimensions." This is a singular work, yet for all its brevity Klee's difficult, staccato prose does not make for effortless reading.

Much of Klee's thinking and writing about art was done in conjunction with his teaching at the Bauhaus. *The Thinking Eye* (1961) and *The Nature of Nature* (1974), published as *Paul Klee Notebooks* (2 vols.), are chiefly collections of Klee's voluminous notes for his Bauhaus courses. These remarkable volumes allow us to glimpse the workings of a great artist and a brilliant mind. Klee observes and comments on artistic vision, form, structure, and creation — without, however, offering a coherent theory of art. Sketches, graphs, and drawings in Klee's inimitable style clarify the text throughout, forming an integral part of this exceptional work.

The published statements on art by Henri Matisse, which have been gathered together by Jack Flam under the title *Matisse on Art* (1973), complement the study of Matisse's paintings in a singular way. For Matisse was not so much a philosopher as he was a painter concerned with his métier. His writings mirror the evolution of his art in that his pronouncements follow rather than precede each new stage of his artistic development, beginning with his "Notes of a Painter,"* written in 1908 at the age of 39.

In 1964 John Cage, the avant-garde composer and critic, said of Marcel Duchamp: "The danger remains that he'll get out of the valise we put him in. So long as he remains locked up — . . ."** In the end, Duchamp did get out of the valise. He had major retrospectives in London, Zurich, Milan, Paris, and New York. In 1971 Pierre Cabanne published his *Dialogues with Marcel Duchamp* in the Documents of 20th-Century Art series, in which Duchamp, shortly before his death, talked (seriously?) about himself and his art. And, finally, the famous *Salt Seller*, by Marcel Duchamp (Marchand du sel), edited by Michel Sanouillet and E. Petersen, was translated into English, including even the nonsensical utterances of "Rrose Selavy," and was published in 1973 by a prestigious university press.

* This essay is also printed in full in Alfred H. Barr's *Matisse: His Art and His Public* (1951), pp. 119ff.

** Quoted from the exhibition catalog *Marcel Duchamp* (1973), edited by Anne d'Harnoncourt and K. McShine, p. 188.

Poets and Critics on Art

Critiques of current works of art by contemporary writers made their first appearance in mid-eighteenth-century France, where public art exhibitions, called Salons, were regularly held. The French encyclopedist Denis Diderot was the first great master of this new literary genre — art criticism — which was to develop into a powerful cultural force in France. Diderot's Salon reviews, covering the years from 1759 to 1781, were barred by censorship from publication and official circulation in France until after the French Revolution (they were written for foreign royalty). The *Salons* have still not been translated into English, but there are excerpts from them in *French Painters and Paintings from the Fourteenth Century to Post-Impressionism* (1970), by Gerd Muehsam.

Reviews and other essays on contemporary art by the French poet Charles Baudelaire show art criticism at its most brilliant and evocative. Baudelaire's hero was the painter Eugène Delacroix. Baudelaire wrote ecstatically about him throughout his literary career, beginning with his very first art critical effort, the "Salon of 1845," and culminating in "The Art and Life of E. Delacroix," published in 1863, the year of Delacroix's death. Baudelaire's complete writings on art are available in an excellent English translation by Jonathan Mayne as *Art in Paris* (1965), which contains chiefly the Salon reviews, and *The Painter of Modern Life* (1964), which includes the superlative essay by the same title on the painter Constantin Guys.

A few years after Baudelaire, the novelist Émile Zola took up his pen in defense of Édouard Manet, whose *Déjeuner sur l'herbe* and *Olympia* had created a public scandal in Paris. Zola wrote ardent and prophetic lines about Manet, demolishing the art "establishment" in the process, which cost him his job as an art critic. Zola's articles on Manet are translated in *Portrait of Manet by Himself and His Contemporaries* (1960), edited by Pierre Courthion and Pierre Cailler, but only excerpts of Zola's other art critical writings have appeared in English-language sources.*

English art criticism in the nineteenth century was dominated by John Ruskin. His writings, which fill thirty-eight volumes, deal not only with art and architecture, but also with natural history, political science, and utopia. *Modern Painters* (1843-60. 5 vols.), has remained historically important for its discussion (primarily in volume 1) of J. M. William Turner, who, in the eyes of Ruskin, was the supreme landscape painter.

**The Genius of the Future* (1971), by Anita Brookner, is a highly readable study of Diderot, Baudelaire, Zola, and other French writers as art critics.

Although Ruskin, in praising Turner and championing also the Pre-Raphaelites in his essay "Pre-Raphaelitism" (1851), was in sympathy with some artists of his own day, he was completely out of touch with the aims of more avant-garde painters. A case in point was his unprecedented attack on James Whistler, whom he denounced as "flinging a pot of paint in the public's face."

Ruskin's well-known *Seven Lamps of Architecture* (1849) and *Stones of Venice* (1851-53. 3 vols.) are not just architectural studies but are pleas for the return to medieval ideals in order to cure the ills of modern society and to restitute true beauty and morality.

Roger Fry, who began his career as a critic at the turn of the century, was among the first to interpret the aims of the post-impressionist and cubist painters. He stressed the formal qualities in art, which cubism had taught him to value. In his important *Cézanne,* which was first published in 1927 by Leonard and Virginia Woolf, Fry recognized Cézanne as the master who paved the way for abstraction because of his effort to create form, and because his paintings conveyed no message and told no story.

A number of twentieth-century poets have written distinguished biographical essays on artists, which qualify as primary sources and which may be read and enjoyed also for their literary merits. *Rodin* (English ed. 1946), by the German poet Rainer Maria Rilke, dates from the period around 1903 when Rilke was closely associated with the great French sculptor. This beautifully written essay is distinguished for its insight into Rodin's art, which resulted from Rilke's personal observation.

Henri Gaudier-Brzeska, a French sculptor killed in action during World War I at the age of twenty-four, would be all but forgotten were it not for *Gaudier-Brzeska: A Memoir* (1916), by the controversial American poet Ezra Pound. It was written under the impact of the news of the young sculptor's death and remains a remarkable literary document about creativity and senseless loss.

Gertrude Stein, a lifelong friend of Pablo Picasso, wrote two essays on the painter, dating from 1909 and 1938, and they, along with some previously unpublished extracts from her notebooks, form the core of *Gertrude Stein on Picasso* (1970), edited by Edward Burns. As one reviewer expressed it, "One artistic giant of the century comments on another, and the air becomes electric with insights both direct and subtle."

Reference Sources and Resources

Bibliographies

A bibliography may be simply defined as a list of books and other references relating to a given subject. Such a bibliography may be part of a book or article or it may stand alone as an independent compilation.

Most monographs and studies with some pretension to scholarship include bibliographies. The importance of these bibliographies becomes evident if one realizes that serious authors not only research and study the pertinent literature but owe it to their readers to state their sources. Any subsequent researcher would waste an enormous amount of time if he did not use the bibliographical leads provided by the author.

The works cited in a bibliography may be arranged alphabetically by author or chronologically by date of publication, or they may be classified — that is, broken down into captioned sections. An annotated bibliography includes brief descriptive or critical comments on some or all of the entries.

The bibliography is usually found at the end of the book preceding the index, under a heading such as "Bibliography," "References," "List of Works Cited," "Recommended Reading," "For Further Study," or the like.

In addition to a bibliography, scholarly works usually have footnotes at the bottom of the pages or notes — indicated by small reference numbers in the text — at the end of the text or chapter. These notes and footnotes document the author's statements and may contain additional bibliographical references. They often lead to the most revelant sources, yet unfortunately they are all too frequently overlooked by the reader. Since the material referred to in these notes is not always included in the general bibliography of the book, both should be studied if the best use is to be

made of the material at hand. A comparison of the general bibliography and the notes in one of the volumes of the exemplary Pelican History of Art series bears out this observation.

Some of the major reference and research tools of art history are particularly important for their comprehensive bibliographies. Notable examples among the encyclopedias and dictionaries are the *Encyclopedia of World Art* and Thieme-Becker mentioned earlier. As has been pointed out elsewhere, the *catalogue raisonné* and the *corpus* in particular offer exhaustive bibliographical documentation. Catalogs of permanent museum collections and of major exhibitions usually have essential bibliographies. Some monographs and histories feature valuable critical bibliographies which are often consulted in their own right, as for example John Rewald's *History of Impressionism.* Bibliographies on specific subjects can also be found in the library's card catalog by looking under the appropriate subject with the subhead "Bibliography," as, for example, "Architecture − Bibliography," "Painting, American − Bibliography," or "Pre-Raphaelitism − Bibliography."

General Trade Bibliographies: Current

A useful source for finding English-language books that are currently being published is the monthly *Cumulative Book Index,* which is cumulated regularly. It covers books published in the United States and in other English-speaking countries − Canada, Great Britain, Australia, and so on − as well as books in English published elsewhere. The helpful feature of the *Cumulative Book Index* is that authors, titles, and subjects are all conveniently listed in one alphabet. Art students should take note, however, that the *Cumulative Book Index* excludes most museum publications except those few which are commercially distributed.

Books in Print, published annually in two or more volumes (one lists authors, the other lists titles), is the fat set that salespeople in bookshops check when customers ask for books the store does not have in stock. *Books in Print* lists only books published in the United States which are "in print," or available from the publishers, as opposed to those which are "out of print," or unavailable. Author, title, publisher, price, series, edition, and often date of publication are given for each item. This work includes a complete directory of U.S. publishers and their addresses, but omits most publications issued by museums.* The companion to

Museum Media, published biennially since 1973, fills this gap to some extent, listing publications and audiovisual materials currently available from U.S. and and Canadian museums and similar institutions. The *Worldwide Art Catalogue Bulletin* is an international, annotated trade list of selected art exhibition and museum collection catalogs distributed by Worldwide Books, Boston.

Books in Print is *Subject Guide to Books in Print,* which groups all classifiable titles by subject. Both *Books in Print* and *Subject Guide to Books in Print* are subtitled *An Index to Publishers' Trade List Annual.* The *Publishers' Trade List Annual* is composed of publishers' catalogs, or trade order lists, bound together in big volumes, in which each publisher — commercial or university press — lists his currently available books. This is the tool to use when one is searching for books in print by a particular publisher. *Paperbound Books in Print,* issued once a year, with supplements, lists currently available paperbacks in two separate alphabets, by author and title. It has a special subject section which includes art subjects.

Art Bibliographies

Guide to Art Reference Books (1959), by Mary W. Chamberlin, is a pioneer work listing about 2,500 scholarly publications — including periodicals — in English and the principal Western languages. It includes brief annotations. "Art" books are defined as publications falling roughly within the "N" class of the Library of Congress classification scheme. The choice of titles on the whole is excellent, although some of the older works have since been superseded. The chief limitation is the omission of artists' monographs and most museum publications.

A more selective bibliography, geared primarily to the undergraduate, is *Art Books: A Basic Bibliography on the Fine Arts* (1968), by E. Louise Lucas, based on her earlier *Harvard List of Books on Art.* Architecture, painting, sculpture, the graphic arts, and the so-called minor arts, as well as iconography and symbolism, are the major subject divisions. Half of the book is given over to monographs on individual artists — arranged alphabetically by artist's name — as well as writings by the artists themselves. Despite errors in classification and misprints in the foreign-language titles, this compilation is nevertheless useful, especially in view of the many relatively recent publications listed.

Fine Arts: A Bibliographic Guide (1975), by Donald L. Ehresmann, consists of a well-organized and well-annotated listing of just under 1,200 recent titles. The coverage of bibliography and topography is particularly thorough. The limitation of this very worthwhile guide is that publications dealing with only a single medium are not included.

Serial Art Bibliographies, Indexes, Abstracts

Until quite recently the *Art Index* and the *Répertoire d'art et d'archéologie* ("Repertory of Art and Archaeology") were the only existing general

serial bibliographies on art. Although they have retained their importance, several newer bibliographic tools have recently come to the fore — especially *ARTbibliographies Modern, RILA, Art Design Photo,* and *Bibliographic Guide to Art and Architecture.* Together with the numerous art library catalogs, several of which are discussed later in this chapter, they offer unprecedented access to the written documentation of the visual arts.

Art Index, published quarterly since 1929, at present with annual cumulations, is an author-subject index of the contents of 150 art journals, including art museum bulletins and important foreign-language journals. "Art" is broadly defined as encompassing architecture, sculpture, painting, the graphic arts, the applied or decorative arts, photography, and film as well as the allied fields of archaeology, city planning, industrial design, interior design, and landscape architecture. The arts of all civilizations, countries, and periods are covered. Many individual works of art are indexed as reproduced in the journals.

ARTbibliographies Modern indexes and abstracts books, exhibition catalogs, and periodical articles on nineteenth and twentieth-century art, architecture, and design. The material is culled from about 300 international journals; coverage of books and exhibition catalogs is also worldwide. *ARTbibliographies Modern* began in 1969 as the annual *LOMA: Literature on Modern Art* but was completely revamped and redesigned beginning with volume 4 (1973, covering material published in 1972) and is now an easy-to-use, attractively produced semiannual publication. Artists and subjects — with ample cross-references — are arranged in a single alphabet, and there is a separate index of authors. Illustrations, biographical data, and bibliographies are always noted. Titles from foreign-language sources are given in the original language and an English translation.

Art Design Photo, another offspring of *LOMA,* began publication in 1973, indexing material published in 1972. Period coverage extends from the late nineteenth century to the present. Subject range is similar to *ARTbibliographies Modern,* but emphasis is on commercial art and photography. The material is divided into two separate, alphabetically arranged sections for artists and subjects, with an author-title index.

RILA (Répertoire international de la littérature de l'art. International Repertory of the Literature of Art) began in 1975, covering material published 1974/75. According to the statement inside the front cover of volume 1 it "publishes abstracts and detailed indexes of current books, periodical articles, newpaper articles, *Festschriften,* congress reports, exhibition catalogs, museum publications, and dissertations in the field of post-classical European and post-Columbian American art." Sponsored and administered by the College Art Association of America, *RILA* is an

"international network of cooperating institutions and publications." Each issue consists of an abstract section and a very full author-subject index. The main body of the abstracts is divided into three periods — medieval, Renaissance and baroque, and modern. Each period is further subdivided by medium and, where appropriate, by a section on artists.

The *Bibliographic Guide to Art and Architecture*, begun in 1975, has a dual function. It is the supplement to the *Dictionary Catalog of the Art and Architecture Division* of the New York Public Library, which is discussed further below, and functions also as a bibliographic tool in its own right. Each volume contains the materials on art and architecture — in all languages — cataloged by the New York Public Library during the year, with additional entries from the Library of Congress. The combined resources of the two large libraries provide a broad spectrum of current publications in the field. As a multi-access bibliography, publications are listed under authors, titles, subjects, and series, if any. Bibliographic citations are as complete as those on Library of Congress cards, but are given in this fullness in the main entries only.

The *Répertoire d'art et d'archéologie*, begun in 1910, is the oldest of these bibliographic tools. Intended for the advanced student and scholar, it is unique as an international bibliography of books, exhibition catalogs, auction catalogs (before 1945), and an index to periodical articles. Coverage is limited to Western art. The volumes up to 1965 include antiquity; subsequent volumes begin with the Early Christian period. The arrangement of the material, which is explained in each volume, is by subject, and there is an alphabetical author index.

Several journals printed annual or semiannual bibliographies of current books and articles in their respective subject areas. Examples are the *American Art Journal, Journal of Aesthetics and Art Criticism,* and *Oriental Art.* This practice appears bound for extinction.

National Library Catalogs

The catalogs issued by the Library of Congress in Washington, D.C. are the most important general bibliographic tools published in the United States. The Library of Congress, being our national library, receives by law every book copyrighted in the United States. In addition, it acquires many thousands of items each year that cover all fields of knowledge and that are published in all countries and languages of the world.

The basic printed catalog of the Library of Congress's vast holdings is *The National Union Catalog,* begun in 1956. As stated in its subtitle, it is a *Cumulative Author List Representing Library of Congress Printed*

Cards and Titles Reported by Other American Libraries. The reporting libraries are identified for each title. For books published before 1956, the Library of Congress puts out *The National Union Catalog: Pre-1956 Imprints,* popularly called "Mansell," (the publisher's name). Begun in 1968, this monumental publication is still in progress. When completed it will comprise more than 600 volumes, which will "make it the largest single publication ever produced" (preface). Mansell also includes "cataloged holdings . . . of the major research libraries of the U.S. and Canada, plus the more rarely held items in selected smaller and specialized libraries, printed before 1956," making it an unsurpassed scholarly research tool. It must be remembered, however, that the books are listed in these catalogs only under the name of the author or main entry, with appropriate cross-references.

The British Library, which was called The British Museum before July 1, 1973, is Great Britain's national library. Its printed catalog, the so-called British Museum catalogue (*General Catalogue of Printed Books,* issued since 1931), is second only to that of the Library of Congress in importance. It gives bibliographic access to what is probably the world's richest library collection. The British Museum catalogue is mainly an author catalog, but it has some catchword titles and biographical subject entries. It is the essential tool for verifying rare titles and editions in all fields of knowledge, including the visual arts.

Art Library Catalogs

The printed catalogs of major art libraries are important tools for art historical research. Their principal function is to serve as subject and biobibliographies. They are also useful for verifying authors, titles, editions, and descriptive data of books and other library materials. Most of these library catalogs are "dictionary catalogs," reproducing photomechanically and in reduced size the author, title, and subject cards for each work in that library.

The most comprehensive art library catalog is the *Library Catalog* of the Metropolitan Museum of Art, New York City, published in 1960 in twenty-five volumes with supplements. This library of over 200,000 volumes, the largest art library in the Western hemisphere, covers many subjects in great depth. Important articles in periodicals antedating the *Art Index* are also found here, thus strengthening access to subject material. Art auction catalogs are in separate volumes. Note that the Metropolitan Museum of Art uses its own classification scheme. The call numbers in the upper left-hand corners of the cards may therefore be ignored for purposes of bibliographic search.

The *Catalog of the Avery Memorial Architectural Library* of Columbia University (2d ed. 1968. 19 vols. and supplements) admirably complements the "Met" library catalog. The great strength of the Avery Library is in the fields of architecture and planning, but it is also rich in allied subjects, especially the decorative arts. Furthermore, the Avery catalog includes the holdings of the Columbia University Fine Arts Library. Like the "Met" catalog, the Avery catalog is in dictionary form, comprising author, subject, and title cards in one alphabetical sequence.

The *Catalogue of the Harvard University Fine Arts Library, The Fogg Art Museum* (1971. 16 vols. and supplement), combines art resources of several distinguished libraries of Harvard University, including the treasures relating to the arts of the book in the Houghton Library, Harvard's rare book library.

The *Dictionary Catalog of the Art and Architecture Division* of the New York Public Library (1975. 30 vols.) has comprehensive holdings on painting, sculpture, drawing, the decorative or minor arts, and the history and design aspects of architecture. Several important art subjects, however, are collected elsewhere in the library and are therefore omitted from this catalog. As noted in the introduction to volume 1, prints and print-making,* photography, and manuscript illumination are among the subjects *excluded.* This set lists only titles cataloged by the New York Public Library through 1971. Annual supplements, called *Bibliographic Guide to Art and Architecture,* began in 1975. They cover the materials cataloged by the New York Public Library each year as well as additional materials, including art subjects omitted in the basic set, supplied by the Library of Congress through its computerized cataloging processes.

The *Dictionary Catalogue of the Library of the Freer Gallery of Art, Smithsonian Institution* (1967. 6 vols.) is the catalog of an important research library specializing in the arts of the Far East, India, and the Near East, and the American painter James Whistler. The library catalog, divided into one section for Western-language books and one for Chinese and Japanese books, lists also many periodical articles not indexed in the standard periodical indexes.

The *Catalog of the Library of the Museum of Modern Art* (1976. 14 vols.) provides access to the museum's unequaled research materials in the visual arts from 1850 to the present. The scope of the collection is broad; it encompasses painting, sculpture, architecture, the graphic arts,

*The New York Public Library's resources on prints and printmaking, which are housed in its Prints Division, have been published under the title *Dictionary Catalog of the Prints Division* (1975. 5 vols.).

photography, and, in addition, industrial design, and film. The catalog
is in dictionary form. The catalog cards, hand-tailored to the needs of the
museum, often contain scope notes and unusual bibliographical detail.

Art Encyclopedias and Dictionaries

To most people an encyclopedia means the *Encyclopaedia Britannica.*
As a general reference tool covering all fields of knowledge the
Encyclopaedia Britannica is, indeed, an essential work. In fact, selected
articles on the arts written for the fourteenth edition were published
separately in book form and are still found in many libraries. Specialized
art encyclopedias, however, give much more information than do general
encyclopedias and should, therefore, be consulted for art subjects when-
ever possible.

The *Encyclopedia of World Art* (1959-68. 15 vols.) is the principal
scholarly art encyclopedia in English. Each volume is half text, half
illustrations. The importance of its biographical entries — on painters,
sculptors, architects, and so forth — has already been mentioned in
Chapter 1. Articles on major art forms (such as painting or sculpture), on
the principal periods and styles (such as baroque art), and on countries
(listed under the adjective form, as, for example, "Greek Art"), are of
book length. Art movements, such as impressionism, and many specialized
subjects (for example, Buddhism, criticism, patronage, perspective) are
discussed in depth. Even geographical areas little known for their art (such
as Alaska) and many of the "minor arts" (for example automata, enamels,
or gold and silver-work) are included. Well-chosen, comprehensive bibliog-
raphies arranged by date, are an important feature of this great encyclo-
pedia. All of volume 15 is given over to a detailed index.

The *Praeger Encyclopedia of Art* (1971. 5 vols.) and the *McGraw-Hill
Dictionary of Art* (1969. 5 vols.) are easier to read than the *Encyclopedia
of World Art* but are also authoritative. Both have the advantage of having
the illustrations on the same page as the text. They cover periods, styles,
schools, and movements in art, as well as individual artists. Both include
some bibliographical references, mainly of English-language publications.
The principal difference between the two is that the *McGraw-Hill
Dictionary of Art,* being a dictionary, has many but fairly brief entries
(which include also technical terms, buildings, and individual works of art),
whereas the *Praeger Encyclopedia of Art* has fewer but more broadly
treated entries. For example, the *McGraw-Hill Dictionary of Art* has only a
one-paragraph definition of mannerism, whereas the *Praeger Encyclopedia
of Art* gives a six-page survey of the subject.

For concise "explanations of terms encountered in the study and practice of the visual arts and their literature," (preface) *A Dictionary of Art Terms and Techniques* (1969), by Ralph Mayer, is a handy source that stresses contemporary usage. Painting, drawing, sculpture, printmaking, ceramics, and a number of closely allied fields are covered. However, most architectural and Oriental art terms are omitted, as are biographical entries.

Notwithstanding the existence of excellent art dictionaries, regular dictionaries should not be forgotten as a source for word definitions and meanings. Words such as "plane," "recession," "linear," "space," "mass," "volume," and "texture," used frequently in discussing works of art, are not art terms in the strictest sense and are therefore not explained in most art dictionaries. *Webster's Third New International Dictionary,* the "Big Webster" or "Webster Three," is the principal American source for defining and spelling words. *The Oxford English Dictionary* (1933. 13 vols. and supplements) is the fundamental authority for English words. It gives the origin and first appearance of every word and traces its history, changing meanings, and usage.

The principal biographical sources, including dictionaries, were discussed in Chapter 1. But more needs to be said here about the so-called Thieme-Becker, the *Allgemeines Lexikon der bildenden Künstler* (1907-50. 37 vols.), by Ulrich Thieme and F. Becker, which was also first introduced in Chapter 1. The importance of this monumental work, which contains the names of about two hundred thousand architects and artists of all descriptions, makes it necessary to explain its basic features.

The entries on each artist — living as well as dead — provide biographical data, information about the artist's work with extensive listings of his works in major collections, and bibliographical references divided into primary sources and subsequent writings, arranged in chronological order.

But Thieme-Becker does have limitations. To begin with, the publication date of volume 1 — 1907 — and the lapse of forty-three years until the final volume appeared, means uneven bibliographic coverage and problems regarding inclusion of living artists.* Furthermore, many of the artists in Thieme-Becker were researched for the first time by the contributors to the encyclopedia expressly for the purpose of being included therein. Although the amount and quality of this original research is truly remarkable, more facts on many of these artists have since come to light. Finally, the editorial policy of Thieme-Becker changed in the course of

*Hans Vollmer's sequel to Thieme-Becker, titled *Allgemeines Lexikon der bildenden Künstler des XX. Jahrhunderts* (1953-62. 6 vols.), updates the material on some of the artists.

publication. Beginning approximately with the letter "M" only factual information is given, and the aesthetic judgments that are prevalent in earlier volumes are eliminated. In short, the latter half of Thieme-Becker is the more useful. Despite all this, it is unlikely that this work will soon be superseded.

Of the many specialized art encyclopedias and dictionaries only a few particularly significant works can be described here.

The Italian *Enciclopedia dell'arte antica, classica e orientale* ("Encyclopedia of Ancient, Classical and Oriental Art." 1958-73. 9 vols.) covers art and architecture in Europe, all of Asia and North Africa (including Ethiopia) from prehistory to A.D. 500. The emphasis is on classical antiquity — that is, Greece and Rome. Entries include names of artists, mythological and historical figures as represented in art, sites and cities, building types, art forms and techniques. The scholarly articles are well illustrated and have extensive bibliographies including English-language sources. Even students with little knowledge of Italian can profit from the illustrations and the bibliographies. Italian forms of names are used throughout, of course. Thus, for example, the city of Athens is entered under "Atene", the emperor Hadrian under "Adriano", and so forth.

The Britannica Encyclopedia of American Art (1973) is at this writing the only encyclopedia devoted exclusively to the arts in the United States. Clearly written and richly illustrated in both color and black and white, it fills a real gap. It is the best general source for the more important American artists.* Articles on major subjects such as architecture, folk art, furniture, painting, and photography are of essay length. The many shorter articles cover diverse subjects such as Ash Can School, Farm Security Administration, macrame, photorealism, scrimshaw, and many others. The body of the text contains no bibliographical references. All bibliographical material is at the end of the volume. There is an excellent general bibliography as well as specific references for the individual articles and biographical entries. There is also a guide to U.S. art museums that have collections of American art, as well as a glossary of terms.

The *Phaidon Dictionary of Twentieth Century Art* (1973) is a useful but somewhat limited source for European and American artists (excluding architects) and art movements from post-impressionism to pop and minimal art, stopping just short of conceptual art. The definitions and

*For downright obscure artists, "either amateur or professional, native or foreign-born, who worked within the present continental limits of the United States between the years 1564 and 1860, inclusive" (introduction), consult *The New-York Historical Society's Dictionary of Artists in America* (1957), by G. C. Groce and D. H. Wallace.

explanations of art movements and styles are concise yet particularly apt. At least one bibliographical reference is given for most entries. Most helpful for the recent past, not to say the present, is the *Glossary of Art, Architecture, and Design since 1945* (rev. ed. 1977), by John A. Walker. According to the subtitle, this volume lists *Terms and Labels Describing Movements, Styles, and Groups Derived from the Vocabulary of Artists and Critics.* Indeed, terms such as "Colourfield Painting," "Concrete Poetry," "Ekistics," "Happenings," "Hard-Edge Painting," "Holography," "Photo-Realism," "Process Art," and many even more obscure avant-garde manifestations are defined here; most of the terms have bibliographic references leading to the source of the term. There are no biographical entries. A useful index, however, lists the names of artists and critics, as well as museums, connected with the terms mentioned in the text.

Directories

The *American Art Directory* is a directory that most people concerned with the visual arts need at some time to consult. Its two principal sections, which are both arranged by states and cities, are titled "Art Organizations" (including art museums) and "Art Schools" (including art departments of colleges and universities). Information on art museums gives type of collection, activities, and curatorial staff. Data on art schools include admission requirements, degrees offered, summer sessions, and a concise summary of courses taught. Major art schools and art museums in Canada and abroad are also listed. Among the other useful features are listings of art scholarships and fellowships and their application deadlines, art magazines and newspapers that carry art notes and the names of their critics, and state councils on the arts.

The Official Museum Directory: United States and Canada, issued by the American Association of Museums, contains the most complete listing of museums in the U.S. In contrast to the *American Art Directory, The Official Museum Directory* lists all types of museums – natural history, science, historical, and so on. The arrangement is by state and city; the information given on each museum is comparable to that of the *American Art Directory.* Each museum is cross-indexed by name, location, and content of the collection, and there is an index of museum personnel.

On an international scale, *Museums of the World* (2d ed. 1975) covers over 17,000 museums of all types, and on all the five continents. The arrangement is by continent, country, and city. This means, for example, that in the United States section, cities are listed in one alphabet, regardless of state. There is a subject, name, and geographical index.

International Directory of Arts (2 vols.) is again restricted to art subjects. Listings include organizations as well as individuals — art museums, art galleries, libraries, art associations, universities and colleges, art dealers, restorers, experts, book publishers and sellers, private collectors, and others active in the arts. All names, organizations, and firms are grouped by country and, whenever feasible, are subdivided by cities.

The Fine Arts Market Place lists a multitude of suppliers of commercial goods and services for artists and art organizations. *Artist's and Photographer's Market* is an even richer guide to potential markets where free-lance artists — illustrators, cartoonists, designers, photographers, and craftsmen — can sell their work.

Most of these directories are updated at regular intervals.

Topographical Guides

Topographical guides and artistic inventories of countries and regions are a special type of art reference source. They describe and usually illustrate the buildings and artistic monuments of a given country in a systematic, "topographical" arrangement — that is, by place. Museum collections are not always part of such inventories.

The most thorough topographical guides are those undertaken by government bodies. They usually take a long time to produce, and are multivolume sets in which each volume inventories a county, province, district, or locality. Excellent, less extensive topographical handbooks have also been compiled by tireless scholars, however.

A detailed listing of these guides is found in Chapter 9 of D. Ehresmann's *Fine Arts* (1975). But, being chiefly architectural, the most accessible one for English-speaking students, *The Buildings of England* (1946-74. 46 vols.), by Nikolaus Pevsner, has not been included. Pevsner's compact volumes, arranged by county, describe the religious and secular buildings and their contents from prehistoric and Roman remains to the present. Most of the texts were written by Pevsner himself, who has also critically assessed many of the buildings. This set is not to be confused with the official inventory of art and architecture undertaken in England by the Royal Commission on Historical Monuments.

Museology

Museology is the study of the purposes, functions, and activities of museums. It is a highly specialized field which cuts across many disciplines. The literature, which is for the most part technical, is concerned with

three principal spheres: the management of museums; the object-related matters of collecting, conservation, exhibition, research, and interpretation; and the people-related aspects of the museum's educational and community role. Most of this material is not published in book form but appears in journal articles, committee and organization reports, conference proceedings, and the like.

An informative, historically oriented study of museums is *The Museum Age* (1967), by Germain Bazin. *On Understanding Art Museums* (1975), a collection of background papers prepared for the 46th American Assembly at Arden House, Columbia University, provides "a general but informed background on art museums" in order to achieve a "better understanding of the art museum, its aims, tasks, problems, and future" (introduction). The basic source for the conservation of art objects is *The Conservation of Antiquities and Works of Art* (2d ed. 1971), by Harold J. Plenderleith.

The American Association of Museums is the official organization of United States museums. It publishes the previously mentioned *Official Museum Directory* and issues valuable studies on aspects of museology. *Museum News* is the association's official journal. The American Association of Museums is closely allied with the International Council of Museums (ICOM) which, in turn, is affiliated with the United Nations Educational, Scientific and Cultural Organization (UNESCO). UNESCO publishes an international journal, *Museum.*

Computer technology arrived in museums about a decade ago. In 1968 the Metropolitan Museum of Art sponsored a conference on "Computers and Their Potential Applications in Museums," of which the proceedings were published by the Arno Press. At that conference a number of ongoing computer-aided projects were discussed. One of them was the Museum Computer Network, which had been formed in 1967 as a consortium of sixteen museums in New York and Washington, and which is now a nonprofit corporation with headquarters at the State University of New York (SUNY), Stonybrook. The ultimate goal of the Museum Computer Network is the establishment of a computer-based information system which will store and disseminate descriptive data about objects in United States public art collections. Its immediate objective is the conversion of collection-related records to machine-readable form, a task which is presently being undertaken by its member institutions.

Art Auction Catalogs

The most common way to acquire or sell works of art is through an art dealer or at auction. Art auctions exist on many levels, from a simple New

England country auction to the great sales at Sotheby Parke-Bernet in New York or Sotheby's in London, which are often glittering social events attended by an international clientele of museum directors, art dealers, and wealthy collectors.

The better art auction houses issue sales catalogs that list the works to be sold in a numerical order established by the auctioneer. The quality and accuracy of the catalogs range from inadequate to excellent, depending largely on the prestige of the auction firm. Some sales catalogs of important collections or estates have in fact become reference tools of continued usefulness.

Auction catalogs are seldom consulted by college students. But they are important for art collecting, and hence are used by museum curators, art dealers, and collectors. Large museums and public libraries keep files of art auction catalogs, but college libraries rarely do. Current auction catalogs, such as those issued by Sotheby Parke-Bernet, may be subscribed to — either "unpriced" or "priced." Unpriced catalogs are available a few weeks before the sale and include a separate list of estimated prices; priced catalogs are, of course, supplied only after the sale and list the actual prices paid.

The Auction Catalogue Collection on microfilm in the Archives of American Art is the most complete record of United States auction catalogs and their contents from 1785 to the cutoff date of 1963. Auction sale prices of works of art are recorded in a number of publications, among them *Art Prices Current, World Collectors Annuary,* and *The International Art Market.*

Audiovisual or Nonprint Materials

Photographs, color reproductions, and slides of works of art have long been commonly available in art libraries for the study and teaching of art and art history. In recent years these and other audiovisual or nonprint materials have also become prevalent in general libraries and learning resource centers, not just to enrich the traditional printed information sources on art, but to serve as visual documentation and "learning materials" for other disciplines as well.

In the visual arts, the term "audiovisual" is used for a broad spectrum of nonprint materials, including slides, photographs, the so-called study prints, films, filmstrips, audio cassettes, and videotapes. Multimedia kits consist of filmstrips or slide sets on a given topic to be viewed in conjunction with a recorded talk or explanation on a disc or cassette, sometimes in combination with music. Typical art subjects are demonstrations of

graphic or crafts techniques, surveys of the art of a country, period, or movement, and interpretations of artists' works. Some of the most instructive slide-cassette programs, which would qualify as primary source materials, record an artist's voice talking about his or her own works which can be viewed on the accompanying slides.

Audiotapes of lectures, discussions, or interviews available on reels or cassettes are another important type of material. They may have been recorded locally from programs sponsored by the parent organization or acquired from commercial or noncommercial sources. Here the speaker(s) may be as important as the subject discussed. The significance of the audiotape lies in the fact that the sound of the speaker's voice gives a directness and an impact which transcripts can rarely provide. Oral history collections, which are being developed throughout the United States by universities and other institutions, are a special category of taped records.

Motion pictures have for some time been one means of demonstrating art techniques, documenting and interpreting works of art and architecture, and recording the creative activities of artists. This type of documentary film serves specific instructional purposes, quite distinct from films "as art", — that is, motion pictures which are independent artistic creations to be viewed and studied for their own expressive and visual qualities.

Videotape, because of its immediacy and relative ease of production, plays an increasingly important role in recording and documenting art and artistic events and, again, as an art medium in its own right, but here the distinction between "art" and "documentation" is subtle.

Microfilm and microfiche have, until now, not really belonged in this category. They have been used in art libraries chiefly to provide access to traditional library materials such as dissertations, rare and out-of-print books and catalogs, periodicals sets, and such. But this is about to change. The University of Chicago Press has just launched a publication program which may well represent a breakthrough in producing high-quality pictorial material on microfiche. Named Text/Fiche, these new scholarly publications, which include several museum collection catalogs, combine print and film. Introductory texts and captions are printed in booklet form, and the illustrations, in full color or black and white, are carried on film for enlargement by a microfiche reader. A single four-by-six-inch microfiche holds eighty-four images. The compact and relatively inexpensive fiche thus permits publication of pictorial resources on a scale which far exceeds the limits of conventional book publishing.

Bibliographic Control

Although audiovisual materials are produced in profusion, bibliographic

control of these nonprint sources is still in its infancy. But projects for better control are in the discussion stage at many quarters. There is at present no comprehensive listing, comparable to *Books in Print,* of what is being published in the nonprint area. The indexes produced by the National Information Center for Educational Media (NICEM) of the University of Southern California, Los Angeles, come closest to being a comprehensive source. Some of these indexes, important for the visual arts, are: *Index to 16mm Educational Films; Index to 35mm Educational Filmstrips; Index to Educational Videotapes; Index to 8mm Motion Cartridges; Index to Educational Slides;* and *Index to Educational Overhead Transparencies.* All of these are kept current by the *NICEM Update of Nonbook Media.* Otherwise there is only a multitude of catalogs put out by publishers, producers, and distributors, many — but by no means all — of whom are listed in the annual *Audiovisual Market Place.*

There is, furthermore, no comprehensive guide or review tool for college-level nonprint material in general, nor is there a subject guide to these resources on art. The two better-known journals listing or indexing reviews, *Previews: Non-Print Software and Hardware News and Reviews* and *International Index to Multi-Media Information*,* lump together reviews of materials for all age and educational levels from kindergarten to college. Art is, at best, only one of the many subjects included. It is equally cumbersome to locate reviews of college-level art media in review tools such as *The Booklist,* published by the American Library Association, and *Landers Film Reviews.*

Much of this material itself is flawed bibliographically, if not educationally, because of the anonymity of authorship. Very few producers and publishers of "learning materials" name the persons who compiled the visual components or wrote the narrations, teachers' manuals, or student guides. This anonymity, to which little attention has been paid in the literature, raises serious questions about accountability — the credentials of those unknown persons who prepared the materials and the authenticity and accuracy of the information presented. Such anonymity is, of course, the very opposite of book and journal publishing, where authors assume full responsibility for their works and stake their professional reputation on their writing. It must be said, however, that the most responsible publishers of audiovisual materials always name those who have prepared or contributed to their products.

*A three-year cumulation, covering the years 1970-72, compiled by W. A. Doak and W. J. Speed, was published in 1975.

Art Sources

Despite the paucity of bibliographic tools for art materials in the nonprint field, it is yet possible to have convenient access to a variety of media. Most helpful are the special art catalogs and listings put out regularly or occasionally by several commercial and noncommercial organizations. A few important examples are mentioned below. The first, *Films on Art: The Arts Council of Great Britain (1975)*, lists thirty-two outstanding films distributed jointly by The American Federation of Arts and Films Incorporated. The catalog itself is a model of its kind, giving fullest documentation and description of each title. *Art + Cinema*, published since 1973, lists and carefully annotates selected art films, videotapes, and slide sets on contemporary art from different sources, which are distributed by Visual Resources, Inc., New York. *Castelli-Sonnabend Videotapes and Films* (1974, with supplements) lists artists' films and tapes that are produced and distributed by these two New York galleries. *Slide Lectures and Films* (1975), issued by the Extension Service of the National Gallery of Art, Washington, D.C., lists slide sets in combination with lectures on recordings or cassettes and 16mm films, all based on the National Gallery collections, lent free of charge. A source book, *Films on Art*, is being prepared by the Canadian Centre for Films on Art, Ottawa, for The American Federation of Arts, and is scheduled for commercial publication in 1977. This book will consist of about four hundred titles and will give technical data, principal credits, and descriptions as well as Canadian and United States sources for rental and sale.

Art Slides

The above-mentioned *Index to Educational Slides*, published by NICEM, makes it possible to search out sources for slide sets on art subjects by title or keyword, but it gives no indication about visual quality nor does it give sources for single slides — and the selection of individual slides, rather than merely the assembling of sets, is still an important ingredient in building art historical slide collections. *The Slide Buyer's Guide* (3d ed. 1976), by Nancy DeLaurier, published by the College Art Association of America, is a dependable tool for this very purpose. It gives commercial and museum sources for all types of art slides, helpful hints on procurement, information about subject coverage, and a professional committee evaluation of slide quality, for each source. The third edition has an extensive subject index.

Pictures, Photographs

The student is often faced with a special problem when pictures, photographs, or other visual materials are needed to illustrate a paper, report, or notebook. Here again, no centralized outlets exist. Since raiding the library's collections is not the thing to do, suitable alternatives are suggested below.

Most museums have a bookshop or sales desk where postcards, slides, and color reproductions of the principal works in the museum can be purchased. Some museums offer, in addition, slides and color reproductions of works other than those in their own collection. Museums also furnish, at a reasonable cost, eight-by-ten-inch glossy photographs — sometimes called "museum photographs" — of all or most of the objects in their collections. As a rule, photographs must be ordered in writing from the museum's registrar or photographic department.

The most important source of inexpensive, medium-size reproductions of paintings, sculptures, and architecture is The University Prints in Winchester, Massachusetts. This basic, continuing collection of some two thousand fine arts reproductions (mostly in black and white) is especially designed for college students taking courses in art history and covers all major styles and periods. The selection is made by experts; only significant and characteristic monuments are included. This material is also available in slide form. A complete catalog is issued periodically.

Color reproductions, especially the large ones suitable for framing, are produced and/or distributed by many firms, some of which issue elaborate catalogs. But the quality of reproductions is hard to judge unless they can be compared with the original; commercial catalogs never give any indications of quality. On the other hand, the color reproductions listed in the two-volume *Catalogue of Colour Reproductions of Paintings,* published by UNESCO (United Nations Educational, Scientific and Cultural Organization), were chosen by an international committee of experts on the basis of fidelity of the reproduction to the original, significance of the artist, and importance of the original work. The UNESCO catalogs, which, in volume 1, cover paintings before 1860, and in volume 2, cover paintings from 1860 to the present, have been updated several times since they were first published in 1949/50. Each entry gives detailed information about the original work as well as the color reproduction — including dimensions of both — and also gives the source from which the reproduction may be obtained. A small black-and-white illustration accompanies each entry.

Photographs of works of art can also be secured from sources other than museums. Numerous commercial, educational, governmental, and

quasi-governmental photographic archives as well as individual photographers can provide photographs of works of art and architecture from large stocks of negatives. The Library of Congress has vast photographic archives which include photographs of early American architecture made for the Historic American Buildings Survey, of Latin American art and architecture, and of the Farm Security Administration. Other examples are the superb architectural photographs taken by Wayne Andrews and George E. Kidder Smith, and the almost inexhaustible number of monuments of Italian art and architecture, photographed by the Italian firm of Alinari. *Picture Sources* (3d ed. 1975), compiled by the Picture Division of the Special Libraries Association, is an authoritative tool listing all types of photographic resources.

CHAPTER 5

Art Histories and Introductions

General histories of art are useful when an overview of the entire field is needed. Such histories, covering in a single volume the development of art from the Stone Age to the present, can obviously deal only with the high points, leaving the detailed treatments to the specialized literature. General art histories have their place, even if they are not read from cover to cover. They often serve as good points of departure when a brief text on a specific period or school is needed, perhaps in preparation for a report or term paper. For example, a general history of art might well be consulted as a first source for basic information on Egyptian art, Dutch painting at the time of Rembrandt, or cubism.

For the beginner who has little or no knowledge of the subject, *The Story of Art* (12th ed. 1972), by Ernst H. Gombrich, one of the leading British art historians, is the book to turn to. It has been said of Professor Gombrich that he wears his learning lightly. *The Story of Art* is, indeed, easy to read and well written − even enjoyable. While it may have a slight bias toward English and Italian art, it has the great advantage that every work of art mentioned in the text is also illustrated. In the appendix, "Books on Art," the author does not merely cite a conventional list of books for further study, but in an informal yet informative way calls attention to some of the truly great books on art that have shaped our knowledge of art and artists.

A standard work since it was first published over fifty years ago is Helen Gardner's *Art through the Ages* (6th ed. 1975). For decades it was practically the only art history available for undergraduates taking a survey course. Although Helen Gardner has been dead for some time, her book continues to be identified with her. The present edition, revised by Horst de la Croix and Richard G. Tansey, and listed as *Gardner's Art through*

the Ages, is a solid handbook with a competent text, good illustrations, and a comprehensive bibliography.

H. W. Janson's *History of Art* (2d ed. 1977) has been enormously successful since its introduction in 1962. It has become the required text in many colleges, introducing the student to the language and attitudes of the art historian. The illustrations, which are numerous, are of particularly fine quality. A selective art dictionary, *From Abacus to Zeus* (1968), edited by James S. Pierce, is especially designed to explain the art terms used in the Janson volume.

Art: A History of Painting, Sculpture, and Architecture (1976. 2 vols.), by Frederick Hartt, is the latest comer among the major art histories. Divided into two beautifully illustrated volumes — from prehistory to the Middle Ages, and from the Renaissance to the "modern world" — it offers broader treatment of the material than is possible in a one-volume work. Nevertheless, it does not take the place of the specialized works which are indispensable for in-depth study of any of the periods covered in this set.

The Social History of Art (1951. 2 vols.), by Arnold Hauser, is important as an attempt — not altogether successful — to treat the entire history of art in terms of socioeconomic conditions from the Marxist point of view.

Indispensable as a study aid for the art history student is *Key Monuments of the History of Art* (1962), by Horst W. Janson. This is a collection of rather dim black-and-white plates reproducing the principal works — "key monuments"— of architecture, painting, sculpture, and occasionally graphics in every period in art. These are the works that an art student, especially an art history major, is expected to know and to be able to identify. For this reason they are many a teacher's favorite choices for slide tests. *Key Monuments* has no text other than the descriptive captions which accompany each plate.

Other introductions to art are not historically oriented, as are the books described above, but use a topical approach instead. *Art in Perspective* (1972), by Henri Dorra, and *Purposes of Art* (3d ed. 1972), by Albert E. Elsen, stand midway between the art histories and the topical volumes. Dorra, while maintaining a historical framework, provides substantial analyses of selected monuments — paintings, sculptures, buildings — suitable for comparison, whereas Elsen brings together works of art from different periods under such universal themes as religion, nature, and death.

Very useful are books which explain how works of art are put together in terms of space, line, color, expression, mass, texture, and so on, and what characterizes two-dimensional form, such as painting, and three-dimensional form, such as sculpture. Three college-level texts are *The Visual*

Experience (1961), by Bates Lowry; *Learning to Look* (1957), by Joshua Taylor; and *The Visual Dialogue* (2d ed. 1971), by Nathan Knobler.

Still other works explore the ways in which we perceive and conceptualize visual forms in general and artistic forms in particular. An important and widely read book of this type is *Art and Visual Perception* (2d ed. 1974), by Rudolf Arnheim, a gestalt psychologist who has written significantly on the arts. *Language of Vision* (1951), by Gyorgy Kepes, who uses some premises of gestalt psychology, demonstrates how artists of the past and present have established visual communication with the spectator through purely graphic or spatial means. This book is a must for the design student but also offers stimulating insights to any person concerned with "fine art."

Art Histories in Series

Most multivolume histories of art are published as a series. A series, in the language of book publishing, generally consists of a specified number of volumes in a broad subject area, published at irregular intervals. The volumes are uniform in format and similar in organization, yet usually are by different authors. There is often a series editor who has general responsibility for the scope and content of the volumes and for the selection of the individual authors. The series editor also sees to it that overall quality and other standards are maintained.

Any discussion of multivolume histories of art must begin with the monumental Pelican History of Art series, produced in England and published in England and the United States by Penguin Books. This series, under the editorship of the British art and architectural historian Nikolaus Pevsner, was begun in 1953 and is still in progress. About forty volumes have been published so far. When completed, the series will comprise over fifty volumes, dealing with the art of every period and every geographical area. Each volume is by a recognized authority in the field. While few volumes are the result of original research, all are up to date and incorporate the most recent findings on their subject. Some of the volumes even offer the first comprehensive treatment in English. Emphasis is always on the text, which is scholarly and on the college level. There are numerous well-selected illustrations of fair quality, mostly in black and white, and good bibliographies. The footnotes lead into the intricacies of advanced research. It is safe to state that if there is a volume in the Pelican History or Art that covers an area or period to be studied, a student is usually well advised to use it as a basic reference source.

Another important series, which originated in France under the joint

direction of the late novelist and art historian André Malraux and the archaeologist André Parrot, has been published in this country by G. Braziller under the series title The Arts of Mankind. Begun in 1960, this series aims at an authoritative presentation in word and picture of the arts of a civilization or epoch. About forty volmes are planned; a dozen or so have been published,* all beautifully designed, richly illustrated in color and black and white, and featuring also maps, full bibliographies, and a glossary-index. An outstanding volume is the first of the series, *Sumer* (1961), by André Parrot, dealing with the arts and civilization of Mesopotamia in the third millenium before our era.

Smaller, less costly, but nevertheless attractively produced volumes make up the Art of the World series, originating from Germany and published in the United States by Crown. The volumes, although authored by experts in each field, are popularly written. Each volume is illustrated with many small color reproductions and black-and-white line drawings. Particularly valuable are the volumes dealing with non-European cultures and ancient civilizations. An example is *Art of the Steppes* (1967), by Karl Jettmar.

The World of Art series, published by Thames and Hudson and presently distributed in the U.S. by Oxford University Press, is a rather loose series, comprising general and specialized histories as well as monographs on individual artists from the Renaissance on. These volumes, although uniform in size and makeup, differ greatly in scope, approach, and quality. The writing is frequently, but not always, on a popular level; the numerous illustrations are only fair. Among the standard volumes in this series are *Greek Art* (rev. ed. 1973), by John Boardman; *American Art since 1900* (rev. ed. 1975), by Barbara Rose; and *A Concise History of Modern Painting* (rev. ed. 1975), by Sir Herbert Read.

The Library of Art History series, published by H. N. Abrams under the general editorship of H. W. Janson, treats the major epochs of Western art in large, well-designed, and well-illustrated volumes written by well-known art historians. Each of these titles has a comprehensive bibliography stressing English-language publications. An example is *Nineteenth and Twentieth Century Art* (1970), by George H. Hamilton.

Landmarks of the World's Art, published by Macmillan, offers succinctly written introductory volumes by noted authors, with good illustrations, covering Western as well as Oriental art of all periods. The volumes of the Universe History of Art, published by Universe Books, have the most

*At this writing, the most recent volumes in this series have appeared in French- and German-language editions only.

compact texts, with excellent illustrations, many in color, and good bibliographies. The Harbrace History of Art, published by Harcourt Brace, has readable, authoritative texts and good bibliographies, but less than satisfactory illustrations. Titles in these and other important series are mentioned throughout this volume.

Although foreign-language material is generally excluded from this volume, an exception must be made for the famous *Propyläen Kunstgeschichte* ("*Propyläen* Art History"), the classic model of a universal history of art, which was published in Berlin, Germany, during the 1920s and early 1930s. The series is distinguished for its excellent illustrations, even by today's standards. While the relatively brief texts are now largely superseded, the selection and quality of the plates are still first-rate visual study material despite the fact that the captions are in German, and go far beyond the coverage offered in the previously mentioned *Key Monuments of the History of Art,* by Janson.

A superbly produced new eighteen-volume *Propyläen Kunstgeschichte,* begun in Germany in 1966, is nearing completion. The scholarly texts and documentation of the plates, in German, incorporate much new material. The comprehensive bibliographies are international in scope, and brilliant plates combine familiar masterpieces with less known works. A particulary fine volume in this series is *Das alte Ägypten* ("Ancient Egypt", 1975), by Claude Vandersleyen.

CHAPTER 6

Periodicals

Magazines are called "periodicals" or "serials" in libraries for the simple reason that they are issued periodically or serially, usually at fixed intervals. Most art periodicals appear monthly, bimonthly, or quarterly. Those issued once a year are often called annuals or yearbooks.

Periodicals contain the most up-to-date information on the latest developments in art. New artists, ideas, concepts, movements, theories, art forms, or media are usually discussed in journals long before books are written about them. Discoveries, new attributions or interpretations of older works of art, also find their way first into the magazines. Many art journals contain reviews of exhibitions, news items of current interest, and book reviews. They are, as a rule, richly illustrated, sometimes with a generous number of color reproductions.

Like the journals in other disciplines, art journals differ considerably with respect to subject content, intellectual or professional level, and popular appeal. Most college libraries subscribe to a variety of art magazines. But it happens quite often that one encounters citations to articles in journals that the local library does not own. If these journals are to be located, the *Union List of Serials* is the source to consult. This massive compilation (3d. ed. 1965. 5 vols.; updated by *New Serial Titles*) lists the periodical holdings of several hundred cooperating libraries in the United States and Canada. The periodicals are arranged in alphabetical order under their latest title with dates of first and, if applicable, last volume and title changes. Under each periodical title the names of the reporting libraries and their exact holdings are given. Libraries are identified by coded abbreviations. If a library owning the material cannot be visited in person, photocopies can usually be ordered.

In the following pages the principal general art magazines are described

even though their character may change over the years. Specialized journals are dicussed under the subjects with which they are concerned.

General Art Journals

The four leading general art magazines in the United States are *Art News, Art in America, Artforum,* and *Arts Magazine.* All four contain well-written essays and critiques by leading art critics, and sometimes interviews with noted artists, Other common features are exhibition reviews, correspondents' reports from major art centers, news of art auctions, and book reviews. Occasionally special issues are devoted to a single important theme or subject. As a rule these special issues are particularly carefully prepared and try to make a fresh contribution to the topic at hand.

Art News, which is the oldest U.S. art magazine still being published, has a balanced coverage of art and artists of the past and present. Capsule reviews of current one-man shows in New York City are an important monthly feature. (Similar brief reviews are also found in *Arts Magazine.*) Such reviews are often the only readily available information on new or little-known contemporary artists.

Art in America, the most lavishly produced and illustrated of these periodicals, is oriented toward modern art. Its articles often discuss social issues, and the institutions, economics, and politics of art. Despite its title, *Art in America* is not restricted to the American art scene.

Artforum and *Arts Magazine* both deal almost exclusively with the latest artistic trends and the work of avant-garde artists. They are attractive in format and sometimes stimulating to read.

The most sophisticated international journal of contemporary art is *Art International.* Although it is published in Switzerland, almost all the articles are in English. This avant-garde journal maintains a high literary quality and is brilliantly illustrated. There are regular reports from New York and the other art capitals of the world.

Studio International is the leading British periodical specializing in the current art scene. It has a decidedly British point of view, but is international in coverage.

Arts in Society, published by the University of Wisconsin Extension, is an interdisciplinary journal concerned with the role of art and artist within the social context of today. Practising artists, teachers, philosophers, sociologists, and scientists are among the contributors to this journal.

Craft Horizons, issued by the American Crafts Council, is the major contemporary crafts journal. Ceramics, jewelry, metalwork, enamels, weaving, and woodwork are among the handicrafts discussed in its pages.

Many of the contributors are practising craftsmen writing about their craft. There is useful information about exhibitions and market places. *Craft Horizon*'s opposite number, so to speak, is *Antiques,* which deals with crafts on a historical level. This periodical is especially popular with collectors.

American Artist is a cut below the journals mentioned above. It offers primarily advice on how to paint and is therefore geared to the self-taught artist and Sunday painter. Most issues feature an illustrated lead article on the life and work of a better-known artist. There are useful lisitings of competitions and scholarships.

Apollo and *The Connoisseur* are two respected British monthlies which are especially valued by collectors because of their emphasis on the decorative arts. But over the years both of these journals have also regularly published informative articles on a wide range of general art subjects.

The bimonthly *ARTgallery Magazine* includes ten monthly issues of the *Guide,* which offers the only comprehensive listing of current art exhibitions. It covers museums and art galleries in New York City and elsewhere in the United States and abroad.

Feminist Art Journal and *Womanart* are an outgrowth of the woman's movement. They are a good source for biographical and critical material on woman artists.

Scholarly Art Journals

The Art Bulletin and *The Burlington Magazine* are the two foremost scholarly English-language art journals currently published. *The Art Quarterly,* which was published from 1938-74 and is scheduled to resume publication in 1977, has been on the same scholarly level. *The Art Bulletin* is written by scholars for scholars. Learned and highly specialized articles with extensive footnotes deal with a wide range of subjects in Western art. The extensive book review section in every issue has longish, probing critiques of scholarly publications, written by specially invited experts in the subject areas of the particular books to be reviewed. *The Art Bulletin* is published by the College Art Association of America, the leading U.S. professional association of art historians and collegiate studio art teachers.

The Burlington Magazine, published in London, stresses research on unexplored artists and subjects, discovery of unknown works, revisions of attribution or interpretation of works of art. This important journal focuses on the history of Western art up the the early twentieth century. Contemporary art, Oriental art, and the applied arts are less frequently

discussed. It is the best source for reviews of major exhibitions on an international scale. There is a special section on recent museum acquisitions and a yearly list of master's theses and doctoral dissertations begun and completed at British universities. A new quarterly, *Art History,* is to be published late in 1977 under the auspices of the Association of Art Historians of Great Britain, a British equivalent of the College Art Association of America.

The Journal of Aesthetics and Art Criticism, published by the American Society for Aesthetics, is a scholarly, interdisciplinary periodical concerned with the philosophy and theory of the arts. The "arts" here means the visual arts as well as the performing arts and literature. This is one of the few art journals which is not always illustrated *The British Journal of Aesthetics* is a comparable British journal.

In addition to *The Art Bulletin,* the College Art Association of America publishes the *Art Journal,* which addresses itself especially to the collegiate art world. The articles, although scholarly, are written in a somewhat lighter vein than those in *The Art Bulletin* and frequently consider questions of college-level art teaching. *Art Journal* has extensive news sections, especially of acquisitions, and exhibitions in college and public art museums, new campus art buildings, new college art programs, and news of college and museum personnel. It also lists U.S. doctoral dissertations in art history.

Several of the foreign art journals carry English-language articles and/or publish English-language summaries. A good example is the *Gazette des Beaux-Arts,* the eminent French scholarly art journal, which for a long time has published material in French and English with equal frequency and which always carries English summaries of articles written in French.

Museum Bulletins

Periodicals published by museums and art galleries fall into a special category. Most major art museums issue a bulletin or comparable serial publication which reports on museum activities and, more important, contains articles about individual works of art in their collection.

These museum publications are of particular value for art historical research, for it is often only in a museum bulletin that a write-up on a particular work of art in that museum can be found.

The *Boston Museum Bulletin,* published since 1903, is the oldest United States art museum bulletin, followed closely by the *Metropolitan Museum of Art Bulletin,* published since 1905. The Metropolitan Museum of Art issues also the *Metropolitan Museum Journal,* begun in 1968. These

journals, as well as other museum serials, are among the periodicals indexed in *Art Index* and, where applicable, abstracted in *RILA* and *ARTbibliographies Modern.*

Periodical Indexes and Abstracts Once More

Periodical indexes and abstracts are the keys to the contents of magazines. *Art Index, ARTbibliographies Modern,* and *RILA,* which were discussed in Chapter 4, are the principal tools available in most libraries. Each prints instructions for the user in every volume and also lists the periodicals indexed or abstracted.

Art Index is similar to *Readers' Guide to Periodical Literature* in makeup and general arrangement and works on the same principles. It is the most generally useful index to art journals, because it covers the visual arts of all periods, countries, and civilizations. It is also the most important tool for locating reviews of art — and architecture — books. Beginning with volume 22 (1973/74) they are gathered at the end of each issue and volume in a separate alphabet under the name of the book's author; in earlier volumes, book reviews are in their regular alphabetical place in the main body of the volume.

ARTbibliographies Modern indexes more magazines than *Art Index,* but does so selectively. It deals with the material in a more extensive manner and with greater typographic clarity, even though it is restricted to nineteenth and twentieth-century materials. *RILA* is also selective, covering only European and American art — exclusive of antiquity and the Pre-Columbian period — and depending on an international network of abstractors. *RILA* produces its own computerized data base. Computer searches of *ARTbibliographies Modern* will be available via the Lockheed Dialog Online Information Service, starting in the Summer 1977.

Part II. Periods of Western Art

Prehistoric Art

The art of early man, produced before the invention of writing and recorded history, is called "prehistoric." Archaeologists have established a time sequence according to the materials and tools that man used or made, calling the successive periods Old Stone Age or Paleolithic, Middle Stone Age or Mesolithic, New Stone Age or Neolithic, Bronze Age, and Iron Age. Anthropologists have named these periods according to man's means of subsistence — the age of the hunter, the cultivator, and the metalworker.

The actual dates and lengths of these periods differ in various regions and cultures, depending on the specific times that script was invented and the historic eras began. In Mesopotamia and Egypt, writing was invented between 3500 and 3200 B.C. In Crete and Mycenae, Minoan script came into use during the Bronze Age, about 2000 B.C. In the Indus valley civilization of Pakistan, and in China, writing developed about 1500 B.C., whereas in northern and central Europe the prehistoric period extended into the Iron Age, around the birth of Christ. Thus, books dealing with "prehistoric" art in different geographic areas do not necessarily cover the same dates.

The field of prehistoric art is truly interdisciplinary: archaeologists, anthropologists, and art historians work together at collecting, analyzing, and interpreting the finds that excavations have brought to light. These finds have steadily pushed back the time of the beginnings of prehistoric art and have made it possible to trace the earliest surviving examples to the Upper Paleolithic or Late Old Stone Age, about 30,000 B.C.

Most general books on prehistoric art deal primarily with the art of Europe. The reasons are, "first, that the conditions for preservation happen

to have been comparatively good, secondly, that the prehistory of Europe has been more intensively studied than that of any other continent, but thirdly, and by far the most important, because the natural complexities of Europe, in topography, climate, and resources, evoked from one region to another more intense and diversified responses than those usually to be found in realms of older story and more prolonged continuity."

Prehistoric Art, by T. G. E. Powell (1966), a volume in the World of Art series, from which the above quotation was taken (page 8), is a good, readable survey, arranged in four broad chapters: the art of the hunters, the art of the cultivators, the art of the metalworkers, and the art of a barbarian nation. By the latter the author means the Celts, whose art and influence spread all over northern Europe and the British Isles until it was absorbed by the Romans and Christianity.

T. G. E. Powell has called Nancy Sandars' *Prehistoric Art in Europe* (1968) "a major event." Her book, a volume of the Pelican History of Art series, covers prehistoric art from the Paleolithic to the La Tène period in much greater depth. The author presents a provocatively written synthesis of archaeological, anthropological, and art historical discoveries, placing much emphasis on the technological and psychological factors in pre-historic art.

Both the Old and the New Stone Age have been singled out for special-ized studies. *Paleolithic Art* (1960), by the Italian anthropologist Paolo Graziosi, is a thorough, detailed study of the earliest appearance of art and artifacts. *Treasures of Prehistoric Art* (1967), by André Leroi-Gourhan, contains the most brilliant illustrations of Paleolithic art in France and Spain. The text, replete with scholarly apparatus, advances new theories of stylistic evolution and dating.

A fascinating account of the more recently excavated Neolithic cultures of Mesopotamia, Syria, Palestine, Lebanon, and Iran is James Mellaart's *Earliest Civilizations of the Near East* (1965). The author himself has conducted the excavations which trace the beginnings of the Mesopotamian cultures back to the ninth millenium B.C.

The Iron Age in Europe is comprehensively treated by J. V. S. Megaw in his *Art of the European Iron Age* (1970), which is excellently illustrated. A related, earlier standard work on the Celts is *Early Celtic Art,* by Paul Jacobsthal (1944. 2 vols.). Very useful is the more recent *Celtic Art* (1973), by Ian Finlay.

Of all aspects of prehistoric art, rock art, and especially cave paintings, have aroused the greatest interest ever since their discovery. One of the pioneers in the exploration of cave painting in Europe and Africa was the French prehistorian Abbé Henri Breuil, whose most comprehensive treat-

ment of the subject, *Four Hundred Centuries of Cave Art* (1952), is still valuable today. A fine pictorial volume in color of the most spectacular of all cave paintings discovered in this century is *Prehistoric Painting: Lascaux* (1955), by Georges Bataille, a volume in Skira's Great Centuries of Painting series. A considerable number of books on prehistoric African cave art have been published in the last few years, especially about the caves of South Africa and the Sahara. Well-illustrated and concise is *African Rock Art* (1970), by Burchard Brentjes.

Continuing interest in man's beginning, new techniques of excavation, and dating through carbon 14 have stimulated the study of the archaeological past in many regions and countries around the world. An excellent series of books dealing with early civilizations and touching much on the arts is Ancient Peoples and Places, a series of many volumes published in London by Thames and Hudson and in New York by Praeger.

How to Locate Books on Prehistoric Art in the Library

One would expect to find books on prehistoric art in the library by looking in the card catalog under "Art, Prehistoric," but this is not the case. Under that heading there is probably just a so-called cross-reference which reads "Art, Prehistoric, see Art, Primitive." Books on prehistoric art may indeed be found under the heading "Art, Primitive," but this heading is also used for materials on the traditional arts of Africa and other regions, which have little or nothing to do with "prehistoric" art. This confusion comes from the ambiguity surrounding the word "primitive." The basic meaning of primitive is "primary," or "first in time." Hence the early phases of art, wherever they occurred, used to be called primitive. But the term "primitive" has also been applied to the arts of the tribal societies of Africa, Oceania, Australia, and the American Indians — people who did not develop writing but had only an oral tradition. These arts were judged to be primitive in the sense of being crude, undeveloped, or lacking in sophistication, compared with the arts of Western man. Such value judgments are gradually disappearing from the specialized literature, as is the term "primitive art" itself.

However, the subject heading "Art, Primitive" still prevails in library card catalogs, and there are books on library shelves with the title *Primitive Art* which lump together the prehistoric arts with the traditional arts of Africa and other regions. Examples of such books which yet contain much that is useful are *Primitive Art* (1963), by Leonhard Adam, and *Primitive Art* (1955) by Erwin O. Christensen. Such omnibus sources are satisfactory when only cursory information on prehistoric art is

needed. However, for more thorough study specialized works should be consulted. If the titles cited in this chapter are unavailable, the entries in the library's catalog under the heading "Art, Primitive" should be carefully screened for appropriate alternate sources concentrating on prehistoric art.

Ancient Art

The arts of the ancient world have come to light through the excavations of archaeologists; their efforts have provided the framework "from which we can view the ancient monuments as art," as Henri Frankfort said in his introduction to *The Art and Architecture of the Ancient Orient.* Thus, archaeology and art history are closely linked, each relying on the other for the fullest exploration of the monuments themselves, their significance, characteristics, and craftsmanship.

Background Study

For the study of ancient art a certain amount of background reading is highly desirable and a familiarity with mythology — the stories of gods and heroes — is an absolute necessity. Any mythology is helpful, but S. N. Kramer's *Mythologies of the Ancient World* (1961) is particularly useful. A basic text for Greek mythology is *Handbook of Greek Mythology* (1954), by H. J. Rose. It is furthermore enlightening to read about the archaeological background of history and ancient art. *What Happened in History* (rev. ed. 1954), by V. Gordon Childe, is an example of one such work which has become a classic of its kind. Two stimulating books which introduce the reader to the extraordinary achievements of the Greek civilization in its totality are *The Greeks* (1964), by H. D. F. Kitto, and *The Greek Experience* (1958), by Cecil M. Bowra. *The Oxford Classical Dictionary* (2d ed. 1970) is the standard modern dictionary of Greek and Roman biography, mythology, and geography. The *Enciclopedia dell'arte antica, classica e orientale*, which was discussed in Chapter 4, is a particularly valuable comprehensive source on the arts of antiquity.

General Surveys

Most books dealing with the arts of antiquity concentrate on one area or culture. Among the exceptions are two introductory volumes with identical titles — *The Origins of Western Art.* The earlier of the two, by Walther Wolf, published in 1971 in the Universe History of Art series and subtitled *Egypt, Mesopotamia, the Aegean,* explains clearly and concisely the stylistic differences of the arts of these three major civilizations and has carefully chosen color and monochrome illustrations of the outstanding monuments. The other, by Ann Powell, published in 1973 in the Harbrace History of Art series, is even broader in coverage. It begins with Paleolithic art and then, in succession, discusses Mesopotamian, Egyptian, Aegean, Greek, and Roman art. *Art of the Ancient World* (1972), by Henriette A. Groenewegen-Frankfort and Bernard Ashmole, covers much the same ground as Ann Powell's *The Origins of Western Art,* although it excludes the Paleolithic, but it is more provocatively written and has better illustrations. Its copious footnotes lead the reader to the scholarly literature, which makes this volume also suitable for the more advanced student. A challenging work, which is fundamental for the understanding of the concepts of space and time in the representational art of the ancient Near East, is *Arrest and Movement* (1951), also by Groenewegen-Frankfort, a work in which "the reader receives a lesson in seeing . . . [and] a clear insight into the basically different nature of Egyptian, Sumerian and Cretan art" (Alfred Neumeyer).

The Ancient Near East

The ancient Near East, or ancient Orient, is the large area of Western Asia which is now generally called the Middle East. It is bordered by Egypt on the west, by Turkey (the ancient Anatolia) and Armenia on the north, by Iran (Persia) on the east, and by the Arab peninsula on the south. Syria, Lebanon, and Israel are within its perimeter. Iraq, the ancient Mesopotamia and the first region to develop a historical civilization, is its geographic and artistic center.

The Art and Architecture of the Ancient Orient, by Henri Frankfort, is the indispensable text. It is actually the first comprehensive treatment of the art of the successive Sumerian, Akkadian, Babylonian, and Assyrian civilizations of Mesopotamia and also considers the peripheral civilizations of the Hittites, Phoenicians, and Persians. The fourth revised impression (1969) has a greatly enlarged "additional bibliography" with brief annotations. *The Art of Ancient Mesopotamia* (1969), by A. Moortgat,

is an attractively produced volume with a particularly readable, well-illustrated text which discusses in five great chapters Sumero-Akkadian, Old Babylonian, Middle Babylonian, Assyrian, and Neo-Babylonian art. A brilliant pictorial volume is *5000 Years of the Art of Mesopotamia* (1964), by Eva Strommenger, with photographs by Max Hirmer. The name of Max Hirmer, a German photographer specializing in the photography of art and architecture, is almost a trademark for excellence in art books. This volume consists of a text written by an expert and a large body of illustrations − superbly reproduced − of architecture, free-standing sculptures and reliefs, seals, metalwork, and ceramics. There is also a catalog of informative notes on each object or monument illustrated, including bibliographical references.

A number of specialized studies have been written on the arts of the individual civilizations of the Middle East, especially Mesopotamia. First of all there is Sumer. Sir C. Leonard Woolley, the leading member of the first team to excavate Ur, principal city of Sumer, in the 1920s, was also the first to publish books on this newly discovered civilization. They include *Ur of the Chaldees* (1933), and *The Development of Sumerian Art* (1935). A richly illustrated, more recent study is *Sumer: The Dawn of Art* (1961) by André Parrot, the first volume in the Arts of Mankind series. *The Arts of Assyria* (1961), by the same author, and which is volume 2 in this series, covers the arts of Nineveh and Babylon, including the period of Persian domination down to the death of Alexander the Great in Babylon in 323 B.C.

Neighboring Iran (Persia) also developed a notable artistic tradition, which culminated in the sixth century in the construction of the palace of Darius at Persepolis. *The Art of Ancient Iran: Pre-Islamic Cultures* (1965), by Edith Porada, is the basic source. It traces the entire course of art in this area from its Neolithic beginnings and the early Elamite culture to the arts of the Sassanian period, which came to an end with the Arab conquest in the seventh century A.D.

The Art of the Hittites (1962), by Ekrem Akurgal, is the standard source on the art of the ancient inhabitants of Anatolia. It has splendid photographs by Max Hirmer, but the present English translation of the text contains serious errors. *Hittite Art* (1955), by Maurice Vieyra, although very brief, is the better text to consult.

If it had not been for the epoch-making exhibition "From the Lands of the Scythians," held in 1975 at both the Metropolitan Museum and the Los Angeles County Museum, few people other than specialists would have heard of the Scythians and their extraordinary gold treasures unearthed

from tombs in the Black Sea region and now, for the most part, in Soviet museums. The catalog of the exhibition was published as a special issue of the *Metropolitan Museum of Art Bulletin,* volume 32, number 5, 1973/74 − actually published in 1975 − and is available in book form, published in 1976. It contains excellent essays on the Scythian culture and its discovery and describes and reproduces in color and monochrome these intriguing, often minuscule objects. Some of these objects were also reproduced in an earlier book, *The Splendor of Scythian Art* (1969), by M. I. Artamonov, with photographs by Werner Forman, − an important pictorial volume which also lists the essential literature.

Egypt

Egypt and its art have exerted a special fascination on the West ever since Napoleon brought the first statues from his Egyptian campaign of 1799-1802 to Paris, where they can still be seen in the Louvre. The monumental, controlled art of the Egyptians, although officially attuned to death, has left in paintings and sculptures the most vivid pictorial record that has come down to us of life in antiquity.

The periods of Egyptian art follow the periods of Egyptian history, which forms the basis for most of our knowledge of ancient chronology. The Old Kingdom was the period in which the great pyramids of Giza were built. During the Middle Kingdom, Egypt suffered invasions and political unrest. From the Eighteenth Dynasty of the New Kingdom date the treasures of the tomb of Tutankhamen, the discovery of which was one of the great archaeological events of the twentieth century.*

The literature on Egyptian art is considerable. The most succinct survey is *The Development of Ancient Egyptian Art* (1973), by Sir Cyril Aldred. This book, originally published in three small volumes, is still divided into three parts, "Old Kingdom Art in Egypt," "Middle Kingdom Art in Egypt," and "New Kingdom Art in Egypt," thus covering the very core of Egyptian art. A more comprehensive history, which includes also chapters on the beginnings of Egyptian art and the late period, but which excludes the Ptolemaic period, is *The Art and Architecture of Ancient Egypt* (1958), an important volume of the Pelican History of Art series, by the distinguished Egyptologist William Stevenson Smith. Chronologically arranged, it deals authoritatively with the major trends and monuments of Egyptian art.

*A full account is found in *The Tomb of Tut-ankh-Amen* (1923-33. 3 vols.), by Howard Carter and A. C. Mace. A shortened, one-volume version, illustrated with color plates, was published in 1972.

William Stevenson Smith is also the author of a very scholarly work, *Inter-connections in the Ancient Near East* (1965), in which he attempts to link the art of Egypt with that of the Eastern Mediterranean. William Stevenson Smith is not to be confused with Earl Baldwin Smith, who also wrote significantly on Egyptian art. His *Egyptian Architecture as Cultural Expression* (1938) is still useful today.

Among the volumes excelling for their illustrations, there is above all *Egypt: Architecture, Sculpture, Painting* (4th ed. 1968), by Kurt Lange, with photographs by Max Hirmer. The superb plates, preceded by an essay entitled "Gods and Temples," are arranged chronologically. The catalog with the lengthy, informative notes on each plate should not be overlooked.

The two principal collections of Egyptian art in the United States are those of the Museum of Fine Arts in Boston and of the Metropolitan Museum of Art in New York City. Both museums have produced excellent and well-illustrated handbooks based on their collections, which at the same time can serve as coherent art historical texts on the development of Egyptian art. *Ancient Egypt as Represented in the Museum of Fine Arts, Boston* (4th ed. 1968), by William Stevenson Smith, is a small, compact volume, whereas *The Scepter of Egypt* (1953-59. 2 vols.), by William C. Hayes, on the "Met's" collection, offers a panoramic view of the subject.

The Aegean and Greece

Of all the arts of antiquity, none has had as profound and lasting an influence on the West as those of Greece. For two thousand years the ideals of classical Greek art were the inspiration, the model, and the measure of beauty in the Western world. It is therefore no accident that the first history of art ever written dealt with Greek art. It was the *History of Ancient Art,* by the German archaeologist Johann Joachim Winckelmann, originally published in German in 1764 and still occasionally read in translation.*

Since the times of Winckelmann our knowledge and understanding of Greek artistic genius has been vastly expanded. The archaeological excavations of Heinrich Schliemann in the 1870s and 1880s proved that the Troy and Mycenae of Homer's *Iliad* and *Odyssey* were not mythical, but were actual localities. Schliemann's book *Mycenae* (1880) still offers a great deal to the modern reader. The excavations of the English archaeologist

*It is ironic that Winckelmann, whose characterization of Greek sculpture as being of "noble simplicity and silent grandeur" is still quoted, never saw an original Greek work. He knew Greek art only from Roman copies of late Greek works, although he was unaware of this fact.

Sir Arthur J. Evans at Knossos on the Mediterranean island of Crete, begun in 1899, uncovered the previously unknown Minoan civilization and its exceptional, naturalistic works of art. Evans' findings were published in a monumental work, *The Palace of Minos at Knossos* (1921-35. 4 vols. and *Index.* 1936), a work that explores not only Minoan architecture but the other arts as well. A modern study, which describes the palace at Knossos and others subsequently excavated on Crete is *The Palaces of Crete* (1962), by James W. Graham.

Until quite recently, the arts of the two great Aegean civilizations — Minoan art (the art of Crete) and Mycenaean art (the art of the Greek mainland) — both of which flourished during the Bronze Age and vanished by the 12th century B.C., were not included in studies of Greek art. However, the decipherment of the so-called Linear B script used by the Mycenaeans has established their language as an early form of Greek. Its use as Knossos indicates that the Mycenaean Greeks eventually conquered the Minoans, but the Mycenaeans were heavily indebted to Crete for their art. A third Aegean civilization has now come to the fore, due to the recent excavations on the Greek island of Thera (Santorini) in the Cyclades. Thera was destroyed by volcanic eruption in about 1500 B.C., but the buildings of the prosperous Bronze Age town, with their extensive fresco paintings, are well preserved. The finds from Thera, the most important recent discovery in Greek archaeology, have been published in preliminary reports by the Greek archaeologist Spyridon Marinatos, titled *Excavations at Thera* (1968-76. 7 vols. in 8).

A number of fine studies on the Aegean have been published in the last decade or two, some of them archaeologically, others art historically oriented. *Greece in the Bronze Age* (1964), by Emily Vermeule, is an archaeological survey dealing principally with the Mycenaeans. An art historical survey is *The Art of Crete and Early Greece* (1962), a volume in the Art of the World series, by Friedrich Matz, a leading German specialist. The outstanding pictorial volume is *Crete and Mycenae* (1960), by Spyridon Marinatos, with brilliant plates by Max Hirmer. As in other volumes associated with Max Hirmer, there is a valuable catalog with descriptions and comments on the monuments illustrated, including floor plans, elevations, architectural reconstructions, and references to the scholarly literature.

Although some of the newer surveys of Greek art now include Crete and Mycenae in their initial chapters — an example is *The Birth of Greek Art* (1964), by Pierre Demargne, — Greek art is traditionally divided into five principal periods: Geometric, Orientalizing, Archaic, Classical, and

Hellenistic. A concise survey of painting and sculpture during these periods is *Greek Sculpture and Painting* (1932), by two British classical scholars, John D. Beazley and Bernard Ashmole. Originally published as the chapters on Greek art in the *Cambridge Ancient History,* this essay, in its elegant prose, remains one of the best introductory statements on the subject.

Art and Experience in Classical Greece (1972), by J. J. Pollitt, is another lucid introduction to Greek art. It is quite different in scope and emphasis. Art and architecture during the climactic 150 years from the Persian Wars to the death of Alexander the Great are examined in the context of Greek culture, especially as they reflect poetic and philosophical thought and the evolving classical ideal. Broad coverage is provided in *A Handbook of Greek Art* (7th ed. 1974) by Gisela Richter. This standard work, attractive in format, well illustrated and clearly written, offers the best general orientation on all phases of Greek art — architecture, monumental sculpture and statuettes, metalwork, vase painting, terracottas, furniture, and so on. A bibliography is attached to each chapter.

Several comprehensive histories of Greek art have been written, but as a brilliant and highly readable synthesis of current scholarship Martin Robertson's *History of Greek Art* (1975. 2 vols.) takes the lead. The author traces the evolution of Greek art from the Geometric through the Hellenistic periods. A prologue deals with "Art in Greece before the Iron Age," that is, Minoan and Mycenaean art, and two epilogues discuss Magna Graecia, Etruria, and the Greek tradition in Republican and Imperial Rome. Although many individual monuments are discussed, architecture has been excluded from this otherwise very rich source. The quality of the illustrations in volume 2 of Robertson's study is only fair. The best illustrated single volume on Greek art is without doubt *Greek Art and Architecture* (1967), by John Boardman and others, with abundant illustrations in color and monochrome by Max Hirmer.

Sculpture

Gisela Richter, who wrote on almost every aspect of Greek art, was one of the authorities in her field. Her *Sculpture and Sculptors of the Greeks* (4th rev. ed. 1970) remains the standard work on the subject. The range of this book is exhaustive. Eight hundred illustrations, indexed under the names of artists, gods and heroes, and locations of the sculptures, add to its encyclopedic scope. Even though the quality of the illustrations is only fair and the physical format of the book is dull, the user should ignore these factors because of the book's valuable content. For superior illustrations, however, one should turn to *Greek Sculpture* (rev. ed. 1960), with a

text by Reinhard Lullies and photographs by Max Hirmer. Here, as in other volumes done by Hirmer, the catalog notes on the illustrations are most informative.

Representation of the human figure was the central concern of the Greek sculptor. An exemplary and exhaustive treatment of the free-standing male figure is *Kouroi: Archaic Greek Youths* (3d ed. 1970), by Gisela Richter. In this work some two hundred statues of male nudes from the eighth to the fifth century B.C. are brought together, photographed from several angles, cataloged, and described with bibliographies appended. The statues have been dated on the basis of anatomical evidence. The illustrations are visually striking and could offer fascinating study material in the sculpture studio. A companion to this essential work is *Korai: Archaic Greek Maidens* (1968), in which about two hundred free-standing female statues − all are draped − are brought together, described, and photographed in a similar manner. Changing costumes and differing techniques in the rendering of the drapery provide the basis for the analyses and dating.

Several important works deal with specific periods of Greek art and Greek sculpture. Examples are *Architect and Sculptor in Classical Greece* (1972), by Bernard Ashmole, which concentrates on three outstanding classical monuments: the temple of Zeus at Olympia, the Parthenon, and tomb of Mausolus at Halicarnassus; and *The Sculpture of the Hellenistic Age* (2d ed. 1961), by Margarete Bieber, a standard work which treats the subject chronologically from the transitional fourth century to the first century B.C. Bieber's other major contribution, *The History of the Greek and Roman Theater* (2d ed. 1961), is valuable as an interdisciplinary study of classical art, architecture, and drama.

Painting

Greek painting has come down to us almost exclusively in the form of vase painting. Martin Robertson's *Greek Painting* (1959), a volume in the Great Centuries of Painting series, is the best introduction to the subject. It is based primarily on the evidence of vases, but the few extant examples of mosaics and fresco painting are also considered. The world authority on vase painting was John D. Beazley, on whose work most research in this area is based. His scholarly compilations, *Attic Black Figure Vase Painters* (1956), *Attic Red Figure Vase Painters* (2d ed. 1963. 3 vols), and his posthumously published *Paralipomena* (2d ed. 1971), with their extensive bibliographic documentation, are for the advanced student. But his essay, published in book form, *The Development of Attic Black Figure* (1951), is

a model of its kind, serving both the student and the scholar. John Boardman calls it "more profound but less complete" than his own *Athenian Black Figure Vases* (1974). Boardman's study, and its companion, *Athenian Red Figure Vases* (1975), are informative and readable handbook surveys tracing stylistic developments and the contributions of individual artists. An admirable pictorial survey, with a text by Paolo E. Arias and luscious plates by Max Hirmer, is *A History of One Thousand Years of Greek Vase Painting* (1962), while *The Techniques of Painted Attic Pottery* (1965), by Joseph V. Noble, sheds light on the superb craftsmanship of the Greek potter.

Architecture

Greek Architecture (1962), by Robert L. Scranton, a volume in the Great Ages of World Architecture series published by Braziller, is concise and well illustrated, hence useful as a first source on the subject. William B. Dinsmoor's *The Architecture of Ancient Greece* (3d ed. 1950) is the standard work. It is in essence an "encyclopedic description of buildings in Greek lands," as A. W. Lawrence puts it — an attempt to register and discuss every structure which has survived in some way, including those built in Greece during Roman times. *Greek Architecture* (1975), by Arnold W. Lawrence, a volume in the Pelican History of Art series, is more discursive in its approach.

 How the Greeks Built Cities (2d ed. 1962), by R. E. Wycherley, is an important specialized work which defines "the form of the ancient Greek city and the place of certain elements in it" (preface). Consequently, the book should not be consulted for the study of isolated buildings but rather for the planning of groups and groupings of buildings, such as the central city area, the *agora*. This book also has a very useful general chapter on the Greek house.

Ancient Italy: Etruria and Rome

In Italy, the extant monuments of antiquity were produced by Greeks, Etruscans, and Romans. The Greeks colonized southern Italy and the island of Sicily, leaving behind splendid Doric temples and temple sculptures. The Etruscans of central Italy, whose origins are still obscure, developed their art under Greek influence. Tomb paintings, terra cotta and stone sculptures, bronze objects, and painted vases are the principal surviving art forms. By the third century B.C. the Etruscans and their art had waned and the Romans had become the sole rulers of Italy. Roman art began to

flourish particularly after the founding of the Roman empire by Augustus and gradually superseded Hellenistic art in the Mediterranean countries. During the third century of our era the Roman empire declined and Christianity made itself increasingly felt. This was the time in which the Greco-Roman tradition of classical antiquity disintegrated and new concepts of life and art sprang up.

Etruscan Art

The best overview of Etruscan art and civilization is offered by Emiline H. Richardson in *The Etruscans* (1964). It is essentially a chronological survey, with additional chapters on the architecture, religion, literature, and music. There is an excellent bibliography, with further references in the notes on the plates. *The Art of the Etruscans* (1971), with a text by Mario Moretti and Guglielmo Maetzke, is most valuable for its superb photographs in color and monochrome by Leonard von Matt, a photographer specializing in the art of the Mediterranean countries. Eleven major Etruscan art centers are discussed in this volume and their characteristic monuments are analyzed. The noted Italian Etruscologist Massimo Pallottino is the author of *Etruscan Painting* (1952), a richly illustrated volume in The Great Centuries of Painting series published by Albert Skira, and the basic study of the subject.

Roman Art

The Art of Ancient Greece and Rome (1967), by Giovanni Becatti, heads this section, because it provides an unusual overview, integrating the phases of both, Greek and Roman art. It has a fine text, attractive illustrations and a comprehensive bibliography, which is not annotated, however.

A very compact and clear introduction is *Roman Art* (1971), by Helga von Heintze, a volume in the Universe History of Art series, with fine plates and a good bibliography. *The Art of Rome and Her Empire* (1963), by Heinz Kähler, a volume of the Art of the World series, interweaves art and political history in a continuous narrative, beginning with the emperor Augustus and ending with Constantine. *Roman Art: From the Republic to Constantine* (1974), by Richard Brilliant, is a learned treatment of the subject in terms of the "major themes" of Roman art — buildings, triumphal arches, portraiture, and so forth. In his highly stimulating *Art Forms and Civic Life in the Late Roman Empire* (1965), the author, H. P. L'Orange, clearly communicates the essence of classical art, its gradual disintegration — paralleling the disintegration of Late Roman society — and "the emergence of a new form of expression" (foreword) in

both, architecture and sculpture, under the emperor Diocletian, circa
A.D. 300.

The two most original and comprehensive studies of Roman art are the
volumes in the Arts of Mankind series contributed by the Italian scholar
R. Bianchi Bandinelli, titled *Rome: The Center of Power: Roman Art
500 B.C. to A.D. 200* (1970) and (its sequel) *Rome: The Late Empire:
Roman Art A.D. 200-400* (1971). In both these works the author uses a
sociopolitical approach, incorporating much new material, especially about
the little-explored Roman plebeian art. Both these volumes deal only with
pagan Rome. *Early Christian Art* (1969), by the French medievalist
André Grabar, in the same series, covers the first centuries of Christian art
up to the death of the emperor Theodosius. All three volumes are copiously
illustrated, have chronologies, maps, bibliographies, and glossary-indexes.

The Architecture of the Roman Empire (1965), by William MacDonald,
is the best and most readable introduction to Roman architecture. The
author focuses on the style and design of four major Roman buildings
or building complexes — the palaces of Nero and Domitian, Trajan's
markets, and the Pantheon. He also deals with Roman building materials
and methods, including vault construction, and the architect's role in
Roman society. *Etruscan and Roman Architecture* (1970), by Axel
Boëthius and John Ward-Perkins, a volume in the Pelican History of Art
series, is a comprehensive handbook offering much new material, particu-
larly on provincial architecture. As a pictorial resource the *Pictorial
Dictionary of Ancient Rome* (2d ed. 1968. 2 vols.), by Ernest Nash,
should be mentioned. The existing architectural monuments of the ancient
city and its immediate vicinity are here recorded photographically in
several views, no matter how little is left of the original structure. The
monuments are arranged in alphabetical order under their present — Italian
— name. A detailed classified index by building type readily locates views
of aqueducts, temples, theaters, and so forth.

Most general works on the city of Pompeii are likely to be found in the
archaeology section of the library. However, the mural paintings of
Pompeii and other Campanian localities are usually considered "art"
subjects and hence are found in the sections on ancient painting or mural
painting. *Roman Painting* (1953), by Amedeo Maiuri, one of the volumes
in the Great Centuries of Painting series, with lavish color plates, is a good
introduction to the subject.

Primary Sources

The most useful source collections on ancient art are *The Art of Greece*

(1965) and *The Art of Rome* (1966), both by J. J. Pollitt and published in the Prentice-Hall Sources and Documents series.

The Art of Greece is "designed to make the major literary sources for the history of Greek art available for the student" (preface). Excerpts from several dozen Greek and Latin authors are presented in English translation in a "chronological framework." The emphasis is on the writings of the Roman encyclopedist Pliny the Elder and the Greek traveler Pausanias, the two classical authors who have left the most extensive and most important descriptions of Greek art.

The Art of Rome cites several authors who have provided "information based on first-hand observation of contemporary artistic development" (introduction). In addition to the ever-present Elder Pliny many eminent classical figures are represented — Plutarch, Cicero, Livy, Ovid, Seneca, Tacitus, and others. The volume contains choice items such as excerpts from Cicero's famous *Verrine Orations,* which castigate the propraetor Verres for his notorious Sicilian art thefts, and the Younger Pliny's description of his luxurious country villa overlooking the sea at Laurentum, near Rome.

Periodicals

The interaction between archaeological discovery and the study of ancient art, which was noted at the beginning of this chapter, characterizes also the periodical literature. Journals dealing with the arts of antiquity are essentially archaeological journals. The *American Journal of Archaeology,* published by the Archaeological Institute of America, is the principal American scholarly journal for the arts of classical antiquity, the ancient Near East, and Egypt. The popular *Archaeology,* also published by the Archaeological Institute of America, is not limited to these areas, however, but includes other ancient civilizations as well. Concise information on current excavations of classical sites is provided in *Archaeological Reports,* published since 1954 as a supplement to the *Journal of Hellenic Studies.* This journal, one of the oldest concerned with classical studies and still being published, frequently prints scholarly articles on Greek art.

CHAPTER 9

Medieval Art

Medieval art is essentially Christian art or, more specifically, art in the service of the church. The ways and forms in which artists gave "visual expression to Christianity" (Michael Levey) frequently strike present-day viewers as remote, with the result that some people find it difficult to enter into this art. One of the best ways to overcome this difficulty is to acquaint oneself with the historical, intellectual, and social conditions — as well as the religious background — which have shaped both Christianity and medieval art. Particularly relevant for this purpose are *The Crucible of Christianity* (1969), edited by Arnold Toynbee, and *The Flowering of the Middle Ages* (1966), edited by Joan Evans, both of which are large, attractive volumes in the same format, with texts by leading scholars and with magnificent illustrations. *The Crucible of Christianity* explores the Judaeo-Hellenic sources of Christianity, its beginnings in Palestine and Imperial Rome, and the early theology, all set in the broad context of the Greco-Roman civilization. *The Flowering of the Middle Ages* interprets important aspects of medieval life and society, including the seminal contributions of the monastic orders.

Art of the Medieval World (1975), by George Zarnecki, is the only recent comprehensive study of medieval art encompassing both East and West and covering 1,000 years from late antiquity to the onset of the Renaissance. The text is lucid, but the illustrations are disappointingly weak. Two concise volumes in the Landmarks of the World's Art series are equally well suited as introductions to the entire spectrum of medieval art: *The Medieval World* (1967), by Peter Kidson, deals with the arts from the seventh to the fifteenth century in the West, while the companion volume, *The Early Christian and Byzantine World* (1967), by Jean Lassus, succinctly surveys Christian art in Rome and the East.

The material discussed here comprises five phases, which are usually

called the Early Christian, Byzantine, Early Medieval, Romanesque, and Gothic. But these terms are quite vague and cannot be dated or defined exactly. The first eight or nine centuries of the Christian era, in which the dying classical tradition, Christianity, and the paganism of the northern barbarians clashed and ultimately interacted, are among the most complex in the history of art. The Pre-Romanesque, Romanesque, and Gothic styles, which subsequently evolved, occurred by no means simultaneously throughout Europe, but up to a century apart (for example in France and Germany), causing cross-currents and overlapping developments.

Early Christian and Byzantine

The term "Early Christian" art applies generally to Christian works — for example the catacomb paintings — produced in Rome from about A.D. 200-600 (with late manifestations up to about 800). The formative first two centuries of Christian art, from A.D. 200 to A.D. 400, are discussed in a comprehensive book by Pierre M. Du Bourguet, *Early Christian Art* (1971), that has good illustrations, partly in color, of sculptures, paintings, and mosaics; chapters on the earliest church architecture; and a useful bibliography listing books and major periodical articles. Comparable subject matter is covered in two more complex works by André Grabar. His *Early Christian Art* (1969), a volume in the Arts of Mankind series, presents the material in a historical narrative. His *Christian Iconography* (1968), a volume in the Bollingen series, investigates the sources of Early Christian imagery, especially portraits, narrative biblical scenes, and images serving as expressions of Christian dogma. *Early Christian Art* (1962), by W. F. Volbach, with photographs by Max Hirmer, is the standard pictorial source. Like similar volumes with Max Hirmer's photographs, it has valuable catalog notes on the plates with descriptions and comments, bibliographical references, and architectural plans and elevations.

Christian art in Eastern Europe and the Near East centered in Greek-speaking Byzantium, or Constantinople (now Istanbul, Turkey), and is hence called Byzantine art. Byzantine art, which spread as far west as Italy (especially Ravenna, Venice, and the island of Sicily), came to an end only with the conquest of Constantinople by the Turks in 1453, but in Russia and the Balkans the Byzantine tradition persisted until the nineteenth century.

A detailed study of Byzantine art is presented by David Talbot Rice in his *Byzantine Art* (rev. ed. 1968). The author, who wrote extensively on the subject, explains the historical and geographical background of Byzantine art and discusses architecture, mosaics, wall paintings, manuscripts, sculpture, and the minor arts. There is a valuable chapter on the

relationship of Byzantine art to the East, the Slavic countries, and the West. The basic pictorial handbook is *The Art of Byzantium* (1959), also by D. T. Rice, with plates by Max Hirmer, in the same format as the aforementioned *Early Christian Art,* by W. F. Volbach.

Early Christian and Byzantine art are closely bound up with one another and are therefore often treated together in a single survey history. The most concise of these is *Early Christian and Byzantine Art* (1971), by Irmgard Hutter, a volume of the Universe History of Art. It covers art and architecture from the third to the thirteenth century and has excellent illustrations, many of them in color, of the principal monuments. A treatment in greater depth is a work with the same title, *Early Christian and Byzantine Art* (1970), by John Beckwith. This volume of the Pelican History of Art series is intended to be "a panoramic story which is to be read rather than consulted" (foreword) and is addressed to the more advanced reader. Architecture is omitted but is treated fully in the companion volume, *Early Christian and Byzantine Architecture,* by Richard Krautheimer, which should be consulted in the thoroughly revised 1975 paperback edition.

Early Medieval

The arts of the Migration period, Hiberno-Saxon (or Irish), Anglo-Saxon, Carolingian, and Ottonian (or Pre-Romanesque) art are sometimes summarily called "Early Medieval" and ignored in the histories of art as belonging to the so-called Dark Ages. But several newer studies are devoted to this very era. The Universe History of Art has again provided the most concise survey, *Early Medieval Art* (1974), by Hans Holländer — a work which contains 100 color and monochrome plates and a good bibliography. *Art of the Dark Ages* (1971), by Magnus Backes and Regine Dölling, is also brief and well illustrated. *Pre-Romanesque Art* (1966), edited by Harald Busch and Bernd Lohse, with an introduction by Louis Grodecki, is a good pictorial volume, reproducing in black-and-white plates the major monuments of architecture, sculpture, ivory, and the goldsmith's work of this period.

The study of the art of the Migration period is particularly difficult. Of help in clarifying the basic characteristics and in unraveling the intricate background and cross-fertilizations are two essays by Philippe Verdier, "Forms and Symbols" and "Historical Survey," both contained in a collection catalog of the Walters Art Gallery, Baltimore, titled *Arts of the Migration Period in the Walters Art Gallery* (1961). The large and copiously illustrated *Europe of the Invasions* (1969), by the French medievalists

Jean Hubert and Jean Porcher and the Vatican scholar W. F. Volbach, is far less readable, but is important for its fine plates, many of them in color. This volume, in the Arts of Mankind series, has a sequel, *The Carolingian Renaissance* (1970), in the same format and by the same three authors, with an excellent text. It is, in fact, the basic account of the first revival of antique thought in the ninth century, through Charlemagne. A very clearly written and sound survey leading the reader from the Carolingian Renaissance to the high Romanesque period of around 1150 is *Early Medieval Art* (1964), by John Beckwith. The title should not mislead. The book begins with Charlemagne and does not touch on earlier developments. A classic of its kind is *Early Medieval Art* (1955), by Ernst Kitzinger, which begins with the transition from pagan to Christian art and also ends with twelfth-century Romanesque. Although limited to objects in the British Museum and originally published in 1940, it is still considered a model of sensitive scholarship and enlightened analyses, while at the same time demonstrating the "continuous struggle between classical and anti-classical tendencies, which is an outstanding feature of the history of early medieval art" (p. 19).

Three volumes of the Pelican History of Art series are devoted to the crucial 400 years from 800 to 1200 (a fourth volume, on sculpture, is yet to be published). *Carolingian and Romanesque Architecture* (rev. ed. 1974), by Kenneth J. Conant, is a standard source on architecture; *Painting in Europe: 800-1200* (1971), by C. R. Dodwell, deals with manuscript illumination and mural painting during this period; *Ars Sacra* (1972), by Peter Lasko, is concerned "with the art of the goldsmith, the metalworker, and the ivory carver in the Carolingian, Ottonian, and Romanesque periods" (preface). The objects created by these craftsmen — reliquaries, processional crosses, liturgical vessels, gospel book covers, and so forth — are sometimes lumped together under the generic term "minor arts," a misnomer if one considers the superior craftsmanship and liturgical importance of these precious works.

Romanesque and Gothic

Most of the volumes just mentioned include Romanesque art as the last stage of an art historical evolution which extended over many centuries. The volumes cited below consider Romanesque and Gothic art as the summit and the very essence of medieval art.

For a first acquaintance with the wide range of Romanesque art, George Zarnecki's *Romanesque Art* (1971) in the Universe History of Art series is recommended. Architecture, sculpture, metalwork, ivories, stained

glass, wall paintings, and manuscript illuminations are discussed in the most succinct manner, and the illustrations are excellent. An equally concise survey in the same series is *Gothic Art* (1973), by Florens Deuchler. *Gothic Art* (1967), by Andrew Martindale, in the World of Art series is another useful introductory volume on the subject. French and Italian Gothic are emphasized here, but there are brief excursions to England, Spain, and Germany. Most of the space is properly given to the great cathedrals and their sculpture, and to Italian painting.

A highly original work on medieval art is *The Art of the West in the Middle Ages* (2d ed. 1969. 2 vols.), by the French art historian Henri Focillon, of which volume 1 deals with Romanesque and volume 2 with Gothic art. Focillon traces the development of these two styles in the architecture, sculpture, and ornament of Western Europe, principally France. His book represents the application of a theory of art concerned with the evolution and transformation of styles, which Focillon had outlined in an earlier study, *The Life of Forms in Art* (English ed. 1943). In the introduction to *The Art of the West,* editor Jean Bony, Focillon's most gifted pupil, explains his teacher's art theory and contribution to art history. The book is most rewarding, but it is not easy to read.

The indispensable pictorial volume for the study of Romanesque art is *Monuments of Romanesque Art* (2d ed. 1967), by Hanns Swarzenski. It is more than just a "picture book." The judiciously selected plates reproduce bronzes, ivories, goldsmith's work, enamels, and illuminated manuscript pages, and the catalog notes include bibliographies for each work reproduced. *A Treasury of Romanesque Art* (1972), by Suzanne Collon-Gevaert and others, is a veritable feast for the eye. It is not a general picture book on Romanesque art but deals with the very special Mosan art — goldsmithing, enamels, bronzes, and illuminations originating from the valley of the Meuse. The color plates are superlative. No other book can give a better idea of the exquisite beauty of these objects, a beauty that culminated in the art of Nicholas of Verdun. The detailed comments on each object reproduced add to the excellence of this volume.

Architecture

Architecture is the fundamental art form of the later Middle Ages, and, accordingly, the literature — especially on Gothic architecture — is voluminous. The three basic volumes on medieval architecture are the brief but well-illustrated surveys in the Great Ages of World Architecture series, published by George Braziller: *Early Christian and Byzantine Architecture* (1962), by William L. Macdonald; *Medieval Architecture* (1962), by

Howard Saalman; and *Gothic Architecture* (1961), by Robert Branner. The Pelican History of Art series devotes three scholarly volumes to the subject; the previously mentioned *Early Christian and Byzantine Architecture,* by Richard Krautheimer; *Carolingian and Romanesque Architecture,* by Kenneth J. Conant; and *Gothic Architecture* (1962), by Paul Frankl. These volumes present continuous narratives that are more concerned with overall developments than they are with detailed discussion of the individual buildings.

Romanesque Architecture (1975), by Hans E. Kubach, in the History of World Architecture series, rivals the above-mentioned volume by Conant as the best comprehensive survey of the subject. It has, furthermore, superior illustrations, and, though lacking footnotes, a more extensive bibliography. A fine pictorial volume on Romanesque architecture and architectural sculpture is *Romanesque Art in Europe* (1968), by Gustav Künstler, a volume condensed from several other works, two of which are also available in English-language editions: *Romanesque Art in Italy* (1959), by Hans Decker, and *The Glory of Romanesque Art* (1956), by Joseph Gantner and Marcel Pobé.

The literature on Gothic architecture is especially rich and varied. The dazzling beauty and daring construction of the great architectural masterpieces have inspired all kinds of studies — from lyrical, exuberant description to sober analysis and interpretation. *The Gothic: Literary Sources and Interpretations through Eight Centuries* (1960), compiled by Paul Frankl, is an exhaustive collection of documents and essays relating to the historical, stylistic, structural, and philosophical aspects of the Gothic "through the ages." Particularly apt explanations of the structural concepts of the architecture and their significance are formulated by Hans Jantzen in his *High Gothic: The Classic Cathedrals of Chartres, Reims, Amiens* (1962). An eye-filling pictorial volume surveying the splendors of the Gothic style is *The Gothic Cathedral* (1969), by Wim Swaan, which reproduces in striking plates the boldly conceived facades and nave vaults, the rich statuary of the portals, and the luminous blues and reds of the stained glass windows.

The Gothic Cathedral (2d ed. 1962), by Otto von Simson, is a theoretical work which thoroughly and penetratingly investigates the symbolic aspects of Gothic cathedral architecture. Gothic form is seen as "measure and light," and its realization is demonstrated on the abbey church of Saint-Denis and the cathedral of Chartres. Very special is *Gothic Architecture and Scholasticism* (1951), by Erwin Panofsky, a brief but brilliant book linking the structural system of Gothic architecture to the philosophic

system of scholasticism. On the other side of the spectrum stands *The Construction of Gothic Cathedrals* (1961), by James Fitchen, which examines in considerable detail the practical side of Gothic building techniques.

There are a number of valuable regional studies dealing with both Romanesque and Gothic architecture, of which only a few examples can be mentioned here. A most appropriate source for the study of a particular twelfth- or thirteenth-century French cathedral is Whitney S. Stoddard's *Monastery and Cathedral in France* (1966), of which the paperback edition has the title *Art and Architecture in Medieval France*. Each building and its notable features are characterized in a particularly perceptive and informative way.

Of the many comprehensive works on British medieval architecture we cite *Architecture in Britain: The Middle Ages* (rev. ed. 1965), by Geoffrey Webb, in the Pelican History of Art series. Three excellent plate volumes, which reproduce exterior and interior views and many details of the sculptured portals of the major medieval cathedrals, are *English Cathedrals* (1961), by Martin Hürlimann, with a text by Peter Meyer; *French Cathedrals* (1967), also by Hürlimann, with a text by Jean Bony; and *German Cathedrals* (1956), with a text by J. Baum and photographs by Helga Schmidt-Glassner.

Chartres Cathedral

Of all medieval buildings none equals the cathedral of Notre Dame at Chartres, France, in fame and importance. With its "unique combination of architecture, sculpture and stained glass" (George Henderson), Chartres is the central and perhaps most affecting example of a Gothic cathedral. Almost any book on Gothic art will devote some pages to Chartres, but this cathedral has also given rise to a considerable specialized literature. *Mont-Saint-Michel and Chartres* (1904), by Henry Adams, is a learned and enthusiastic evocation of Chartres as "a revelation of the eternal glory of medieval art" (Ralph Adams Cram) which has become a classic in itself. A worthwhile modern account is *Chartres* (1968), by George Henderson, in which the author has "tried to explain why, over the centuries, the cathedral of Chartres took the form which we now admire," by tracing the complex and revealing history of the building, its sculptures, and its stained glass windows. *The Sculptural Programs of Chartres Cathedral* (1959), by Adolf Katzenellenbogen, is the essential investigation into the style and iconography of the sculptural ensembles of the three great triple portals. Vivid descriptions of the stained glass windows, including some

illustrations in color, are found in *The Radiance of Chartres* (1965), by
J. R. Johnson. *Chartres Cathedral* (1969), edited by Robert Branner,
contains a brief introduction by the editor and a collection, in translation,
of medieval textual documents as well as extensive modern studies
and critiques.

Sculpture

Most major medieval sculptures up to the late Gothic were not free-
standing independent works but formed sculptural groups which were
integral to their architectural settings. They are, therefore, often discussed
in the literature in conjunction with the buildings for which they were
created. Thus, good information on medieval cathedral sculpture can be
found in architectural books, as is the case with the previously mentioned
Monastery and Cathedral in France, by W. S. Stoddard. There is actually
only one fairly recent multinational survey of the subject, *Medieval
Sculpture* (1967), by Roberto Salvini. The material is divided into Early
Medieval, Romanesque, Gothic, International Gothic, and Late Gothic
sculpture and covers Italy, France, Germany, Great Britain, and Spain. The
plates are adequate, the text is clear, and there are useful bibliographical
references given with the comments on the plates.

French sculpture occupies a central position in the literature on
medieval sculpture. The sculptured church portals — both Romanesque
and Gothic — are described in detail by Arthur Gardner in his *Medieval
Sculpture in France* (1931). Conceived as a text, it is nevertheless readable,
but since it is also quite old the illustrations are dim and not too numerous.
French Sculpture of the Romanesque Period (1930), by Paul Deschamps,
is a well-illustrated basic survey of the major sculptural ensembles of that
period. The particular sculptures adorning the Romanesque churches built
along the pilgrim routes through France to Santiago de Compostela in
northern Spain are the subject of an exhaustive study by A. Kingsley
Porter, *Romanesque Sculpture of the Pilgrimage Roads* (1923. 10 vols.),
which attempts to trace, classify, date, and reproduce all extant works
from these regions and related works from other regions as well.

Gothic Sculpture in France (1972), by Willibald Sauerländer, with
photographs by Max Hirmer, supersedes all previous surveys of the subject
for the excellence of the text and the comprehensiveness and superior
quality of the over three hundred plates. The text examines, in terms of
today's sensibilities, the categories and functions of the sculptures, their
techniques, subject matter, and form. The "Documentation" section
describes the program of each monument and cites the essential
scholarly literature.

The basic work on Italian Gothic sculpture is the first volume of John Pope-Hennessy's masterly three-volume *Introduction to Italian Sculpture.* This volume, separately titled *Italian Gothic Sculpture* (rev. ed. 1972), has a lucid introductory essay, excellent plates, and most informative, detailed comments, with bibliographies, on the individual sculptures reproduced in the illustrations.

Painting

Medieval painting before about 1300 means mural decorations of churches in mosaic or fresco, manuscripts embellished with images and ornaments painted on parchment, and stained glass windows. All of these were executed by artists whose names have, for the most part, not been recorded. Panel painting — that is, portable paintings detached from the wall — came into existence only during the latter part of the thirteenth century.

Consequently, mural paintings, mosaics, and illuminated manuscripts are the pictorial arts discussed in the relevant literature, for example the three volumes of the Great Centuries of Painting series published by Albert Skira: *Early Medieval Painting* (1957), and *Romanesque Painting* (1958), both by André Grabar and Carl Nordenfalk, and *Byzantine Painting* (1953), by André Grabar alone. All three have authoritative, absorbing texts written in nontechnical language, lavish illustrations in color, and good bibliographies. *Romanesque Mural Painting* (1970), by Otto Demus, is the capital work on the subject, with a sensitive text and a rich body of plates reproducing Max Hirmer's superb photographs of Italian, French, Spanish, English, German, and Austrian painted church interiors.

Gothic Painting (1954), by Jacques Dupont and Cesare Gnudi, the sequel to the above-mentioned volumes of the Great Centuries of Painting series, takes its account up to the art of the early Italian panel painters, including Giotto and Duccio, as well as their counterparts in Bohemia (now part of Czechoslovakia), Germany, Austria, and Spain.

Fourteenth-century painting in Italy, especially Florence and Siena, has been studied extensively. This period, often called the Proto-Renaissance, is marked by the art of Giotto, the great innovator and forerunner of Renaissance painting. The first two sections of Ernest T. Dewald's *Italian Painting: 1200-1600* (1961), mentioned previously, have excellent chapters on the thirteenth and fourteenth centuries with the emphasis on stylistic analysis. By contrast, another essential study of the period, *Painting in Florence and Siena after the Black Death* (1951), by Millard Meiss, places later fourteenth-century painting in its social context, connecting the stylistic changes with the catastrophic outbreak of the plague in 1348,

which devastated the country. It should be noted that Giotto, who had died in 1337, is considered only indirectly. The central figures of Meiss's book are Andrea Orcagna, Andrea da Firenze, and other lesser masters. The interaction of art and society in fourteenth-century Florence is examined from the Marxist point of view by Frederick Antal in his *Florentine Painting and Its Social Background* (1948). Antal extends his discussion to the early fifteenth century, stopping short of the rise to power of Cosimo de' Medici in 1434.

An exhaustive study of late fourteenth- and early fifteenth-century painting in France, dealing essentially with manuscript illumination, is *French Painting in the Time of Jean de Berry,* by Millard Meiss, in three parts and five volumes. The first part (1967. 2 vols.), deals with questions of dates and authorship, the role of the Duc de Berry as a patron, and his early commissioned manuscripts. There is also a detailed *catalogue raisonné* of the manuscripts. In the second part (1968) Meiss establishes the *oeuvre* of the so-called Boucicaut Master, an important artist whose actual name is not known. The two final volumes (1974) on the Limbourg brothers, illuminators of the *Très Riches Heures,* and the Rohan Master, complete this monumental set. Over two thousand illustrations provide a rich source of visual information for the so-called International Gothic style of this period.

Illuminated Manuscripts

The study of illuminated manuscripts is "inherently intricate" (Millard Meiss). A book that will give the user a "feel" of the subject and will introduce the wide range of styles, schools, and types of illuminations is *The Art of Illumination* (1969), by Paolo d'Ancona and Erardo Aeschlimann. Fine illustrations of carefully selected manuscript leaves are featured, in color and monochrome, and a historical outline reviews the characteristics of regional styles from the sixth to the sixteenth centuries. The "Notes on the Plates" contain bibliographical references.

A first source to be consulted when information on a particular illuminated manuscript is needed is *The Illuminated Book* (rev. ed. 1967), by David Diringer. This compendium is arranged in broad chapters by period and region and is further subdivided by school or scriptorium, all of which are aptly characterized. Important manuscripts belonging in each category are enumerated and briefly identified. Summaries of critical and/or controversial opinion are given for the major manuscripts. Excellent bibliographies refer the reader to the specialized literature. A detailed index makes it easy to locate the desired information, and there is a special

index historicus (historical index) that lists each manuscript by approximate date.

The fundamental analysis of the *principles* governing medieval illumination is *Illustrations in Roll and Codex* (1947), by Kurt Weitzmann, subtitled *A Study of the Origin and Method of Text Illustration.* This book, dealing in essence with the relationships between the written word and the visual image in a manuscript is, in the author's own words, "primarily methodological and only secondarily historical." To put it differently, Weitzmann develops a typology rather than a historical account of the medieval illuminated manuscript.

Illuminated Manuscripts – Facsimile Editions

Original medieval manuscripts are rarely accessible to the student. An acceptable alternative is the study of so-called facsimile editions of illuminated manuscripts, of which a fair number has been published in recent years.* Facsimile editions are more or less complete reproductions of manuscripts (also of drawings, rare printed books, and the like) which approximate the original as closely as mechanical reproduction processes permit, yet do not claim to be exactly the same as the original. Some of these facsimile editions may be available in the college or local museum library.

In the following paragraphs a few representative examples will be mentioned – Gospels (the story of Jesus Christ as told in the first four books of the New Testament), Psalters (Books of Psalms, from the Old Testament), and books of hours (layman's prayerbooks or manuals of devotion).

Three superb facsimile editions of Irish or Hiberno-Saxon Gospel books, representing the finest examples of seventh- and eighth-century illumination, are the *Book of Durrow* (1960. 2 vols.), the *Lindisfarne Gospels* (1956-60. 2 vols.), and, above all, the *Book of Kells* (1950-51. 3 vols.), which has been called the "chief relic of the Western world." Each of these has an accompanying text with full scholarly documentation – data on the origin, authorship and history of the manuscript, description of the text, analyses of the paleography, decorations, and miniatures, and so forth. *The Book of Kells . . . with a Study of the Manuscript by Françoise Henry* (1974) is another facsimile edition which reproduces all the full-page illustrations and a representative group of the calligraphic

Color of the Middle Ages (1976) contains a useful catalog, by Carl Nordenfalk, of medieval manuscripts reproduced in facsimile.

pages in full color. There are also thirty additional color plates with greatly enlarged details and a most informative text by Françoise Henry, a Belgian scholar and a major authority on Irish art.

The best-known Carolingian manuscript is the ninth-century *Utrecht Psalter* (named for its present location in the library of the University of Utrecht), which was produced at Reims, France, and is illustrated with remarkable drawings in deep brown ink. E. T. Dewald has edited a facsimile with the title *The Illustrations of the Utrecht Psalter* (1932).

An Ottonian, or German Pre-Romanesque, manuscript of extraordinary beauty is *The Golden Gospels of Echternach* (1957), edited by Peter Metz. Its name is derived from the illumination in gold, the effect of which on the purple-dyed parchment is most striking, even in the reproduction. From the late Middle Ages we have *The Hours of Jeanne d'Évreux, Queen of France* (1957), edited in partial facsimile by J. J. Rorimer. This tiny manuscript was done in Paris between 1325 and 1328 by Jean Pucelle, who may have been influenced by contemporary Italian artists.

The facsimile of *The Hours of Catherine of Cleves* (1966), by an anonymous master, reproduces only the enchanting miniatures, with facing commentaries by the editor, John Plummer. In his introduction Plummer has provided a detailed analysis of this fifteenth-century manuscript.

Among the most beautiful and best known of all books of hours is undoubtedly the *Très Riches Heures of Jean, Duke of Berry* (1969). This splendid facsimile includes all the 129 miniatures and a selection of the ornamented text pages. In conjunction with this manuscript, one should consult the above-mentioned set by Millard Meiss, *French Painting at the Time of Jean de Berry*.

These and other facsimiles are not always found in the library's card catalog under their titles, although there may be a cross-reference from the title of the manuscript to the entry under which it is cataloged. Biblical manuscripts are the hardest to locate. Illuminated Gospel books are entered under "Bible. Manuscripts, Latin (or Anglo-Saxon, etc.). N. T. Gospels." The *Utrecht Psalter,* however, is cataloged under "Catholic Church. Liturgy and Ritual. Psalter." Books of hours may be found in the card catalog under the subject heading "Hours, Books of." In addition, there is usually an entry for the name of the facsimile's editor.

Mosaics

Mosaic is a very old technique which had its most brilliant applications in Early Christian and Byzantine art. *Mosaics* (1966), by H. P. L'Orange and

P. J. Nordhagen, is essentially an account of medieval mosaics. The second part of this informative book, by Nordhagen, discusses the development of mosaic technique.

Basic for the understanding of the iconography of the Byzantine mosaic and its function in the church interior is *Byzantine Mosaic Decoration* (1948), by Otto Demus, which concentrates on the Middle Byzantine period of the tenth to twelfth centuries. The rigidly controlled decorative and pictorial schemes are explained here in their relationship to the East Christian dogma. The content of this book is exceptionally informative but the text is somewhat unidiomatic, having been written in English by a foreign scholar, a flaw that should be overlooked.

Some pictorial volumes containing color reproductions give at least an inkling of the splendor of medieval mosaics. *Ravenna Mosaics* (1956) and the more recent *Ravenna* (1973), both with excellent texts by Giuseppe Bovini, reproduce in superb plates interior details and larger wall areas of the Early Christian and Byzantine buildings in this north Italian city, which in the fifth century was the capital of the Roman empire and in the sixth century fell to Byzantium. *The Mosaics of Rome* (1967), by Walter Oakeshott, shows rarely reproduced mosaics of Early Christian basilicas down to fourteenth-century examples, which end the mosaic tradition in Italy. *The Mosaics of Monreale* (1960), by Ernst Kitzinger, presents splendid details of mosaics depicting scenes from the Book of Genesis and the Miracles of Christ. Plans and diagrams show the exact locations of the mosaics on the walls of this great Sicilian cathedral, and there is a scholarly text.

Stained Glass

As windows replaced the solid walls in Gothic architecture, stained glass superseded mural decorations in the churches and a new mode of color and pictorial representation emerged. The intense, glowing hues and rich compositions of the windows which can still be seen at Chartres, Reims, Bourges, and Paris have remained a source of marvel and are technically unsurpassed.

The stained glass of Chartres has been described by James R. Johnson in *The Radiance of Chartres* (1965). *Stained Glass in French Cathedrals* (1968), by Elisabeth von Witzleben, contains fine color plates, an informative historical essay, and a brief explanation of medieval glass techniques as recorded in early recipe books. A good account of stained glass in England is found in *English Stained Glass* (1960), by John Baker. *Stained Glass: History, Technology and Practice* (1959), by E. L. Armitage, is

a comprehensive text leading up to present-day developments. The most complete scholarly publication in progress is the *Corpus Vitrearum Medii Aevi* ("Corpus of Medieval Painted Glass"). This international project, begun in 1958, aims at recording and publishing all extant stained glass of the Middle Ages and the early Renaissance. Several volumes (or fascicles) from a number of European countries including France, England, Belgium, Germany, Italy, Switzerland, and Scandinavia have been published at this writing.

Primary Sources

Two major documents from the Gothic period have come down to us and are easily accessible in English-language editions. The first consists of the writings of the Abbot Suger, translated and interpreted by Erwin Panofsky in *Abbot Suger on the Abbey Church of St.-Denis and Its Art Treasures* (1946). It was Suger who commissioned the epoch-making rebuilding of the choir of Saint-Denis Abbey near Paris, which initiated the Gothic style in 1140. His writings are therefore considered to be crucial for the under-standing of the spiritual – and theological – bases of Gothic art. Panofsky's excellent introduction is reprinted in his *Meaning in the Visual Arts* (1955).

The second document is a small notebook by the thirteenth-century French architect Villard de Honnecourt, edited by Theodore Bowie as *The Sketchbook of Villard de Honnecourt* (1959). This fascinating little book, which has only a brief text, contains all kinds of figure drawings, fantastic human heads formed like leaves, and, most particularly, eleva-tions, ground plans, and architectural details of imagined as well as actual buildings, such as the cathedrals of Laon and Reims in France.

Selections and excerpts from primary source material is found in three volumes of the Sources and Documents series, published by Prentice-Hall: *Early Medieval Art* (1971), by Caecilia Davis-Weyer; *Gothic Art* (1971), by Teresa G. Frisch; and *The Art of the Byzantine Empire* (1972), by Cyril Mango.

Periodicals

The only English-language journal devoted exclusively to medieval art and architecture is *Gesta,* which is published by the International Center of Medieval Art at the Cloisters in New York City, and which contains highly specialized, scholarly articles. The Dumbarton Oaks Research Library and Collection, located in Washington, D.C., but organizationally a part of Harvard University, is a center for advanced Early Christian and Byzantine

studies (it also has a Pre-Columbian department) and owns fine collections of Early Christian and Byzantine art objects. It publishes an annual, *Dumbarton Oaks Papers,* that contains valuable articles on Early Christian and Byzantine history and art. *Speculum,* published by the Mediaeval Academy of America, is a scholarly, interdisciplinary journal of medieval studies, which include the visual arts. It also prints bibliographic material of varying interest to art students.

CHAPTER 10

The Renaissance and Mannerism

The idea of the "Renaissance" as the "rebirth" of the arts and of classical learning after the long interval of the Middle Ages was first expressed by the Italian humanists and by Giorgio Vasari, author of the famous *Lives of the Painters, Sculptors, and Architects* (1550 and 1568). It became the generally accepted view of the Renaissance, even though it was already scored as being too narrow by the Swiss historian Jacob Burckhardt in *The Civilization of the Renaissance in Italy*. Burckhardt's pioneering work, which was originally published in 1860 and has been reissued many times since, has remained the classic introduction to this era, treating the great themes of the state, the individual, society, the revival of antiquity, and the discovery of the world, but not the visual arts proper. Scholars in our own time have reexamined and modified the traditional views about the Renaissance. *The Renaissance: Basic Interpretations* (2d ed. 1974), a collection of readings selected and edited by Karl H. Dannenfeldt, gives a "representative sample of the conflicting opinions on several of the most important aspects" of the "problem of the Renaissance" (introduction). Especially useful is the concluding essay, "The Re-interpretations of the Renaissance," by the well-known Renaissance scholar Wallace K. Ferguson. As for the place of the arts in this context, there is little dispute among modern scholars that the Renaissance represents a "magnificent climax in the arts" (Erwin Panofsky).

Most books dealing with the art of the Renaissance touch at least briefly on the general aspects of the period. The *Larousse Encyclopedia of Renaissance and Baroque Art* (1964), edited by René Huyghe, is a good example and is useful as an initial source. It gives, in well-articulated capsule form, the important historical, political, social, and intellectual data and provides, in the same condensed form, essential information on the arts and the principal artists themselves. However, it lacks bibliographies.

By contrast, a most learned exploration of the "Renaissance problem" is *Renaissance and Renascences in Western Art* (1960), by Erwin Panofsky. This important work, which is "distinguished throughout by a great density of content and felicity of expression" (Paul O. Kristeller), begins by "dealing with the question as to whether there was such a thing as the Renaissance" (preface). It then takes up the views of Renaissance authors about their own period, the Carolingian and twelfth-century "Renascences," the impact of the fourteenth-century Italian painters — especially Giotto and Duccio — on their contemporaries elsewhere in Europe, and, in the final chapter, compares fifteenth-century Italian classicism with Netherlandish naturalism. As a significant contribution to the history of ideas, this book is for the advanced student who has some familiarity with medieval and Renaissance literature and philosophy.

General Surveys and the Italian Renaissance

More works of art have survived from the Renaissance than from any preceding period, thus providing the scholar with a vast amount of material for study and publication. Consequently, the literature on Renaissance art, especially in Italy where the Renaissance began and culminated, is extensive. General works on Renaissance art may be found in the library's card catalog under the subject heading "Art, Renaissance." Books on a single art form, for example Renaissance sculpture, are listed under the subject heading "Sculpture, Renaissance." It should be noted that monographs on a specific artist — for example, the sculptor Donatello — are usually not found under such general subject headings as "Art, Renaissance" or "Sculpture, Renaissance," nor even "Sculpture, Italian," but only under the name of the artist, in this case "Donatello" (beside the entry for the name of the author who wrote the book). Although, generally speaking, the Renaissance period comprises the fifteenth and sixteenth centuries, some authors discussing Renaissance art — for example Panofsky, Hartt, Gilbert — include the fourteenth century in Italy, whereas others — for example Martindale (see the preceding chapter) — treat that century within the framework of Late Gothic art.

One of the few works that deal with the Renaissance in Italy and elsewhere in Europe is *History of Renaissance Art* (1973), by Creighton Gilbert, but the author's preference for Italian art is quite obvious. Popular and easy to read is *The Art of the Renaissance* (1963), by Peter and Linda Murray, in the World of Art series, which deals essentially with the early Renaissance in Italy, the Netherlands, France, and Germany, except for the concluding chapter, which outlines the arts at the beginning of the

sixteenth century. Unfortunately, this volume lacks a bibliography. It has two sequels, however, both by Linda Murray and both with brief bibliographies: *The High Renaissance* (1967), which covers the brief period from 1500 to 1530 in Italy, and *The Late Renaissance and Mannerism* (1967), which takes up the arts of the later sixteenth century in Italy, Northern Europe, and Spain.

History of Italian Renaissance Art (1970), by Frederick Hartt, is an excellently organized, comprehensive handbook which discusses painting, sculpture, and architecture in their interrelationships. This large, lavishly illustrated volume is divided into three broad sections: the Late Middle Ages, or so-called Proto-Renaissance, the Quattrocento (the Italian term for the "fourteen hundreds" or fifteenth century), and the Cinquecento (the "fifteen hundreds" or sixteenth century). There is a glossary, a chronological chart, and, of course, "Books for Further Reading."

Painting

The greatest innovations in Renaissance art took place in painting, which became the characteristic medium of the Renaissance and its leading art form.

Generations of art students were brought up on two books which are "old" by now — both were written at the turn of the century — but which are still indispensable in any bibliography on Renaissance art. One is *The Italian Painters of the Renaissance* (latest printing 1967), by the renowned American connoisseur Bernard Berenson, and the other is *Classic Art* (2d ed. 1964), by Heinrich Wölfflin, who was one of the most influential of all art historians. *Classic Art,* a masterful study of the High Renaissance in Italy, has remained invaluable for its keen analyses and comparisons of the works of Leonardo da Vinci, Raphael, Michelangelo (including his sculptures), Andrea del Sarto, and Fra Bartolommeo, and for its brilliantly formulated characterizations of the High Renaissance style. This book should be read in the excellent translation by Peter and Linda Murray in the Phaidon edition, which also has an illuminating introduction by Sir Herbert Read, assessing Wölfflin's contribution to art history. The same book exists in an earlier English translation by W. Armstrong, under the title *The Art of the Italian Renaissance: A Handbook for Students and Travellers.* This is a decidedly inferior version and should be avoided if the Murray translation is available.

Bernard Berenson's *Italian Painters of the Renaissance* is a suave, highly readable overview of painting in Florence, Venice, and central and northern Italy of the fifteenth and sixteenth centuries. The artistic judgments expressed are still sound.

Indispensable as a pictorial reference are the three sets of Bernard Berenson's *Italian Pictures of the Renaissance,* based on his so-called lists. The Berenson lists are three little octavo volumes on Florentine, Venetian, and north and central Italian painters, none of them illustrated, but naming the major artists and their principal works. A one-volume edition of these lists was published in 1932. The Phaidon Press has assembled and published a pictorial *corpus* — although it is not complete — of the paintings in the revised lists, arranged in chronological and systematic order, under the original titles: *Italian Pictures of the Renaissance: Florentine School* (1963. 2 vols.), *Italian Pictures of the Renaissance: Venetian School* (1957. 2 vols.), and *Italian Pictures of the Renaissance: Central Italian and North Italian Schools* (1968. 3 vols.). These seven volumes, comprising nearly five thousand illustrations, are an iconographic tool of the first magnitude.

Of the many important studies of Italian Renaissance painting, only a few major works can be cited. The most comprehensive scholarly work is *The Development of the Italian Schools of Painting* (1923-38. 19 vols.), by Raimond van Marle, of which volumes 10 through 18 deal with fifteenth- and sixteenth-century artists. (Volume 19 contains a detailed index.) Many minor artists are discussed in these pages. In some instances this is the only readily available English-language source on these artists. E. T. Dewald's *Italian Painting: 1200-1600* (1961) has been mentioned previously as a sound one-volume work. *Sienese Painting* (1956), by Enzo Carli, has exceptionally fine color plates and a brief outline of fourteenth- and fifteenth-century painting in Siena with informative descriptions of the works reproduced. John Pope-Hennessy's *Sienese Quattrocento Painting* (1947) is basic for its period, the fifteenth century, but, of course, does not cover the important fourteenth-century artists such as Duccio and Simone Martini. *The Mural Painters of Tuscany* (1960), by Eve Borsook, is the essential study of the great fresco cycles of Florence, Arezzo, Siena, Assisi, Padua, and other cities. There are hard-to-find views of entire walls and chapels, as well as good details, in this book.

Two important scholarly volumes on painting in the High Renaissance are both by Sydney J. Freedberg. *Painting of the High Renaissance in Florence and Rome* (1961. 2 vols.) focuses on Leonardo, Raphael, and Michelangelo, and the years from 1500 to 1521 — the beginning of mannerism. *Painting in Italy: 1500-1600* (rev. ed. 1975), a volume in the Pelican History of Art series, is broken down into twenty- to forty-year periods, each period covering the major art centers — Rome, Florence, and Venice — as well as some lesser ones, such as Parma and Milan.

There are numerous specialized studies on Renaissance painting as, for example, works on specific genres, such as the portrait (*The Portrait in the Renaissance* [1967], by John Pope-Hennessy), or the landscape (*The Vision of Landscape in Renaissance Italy* [1966], by Richard A. Turner), or the individual locality, such as *The Paintings in the Studiolo of Isabella d'Este at Mantua* (1971), by Egon Verheyen, or the excellent essay collections by Ernst H. Gombrich, titled *Norm and Form* (1966), *Symbolic Images* (1972), and *The Heritage of Apelles* (1976).

One particular but very important aspect of Renaissance art was the artist's concern with perspective. This subject is clearly and thoroughly treated in *The Renaissance Rediscovery of Linear Perspective* (1975), by Samuel Y. Edgerton. *The Birth and Rebirth of Pictorial Space* (2d ed. 1967), by John White, is broader in scope, tracing the evolution of illusionism, perspective, and space in painting, relief sculpture, and drawing, and discussing the ways in which artists from Giotto to Leonardo da Vinci have confronted these problems.

Sculpture

Renaissance sculpture means primarily Italian sculpture. Even a general handbook such as *Sculpture: Renaissance to Rococo* (1969), by Herbert Keutner, emphasizes the sculptors of Italy over those of other countries. But altogether, Italian Renaissance sculpture has received much less critical attention than painting, although some outstanding monographs have been written on individual sculptors, in particular *Lorenzo Ghiberti* (1956), by Richard Krautheimer and Trude Krautheimer-Hess, *The Sculpture of Donatello* (2d ed. 1963. 2 vols.), by H. W. Janson, and *Michelangelo* (1943-60. 5 vols.), by Charles De Tolnay (who discusses also Michelangelo as a painter).

Volumes 2 and 3 of John Pope-Hennessy's *Introduction to Italian Sculpture* are the indispensable references on the subject. Volume 2, *Italian Renaissance Sculpture* (rev. ed. 1971), discusses Donatello, Luca della Robbia, Verrocchio, Rossellino, and others in exemplary fashion, and volume 3, *Italian High Renaissance and Baroque Sculpture* (rev. ed. 1970), traces the development of sculpture and sculptural techniques from Michelangelo to the baroque sculptor Bernini. *Sculpture in Italy: 1400-1500* (1966), by Charles Seymour, a volume of the Pelican History of Art series, basically deals with sculptural programs rather than artistic biography. "Program" in this context means subject matter, function, commission, and execution of a given work of art.

Architecture

Although Renaissance architecture is generally covered in architectural histories, as for example in the excellent chapter on the Renaissance and mannerism in Nikolaus Pevsner's *Outline of European Architecture* (7th ed. 1974), recent works in English are not very numerous. The briefest survey is *Renaissance Architecture* (1962), by Bates Lowry, in the Great Ages of World Architecture series, which deals with the Italian Renaissance only. *Architecture in Italy: 1400-1600* (1974), by Ludwig H. Heydenreich and Wolfgang Lotz, in the Pelican History of Art series, has been called the most comprehensive and reliable introduction to Italian Renaissance architecture. *Architecture of the Renaissance* (1971), by Peter Murray, a volume in the History of World Architecture series published by Abrams, is primarily a pictorial volume with good black-and-white plates, including photographs of architectural details, plans, sections, and isometric drawings. The bulk of the material is devoted to buildings in Italy. Sound and very well written is another book by Peter Murray, *The Architecture of the Italian Renaissance* (2d ed. 1969), which strikes a proper balance between factual information and esthetic interpretation of Italian Renaissance churches and palaces. It has a fine bibliography in essay form. A specialized, highly original contribution to Italian architectural theory is Rudolf Wittkower's *Architectural Principles in the Age of Humanism* (1965), which is essentially a study of the ideal proportions in classical architecture.

Theory

Renaissance artists were much concerned with the theoretical foundations of art. A succinct but highly perceptive synopsis of the principal artistic theories of Renaissance artists is *Artistic Theory in Italy* (2d ed. 1957), by Anthony Blunt. Here are chapters on the artistic thought of Leone Battista Alberti, Leonardo da Vinci, Michelangelo, Vasari, and others, plus a general chapter entitled "The Social Position of the Artist," and another entitled "The Council of Trent and Religious Art." The last-named chapter explains the effects of the Counter-Reformation on the art and architecture of the later sixteenth century in Italy.

The Codex Huygens and Leonardo da Vinci's Art Theory (1940), by Erwin Panofsky, and *Michelangelo's Theory of Art* (1961), by Robert J. Clements, are important specialized studies.

Primary Sources

The principal biographical source for Italian Renaissance art is *The Lives of the Painters, Sculptors, and Architects,* by Giorgio Vasari. This first major art historical work was published in Florence in 1550 and republished in an expanded edition in 1568. Complete as well as abridged editions are available in English translation. Vasari begins his account with the thirteenth-century painter Cimabue and ends with his own life story and that of his contemporary and friend, Michelangelo. Underlying his narrative is the view that the arts have steadily progressed since the time of Cimabue and have reached their high point with Michelangelo. The individual biographies contain vividly drawn character studies and relate colorful personal incidents and episodes connected with commissioned works. Throughout the book, but especially in his long introduction,* Vasari comments on the qualities, functions, and techniques of art. To sum up, Vasari's *Lives* is the indispensable source material for the serious student of Renaissance art.

The writings of Leonardo da Vinci are incomparable for their wealth of ideas and observations and their range of subject matter. They reflect Leonardo's probing mind, his explorations of nature, and his scientific experiments, but above all his overriding concern with painting. For painting was to Leonardo the mother of all the arts and sciences.

Leonardo's writings exist in several editions. The most complete collection in English is *The Literary Works of Leonardo da Vinci* (3d ed. 1970. 2 vols.), edited by Jean P. Richter. It contains 1,500 extracts from Leonardo's notebooks and other manuscripts, arranged by subject in the original Italian — with an English translation in parallel columns, — and copious comments, footnotes, and illustrations. Other writings by Leonardo include *Treatise on Painting* (1956. 2 vols.) and the recently rediscovered *Madrid Codices* (1974. 5 vols.), of which volumes 4 and 5 contain a translation of the texts, which are reproduced in facsimile in volumes 1 and 2.

Michelangelo's sonnets have been well translated into English by several authors. These beautifully phrased, intense poems are as striking as poetry as they are revealing about Michelangelo's thoughts on art and beauty. His *Letters* (2 vols. 1963), edited by E. H. Ramsden, on the other hand, are "not stylistic exercises but intimate communications addressed to his

*This introduction, dealing with the "Arts of Design," that is, architecture, sculpture, and painting, has been published in a separate translation under the title *Vasari on Technique* (1960). It is omitted from the commonly available four-volume edition of the *Lives* published by Everyman's Library.

family and to his friends" (preface) and thus provide essential information on Michelangelo's personality and his works, his relationship with his patrons, and especially the never-ending difficulties with the tomb of Pope Julius II, which haunted him for forty years.

One of the most important theoretical works dating from the early Renaissance is *On Painting* (*De Pictura*), by Leone Battista Alberti, originally written (about 1435) in Latin, later translated into Italian by Alberti himself, and dedicated to his friend Brunelleschi. Here Alberti defines painting as the imitation of nature and states his concept of beauty in a way that was to become programmatic for the new humanistic ideals on which Leonardo was to build later. The best translation is that by Cecil Grayson (1972), who has furnished a readable, annotated text and an introduction which places Alberti's writings on art (Alberti's *On Sculpture* is also included in this volume) in their proper historical context.

A famous, still popular sixteenth-century source, which vividly portrays life in Florence during the declining Renaissance, is the *Autobiography of Benvenuto Cellini*, the celebrated goldsmith who was attached to the court of the Medici and who died in 1571. The commonly available translation is that by John A. Symonds.

The student who wants to probe more deeply into the primary sources of the Renaissance and who is not limited to material in English translation should consult *La letteratura artistica* ("The Literature of Art"; 3d ed. 1964), by Julius Schlosser. Although this important bibliographic treatise discusses source writings from the Middle Ages to about 1800, its most valuable chapters deal with the Italian Renaissance.

A few major Renaissance treatises on architecture are discussed in Chapter 13.

Northern Renaissance

The principal northern countries which produced significant works of art during the Renaissance were the Netherlands (today Holland and Belgium), Burgundy (which became a French province in 1477), France, Germany, and England. Fifteenth-century art in the North, however, is by no means the equivalent of the early Renaissance in Italy. Although painters and sculptors were innovative in their own way, they were not influenced by classical models and consequently are considered by some writers as "Late Gothic" rather than "Renaissance." Van Eyck's paintings and Claus Sluter's sculptures, for example, are called "a product of the waning Middle Ages" by the noted Dutch historian J. Huizinga in *The Waning of the Middle Ages* (1924), his brilliant study of fourteenth- and fifteenth-

century culture in France and Burgundy. Likewise, some art histories include fifteenth-century Flemish, French, Burgundian, and German painting with medieval — Gothic — art and place the beginnings of the Northern Renaissance in the early sixteenth century, when Albrecht Dürer emerged as the transmitter of Italian ideas to the North.

The problem of applying the term "Renaissance" to Northern art is discussed by Alastair Smart in the introductory chapter of his *Renaissance and Mannerism in Northern Europe and Spain* (1972), an excellent brief survey in the Harbrace History of Art. This account begins with the late fourteenth-century Burgundian court style and International Gothic as the antecedents of Van Eyck and the Master of Flémalle and ends with the art of El Greco in Spain. Smart's concise and clearly written volume is one of the few that encompasses all the major schools of the fifteenth and sixteenth centuries outside of Italy. Although his emphasis is properly on painting, sculpture is not neglected and architecture is briefly considered.

A very important but more complex survey of the period is *The Art of the Renaissance in Northern Europe* (rev. ed. 1965), by Otto Benesch. As the subtitle *Its Relation to the Contemporary Spiritual and Intellectual Movements* indicates, this work is concerned with concepts rather than with the different schools and their representative artists. This fact is evident from the chapter headings, which include: "The Medieval Heritage and the New Empiricism"; "The New Attitude Toward Nature"; "Reformation, Humanism and the New Notion of Man"; "The Pictorial Unity of Late Gothic and Renaissance"; "Extremists in Art and Religion"; and others. This study is concerned mainly with sixteenth-century artists. Some knowledge of the philosophy, political, and literary history of the age is helpful for an understanding of the book.

The Netherlands

The early Netherlandish, or Flemish, painters, though highly esteemed by their Italian contemporaries who considered their art as equal to their own, have been systematically studied and interpreted only in this century. Two great names in art history are indelibly linked with the critical study of Flemish painting — Max J. Friedländer and Erwin Panofsky. *From Van Eyck to Bruegel: Early Netherlandish Painting* (3d ed. 1969), by Max J. Friedländer, is the basic introductory volume. Friedländer's monumental and detailed fourteen-volume work on the same subject, *Early Netherlandish Painting* (1967-76), which was originally published in German (1924-37), is now available in English for the first time. The text itself has been left unaltered by the translators, but the footnotes, bibliographic

references, and illustrations have been updated. The outstanding feature of the English edition is the large body of new black-and-white illustrations, which include much comparative material.

Erwin Panofsky called Friedländer's book "one of the few uncontested masterpieces produced by our discipline." Panofsky himself is the author of an exceptional work on the subject, *Early Netherlandish Painting: Its Origins and Character* (1954. 2 vols.), which in turn has been called the greatest art historical work ever written. In this work Panofsky singles out the Master of Flémalle, the Van Eycks, and Roger van der Weyden. He discusses their antecedents and pictorial innovations and unravels the complex iconography of their paintings. Like all of Panofsky's writings, *Early Netherlandish Painting* is erudite yet superlatively written. It is not likely to be superseded for a long time.

Charles D. Cuttler's *Northern Painting from Pucelle to Bruegel* (1968) owes a debt to both Friedländer and Panofsky, but his comprehensive, well-illustrated study is easier to read and broader in geographical coverage. It is "a survey and analysis of the great artistic tradition that developed North of the Alps from the 14th to the 17th century" (preface), thus adding France, Burgundy, Germany, Bohemia, and also the Spanish schools of painting and illumination to the treatment of the Flemish masters.

The definitive catalog of early Netherlandish paintings is a multivolume *corpus* in progress since 1951, *Les Primitifs flamands* ("The Flemish Primitives"). The object of this great *corpus,* published by the National Research Center for the "Flemish Primitives" in Brussels, Belgium, is to record, document, and publish all existing fifteenth-century Flemish paintings, region by region, museum by museum. Among the museums which have published their holdings are the Louvre in Paris and the National Gallery in London. (The latter owns one of the masterpieces of all Flemish painting, the double portrait of Giovanni Arnolfini and his wife, by Jan van Eyck.) So far, only one slim volume of Flemish paintings owned by United States museums has appeared: *New England Museums* (1961), by Colin T. Eisler, which is volume 4 of the *corpus,* covering museums in Massachusetts and Connecticut.

In this *corpus* the critical, bibliographical, and pictorial documentation for each painting is uniform throughout and exhaustive; so far the language in most of the volumes is French. *Les Primitifs flamands* actually consists of three separate series, the *corpus* proper or main series, the title of which reads, in translation, "Corpus of Fifteenth-Century Paintings in the Former Southern Low Countries," and two subsidiary series of minor works and preliminary studies: the *Répertoire,* or "List of Flemish

Fifteenth- and Sixteenth-Century Paintings," and "Contributions toward the Study of the 'Flemish Primitives.' "

France and Germany

Most painters of the fifteenth-century French, German, and Iberian schools pale before the early Netherlandish painters. This may account for the fact that they have been studied less than the Flemings. The basic volume for the early period in French panel painting is Grete Ring's *A Century of French Painting: 1400-1500* (1949). The relevant chapters in Albert Châtelet's and Jacques Thuillier's excellent *French Painting: From Fouquet to Poussin* (1963) are most informative and very readable, besides being beautifully illustrated in color, as befits the Skira Painting, Color, History series.

Two volumes in the same series, also strikingly illustrated in color, are devoted to German painting from the mid-fourteenth to the mid-sixteenth century. *German Painting: The Late Middle Ages* (1968), by Hanspeter Landolt, discusses less familiar artists who were active before the time of Dürer in the various local centers from the Rhine to Austria and Bohemia. The sequel, *German Painting: From Dürer to Holbein* (1966), by Otto Benesch, deals with the "golden age" of German painting, which highlights, besides Dürer and Holbein, also Mathias Grünewald, Lucas Cranach, and the Danubian school of landscape painters.

While the most brilliant artistic achievements in the North occurred in painting, sculptors and wood-carvers such as Claus Sluter, Nicolaus Gerhaert, Veit Stoss, Tilman Riemenschneider, and others carried the late medieval and sculptural tradition to new heights. Very little has been written in English about these artists. *Sculpture in the Netherlands, Germany, France, and Spain: 1400-1500* (1966), by Theodor Müller, a volume in the Pelican History of Art series, fills this gap, deftly tracing the accomplishments of these masters. *Painting and Sculpture in Germany and the Netherlands: 1500-1600* (1969), by Gert van der Osten and Horst Vey, in the same series, is particularly useful for the chapters on sculpture, another territory which is largely unfamiliar to English-speaking readers.

Primary Sources

Dutch and Flemish Painters (1936), by Carel van Mander, originally published in Dutch in 1604, is the early biographical source for Netherlandish artists. Although Van Mander's *Schilderboek* (the original title) has sometimes been compared to Vasari's *Lives,* it is in every respect a much more limited work.

The great theorist among the Northern artists was Albrecht Dürer
(1471-1528), who wrote a treatise on proportion and several other
important works. There is no good edition of Dürer's writings in English.
For lack of anything better, *The Writings of Albrecht Dürer* (1958), edited
by W. M. Conway, is cited here. The chapter "Dürer as a Theorist of Art"
in Erwin Panofsky's masterful *Albrecht Dürer* (4th ed. 1971) is essential
for the understanding of Dürer's thought.

Artists' Monographs

Notwithstanding the many works cited in this chapter, artists' mono-
graphs are a major and very basic source of information on Renaissance
painters and sculptors and — for that matter — on artists of all subsequent
periods. For only with the Renaissance did the artist's personal vision
become a moving force in art. It is beyond the scope of this volume to
single out the important monographs — the field is too vast. However, the
last section of *Art Books* (1968), by E. Louise Lucas, offers a serviceable
list of basic titles published before 1968, and the first chapter of this book
should provide general guidance about the different types of monographs
on artists that have been written.

Mannerism

The Italian word *maniera,* from which the general term "mannerism"
derives, is old; it was already used by Vasari to describe certain anti-
classical currents of his own time. The significance of these trends was
pointed out in this century by the art historian Walter F. Friedlaender,
who most skillfully interpreted the aesthetics of sixteenth-century manner-
ism in his *Mannerism and Anti-Mannerism in Italian Painting* (1965). The
two essays which comprise the small volume, introduced by Donald Posner,
are still the fundamental exposition of mannerism. They admirably
delineate this style and offer penetrating analyses of individual
mannerist paintings.

Another basic essay is "Mannerism and Maniera" (1962), by Craig H.
Smyth, who reviews critically the concepts and the literature of mannerism
from the sixteenth century to the present. Footnotes make up over half of
the text, but the author himself recommends that the essay be read first
without reference to the footnotes. Originally a lecture, it was published
without footnotes in an important volume, *Renaissance and Mannerism,*
volume 2 of *Studies in Western Art,* the *Acts* of the 20th International
Congress of the History of Art (1963), edited by Millard Meiss.

Several other useful works exist, above all John Shearman's very fine *Mannerism* (1967) in the Penguin Style and Civilization series. *Mannerism: The Crisis of the Renaissance and the Origin of Modern Art* (1965. 2 vols.), by Arnold Hauser, dealing with both art and literature up to the twentieth century, is not strictly art historical. The actual theme of the book, as stated by the author, is the role of convention in art, which is explored from sociological and psychological angles.

Excellent plates are found in *Mannerism* (1963), by Franzsepp Würtenberger, and *Mannerism* (1964), by Jacques Bousquet, both of which reproduce some rarely seen examples of mannerist art by Italian and Northern masters, including graphic works. Both volumes have scholarly texts and extensive bibliographies. *Italian Mannerism* (1962), by Giuliano Briganti, is restricted to painting and features 100 color plates.

The best essay on mannerist architecture is "The Architecture of Mannerism," by Nikolaus Pevsner. First published in an obscure periodical, *The Mint* (no. 1, 1946), it has been reprinted with additions by the author in *Readings in Art History* (2d ed. 1976. 2 vols.), edited by Harold Spencer.

CHAPTER 11

Baroque and Rococo Art

The term "baroque" was originally used to characterize Post-Renaissance art in a negative sense. The implication was that artists, especially in Italy, had abandoned the lofty Renaissance principles for the sake of mindless virtuosity and theatricality. "Baroque" has now come to be merely a descriptive term for the period from about 1600 to 1750 – the period which has produced artists of the magnitude of Caravaggio, Bernini, Velázquez, Rubens, Rembrandt, Poussin, to name but a few. The last phase of the baroque, from about 1720 to 1750, is usually called the rococo period.

The scholar who first recognized the special quality of the baroque was the renowned art historian Heinrich Wölfflin. His *Renaissance and Baroque* (1888; first American ed. 1966) defines the stylistic differences between the two and seeks to determine the laws which govern the historical transformation of styles in general. Wölfflin developed these ideas more fully in his seminal work, *Principles of Art History* (1915; first English-language ed. 1932). This is the book in which he evolved his famous five pairs of contrasting modes of representation by which works of art are organized. They are the following:

1. Linear and painterly
2. Plane and recession
3. Closed and open form
4. Multiplicity and unity
5. Absolute and relative clarity of subject matter

According to Wölfflin, the sequence of art historical styles moves from linear to painterly, from plane to recession, and so on.

The importance of Wölfflin's contribution lies not so much in the discovery of these five pairs of concepts but in the fact that stylistic

analysis as he developed it permits a more objective interpretation of works of art than do judgments based on personal taste or emotional response.

Turning from these theoretical works to surveys of baroque art as a whole, there is *The Age of the Baroque* (1966), by Michael Kitson, in the Landmarks of the World's Art series, which succinctly discusses art and architecture in Italy, France, Germany, England, the Low Countries, and Spain. The book has excellent illustrations and a brief but sound "Further Reading List." A compact, well-balanced, and coherent account is *Baroque and Rococo* (1972), by A. C. Sewter, in the Harbrace History of Art series. This volume gives a somewhat broader coverage to the eighteenth century – the century of Watteau, Hogarth, and Tiepolo; it has an extensive, well-organized bibliography. *The Age of Grandeur* (1960), by Victor Tapié, stresses architecture and is particularly eloquent in bringing out the contrast between the Italian baroque and the continuing classicizing trends of French baroque. Central Europe, England, and the Iberian peninsula and colonies receive less attention. *Rococo to Revolution* (1966), by Michael Levey, deals with the history of painting from Watteau to Goya. The author has a fresh point of view and a particularly vivid style of writing.

A good source for illustrations is *Seventeenth and Eighteenth Century Art: Baroque Painting, Sculpture, Architecture* (1971), by Julius S. Held and Donald Posner. *The Rococo Age* (1960), by Arno Schönberger and H. Soehner, has remarkable plates which give a good idea of the luxuriousness and extravagance of this age.

The baroque was one of the seminal periods in Western painting; at the same time the national schools of art assumed great diversity and importance. The fundamental and indispensable books on the arts of these schools are the pertinent ten volumes of the Pelican History of Art, which treat the respective subjects in exemplary fashion.

The baroque began in Italy, hence it is only fitting to name first Rudolf Wittkower's brilliant *Art and Architecture in Italy: 1600-1750* (3d ed. 1973). Caravaggio and the Carracci are highlighted in the section on the early baroque. The chapters on the high baroque focus on Bernini and Borromini. The concluding section deals with the late baroque and the rococo, chiefly in the cities of Turin and Venice.

The two volumes devoted to the baroque in the Low Countries stress the accomplishments of the painters. In *Art and Architecture in Belgium: 1600-1800* (1960), by Horst Gerson and E. H. ter Kuile, the accent is on the art of Rubens and his school. *Dutch Art and Architecture: 1600-1800*

(1966), by Jakob Rosenberg, Seymour Slive, and E. H. ter Kuile, has important chapters on Rembrandt, Frans Hals, and Vermeer. Portrait, landscape, still life, and genre painting are all given their due in this volume.

French art is discussed in two distinguished contributions to the Pelican series. *Art and Architecture in France: 1500-1700* (rev. ed. 1970), by Sir Anthony Blunt, is a broad study which includes also the little known Renaissance and mannerist periods. *Art and Architecture of the Eighteenth Century in France* (1972), by Wend Graf Kalnein and Michael Levey, breaks new ground in an area which was first seriously explored by the Goncourt brothers over one hundred years ago.* The Pelican volume, covering painting as well as architecture and sculpture but excluding the decorative arts, offers a synoptic view of the century, which, particularly in sculpture, has not been attempted heretofore.

Baroque Art and Architecture in Central Europe (1965), by Eberhard Hempel, is the first comprehensive English-language study of the subject. In addition to Germany, it covers Austria, Switzerland, Hungary, Bohemia, and Poland. *Art and Architecture in Spain and Portugal: 1500-1800* (1959), by George Kubler and Martin Soria, is another first, probing into the entire complex of the arts in the Iberian peninsula and its Latin American colonies. Three volumes of the Pelican History of Art encompassing the English baroque give very thorough treatment to this period: they are *Architecture in Britain: 1530-1830* (5th rev. ed. 1969), by John Summerson; *Painting in Britain: 1530-1790* (3d ed. 1969), by Ellis Waterhouse; and *Sculpture in Britain: 1530-1830* (1964), by Margaret Whinney. Margaret Whinney and Oliver Millar have jointly contributed a volume to the Oxford History of English Art series, with the title *English Art: 1625-1714* (1957).

Artists' Monographs

The baroque may well be studied through the works of its great artists and the literature about them − not in the least because many of these writings are also valuable art historical exemplars. The principal monographs on seventeenth and eighteenth-century artists are noted in the bibliographies of the relevant volumes of the Pelican History of Art. *Art Books* (1968), by E. Louise Lucas, furnishes another acceptable list. A few major titles, including some that are too recent to be included in these sources, are given below.

─────────

*The classic two-volume *L'Art du XVIIIe siècle,* by Edmond and Jules de Goncourt, was published in a partial translation as *French Eighteenth Century Painters* (1948).

Caravaggio, who stands as the threshold of the era, has been studied extensively in the past decades. *Caravaggio Studies* (1955), by Walter F. Friedlaender, is still the basic scholarly monograph, containing also an *oeuvre* catalog of Caravaggio's paintings and contemporary documents in the original languages and in English translation. Caravaggio's profound influence on painters in Italy and elsewhere in Europe has been traced by Richard E. Spear in *Caravaggio and His Followers* (rev. ed. 1975), an important work based on the 1971 exhibition of the same title, organized by Spear at the Cleveland Museum of Art. Alfred Moir, in *The Italian Followers of Caravaggio* (1967. 2 vols.), has compiled an extensive record of the existing research on Italian Caravaggism.

Gian Lorenzo Bernini (2d rev. ed. 1966), by Rudolf Wittkower, is the essential monograph on Bernini as a sculptor. It includes an important text, a critical catalog, and excellent black-and-white plates. There is no comparable English-language source on Bernini as an architect, but Howard Hibbard's *Bernini* (1966) is a good biographical study covering Bernini's activities both as an architect and as a sculptor.

José López-Rey is the author of two standard volumes on Velázquez with the titles *Velázquez: a Catalogue raisonné* (1963) and *Velázquez' Work and World* (1968). The last-named is an expansion of the earlier volume's introductory text.

Sir Anthony Blunt's Poussin catalog, *The Paintings of Nicolas Poussin* (1966), should be used in conjunction with Blunt's *Nicolas Poussin* (1967. 2 vols.), the summation of his lifelong research on this painter. *Nicolas Poussin: A New Approach* (1966), by Walter F. Friedlaender, in the Library of Great Painters series, is another major contribution to the Poussin literature.

The *Corpus Rubenianum,* begun in 1968 and projected to comprise about forty volumes by different contributors, will be the definitive work on Rubens and exhaustively document his enormous *oeuvre.* At present, however, there is a lack of general studies on the art of Rubens. *Rubens: Paintings and Drawings* (1939), with an introduction by R. A. M. Stevenson, is still useful as a pictorial volume illustrating the major works. *The World of Rubens* (1967), by Cicely V. Wedgwood, is a popular volume in the Time-Life Library of Art. The Rubens year 1977, commemorating the 400th anniversary of Rubens' birth in 1577 with exhibitions throughout the world, is expected to bring a fresh impetus to Rubens studies and is bound to generate new books on this master.

Rembrandt: Life and Work (3d ed. 1968), by Jacob Rosenberg, has been mentioned in a different context as an excellent basic monograph. *Rembrandt: The Complete Edition of the Paintings* (3d ed. 1969), by

A. Bredius, with the revisions by H. Gerson, is the indispensable *oeuvre* catalog of Rembrandt's paintings. *Rembrandt as an Etcher* (1969. 2 vols.), by Christopher White, and *Rembrandt's Etchings: An Illustrated Critical Catalogue* (1970. 2 vols.), by Christopher White and K. G. Boon, are both fundamental studies of Rembrandt as a printmaker.

The literature in English on Antoine Watteau, the earliest of the major eighteenth-century painters, is scarce. *The Complete Paintings of Watteau* (1971), a volume in the Classics of the World's Great Art series, by John Sunderland and Ettore Camesasca, has informative textual matter, a basic catalog, and many color plates. The definitive monograph on William Hogarth is *Hogarth: His Life, Art, and Times* (1971. 2 vols.), by Ronald Paulson, who has also compiled a complete, critical edition of Hogarth's prints, titled *Hogarth's Graphic Works* (1965. 2 vols.). The art of G. B. Tiepolo, the last of the great Venetian painters, has been studied most extensively by Antonio Morassi. *G. B. Tiepolo: His Life and Work* (1955) is the basic biographical source, for which *A Complete Catalogue of the Paintings of G. B. Tiepolo* (1962), also by Morassi, is the necessary complementary volume.

Modern Art:
Nineteenth and Twentieth Centuries

"Modern" art is an ambiguous term. Historians divide world history into three principal periods — ancient, medieval, and modern; for them "modern" means the period from the Renaissance to the present. Art historians speak of ancient, medieval, and modern art, but they also speak of the Renaissance period, the baroque, and the rococo. The question must therefore be asked when "modern" art is supposed to begin and where the dividing line lies between the historical periods and the "modern."

Different surveys of "modern" art have different answers. *What Is Modern Painting?* (5th ed. 1966), by Alfred H. Barr, issued by the Museum of Modern Art, New York, explains the principal styles and movements from mid-nineteenth-century realism to mid-twentieth-century abstract expressionism. This slim booklet, which is written in simple, straightforward language, is the briefest of surveys yet contains very apt characterizations and comparisons of individual paintings, all of which are illustrated. *Mainstreams of Modern Art* (1959), by John Canaday, begins with the French Revolution and the art of the painter Jacques-Louis David and also ends in the mid-twentieth century. Canaday emphasizes French painting throughout his book but also touches on other schools, such as the English Pre-Raphaelites, painting and sculpture in the United States, and the twentieth-century Mexican muralists.

Nikolaus Pevsner's *Pioneers of Modern Design* (rev. ed. 1964), which leans heavily toward architecture, covers essentially the years from 1890 to 1914, the period when the so-called modern movement came into its own. Pevsner's underlying theme is the confrontation between art and technology in the early twentieth century and the positive efforts by

Walter Gropius to resolve this conflict through the teachings of the Bauhaus.

H. H. Arnason's *History of Modern Art* (2d ed. 1977) treats the nineteenth century only very briefly. Arnason speaks of the period between 1850 and 1900 as the "prehistory of modern art" and defines the art of the Fauves as the first truly "modern" movement. This encyclopedic work, which is generously illustrated, attempts to do justice to all important movements and figures. Thus, many artists and works are discussed, or at least mentioned. The bibliography, too, is quite comprehensive and lists useful bibliographic sources for many secondary artists. *Nineteenth and Twentieth Century Art* (1970), by George H. Hamilton, is again a broad survey of "modern" art, which is highly readable and profusely illustrated. In a chapter titled "Romantic Classicism" Hamilton traces the antecedents of modern art back to the mid-eighteenth century. He continues through all the styles and movements up to optical art, pop art, and the Happenings of the 1960s. His is a balanced account in which the contribution of each country and the characteristics of each movement are skillfully appraised. The well-selected bibliography contains only recent works, most of which are in English, and is therefore of particular value to students.

Two excellent volumes of the Pelican History of Art provide a more extensive treatment of the 150 years from the 1780s to the beginning of World War II. They are *Painting and Sculpture in Europe: 1780-1880* (1960), by Fritz Novotny, and *Painting and Sculpture in Europe: 1880-1940* (1967), by George H. Hamilton, author of the previously mentioned *Nineteenth and Twentieth Century Art.* Novotny begins his account with the emergence of neoclassicism in France and ends with the culmination of French impressionism in the 1880s. Impressionism and post-impressionism are the points of departure for Hamilton, who ends with a discussion of the School of Paris from 1920 to 1940 and the arts in central and northwestern Europe from 1900 to 1940.

Modern Painting and the Northern Tradition (1975), by Robert Rosenblum, suggests, in the words of the author, "an important, alternate reading of the history of modern art which might well supplement the orthodox one that has as its most exclusive locus Paris, from David and Delacroix to Matisse and Picasso . . . " (p. 7). This alternate reading, the author goes on to say, "is by no means intended to minimize the glories of the French tradition of modern art," but implies the existence of a long northern romantic counter-tradition, "which may help us to understand better the ambitions and the achievements of such great artists as Friedrich, Van Gogh, Mondrian, and Rothko."

Neoclassicism, Romanticism, Realism

The sober neoclassic style and the exuberant, passionate romantic move-
ment both originated in the eighteenth century as a reaction against the
overornate, extravagant, and playful artificiality of the rococo age.
Neoclassicism ceased to be influential by the third decade of the nineteenth
century, whereas romanticism culminated about 1830 in France, to be
succeeded by realism, which in France is especially identified with the art
of the painter Gustave Courbet.

The indispensable work on this period is *David to Delacroix* (1952),
by Walter F. Friedlaender. This book goes beyond the traditional
confrontation between classicism (David, Ingres) and romanticism
(Géricault, Delacroix). By tracing "the historical sources of the various
stylistic and intellectual currents of the time" (preface), significant parallels
from earlier centuries become apparent, which in turn clarify the historic
roles of the artists under discussion without detracting from their
individual contribution. This study (which lacks a bibliography) offers also
lucid analyses of individual paintings.

The exhibition catalog *French Painting 1774-1830: The Art of Revolu-
tion* (1975) is an essential complementary volume to Friedlaender's book.
The exhibition, which was seen at the Metropolitan Museum of Art and
the Detroit Institute of Arts, showed the art of this period in a new light.
The catalog contains major essays by Frederick Cummings, Robert
Rosenblum, and Antoine Schnapper and comments on each painting,
presenting fresh insights. There is also an exceptionally full bibliography.

Neo-classicism (1968), by Hugh Honour, in the Penguin Style and Civil-
ization series, is a well-written survey dealing with the fine and applied arts
in Europe and the United States. Particularly worthwhile are the chapters
"Classicism and Neo-classicism" and "Art and Revolution." The latter
deals with the problem of art and politics in general and with the impact
of the French Revolution on the arts in particular. The "Catalogue of
Illustrations" has useful comments and bibliographical references on the
works illustrated, and there is an additional list of "Books for Further
Reading" in essay form. In this list Honour refers to a more learned work,
Transformations in Late Eighteenth Century Art (1967), by Robert
Rosenblum, which he characterizes as "the best account of Neo-classical
painting, sculpture, and architecture in Europe and North America."

Art of the Romantic Era (1966), by the French critic Marcel Brion,
a volume in the World of Art series, is a very broad survey which discusses
romanticism, classicism, and realism in Europe and North America.
Architecture, painting, and sculpture are considered from social, psycho-

logical, philosophical, and strictly visual aspects. *Romantic Art* (1960), by the same author, is particularly useful for its large plates, many of them in color. Pierre Courthion's discerning *Romanticism* (1961), in the Skira Taste of Our Time series, interprets the international phenomenon of romantic painting mainly in the light of the work of the French painter Eugène Delacroix. *The Romantic Rebellion* (1973), by Lord Kenneth Clark, explores the classical, romantic, and realistic element in the work of thirteen artists from Piranesi and Goya to Degas.

The catalogs of two huge international exhibitions, *The Age of Neo-classicism* (1972) and *The Romantic Movement* (1959), which were organized by the Arts Council of Great Britain under the auspices of the Council of Europe and shown in London at various museums, have remained major documents of the visual arts from about 1770 to 1850. Viewing the three thousand works of art — chiefly from England, France, and Germany — shown in these two exhibitions one becomes aware that the seemingly irreconcilable opposites of classicism and romanticism are, in retrospect, only two sides of the same coin.

French Painting between the Past and the Present (1951), by Joseph C. Sloane, deals with the emerging realism during the important decades preceding impressionism. Sloane examines the period from 1848 to 1870 chiefly through the conflicting attitudes and judgments expressed by the contemporary critics — avant-garde and "establishment" — toward the works of the great painters of the period: Corot, Daumier, Millet, and Courbet. His study ends with the young Manet.

Realism (1972), by Linda Nochlin, in the Penguin Style and Civilization series, looks at the phenomenon of realism from a very broad point of view. In contrast to the above-mentioned volume by Sloane, Nochlin does not limit herself to mid-nineteenth-century painting in France but looks at the fundamental qualities of realism as a historical movement. She examines a few principal themes: the representation of death in art, the emerging social conscience, and the essentially antiheroic character of the period.*

Impressionism, Post-Impressionism, Symbolism

Impressionism was the brief but pivotal art movement of the 1870s and 1880s in France, which became enormously influential all over the

*In this context T. J. Clark's *The Absolute Bourgeois* and *The Image of the People* (both published 1973) are of considerable importance, discussing Daumier, Millet, Delacroix, Baudelaire, and Courbet in relation to the politics of the Second French Republic, 1848-1851.

world — after having first been ridiculed and maligned by the public and most of the critics. John Rewald's *History of Impressionism* (4th rev. ed. 1973) remains the most exhaustive treatment of this movement. Rewald, having unearthed every available document and ascertained all available facts, has produced the most detailed account of the relevant events. Rewald's goal has been, furthermore, to "reconstitute to a certain extent the atmosphere of the period, placing the reader in direct contact with the original texts" (introduction). The story begins with the "immediate roots" of the movement, the Paris World's Fair of 1855 and the *Salon des Refusés* ("Salon of the Rejected [Artists]") of 1863, and ends with the last of the eight impressionist exhibitions in 1886. The bibliography is another of the book's fine features because of its logical organization and exhaustive coverage. There is also a useful chart of the eight impressionist exhibitions which lists the names of all participating artists.

The sequel to this volume, *Post-Impressionism: From Van Gogh to Gauguin* (2d ed. 1962), also by John Rewald, covers the years from 1886 to 1893 and the activities of Vincent van Gogh, Paul Gauguin, Georges Seurat, Odilon Redon, Émile Bernard, and Paul Signac. In organization and treatment *Post-Impressionism* follows its predecessor, and here, too, Rewald presents a "historical reconstruction which would put every person, every work, every action, and every utterance in its proper place" (preface) in order to come as close as possible to the historical truth.

While Rewald's much-quoted two volumes are the indispensable references for the period because of the extraordinary completeness with which the events are described and documented, one has to turn elsewhere for critiques other than those by contemporaries on the artists and their works. It must also be remembered that Rewald's two books cover only a brief span of time, whereas most of the artists discussed remained active for a considerable period thereafter.

Besides *Impressionism* (1955. 2 vols.), by Jean Leymarie, mentioned elsewhere, there is a lively, literate, and even shorter account, also titled *Impressionsim* (1967), by Phoebe Pool, in the World of Art series. The beginnning chapter on the roots of impressionism is particularly informative and the characterizations of the impressionists and their art are felicitous. Another useful work is *Impressionists and Symbolists* (1950), by Lionello Venturi, volume 2 of his *Modern Painters,* with chapters on Manet, Degas, Monet, Pissarro, Renoir, Cézanne, Seurat, Gauguin, Van Gogh, and Toulouse-Lautrec. Numerous sensitive analyses of individual paintings are given here. But a word of caution is advisable: Venturi believes that an art historian has the obligation to make value judgments and consequently does not hesitate to pronounce certain paintings or

artists good or bad on the basis of what he calls taste. For example, Venturi specifically excludes Claude Monet from his list of nineteenth-century painters of "supreme greatness," a mark of excellence he gives to Goya, Manet, Renoir, Cézanne, Seurat, and Van Gogh.

Excellent pictorial volumes on impressionism are *Impressionism* (1972), by Pierre Courthion, *Impressionism: A Visual History* (1970), by William Gaunt, and *Impressionists and Impressionism* (1970), by Marie and Godfrey Blunden.

The catalog of a comprehensive exhibition *Neo-Impressionism,* by Robert L. Herbert, shown at the Solomon R. Guggenheim Museum, New York, in 1968, is the best source for this post-impressionist interlude. Herbert focuses on Georges Seurat and Paul Signac and includes also a host of lesser followers as well as a few major twentieth-century painters, such as Matisse, Braque, Mondrian, and Balla, who briefly flirted with "division-ism," or "pointillism." Herbert's explanation of this technique is lucid.

The art of post-impressionist symbolism is still awaiting full treatment. *Dreamers of Decadence* (1971) and *The Symbolists* (1973), both by Philippe Jullian, a specialist on this subject, are difficult to use as texts but are valuable pictorial sources. A superb study of post-impressionist symbolism and the interaction between artist and critic is *The Genesis of Modernism: Seurat, Gauguin, Van Gogh and French Symbolism in the 1880's* (rev. ed. 1971), by Sven Lövgren. Three key works considered revolutionary in concept and execution form the nucleus of Lövgren's investigation. They are *A Sunday Afternoon on the Island of La Grande Jatte,* by Georges Seurat; *Jacob Wrestling with the Angel,* by Paul Gauguin; and *Starry Night,* by Vincent van Gogh. These three paintings are analyzed as works of art per se and in the light of the artistic, social, and political climate of the time. They form the author's point of departure, which aims to "unravel the tangled web of relations that existed between the various representatives of art and literature . . . to determine on what level and at what points of intersection artists and poets were able to understand each other" (preface). During the last decade of the nineteenth century, the Nabis were closely linked to the symbolists. *The Nabis and Their Period* (1969), by Charles Chassé, is the authoritative and sympathetic treatment of this brief post-impressionist episode.

The Twentieth Century

The art of the twentieth century cannot be studied in a serious way without at least some reference to primary literary documents, such as statements by the artists themselves, or by contemporary poets and critics who

were able to articulate the qualities and goals of the particular movements with clarity and distinction.

Some twentieth-century primary source materials have been discussed in Chapter 3. Further primary sources are found in the appropriate sections below and also in the relevant sections of Chapter 21 on European art. It bears repeating here that the *Phaidon Dictionary of Twentieth-Century Art* and J. A. Walker's *Glossary of Art, Architecture, and Design since 1945,* which are discussed in Chapter 4, offer particularly good definitions of twentieth-century art movements — both well-known and obscure.

Art Nouveau, Art Deco

Art nouveau ("new art") and its German equivalent, *Jugendstil* ("youth style"), which evolved around 1900, were decorative styles of fluid undulating lines which affected architecture, interior design, the applied arts — furniture, textiles, wallpaper, glass, metalwork, jewelry — and the graphic arts — book illustration, typography, posters. The architects Victor Horta and Antonio Gaudí, the glass makers Émile Gallé and Louis C. Tiffany, and the illustrator Aubrey Beardsley were among its key figures.

Robert Schmutzler's authoritative and beautifully illustrated *Art Nouveau* (1964) offers a comprehensive overview of the subject, tracing its pictorial sources and significant manifestations throughout Europe and in the United States. *Art Nouveau: Art and Design at the Turn of the Century* (1960) is the catalog of an important exhibition organized by Peter Selz and Mildred Constantine, held at the Museum of Modern Art. It contains informative essays, written by various specialists, on the fine and decorative arts, architecture, and graphic design, and includes a comprehensive bibliography. *Sources of Art Nouveau* (1956), by Stephan T. Madsen, was one of the first serious studies of the subject when, after several decades of neglect, interest in this style reemerged in the 1950s. A special primary source volume is *The Lectures on Art* (1975), by Alphonse Mucha, the art nouveau designer whose posters have seen a veritable Renaissance. His art lectures constitute, in effect, a design manual for the art nouveau style.

Art deco is a recently coined term — not yet listed in most art dictionaries — for the decorative style of the 1920s and 1930s, following art nouveau. The name is derived from the International Exposition of Modern Decorative and Industrial Arts (*arts décoratifs et industriels*), held in Paris in 1925, where interiors, furniture, and furnishings in this style were first shown on a large scale. A basic study of art deco has not yet been undertaken. Meanwhile, *Art Deco: A Guide for Collectors* (1972),

by Katharine M. McClinton, is a usable source, with an introductory chapter entitled "What Is Art Deco?" and illustrations of art deco objects in subsequent chapters. A readable book by an influential American art deco designer is *New Dimensions: The Decorative Style of Today,* by Paul T. Frankl, which was first published in 1928, the heyday of art deco.

Fauvism and Expressionism

In 1905 the so-called fauvist painters, with Henri Matisse as the leading artist, created a stir in Paris with their violent color schemes, bold anti-naturalististic distortions, and broad painting technique. Jean Leymarie's *Fauvism* (1959), in Skira's Taste of Our Time series, offers a sympathetic treatment of this brief episode, the men, and their paintings. Excellent color plates are found in *The Fauves* (1962), by Jean-Paul Crespelle, and *The Fauves* (1975), by Gaston Diehl.

In Germany, the expressionists pursued similar artistic objectives but voiced also their social and political commitments through their art. They remained a cultural force until the rise to power of the Nazis, who banned and silenced them as "degenerate" artists. *The German Expressionists: A Generation in Revolt* (1963), by Bernard S. Myers, and *German Expressionist Painting* (1957), by Peter Selz, are good studies about these artists who, in the early years of the century, had formed two loose groups, "The Bridge" (*Die Brücke*), and the more important "Blue Rider" *(Der Blaue Reiter)*. The history of the last-named movement and its principal artists, Wassily Kandinsky, Paul Klee, Franz Marc, and August Macke has been traced in *The Blue Rider* (1971), by Hans K. Roethel. *The Blaue Reiter Almanac* (1974), a volume of the Documents of 20th-Century Art series, is a complete translation of the essential literary document of the movement, which was originally published in Munich from 1912 to 1914. The Almanac was edited by Wassily Kandinsky and Franz Marc whose writings, along with those of other contemporary avant-garde artists — among them the composer Arnold Schönberg — appear in these pages. The editor of the English-language version is Klaus Lankheit, who has provided an excellent introduction to this book.

Cubism and Abstract Art

Cubism, which originated in Paris in 1907 with Pablo Picasso's revolutionary painting *Les Demoiselles d'Avignon,* now in the Museum of Modern Art in New York, represents a radical departure from the naturalism of the past and is the key to most subsequent twentieth-century styles. Its

aesthetic has been formulated in two early essays which have remained essential for the understanding of cubism. The first essay, "Du cubisme" (1912), by two practising cubists, the painters Albert Gleizes and Jean Metzinger, is available in English translation under the title "Cubism" in Robert L. Herbert's *Modern Artists on Art* (1964). The other, "The Cubist Painters: Aesthetic Meditations, 1913," by the French poet Guillaume Apollinaire, appeared in English in 1949 as one of the Documents of Modern Art published by George Wittenborn, and is also included with a few deletions in H. Chipp's *Theories of Modern Art* (1968).

Although cubist paintings were seen in New York as early as 1913 at the famous Armory Show, the New York Museum of Modern Art's great exhibition "Cubism and Abstract Art" (1936) was a milestone – an attempt to bring together a large number of significant paintings, sculptures, drawings, and prints in order to present this movement "as an historical survey . . . conceived in a retrospective – not in a controversial spirit," as Alfred H. Barr, the organizer of the exhibition and author of the catalog, states in the preface to the catalog. This objective was fully realized. The catalog of the exhibition is still one of the basic studies of cubism.

In 1970 the British art historian Douglas Cooper, another of the early champions of cubism, put together a large exhibition, shown at the Metropolitan Museum of Art and the Los Angeles County Museum of Art, called *The Cubist Epoch*. It concentrated on Picasso, Braque, and Juan Gris but included also cubists elsewhere in Europe and in the United States. This catalog, too, is a basic tool.

The most scholarly and painstakingly detailed work on the subject is *Cubism: A History and an Analysis, 1907-1914,* by John Golding (rev. ed. 1968). The initial seven years researched by Golding are indeed the crucial years of this movement, hence the importance of this particular study. Robert Rosenblum's scintillating writing makes his *Cubism and Twentieth Century Art* (1961), discussing developments up to 1940 in Europe and the United States, a pleasure to read. Moreover, the book is splendidly illustrated and has an excellent bibliography in essay form. A briefer survey, which includes many documents in excerpts, is *Cubism* (1966), by Edward Fry.

Cubism had important parallels in other countries – futurism in Italy, *De Stijl* ("the Style") in Holland, vorticism in England, and constructivism in Russia. Works on the first three movements are cited in Chapter 21 under Italy, the Low Countries, and Great Britain, respectively.

Constructivism had wide ramifications outside Russia, after two of its initiators, Naum Gabo and his brother Antoine Pevsner, left the country because of political repression. The works cited below deal with both the

early manifestations in Russia and its spread abroad. *Constructivism: Origins and Evolution* (1967), by George Rickey, is the basic survey. *Circle: International Survey of Constructive Art* (1937) includes "The Constructive Idea in Art" by Naum Gabo, and "Plastic Art and Pure Plastic Art," by Piet Mondrian, as well as critical essays by Herbert Read, Lewis Mumford, Marcel Breuer, and others. *The Tradition of Constructivism* (1974), edited by Stephen Bann, in the Documents of 20th-Century Art series, is another important collection of primary sources which is international in coverage. It has an excellent comprehensive bibliography by Bernard Karpel.

Dada and Surrealism

Dada, the shocking antiart of the post-World War I period, and its offspring surrealism, are the direct opposites of the reasoned abstraction of cubism. Poets as well as painters embraced these movements, which accounts for dadaists and surrealists having had the most articulate spokesmen, who created a literature rich in glittering prose.

Robert Motherwell's *The Dada Painters and Poets* (1951) is a multifaceted collection of pronouncements on the dada movement in English translation, an "accumulation of raw material for the student," as Motherwell states in the preface. There is an excellent critical bibliography by Bernard Karpel (a certain number of documents listed by Karpel in French or German exist now in English translation). Lucy R. Lippard's *Dadas on Art* (1971), containing some newly translated writings by poet-critics and painters in excerpts, supplements Motherwell's compilation. Hans Richter, one of the original dadaists, is the author of an enlightened survey, *Dada: Art and Anti-Art* (1970), which also incorporates many extracts of documents. Two major source volumes, written by two founders and key figures of the early dada and published in English in the Documents of 20th-Century Art series, give a vivid picture of the beginnings of dada in Zurich, Switzerland, and Berlin, Germany. One is the remarkable autobiographical *Flight out of Time: A Dada Diary* (1974), by Hugo Ball, founder of the famous Cabaret Voltaire in Zurich. First published in Germany in 1927, it has retained its freshness. In the present volume Ball's two dada manifestoes of 1914 and 1916 have been added, translated into English. The other is *Memoirs of a Dada Drummer* (1974), the casual, witty, and ironical recollections of Richard Huelsenbeck, and other essays. Both volumes have excellent introductions by John Elderfield and Hans J. Kleinschmidt, respectively, telling of the background of the two men and their fascinating times.

The concepts of surrealism were eloquently formulated by the founder and theorist of the movement, the French poet André Breton, who composed the two major "surrealist manifestoes" and wrote other illuminating essays on the subject. They have been published in English translations under the titles *Manifestoes of Surrealism* (1969) and *Surrealism and Painting* (1972). For excerpts on surrealism by André Breton, Paul Éluard, Louis Aragon, and a host of painters — including Salvador Dali, Jean Arp, and Max Ernst — Lucy R. Lippard's *Surrealists on Art* (1970) may be consulted. It is comparable in coverage and scope to her aforementioned *Dadas on Art.*

It is no accident that several of the twentieth-century art movements have been significantly explored through memorable exhibitions that allowed the public and the critics to view a large number of carefully chosen works together, which of course is not possible when these works are scattered in many places. Thus, the year 1936, when the Museum of Modern Art put on its pioneering exhibition "Cubism and Abstract Art," was also an important one for surrealism. At the New Burlington Gallery in London the "International Surrealist Exhibition" was shown. (The catalog had contributions by Sir Herbert Read and André Breton.) In connection with this exhibition, Sir Herbert Read edited a collection of essays, by surrealist writers, titled *Surrealism* (1936). Sir Herbert's long introduction is the most valuable piece in this volume and is in itself a brilliantly written manifesto defining the ideas and aims of the surrealist movement.

Shortly after the London show the Museum of Modern Art in New York mounted its own exhibition, "Fantastic Art, Dada, Surrealism," with a catalog by Alfred H. Barr. This exhibition traced the ancestors of surrealism to Hieronymus Bosch, Pieter Bruegel the Elder, Giuseppe Arcimboldi, and other old masters. It was the first massive exposure of the American public to dada and surrealism. The public was shocked; one critic called the exhibit "brilliant nonsense by diabolical playboys" and "fever charts of an ailing Bohemia."

No eyebrows were raised, however, when the Museum of Modern Art staged another comprehensive exhibition in 1968: "Dada, Surrealism, and Their Heritage," conceived by William S. Rubin. Rubin's catalog has a detailed bibliography compiled especially with the student in mind. The exhibition also served as the point of departure for his *Dada and Surrealist Art* (1968), to date the most comprehensive treatment of the subject. Rubin's book is important because he has undertaken to develop stylistic criteria, in contrast to the earlier writings of the poet-critics who had

concerned themselves almost exclusively with the pictorial content — the imagery — of surrealist art.

The literature on surrealism is considerable. We mention *The History of Surrealism* (1965), by Maurice Nadeau, a condensed revised translation of an important French two-volume work, *Histoire du surréalisme* (1945-48), and *The History of Surrealist Painting* (1960), by Marcel Jean, which is particularly well illustrated. There are two excellent small volumes by Patrick Waldberg, both with the identical title, *Surrealism.* The earlier of the two, published in 1962 by Albert Skira in the Taste of Our Time series, is a straightforward account of surrealist painting and is illustrated with small reproductions, in color, of paintings only. The later volume, published in 1966, is a "documentary history" and incorporates many excerpts from surrealist documents. It is illustrated with reproductions of paintings, sculptures, graphics, and photographic portraits of surrealist poets and painters. Excellent color plates and useful texts are featured in *The Surrealists* (1972), by William Gaunt, and *Surrealism* (1974), by Uwe Schneede.

Abstract Expressionism

Abstract expressionism, which emerged during the 1940s, was the first American art movement to win international recognition. With this movement the center of the international art scene shifted from Paris to New York.

Works by the leading abstract expressionists were shown at a major exhibition — organized by Maurice Tuchman — at the Los Angeles County Museum of Art in 1965, under the title "The New York School: The First Generation." The valuable catalog contains statements by the participating artists and by some of the most prominent art critics of the decade — Lawrence Alloway, Robert Goldwater, Clement Greenberg, Harold Rosenberg, William Rubin, and Meyer Schapiro. There is also a detailed bibliography.

The essential study of the subject is *The Triumph of American Painting: A History of Abstract Expressionism* (1970), by Irving Sandler. This is a lucidly written and absorbing history of the movement up to the 1950s and has an appraisal of each artist, based on the author's personal conversations and interviews with the artists. Artists discussed are the "gesture painters" Jackson Pollock, Willem de Kooning, and Hans Hofmann, and the "color field painters" Clyfford Still, Mark Rothko, Barnett Newman, Robert Motherwell, and Ad Reinhardt.

The 1960s and 1970s

Abstract expressionism has been followed by a multitude of trends, styles, and movements: pop art, optical ("op") art, Minimal art, earthworks, conceptual art, photorealism, and so forth, all of which have had their prophets and their practitioners. Some exhibitions of the past decade stand out, as for example the 1965 exhibition of optical art, "The Responsive Eye," at the Museum of Modern Art, organized by William Seitz, and the 1966 exhibition, "Primary Structures," at the Jewish Museum, New York.

Thoughtful articles on the most recent developments have been published in magazines such as *Art in America* and *Art News,* and particularly in the more avant-garde *Arts Magazine, Art International,* and *Artforum.*

It is obviously not possible to interpret the art of the present or immediate past with the objectivity and proper distance with which an art historian can explore the art of a period long past. Thus reviews of current exhibitions and articles discussing the current art scene, sometimes issued subsequently in book form, take the place of comprehensive surveys and detailed studies. Sensitive, witty, or incisive, they have the advantage of immediacy, shedding light on the bewildering art scene of today. Among the most illuminating of these essay collections are *Art and Culture* (1961), by Clement Greenberg; *Icons and Images of the Sixties* (1971), by Nicolas and Elena Calas; *Other Criteria* (1972), by Leo Steinberg; *Great Western Salt Works* (1974), by Jack Burnham; several volumes by Harold Rosenberg, from *The Tradition of the New* (1959) to *Art on the Edge* (1975); and *Topics in American Art since 1945* (1975), by Lawrence Alloway. Collections of essays by several critics, selected by knowledgeable editors, also offer stimulating and informative reading materials. Good examples are *The New Art* (rev. ed. 1973), edited by Gregory Battcock, and *Conceptual Art* (1972), edited by Ursula Meyer.

An attempt to gather together documents and information, no matter how fragmentary, on the artistic events of the critical years from 1966 to 1972 has been made by Lucy R. Lippard in her *Six Years: The Dematerialization of the Art Object from 1966 to 1972* (1973). The exceedingly long subtitle of this important, albeit quite personal, compilation describes its characteristics and purpose accurately. It reads: *A Cross-Reference Book of Information on Some Esthetic Boundaries: Consisting of a Bibliography into which Are Inserted a Fragmented Text, Art Works, Documents, Interviews, and Symposia, Arranged Chronologically and Focused on So-called Conceptual or Information or Idea Art with Mentions of Such Vaguely Designated Areas as Minimal, Anti-Form, Systems, Earth, or*

Process Art, Occurring Now in the Americas, Europe, England, Australia, and Asia. . . ." The author's note, on page 9, describes the arrangement and makeup of this volume in further detail. *The New Avant-garde: Issues for the Art of the Seventies* (1972), by Grégoire Müller, which is distinguished by an exceptionally lucid text, should be used in conjunction with Lucy Lippard's documentary survey.

Art and Technology

A special aspect of the history of modern art concerns the relationship of art and technology. A conflict between the two arose in the nineteenth century when the industrial revolution caused machines to take over the work of craftsmen and industrial products replaced handmade household goods. *Pioneers of Modern Design* (rev. ed. 1964), by Nikolaus Pevsner, and *Space, Time, and Architecture* (5th ed. 1967), by Sigfried Giedion, explored this problem as it had developed in the nineteenth and early twentieth century. In *Art and Industry* (5th ed. 1966) Sir Herbert Read looked at mass-produced twentieth-century industrial design with the eyes of an art critic and attempted to create the aesthetic of machine art.

In 1956 Gyorgy Kepes published his *New Landscape in Art and Science,* a seminal work in which he proclaimed the interdependence of artist and scientist in the sense that both "reach beneath the surface phenomena to discover basic natural pattern and basic natural process" (p. 24). Kepes' book, which fuses visual images and verbal statements into a single, inseparable document, presents a fascinating body of illustrations which juxtapose scientific photography with works of art and architecture of all ages and, built around it, essays by artists, architects, designers, and scientists in support of his thesis.

More recently, the electronic age has brought about another revolution in art: kinetic art, light sculpture, holography, video art, and computer art are only some of the new art forms and media made possible by electronics. In 1968 the exhibition "Cybernetic Serendipity," organized by Jasia Reichardt at the Institute of Contemporary Arts in London, was a first attempt to demonstrate the creative possibilities of the computer. The account of the exposition was published both as a special issue of the *Studio International* and as a book, under the title: *Cybernetic Serendipity: the Computer and the Arts* (1969), by Jasia Reichardt. An excellent explication of the uses to which science and technology can be put by the artist in *Science and Technology in Art Today* (1972), by Jonathan Benthall. The journal *Leonardo* stresses the interaction of art and science and regularly prints articles and reports on this theme.

Part III. Art Forms and Techniques

CHAPTER 13

Architecture

Although we live in buildings, use them, and are constantly surrounded by them we are rarely aware of them as architecture. *Experiencing Architecture* (1959), by Steen E. Rasmussen, is one of the more stimulating books that help to create such an awareness. Architecture is seen here as an experience in space, consisting of solids and cavities, and having color, scale, proportion, rhythm, and textures, quite aside from serving specific functions.

The literature of architecture may be divided into two distinct categories. One category is concerned with the design of buildings or building complexes, such as houses, schools, office buildings, shopping centers, and so forth. This is the type of material needed by the professional architect or architectural student. It is closely related to building technology and is therefore outside the scope of this book.

The other category is concerned with architecture in terms of changing styles and social needs. It stresses the forms, functions, and aesthetic qualities of significant buildings and the work of significant architects. This material is studied by both art and architecture students.

Dictionaries, Reference Works

Architecture has its own special language and technical terms. Hence architectural dictionaries are a necessity if we are to understand a writer on architecture. Whereas words such as "apse," "vault," and "pediment" can be found in any English-language dictionary, the definitions given for them and for other terms in architectural dictionaries are usually far more detailed and also better illustrated with graphs and diagrams.

A Dictionary of Architecture (rev. ed. 1976), by three leading British

architectural writers — Nikolaus Pevsner, John Fleming, and Hugh Honour — is the best recent, historically oriented, architectural dictionary. It defines architectural terms, building materials, building types, and structural systems. Its special mark is its well-phrased brief essays on architectural styles, the architectural histories of countries, and biographies of major architects. There are numerous illustrations and brief bibliographies. *The Penguin Dictionary of Architecture* (2d ed. 1972), by the same authors, issued as a paperback, is an earlier version and lacks both the photographic illustrations and the bibliographical references. *Dictionary of Architecture and Construction* (1975), edited by Cyril M. Harris, defines many more terms including those used in architectural engineering and building technology. The definitions are authoritative and concise, and the illustrations clear.

A good reference source for modern architecture up to the middle of the twentieth century is the *Encyclopedia of Modern Architecture* (1963), edited by Gerd Hatje, which covers architects, the architecture of various countries, building materials, major structural systems, and some important movements and organizations. It is illustrated with numerous small photographic views of buildings.

An old standby is *A Dictionary of Architecture and Building* (1901-2. 3 vols.), by Russell Sturgis. Whereas no one would consult this particular dictionary for, say, information on Buckminster Fuller, it is still occasionally useful for detailed information on older and standard architectural subjects.

There is at least one technical reference volume that is worth knowing about. It is *Architectural Graphic Standards* (6th ed. 1970), by Charles G. Ramsey and Harold R. Sleeper, edited by J. N. Boaz, called by some "the architects' bible." While it is primarily intended for the practicing architect, it has much to offer to nonarchitects on the conventions operating within the architectural and building trades. In the sections on interior furnishings, for example, it gives the standard dimensions of chairs, sofas, desks, and beds, or tells how much space is required for a round table with a 36-inch diameter plus four chairs. Many other useful data — even the proportions of the human figure — can be discovered here.

Architectural Histories

Histories of architecture are found in most college libraries. Some of these are mainly for reading, others primarily for reference.

The indispensable reference tool for information on a specific architectural monument (temple, church, palace, gate and so on) is *Sir Banister Fletcher's A History of Architecture,* by Sir Banister Fletcher, called

simply "Banister Fletcher." First published in 1896 and frequently updated and expanded since, it is now in its eighteenth edition (1975), revised by J. C. Palmes. Here is the most compact information on important buildings — dates, building history, names of architects, frequently even dimensions. Its unique feature consists of hundreds of views, elevations, sections, ground plans, and architectural details. The arrangement is in a historical sequence from prehistory to the twentieth century. A detailed index makes it easy to locate a building under its name, building type, or the town in which it is located. In addition to the essential information on individual buildings there are essays on the architectural styles of each period and good bibliographies at the end of the chapters.

Selective in its approach and scope is Henry A. Millon's *Key Monuments of the History of Architecture* (1964), a companion to H. W. Janson's *Key Monuments of the History of Art.* Unlike Banister Fletcher, Millon's *Key Monuments* has no text, but only illustrations with descriptive captions. Millon singles out a few important buildings for each period, style, and country. There are selected exterior and interior views, frequently — but not always — ground plans, and occasionally cross-sections. The photographs are good but not outstanding.

The most readable and truly enlightened architectural history is *An Outline of European Architecture,* by Nikolaus Pevsner; the current seventh edition (1974) is much more attractive and better illustrated than the earlier ones. As the author states in his foreword, he deals with "Western architecture as an expression of Western civilization, described historically in its growth from the ninth to the twentieth century." Despite the title, there is an "American Postscript," outlining the history of architecture in the Americas. Greek and Roman architecture are discussed only in a few introductory paragraphs.

An older book by one of the most respected architectural historians of the United States is *Architecture through the Ages* (1953), by Talbot Hamlin, a kind of college text treating architecture from its prehistoric beginning to the twentieth century, particularly in its relationship to economic conditions and social needs.

Books dealing with the architectural history of specific countries and periods are too numerous to mention here. They can be located through the library's card catalog under the heading "Architecture," with the appropriate subdivision for country or period, as, for example, "Architecture — France," or "Architecture, Gothic."

Highly recommended as basic surveys are the slim but authoritative volumes of The Great Ages of World Architecture series issued by the

publisher George Braziller. Clearly written and well illustrated, they cover the major European architectural periods from ancient Greek to "modern" and, in addition, they treat Chinese and Indian, Japanese, Western Islamic, and Pre-Columbian architecture.

A projected fourteen-volume series, History of World Architecture, produced under the editorial supervision of the noted architect-engineer Pier Luigi Nervi and published by Harry N. Abrams, promises to become the best overall pictorial source for architecture of all periods, styles, and regions. The volumes have, furthermore, excellent texts written by leading scholars. Among the titles published so far are *Baroque Architecture* (1972), by Christian Norberg-Schulz, *Oriental Architecture* (1975), edited by Mario Bussagli with contributions by several other Orientalists, and *Byzantine Architecture* (1976), by Cyril Mango.

Modern Architecture

The architecture of this century has been examined from many points of view. *Modern Architecture* (rev. ed. 1974), by Vincent Scully, in the previously mentioned Great Ages of World Architecture series, presents a concise, but fairly personal overview. *The Master Builders* (1960), by Peter Blake, is a lively biographical and critical study dealing with the achievements of the three innovators of twentieth-century architecture, Frank Lloyd Wright, Le Corbusier, and Ludwig Mies van der Rohe. The most brilliantly original book on modern architecture, which has inspired several generations of architects and architectural students, is *Space, Time and Architecture,* by Sigfried Giedion, which is based on a series of lectures the author gave at Harvard University in 1939, and is now in its fifth edition (1967). Giedion, who traces the precursors of modern architecture to the baroque period, examines the structural and aesthetic potential of steel, concrete, and glass, the modern building materials which evolved in the nineteenth and twentieth centuries and have since transformed architecture. The architect and the urban planner are exhorted to be men of vision and social commitment who should be able to use the inevitable technological advances toward humanitarian goals.

Henry R. Hitchcock, one of the most distinguished U.S. architectural historians, was one of the first in this country to write authoritatively about twentieth-century architecture. Among his important books is *Architecture: Nineteenth and Twentieth Centuries* (3d ed. 1971), a volume in the Pelican History of Art. This is a sober and thorough treatment on the successive styles in architecture from 1800 to the mid-twentieth century, with a carefully selected bibliography arranged by

country and by name of architect under each of the two centuries covered. By contrast, Leonardo Benevolo's *History of Modern Architecture* (1971. 2 vols.) is less concerned with stylistic developments than with the growth of cities and the effects of economic and technological changes on urban design. In this work Le Corbusier is seen as the central figure of the "modern movement." A superior pictorial volume is *A Visual History of Twentieth-Century Architecture* (1972), by Dennis Sharp. International in scope, it reproduces in color and in black and white the most significant buildings constructed from 1900 to 1970. There is a descriptive text and, whenever possible, a plan for each building, a useful general introduction, a chronology, and a bibliography.

Architects: Dictionaries and Directories

No truly comprehensive biographical dictionary of architects exists as yet.* However, biographies of architects are included in the *Encyclopedia of World Art,* the *McGraw-Hill Dictionary of Art,* the *Praeger Encyclopedia of Art,* and the architectural reference works cited in the beginning of this chapter. But Thieme-Becker and its sequel, Vollmer, are still the most comprehensive reference sources for architects.

For architects in the United States there is the *Biographical Dictionary of American Architects (Deceased)* (1956), by Henry F. and E. R. Withey. Nearly two thousand architects who died between 1740 and 1952 are included here. The information was gathered from obituaries published in *The New York Times,* from the *AIA* (American Institute of Architects) *Journal,* from general biographical sources, and from local records of historical societies and chapters of the AIA.

The *American Architects Directory* (3d ed. 1970) is an "authoritative reference on living architects of the United States" (preface) and on architectural firms. Sponsored by the AIA, the foremost professional organization of practising architects in the United States, this directory for the most part includes its members. Under the name of each architect is a list of the principal buildings designed by him.

Architects: Monographs and Series

The literature in English on architects of the past is sketchy, although recently several good books have come out, among them *Jacopo Sansovino* (1975), by Deborah Howard, and *Palladio and Palladianism* (1974), a

Who's Who in Architecture: From 1400 to the Present Day, edited by J. M. Richards, was published too late (1977) for inclusion here.

collection of essays by Rudolf Wittkower. But generally speaking, few architects seem to be favored by the architectural historians. One of the exceptions is Sir Christopher Wren, the architect of St. Paul's in London, on whom a new monograph appears every few years. *Christopher Wren* (1971), by Margaret Whinney, is one of the best of the lot.

The best-documented architect is probably going to be Andrea Palladio, once the monumental *Corpus Palladianum,* begun in 1968, is completed. Each of Palladio's buildings will be the subject of an individual monograph that will give a detailed history of the building from its commission to its completion, and an analysis and critique of its design and design sources. Full pictorial coverage, including elevations and plans, and exhaustive bibliographies, will also be provided. Volume 1, *The Rotonda of Andrea Palladio,* by Camillo Semenzato, deals with one of the most influential of Palladio's buildings, the Villa Rotonda, near Vicenza, Italy.

Studies in Architecture, a loosely conceived series issued by the British publisher A. Zwemmer, offers the most distinguished architectural writing of today. The common denominator of these scholarly volumes, which deal with biographical as well as historical subjects, is the excellence of virtually every title. Some of the monographs, which have become the definitive studies of the respective architects, are *The Architecture of Michelangelo* (rev. ed. 1966. 2 vols.), by James S. Ackerman; *Carlo Maderno and Roman Architecture* (1971), by Howard Hibbard; and *François Mansart* (1973. 2 vols.), by Allan Braham and Peter Smith. In the absence of book-length studies on many notable architects, however, information must often be sought from encyclopedias and dictionaries as well as from architectural histories and periodicals.

Modern architects have generally been accorded better treatment. Authoritative monographs, too numerous to mention here, are available on the major architects. A basic series, Masters of World Architecture, has been issued by the publisher George Braziller, consisting of volumes on Alvar Aalto, Antonio Gaudí, Walter Gropius, Le Corbusier, Eric Mendelsohn, Pier Luigi Nervi, Richard Neutra, Oscar Niemeyer, Ludwig Mies van der Rohe, and Frank Lloyd Wright. A supplementary series, Makers of Contemporary Architecture, includes studies of Louis I. Kahn, Eero Saarinen, and others. All these volumes are concise, readable, well illustrated, and have good bibliographies. They are written by leading architectural writers.

Architects on Architecture: Primary Sources

Only one architectural treatise has come down to us from antiquity – the famous *Ten Books on Architecture (De architectura libri X),* by the

Roman architect Vitruvius, who lived in the first century B.C. In this work, of which the most accessible English translation is by M. H. Morgan, Vitruvius formulates the essential qualities of classical architecture: order, proportion, and harmony. His book set the pattern for architectural thought and writing from the Renaissance to the end of the classical tradition. Vitruvius became so universally known that his name simply came to stand for "architect" as such. In 1715 the English architect Colen Campbell began issuing the *Vitruvius Britannicus; or, The British Architect,* * a great collection of engraved views and plans of British buildings, which was continued by others and ultimately comprised five folio volumes and a two-volume supplement, *The New Vitruvius Britannicus* (1802-8). As late as 1922, a treatise on American civic architecture with the title *The American Vitruvius* was written by Werner Hegemann and Elbert Peets.

But the first disciple of Vitruvius was the fifteenth-century Italian humanist Leone Battista Alberti, author of the earliest Renaissance treatise on architecture. Alberti's *Ten Books on Architecture (De re aedificatoria),* written in 1452 but printed only in 1485, after Alberti's death, follows Vitruvius in the general division into ten books and in some other respects, but remains important in its own right for Alberti's humanistic concepts and his plan for an "ideal" city.

The most influential Renaissance treatise on architecture was *The Four Books of Architecture (Quattro libri dell'architettura),* by Andrea Palladio. It was first published in 1570 with woodcut illustrations of ancient Roman buildings and Palladio's own designs, and was republished in many editions. The best-known English edition is that by Isaac Ware (1738), illustrated with copper engravings, which was issued in a reduced-size facsimile edition in 1965, with an introduction by Adolf K. Placzek. Palladio's *Four Books* are still studied today, both because his general ideas on architecture have retained interest ("A building must have utility, durability, and beauty," he wrote) and because his own buildings, on which he comments, can still be seen in Vicenza, Venice, and the Veneto in northern Italy. Palladianism, the architectural style derived from Palladio's writings and buildings, was introduced to England by the architect Inigo Jones and was transmitted to the United States during the eighteenth century. It became the dominant feature of Thomas Jefferson's architectural work.

A third very influential book was *The Five Orders of Architecture (Regola delli cinque ordini d'architettura),* by Giacomo Vignola,

*The reprint edition (1967) contains a most informative, additional volume: *Guide to Vitruvius Britannicus: An Annotated and Analytic Index to the Plates,* by Paul Breman and Denise Addis.

Michelangelo's successor to the construction of St. Peter's and the architect of the church of the Gesù in Rome. First published in 1562, this book went through innumerable editions in several languages. Vignola simplified the explanation and design of the five architectural orders (Doric, Ionic, Corinthian, Tuscan, and Composite) in such a way that his book was to become a standard reference in the office of practising architects as late as the early twentieth century, when columns were still used as a basic element of architectural design.

Architects on Architecture: The Twentieth Century

Although the classical tradition in architecture was slow to die out, the great innovative architects of this century were the first and most articulate spokesmen for, and defenders of, the architecture they had created.

Frank Lloyd Wright, the greatest American architect, was also a prolific writer on architecture. His essential books are considered to be his *Autobiography* (1943), *Modern Architecture* (1931), and *An Organic Architecture: The Architecture of Democracy* (1939). In his later writings he more or less reiterated many ideas presented in his earlier books. *The Architecture of Frank Lloyd Wright: A Complete Catalog* (1974), by William A. Storrer, is the indispensable reference compendium for Wright's architectural work.

Le Corbusier, the Franco-Swiss architect who is entered in most library catalogs under his actual name. C. E. Jeanneret-Gris, was also an imaginative city planner, a gifted abstract painter, and a brilliant literary champion of his architectural ideas. His most important book, published in 1923 under the title *Vers une architecture,* appeared in an English version as *Towards a New Architecture* (1959). It contains his usually misunderstood definition of a house as a "machine for living." Under the title *Oeuvre complète (Complete Works.* 1946-66), Le Corbusier designed and edited a seven-volume compilation of his architectural designs and completed buildings from 1910 to 1965. A supplementary eighth volume, *The Last Works,* was published in 1970 after his death. He also planned and designed a one-volume selection of his major works, which was published under the title *Creation is a Patient Search* (1966).

Walter Gropius, whose contribution as an architect was overshadowed by his significance as an educator, laid down his philosophy of art and architecture in *The New Architecture and the Bauhaus* (1935). This essay was the outcome of Gropius' activities as the creator and director of the Bauhaus, in Germany, which achieved renown for its concepts of training artists and architects and which helped develop a new aesthetic of twentieth-century art and design.

Other twentieth-century architects have expressed themselves in writing — Louis Sullivan, Eliel and Eero Saarinen, Alvar Aalto, Robert Venturi, to name but a few. *Programs and Manifestoes on Twentieth Century Architecture* (1971), edited by Ulrich Conrads, is a valuable collection of documents relating especially to the earlier phases of twentieth-century European architecture. A cross-section of mid-century architectural opinion in the United States is found in *Architects on Architecture* (1966), compiled by Paul Heyer. *Conversations with Architects* (1973), by John W. Cook and Heinrich Klotz, consists of transcriptions of taped interviews conducted by the authors with Philip Johnson, Kevin Roche, Paul Rudolph, Bertrand Goldberg, Morris Lapidus, Louis I. Kahn, Charles Moore, and Robert Venturi. They freely discuss their own work and the work of fellow architects, often expressing conflicting views.

Periodicals

Architectural Record, begun in 1891, and *Progressive Architecture,* begun in 1920 with the title *Pencil Points,* are the two best-known current architectural journals. Until it ceased publication in 1974, *The Architectural Forum* was the foremost architectural journal in the United States.

Architectural Record and *Progressive Architecture* cover similar ground: they publish new buildings and "portfolios" of individual architects and architectural firms, report on new trends in architectural design and construction, and describe new building materials and products. Articles are usually well illustrated with photographic views, plans, and architectural or structural details. Each of the journals has its special features. *Progressive Architecture* publishes its annual design awards in the January issue. *Architectural Record* publishes an annual mid-May issue, *Record Houses and Apartments of the Year,* which surveys the best current architect-designed houses and apartments. *Record Houses* is for the general public; otherwise the two journals are addressed to the practising architect. They are useful in the library because they are often the only good sources for descriptive and visual information on recent buildings, building complexes, and the work of recent architects.

Architectural Record and *Progressive Architecture* are magazines which essentially only describe and report. They rarely express critical opinion or discuss controversial ideas. Their British counterparts, *The Architectural Review* and *Architectural Design,* are more adventurous in their articles and editorial policies. They include architectural critiques and do not limit themselves to British material, but take an international posture.

For the fifteen years of its existence, *Zodiac* was the most visually and

intellectually stimulating architectural journal. Founded by the Italian industrialist A. Olivetti, it was truly contemporary and cosmopolitan in outlook and was a forum for the articulate and imaginative architectural critics of the 1960s. The journal's central theme was concerned with the role of architecture in today's environment. Most of the articles were written in English; those written in other languages have full English translations.

Oppositions was begun in 1973 in opposition to the presumed parochialism and intellectual complacency of the traditional architectural journals. The aim of *Oppositions* has been to reestablish an architectural dialogue and critique, to reexamine the architect's role in an urban society, and to develop architectural theory. Its articles have ranged from a critique of the "New York Five" architects and Aldo Rossi and his controversial cemetery in Modena, Italy, to a discussion of semiotics and architecture. This journal is for the advanced student.

The periodicals discussed above deal primarily with contemporary architecture. The *Journal of the Society of Architectural Historians* is the only major U.S. architectural journal with a historical orientation. Its subject coverage includes architectural history, theory, and aesthetics; the writing is scholarly.

Access to the material published in the major architectural periodicals can be found through *Art Index*. In addition to the names of architects and architectural firms and references to individual buildings (listed under the name of the city), the principal subject categories include building types, building materials, structural systems and details. The most comprehensive index to architectural journals, however, is the *Architectural Periodicals Index,* compiled by the British Architectural Library at the Royal Institute of British Architects (RIBA) and published quarterly, with the fourth issue being an annual cumulation. Begun in 1972, it indexes about 500 international journals concerned with architecture and architectural history, construction, planning, and the environment.

CHAPTER 14

Sculpture

"The language of sculpture is a universal language," says Leonard R. Rogers in an excellent little book which is titled, simply, *Sculpture* (1969). A work of sculpture "can speak directly to us," he goes on to say, even if we know nothing about it apart from what we see with our own eyes. The forms, compositions, materials, and processes of sculpture are discussed from a universal point of view, with examples taken from all civilizations and all periods. In contrast, Sir Herbert Read in his important study, *The Art of Sculpture* (2d ed. 1961), fashions an aesthetic of sculpture almost exclusively on Western concepts and the Western sculptural experience.

Fewer books have been written on sculpture than on the other major arts, although sculpture is not only an integral part of the visual arts and therefore included in all general art histories, but is actually the predominant art of many cultures and civilizations. This is true most particularly of the ancient world (Egypt, Mesopotamia, Greece), as well as of India, South East Asia and China, Pre-Columbian Central and South America, and the tribal cultures of Africa and Oceania. Most of the books dealing with the arts of these peoples or regions deal largely with their sculpture.

Reference Works

As is the case with the general histories of art, the general art encyclopedias and dictionaries all include information on sculpture and sculptors along with the other arts. It is the exceptional reference tool, however, that is devoted exclusively to sculpture. One of these exceptions is the *New Dictionary of Modern Sculpture* (2d ed. 1971). This biographical dictionary of important twentieth-century sculptors characterizes the style and technique of each artist, as well as giving biographical facts. A small black-and-white illustration of a typical work is often added.

Sculpture Index (1970-71. 2 vols. in 3), by Jane Clapp, is "a guide to pictures of sculpture in a selected number of about 950 publications" (preface). Monographs of individual sculptors are not indexed here. Sculpture is taken in a very broad sense to include many utilitarian three-dimensional objects. The primary listing of sculptures is by the name of the sculptor, if known, or, in case of unknown authorship, by school, country, region, or tribe. There is also a subject and title index which may serve as a useful iconographic reference to illustrations of religious and mythological figures and to portraits of historical characters. Although this index covers all periods, emphasis is on American and European sculpture from 1900 to the cutoff date of approximately 1968.

Techniques

A knowledge of how sculpture is made is obviously needed in the sculpture studio; it is also useful for the study of works of sculpture in art history courses.

The Materials and Methods of Sculpture (1947), by Jack C. Rich, is the standard handbook covering the traditional materials — clay, wax, plaster, cast metal, stone, wood, and so on — and the traditional techniques — modeling, casting, and carving. *The Technique of Sculpture* (1976), by John W. Mills, is a clear, well-illustrated presentation of both traditional and contemporary processes, including direct metal techniques such as welding, working with plastics, constructions, assemblages, and the like.

For detailed explanations of individual techniques and materials, specialized works must be consulted. In the library's card catalog these works are entered under the subject heading "Sculpture — Technique," which brings together general and specialized works, alphabetically, under the authors' names. Subject headings such as "Wood Carving," "Modeling," "Plastics," are also likely to locate such titles in the library.

Histories

The History of World Sculpture (1968), by Germain Bazin, is one of the few comprehensive and well-illustrated surveys covering sculpture East and West, but of necessity it gives only cursory attention to each particular culture and period. More detailed treatment of Western sculpture is provided in the four-volume series A History of Western Sculpture, which comprises *Classical Sculpture* (1967), by George M. A. Hanfmann; *Medieval Sculpture* (1967), by Roberto Salvini; *Sculpture: Renaissance to Rococo* (1969), by Herbert Keutner; and *Sculpture: Nineteenth and Twentieth*

Centuries (1967), by Fred Licht. A particularly useful feature of these authoritative volumes is the list of illustrations, which serves also as a catalog of sculptures, giving brief comments and sometimes bibliographic references for each work illustrated.

In the twentieth century sculpture has had an unparalleled revival and has moved into the forefront of innovation and change. In *What is Modern Sculpture?* (1969) the author, Robert Goldwater, explains the modern sculptor's treatment of the figure, torso, head, and portrait — representation of the human figure has always been a major concern of the sculptor — and then succinctly analyzes the sculptural forms and styles from impressionism to minimalism. The historical development of modern sculpture has been traced in other noteworthy studies. *A Concise History of Modern Sculpture* (1964), by Sir Herbert Read, gives an overview of the subject, starting with the contribution of Rodin at the turn of the century and stressing the adoption of the cubist idiom and abstraction in the course of the twentieth century. *Origins of Modern Sculpture: Pioneers and Premises* (1974), by Albert E. Elsen, takes a different approach. Beginning with the chapter "Sculpture the Way It Was," the author takes up certain sculptural subjects and formal problems faced by Rodin and other pioneers: the nude, heads, portraits and self-portraits, abstraction, as well as expression, proportion, light, color, and so on. *Sculpture of the Twentieth Century,* by Andrew C. Ritchie, based on an exhibition of modern sculpture held at the Museum of Modern Art in 1952, has brief but important statements by the sculptors on their artistic objectives. *Contemporary Sculpture* (3d ed. 1961), by Carola Giedion-Welcker, is particularly useful for its fine plates.

The 1960s and 1970s have seen even more radical change and experimentation. Light sculpture, soft sculpture, pop art, Minimal art, earthworks, environments, process works, conceptual art, have all enriched the repertory of sculpture beyond the previous innovations of kinetic sculptures, assemblages, and constructions. Such works have all but obliterated the traditional definition of sculpture as a "three-dimensional art concerned with the organization of masses and volumes" (Jack C. Rich), and, moreover, have abolished the traditional distinctions between the different media. At the same time, contemporary sculptors often make use of technology for the realization of their conceptions: works are frequently executed in factories by assistants and workmen working under the direction of the sculptor. *Beyond Modern Sculpture* (1968), by Jack Burnham, is a serious attempt to trace the "effects of science and technology on the sculpture of this century." In focusing on the innovations of kinetic sculpture, light sculpture, and environments, the author explains how the old sculptural criteria — purpose, material, technique — developed

by nineteenth-century critics have been replaced by other sets of values. *American Sculpture of the Sixties* (1967), by Maurice Tuchman, based on an exhibition held at the Los Angeles County Museum of Art, gives a well-illustrated cross-section of the prevailing sculptural trends during the decade.

John Walker's *Glossary of Art* (1977) helps to clarify current terms, and Lucy Lippard's *Six Years: The Dematerialization of the Art Object from 1966 to 1972* (1973) gives appropriate bibliographic sources and relevant exhibitions for the turbulent developments of those years. But the best sources for the today's currents in sculpture are found in exhibition catalogs and journal articles.

Detailed histories of sculpture in a given country or period are treated in specialized publications, several of which are discussed in the appropriate chapters of this volume. Four important titles bear repeating here: *The Sculpture and Sculptors of the Greeks* (4th ed. 1970), by Gisela Richter, is an encyclopedic handbook on the subject; *Gothic Sculpture in France* (1972), by Willibald Sauerländer, has eclipsed all previous books on this important area of medieval art; *An Introduction to Italian Sculpture* (2d ed. 1970-72. 3 vols.), by John Pope-Hennessy, is the indispensable work on Italian Gothic, Renaissance, and baroque sculpture; *American Sculpture in Process: 1930-1970* (1975), by Wayne Andersen, is a study of American sculpture during the four important decades that signified its entry into the mainstream of world sculpture.

Periodicals

Two journals are concerned exclusively with sculpture. The *National Sculpture Review* is the organ of the National Sculpture Society, which leans toward the traditional concepts in sculpture. *Sculpture International,* a short-lived British journal published from 1966 to 1970, contains critical articles, mostly on avant-garde artists.

CHAPTER 15

Painting Techniques

Books on how to paint are legion, and new ones are coming out every year. Most of these how-to-do-it volumes are addressed to the amateur or Sunday painter who does not have the benefit of instruction in art and must therefore fend for himself. Unfortunately, they often make the user believe that one can learn to create works of art by simply following step-by-step instructions. Readers looking for sound information on art materials and their use will shun such a type of book and will instead consult solid handbooks on the various techniques. Many college libraries stock some of the basic handbooks, whereas the how-to-paint books are usually more plentiful in public libraries.

The most comprehensive and dependable handbook in the field is *The Artist's Handbook of Materials and Techniques* (3d ed. 1970), a fat volume of 750 pages by Ralph Mayer. This is the book that the professional artist is apt to consult for authoritative information on the technical side of painting. A large part of the volume is devoted to pigments, including a descriptive listing of each pigment in alphabetical order. The characteristics and properties of all painting media are also described in detail. Of these, oil painting is treated most extensively. Historical notes are given whenever appropriate. There are chapters on grounds for oil and tempera, on solvents and thinners, and on binders and adhesives. A chapter on "The New Materials" covers synthetic paints and, briefly, the new printmaking techniques. The chemistry of paints has not been overlooked, and the conservation of pictures forms another considerable chapter. There is information on brushes, palettes and palette knives, and other tools.

More selective in its coverage of techniques is *The Painter's Craft* (3d ed. 1975), by the same author. This book is practical in its approach and is therefore a helpful manual for the student painter. An excellent

handbook is *The Materials of the Artist* (4th ed. 1969), by Max Doerner, which has an important chapter on the painting techniques of the old masters.

Books dealing with only one painting medium, such as oil painting or water color painting, are quite numerous. They may be found in the library's card catalog under the subject heading "Painting — Technique." Books on water color painting are listed under "Water-Color Painting". Books on Acrylic painting are listed under "Polymer Painting" or under the general heading of "Painting — Technique." Pastel painting (because it is done with crayons) is often found in the section on drawing; the heading used in most card catalogs is "Pastel Drawing."

Primary Sources

Surviving artists manuals from earlier centuries give us insight into painting practices of the past. They are still of interest to us, especially when paintings dating from these periods are being studied. Best known among these is *The Craftsman's Handbook* (1954), by a fourteenth-century artist, Cennino Cennini, whose reputation rests on this handbook, which was also published under its Italian title *Il libro dell'arte,* together with a translation by D. V. Thompson (1932-33. 2 vols.). This is one of the principal surviving sources for late medieval artistic practices.

Color

Color is a subject of great concern to the painter. It is a complex phenomenon having physical, chemical, physiological, and psychological aspects. There are numerous popular books on color; among the better ones are those by the well-known color authority Faber Birren. His *Principles of Color* (1969), subtitled *A Review of Past Traditions and Modern Theories of Color Harmony,* presents a difficult subject in clear and relatively simple language. It is recommended in spite of its inadequate color plates. *History of Color in Painting* (1965), also by Faber Birren, analyzes palettes and the expressive use of color by painters from the Renaissance to the present.

Students concerned with the identification and matching of colors need to familiarize themselves with color systems — that is, the systematic arrangements of hues with respect to saturation and brightness. The two color systems of major importance to artists are the Ostwald system and the Munsell system, both named for their creators.

The Color Primer (English-language version 1969), written by Wilhelm Ostwald and edited by Faber Birren, is the basic statement of Ostwald's

color theory, with comments by the editor. *Colour Science* (1931-33. 2 vols.) is Ostwald's comprehensive and advanced treatise on the subject. *Basic Color* (1948), by Egbert Jacobson, gives a thorough interpretation of the Ostwald system in four broad sections: Principles of Color Organization, Principles of Color Harmony, Light and Sensation, and Color and Painting.

A Grammar of Color: A Basic Treatise on the Color System of Albert H. Munsell (1969) is Faber Birren's version and interpretation of the Munsell system, based on an older volume with the same title written and illustrated by T. M. Cleland. *A Color Notation,* by Albert H. Munsell, first published in 1905 and republished many times, is the definitive, concise exposition of the Munsell system as laid down by Munsell himself.

Two artists, both stemming from the Bauhaus tradition, have authored two highly significant volumes on color for artists: *The Art of Color* (1961), by Johannes Itten, a large, sumptuously illustrated work, and *Interaction of Color* (1963), by Josef Albers. In *The Art of Color,* Itten develops an aesthetic of color derived from its psychological, symbolical, and intellectual effects. He explains the seven basic color contrasts and analyzes the use of color in twenty-eight works by master colorists, from medieval stained glass windows to paintings by Picasso and Paul Klee.

Outstanding in its conception and as a book is *Interaction of Color,* by Josef Albers. The original limited edition of 1963, consisting of an admirable text and eighty folders of meticulously executed silk screen color reproductions, is in effect a replica of the famous color course taught by Albers at Yale University. The 1975 reissue consists of the unabridged text with a few selected color plates — unfortunately printed in a cheaper process, however. Albers' approach is unique. He does not present yet another color theory or system but teaches the student to develop his own sensitivity to color by means of direct perception and experimentation.

Research on all aspects of color is conducted by the Inter-Society Color Council, ISCC for short, an international association of color experts. A cooperative effort of the Council and the National Bureau of Standards, a U.S. government agency, has produced *The ISCC-NBS Method of Designating Colors and a Dictionary of Color Names* (1955), by Kenneth L. Kelly and D. B. Judd, a reference work dealing primarily with the knotty problem of nomenclature.

Since color belongs essentially in the field of optics, the volume cited above, along with certain other titles on color, may be located in the science section of the library.

Drawing

It has been said that to understand the art of a painter one should also know his drawings. The "spontaneous and rapid notation" (Bernard Berenson) of an idea, a motif, or an object can tell much about the creative process, the trials and successes of an artist. As preparations for paintings or sculptures, drawings yield important clues to the artist's intentions. But they are also valued and studied as works of art in their own right, for their technical, formal, and expressive qualities.

Like so many works of art, drawings have to be studied mostly through reproductions, but certain reproduction methods have made it possible to reproduce drawings with considerable fidelity. The closest approximations to original drawings are the so-called facsimile reproductions, made in the expensive, nearly extinct, color collotype process, which was used successfully in the earlier decades of this century. Unequalled are the large portfolios of master drawings that were issued by the Uffizi Gallery in Florence and the Albertina in Vienna, Austria, in the 1920s and 1930s. Of excellent quality also are the facsimile drawings of the Vasari Society and the Marées Society, published about the same time. Any of these volumes, if available, offers unsurpassed opportunity for study.

Reproductions of artists' sketchbooks in their entirety constitute another type of facsimile drawings. Some of these sketchbooks resemble the originals so closely that even smudges, grease spots, and any other flaws present in the original become visible in the facsimile. The intimate, often casual pen or pencil sketches preserved in these sketchbooks are among the most fascinating and revealing artistic documents. An example is *Paul Cézanne Sketch Book Owned by the Art Institute of Chicago* (1951. 2 vols.), with an introduction by Carl O. Schniewind.

Numerous pictorial volumes reproducing master drawings have been published in recent years. A particularly wide choice of drawings from all

schools and periods is contained in a four-volume compilation, *Great Drawings of All Time* (1962), by Ira Moskowitz. Although the quality of the reproductions is uneven, the range of techniques and styles in the drawings compensates for this deficiency, making this set well suited for visual exploration.

Collections

Most valuable are the publications devoted to the world's great collections of drawings, which combine authoritative texts and catalogs with well-produced illustrations. These publications serve the dual purpose of being excellent visual study material as well as supplying scholarly art historical data. Among the finest of these are the volumes dealing with the drawings in the royal collection at Windsor Castle, England, one of the world's outstanding collections of drawings, which were assembled by the British kings over several centuries. The publication of these treasures, which has been carried out intermittently for thirty years, began with *The Flemish Drawings . . . at Windsor Castle* (1942), by Leo van Puyvelde. Several distinguished volumes have been published on the Italian drawings, by far the largest and most celebrated group in the collection. They are dealt with either by local school (such as Roman drawings, Venetian drawings) or grouped under the names of individual artists, such as *The Drawings of Leonardo da Vinci . . . at Windsor Castle* (2d ed. 1968. 3 vols.), by Kenneth Clark.

Drawings in the Fogg Museum of Art (2d ed. 1946. 2 vols.), by Agnes Mongan and Paul J. Sachs, is one of the earliest and foremost publications of a great collection of drawings in the United States. It has excellent plates, and the extensive commentaries on each work were written with the student user in mind. More recently, several volumes of a series, Drawings from New York Collections, have made their appearance, based on exhibitions from the collections of the Metropolitan Museum of Art and the Pierpont Morgan Library, which have been held since the 1960s. About a hundred and fifty to three hundred drawings are included in each volume, each of these with full-page illustrations. The catalogs are carefully compiled, giving technical data, provenance, exhibition records, bibliographical information, and a commentary on each work. An example is *The Eighteenth Century in Italy* (1971), compiled jointly by Jacob Bean and Felice Stampfle, curators of drawings at the "Met" and the Morgan Library, respectively. Another example of a pictorial volume from a major museum is *Great Drawings of the Louvre Museum: The French Drawings* (1968), by Maurice Sérullaz. Here, too, are good illustrations and scholarly

catalog entries with detailed comments. *Master Drawings in the Albertina* (1967), by Otto Benesch, has particularly fine illustrations and a sound text.

One of the capital works in a specialized area is *The Drawings of the Florentine Painters* (rev. ed. 1938. 3 vols), by the American connoisseur Bernard Berenson. Volume 1 contains a persuasive, enthusiastically written, and highly readable text; volume 2 contains a systematic catalog; and volume 3 contains about 1,000 illustrations. This set is Berenson's pioneer attempt to classify and attribute to a specific painter the drawings (mostly unsigned) by Florentine artists from the fourteenth to the sixteenth century. The author, whose method was, admittedly, largely intuitive, based his attributions on criteria of form and what he called "tactile values."

The collected drawings of a single great master reproduced in book form can provide an almost inexhaustible source of inspiration and wonder. This is certainly true of the monumental six-volume catalog of *The Drawings of Rembrandt* (rev. ed. 1973), edited by Otto Benesch. The catalog itself is a model of scholarship which will remain an essential tool for research on Rembrandt. The plates enable the user to study the full range and development of Rembrandt's mastery of the drawing medium, his unique freedom of expression, vibrant technique, subtlety, breadth, and inventiveness.

Periodicals

Master Drawings, a quarterly published since 1963, is the only journal devoted exclusively to drawing. It is scholarly, well illustrated, and also contains pertinent book reviews. It succeeds an earlier British periodical, *Old Master Drawings,* published from 1926 to 1940. The 1970 reprint of *Old Master Drawings* includes an index of artists, authors, subjects, and collections.

Techniques

There are many popular volumes on drawing techniques, but few meet the exacting standards of a truly good book. In general, texts providing step-by-step instructions on how to draw are of dubious value. The better books avoid such formulas. They attempt to train the student's eye and then lead him or her to translate this vision into the graphic medium. As a rule of thumb, the better books on drawing can be recognized by the fact that they are illustrated primarily with reproductions of master drawings rather than with drawings supplied by the authors themselves.

One of the best recent manuals is *The Art of Drawing* (1970), by

Bernard Chaet. The author first explains the materials and tools of drawing, then explores the principal visual themes – landscape, figure, man-made objects – and the various ways in which they may be rendered. In the final section a large and varied group of significant master drawings is reviewed.

Drawing Lessons from the Great Masters (1964), by Robert B. Hale, is also a good book. It deals with figure drawing based on the techniques of the masters from the Renaissance to the present. This includes the nude and the draped figure, as well as heads, hands, and other parts of the human body. The art of drawing is explained in terms of line, light, and planes; mass and position; thrust or direction. Characteristic master drawings are analyzed in some detail. There is also a chapter on artistic anatomy.

A classic in its field is an older, still useful work, *The Natural Way to Draw* (1941), by Kimon Nicolaides. The author's once famous drawing classes at the Art Students League in New York are here perpetuated in book form. Nicolaides developed a highly structured course of study, prescribing specific exercises for specific problems. *The Craft of Old-Master Drawings* (1957), by James Watrous, has been "consciously written to present the craft of old master drawings to contemporary artists, scholars and students of drawing" (foreword). The old drawing media examined here are metalpoint, chiaroscuro drawing, pen drawing, chalk, pastel, crayon, charcoal, and graphite.

The theory and aesthetic of drawing are lucidly presented in two small studies, *The Language of Drawing* (1966), by Edward Hill, and *Drawing* (1969), by Philip S. Rawson. *A Guide to Drawing* (1976), by Daniel M. Mendelowitz, a larger and more comprehensive volume, is particularly valuable for its section on the history of drawing from cave art to the present.

Anatomy and Perspective

Two auxiliary subjects usually connected with the practical study of drawing are anatomy and perspective. Anatomy books for artists, which differ considerably from those used by students of biology or medicine, are found in the library's card catalog under the subject heading of "Anatomy, Artistic." The best of these emphasize bone and muscle structure of the full figure as well as of the head and limbs, and are often illustrated with photographs. Examples are *Atlas of Human Anatomy for the Artist* (1951) by Stanley R. Peck, and *An Atlas of Anatomy for Artists* (1957), by Fritz Schider. This latter volume has an annotated bibliography by Adolf K. Placzek. Jack Kramer, in *Human Anatomy and Figure Drawing* (1972), demonstrates anatomical structure, form, and movement of the

human figure, by analyzing master drawings — chiefly of the Italian High Renaissance and mannerism. An unusual but excellent source of anatomical illustrations for artists is *The Illustrations from the Works of Andreas Vesalius of Brussels* (1950), by J. B. de C. M. Saunders and Charles D. O'Malley. Vesalius was a sixteenth-century Flemish anatomist whose medical treatises might have been forgotten, were it not for the fine copper engravings of skeletons, muscle structure, and other anatomical details which adorned his works.

Perspective: A New System for Designers (1956), by Jay Doblin, is one of the better texts on this subject.

Prints

Definitions, Reference Sources

The word "print" is used so loosely for a multitude of things printed that it needs to be defined more closely if it is to mean an original work of art. Such a definition, which clearly states the artist's responsibility with respect to the creation and execution of an original print, has been formulated in a thirty-page booklet titled "What Is an Original Print?" (1961), edited by Joshua B. Cahn and sponsored by the Print Council of America, which is an important nonprofit organization to promote the appreciation of fine prints.

An original print differs in at least one essential aspect from most other original works of art: Whereas an original painting or drawing is *unique,* an original print (except for the monotype) is a *multiple.* This means that each and every print — usually called "proof" — pulled from the master image is considered to be an original so long as it meets the basic criteria defined.

The word print is often used when "reproduction" would be the correct word. Reproductions are the printed illustrations in color or black and white in books and magazines; they are the large color "prints" used for decorating walls; and they are the so-called study prints and art prints found in library files or sold in museum bookshops. Reproductions are as a rule printed commercially by means of photomechanical processes and can be produced in an almost unlimited number.

The word "copy" does not always mean the same thing as the word "reproduction," nor should it be used to denote a single proof, or impression, of a print, for copy has a special meaning when applied to works of art. A copy of a work of art is usually in the same medium as the original but is made by a person other than the artist who created the original; it is

therefore never quite the same as the original. An artist's copy of one of his own works is called a "replica." A forgery is an imitation of a work of art which is fraudulently claimed to be an original. In dealing with art subjects it is, therefore, advisable to use the words "print," "reproduction," and "copy" only in their most specific sense.

Printmaking is one of the *graphic arts*. It shares this classification with drawing and illustration. Recent practice has tended to include also book design, typography, and commercial art with the graphic arts.

Comprehensive books dealing with printmaking are frequently arranged by the printing *process* – relief, intaglio, planographic, and stencil – rather than the corresponding print *medium* – woodcut, engraving and etching, lithography, and silk screen printing (serigraphy). *A Guide to the Collecting and Care of Original Prints* (1965), by Carl Zigrosser and Christa M. Gaehde, is a basic and concise reference source explaining these traditional print processes and media in nontechnical language, but unfortunately it is not illustrated. The definitions include also the chief photomechanical reproductive processes, or process prints, and other relevant subjects such as paper and collector's marks. French and German equivalent terms are frequently given. A particularly informative chapter deals with "The Historical Background of Originality."

A Handbook of Graphic Reproduction Processes (1962), by Felix Brunner, has fuller explanations and numerous illustrations with enlarged details of all graphic processes – artistic and commercial. This comprehensive trilingual work in English, French, and German discusses in each chapter the hand-produced technique along with the comparable mechanical printing method.

Introductory Works and Historical Surveys

The study of prints and printmaking is a subject somewhat apart. General art histories often devote little if any space to prints. Prints have therefore developed a specialized literature of their own, consisting of technical manuals on the various graphic processes; histories of the print media, schools, and periods; comprehensive print catalogs; and *catalogues raisonnés* of prints devoted to the work of individual printmakers such as Dürer, Callot, Rembrandt, Goya, Daumier, and others.

Of all art forms, printmaking is the medium where a knowledge of the techniques and the graphic possibilities and limitations of each process is indispensable for a proper understanding of the expressive and aesthetic quality of prints. Hence most introductory volumes and surveys allow a considerable amount of space for the discussion of the various print

processes. The books cited below discuss prints from diverse angles.

A mainly visual approach: *How Prints Look* (1943), by William M. Ivins, is, in the words of the author, "an elementary introduction to the appearance . . . of prints. It is not a history and it contains no technical recipes or instruction for printmaking." It does contain enlarged details of prints showing the traditional techniques. The comments on each print draw attention to the specific qualities of line and surface which characterize the process used.

A printmaker's approach: *About Prints* (1962), by Stanley W. Hayter, is a very personal, vividly written account by a master printmaker and founder of the famous Atelier 17 the activities of which are also described by the author.

A social history of prints: A. Hyatt Mayor's *Prints and People* (1971) discusses prints as social documents.

Pictorial histories: Carl Zigrosser's *The Book of Fine Prints* (1956), a revised edition of an earlier work, *Six Centuries of Fine Prints,* is a fairly comprehensive survey. A recent survey with particularly fine plates and a good informative text is *Prints and Drawings* (1970), by Gottfried Lindemann.

Standard historical treatment: Two older works by the British print connoisseur Arthur M. Hind are *An Introduction to a History of Woodcut* (1935), discussing primarily and in great detail the fifteenth-century beginnings, and *A History of Engraving and Etching* (1927), covering the development of these two media up to 1914. Lithography, which was not invented until about 1800, is not considered in the latter work, but its history is very well covered by Felix Man, in *Artist's Lithographs* (1970). Printmaking from 1900 to the present is the subject of *Prints of the Twentieth Century* (1976), by Riva Castleman, based on the print collection in the Museum of Modern Art, New York. It begins with Bonnard's lithographic illustrations for Verlaine's poetry and ends with the work of the new realists and conceptualists.

Prints in the wider context of civilization: *Prints and Visual Communication* (1953), by William M. Ivins, is also historically oriented. However, in this study, prints, or "printed pictures," are not considered as "art" but as tools of information. Ivins develops the brilliant thesis that man's ability to produce prints or "exactly repeatable pictorial statements" in quantity "has had incalculable effects upon knowledge and thought, upon science and technology of every kind," matching in importance the invention of writing.

Printmaking Techniques

While most of the previously mentioned titles offer a certain amount of technical information, the practising printmaker needs handbooks that will aid him or her in the actual creating of prints.

An excellent comprehensive and up-to-date handbook of the traditional as well as avant-garde printmaking techniques is *The Complete Printmaker* (1972), by John Ross and Clare Romano. Authoritative, lucidly written, and eminently practical in its approach, it presents the basic techniques while encouraging both experimentation and searching for original solutions. As an outgrowth of this comprehensive, profusely illustrated folio volume, the same two authors have compiled four large but handier paperback volumes, all published in 1974, with the titles *The Complete Intaglio Print, The Complete New Techniques in Printmaking, The Complete Relief Print,* and, finally, *The Complete Screenprint and Lithograph.*

Several other good manuals could be named. An example is *Printmaking* (2d ed. 1971), by Gabor Peterdi, a respected printmaker, who discusses relief and intaglio printmaking and also includes a chapter on "Printmaking for Young Children."

In addition to these and other comprehensive works there are also manuals dealing with a single print medium. They are found in the library's card catalog under the name of the specific medium, for example "Etching," "Mezzotint," "Woodcut," and so forth. The older handbooks on the traditional techniques should not be ignored if they are available, for the newest ones are not always the best. Some of the standard works on etching, for instance, are quite serviceable in spite of their age. *A Treatise on Etching* (1885), by the French nineteenth-century etcher Maxime Lalanne, is probably one of the oldest practical handbooks still in use. The practices outlined in *The Art of Etching* (1924), by Ernest Lumsden, are also still of value. *Woodcuts and Wood Engravings: How I Make Them* (1939), by Hans A. Müller, and his less-elaborately produced *How I Make Woodcuts and Wood Engravings* (1945), are considered to be the best manuals on these relief processes.

The Tamarind Book of Lithography (1970), by Garo Z. Antreasian and Clinton Adams, has superseded all earlier books on this medium for completeness of information, authority, and excellence of presentation. The authors have been associated with the highly influential Tamarind Workshop, which has been instrumental in the current revival of lithography. This book discusses both the artistic and practical aspects in great detail, with emphasis on present-day trends. Yet, for a more traditional approach, *How to Draw and Print Lithographs* (1950), by Adolf Dehn and

L. Barrett, has remained of interest because of the renown of its author, the painter Adolf Dehn. A primary source and the first treatise on lithography, of which a modern edition is available, is *A Complete Course in Lithography* (1819), by Aloys Senefelder, the inventor of this process.

The silk screen process was developed only in the late 1930s. Most of the early books and articles on the subject were written by J. I. Biegeleisen, whose books are still found on many library shelves. However, in this case the more recent treatments of screen printing are preferable to the old standbys. *Serigraphy* (1965), by Kenneth W. Auvil, and *Silk-Screen as a Fine Art* (1967), by Clifford Chieffo, are standard titles.

Print Catalogs

The serious student of prints will sometimes find it necessary to consult scholarly print catalogs and *catalogues raisonnés,* of which the earliest and most important is *Le peintre graveur,* by the Austrian engraver and art historian Adam von Bartsch. Originally published (1803-21) in twenty-one volumes, and available in modern editions, this pioneer work laid the foundation for the art-historical study of prints. The French title *Le peintre graveur,* literally translated "The Painter Engraver," is not unique with Bartsch, but occurs in several later publications. It means a printmaker who conceives and executes his own compositions, as distinguished from printmakers or engravers who merely engrave someone else's design.*

Bartsch's *Le peintre graveur* is a descriptive catalog of fifteenth to eighteenth-century Netherlandish, Italian, and German prints, which originally comprised the print collection of the imperial court in Vienna. In this work, both known and unknown artists are grouped by school and period, their prints classified by broad subjects, numbered consecutively, and briefly described (in French). These catalog numbers have since come to identify prints permanently and are still quoted in the literature. Thus the number B.98, for example, found in connection with Albrecht Dürer's engraving *Knight, Death and Devil,* refers to number 98 under Dürer in volume 7 of Bartsch's catalog. (Rembrandt's etchings are not included

*Until the invention of photography and photomechanical reproduction methods, handmade prints were the only means by which any kind of image or picture could be reproduced in quantity. This type of print is usually called a *reproductive print.* The woodcut was the principal reproductive medium for illustrations in early printed books. During the sixteenth century copper engravings came into use and were prevalent in seventh- and eighteenth-century book illustration. In the nineteenth century, steel engravings, lithographs, linecuts, and, finally, halftone illustrations successively replaced the earlier techniques.

with the Netherlandish prints; they were cataloged by Bartsch in a separate publication.)

Having a French text and no illustrations, Bartsch's usefulness for the majority of today's students is unfortunately rather limited. However, the publication of the so-called Illustrated Bartsch which, when completed, will make available illustrations of all the Italian prints cataloged by Bartsch, revives the importance of Bartsch as an essential reference tool. The first volume of the Illustrated Bartsch, *Italian Chiaroscuro Woodcuts* (1971), edited by Caroline Karpinski, corresponds to volume 12 of the original edition. The present volume also contains a valuable essay on Bartsch's life and work and a description of the project. Companion volumes in English, annotating and updating Bartsch's work, are to appear along with the volumes of illustrations.

A comprehensive catalog of Dutch and Flemish prints has been in progress since 1949, issued under the authorship of F. W. H. Hollstein, and, beginning with volume 15, edited by Karel G. Boon and J. Verbeek. This set, titled *Dutch and Flemish Etchings, Engravings, and Woodcuts: ca. 1450-1700,* attempts to catalog all known prints and states thereof by known and unknown masters of these two schools, and to reproduce all the important prints. Some of the volumes have been issued separately, as for example the two-volume catalog of Rembrandt's etchings, compiled by Christopher White and K. G. Boon, and published in 1970 under the title *Rembrandt's Etchings* — in commemoration of the 300th anniversary of the artist's death in 1969.

German Engravings, Etchings, and Woodcuts: ca. 1400-1700, also with F. W. H. Hollstein as the author and published since 1954, is similar in coverage and scope for German prints.

Other major print catalogs in English are those by Arthur M. Hind, *Early Italian Engraving* (1938-48. 7 vols.) which includes reproductions of each print cataloged, and *Engraving in England in the Sixteenth and Seventeenth Centuries* (1952-64. 3 vols.), by the same author.

Unfortunately for English-speaking students, many of the scholarly print catalogs were the work of French or German art historians. An important example for nineteenth- and early twentieth-century prints is *Le peintre-graveur illustré (XIXe et XXe siècles)* (1906-30. 31 vols.), by Loÿs Delteil. The reprint edition (1968-70), with the title *Le peintre-graveur illustré: The Graphic Work of Nineteenth and Twentieth Century Artists,* includes an additional volume 32 with a multilingual glossary of printmaking terms and a vocabulary in English, French, German, and Spanish. The majority of artists represented in this work are French. One of the few exceptions is Goya, the Spanish painter and etcher. Ten

volumes (vols. 20-29) of Delteil's monumental catalog are devoted to the graphic work of Honoré Daumier. With nearly 4,000 entries, all illustrated, this is the most complete reference source for Daumier's masterful lithographs of social and political satire.

The surging interest in prints as collectable works of art has resulted in large numbers of exhibitions and exhibition catalogs of prints as well as the publication of many *catalogues raisonnés* of the works of individual printmakers old and new. This proliferation of material has led to the publication of *Print Reference Sources* (1975), compiled by Lauris Mason and Joan Ludman. This selective bibliography consists of an alphabetical list of eighteenth- to twentieth-century printmakers of all nationalities, and cites under the name of each artist the most pertinent catalogs and other sources, arranged by date of publication. Artists such as Dürer or Rembrandt, who, of course, lived before the eighteenth century, are not included.

Periodicals

Artist's Proof, published from 1961 to 1972 under the auspices of the Pratt Graphics Center, is still a valuable visual source for contemporary international developments in printmaking. Its successor is the scholarly *Print Review,* published since 1973. *The Print Collector's Newsletter* publishes articles on prints and printmakers and has several regular columns: news of interest to print collectors, listings of new prints and photographs published (with prices), new museum and dealers' exhibition and stock catalogs, and book notes and reviews. Volume 3, number 1, March/April 1972, contains "Prints: A Very Basic Bibliography," by Andrew Robison.

Print Collections

Original prints are collected by museums and some of the largest United States public libraries. The Library of Congress also owns vast print collections. Unlike paintings, prints are, as a rule, not permanently displayed on the walls of museum galleries. They are kept in so-called print rooms of museums and libraries, where they are stored in specially constructed print boxes. In many museums and libraries they are available for study only under special conditions or by special appointment with the curator in charge.

CHAPTER 18

Photography

"From today painting is dead!" was a dire prediction made in the early days of photography.* But painting continued to flourish, and "photography," as László Moholy-Nagy was to remark about a hundred years later, "has not yet reached anything but its full stature. Yet . . .," Moholy-Nagy went on to say, "this does not contradict in any way the almost unbelievable impact which photographic vision has had upon our culture."

Photography has remained controversial. Some people are still debating whether it is an "art" or merely a tool for recording visual data. But a reader of the eloquent essays gathered together in *Photographers on Photography* (1966), edited by Nathan Lyons, cannot but feel the presence of true artists – artists who are concerned with artistic problems, along with problems of technique. The artistic problems, indeed, are often quite similar to those experienced by artists working in other media.

Books on photography are of three basic types: manuals and handbooks, books on photography as an art form, and pictorial volumes. To these must be added reference works such as encyclopedias and bibliographies as well as journals and annuals.

Manuals

Numerous manuals are especially written and designed for the user of a particular camera. Many of these are issued by the camera manufacturers themselves. They vary in length and scope from no more than a simple instruction booklet to detailed handbooks that go beyond the immediate purpose of explaining the particular make or type of camera, lenses, or

*This quotation was also used as the title of a 1972 exhibition in London subtitled *The Beginnings of Photography*.

other attachments. These manuals are updated periodically as new camera models and new equipment appear on the market. They are usually readily identifiable by their titles, such as *Leica Manual, Nikon System,* and the like. They are more likely to be found on the shelves of the public library than in the college library.

General handbooks for the student, the professional, and the amateur photographer exist in profusion. Of particular value are those written by experienced photographers who do not mind sharing their wisdom and expertise. Two master photographers who have done just that are Ansel Adams and Andreas Feininger.

Highly commendable is the Basic Photo Series by Ansel Adams, which consists of five fundamental volumes: *Camera and Lens: The Creative Approach* (1970); *The Negative: Exposure and Development* (1948); *The Print* (1950); *Natural Light Photography* (1952); and *Artificial-Light Photography* (1956). To these must be added the *Zone System Manual* (1972), by Minor White, which is based on Ansel Adams' zone system, allowing for full control of tone reproduction in photography.

Andreas Feininger is the author of several excellent handbooks emphasizing the artistic and creative aspects of photography. *The Creative Photographer* (1975) deals with black-and-white photography. The art and technique of color photography are discussed authoritatively in his *Basic Color Photography* (1972). *The Complete Photographer* (1965) is one of the few manuals that discusses black-and-white versus color film both sensibly and with authority.

Well illustrated, with down-to-earth texts, are the volumes of the Life Library of Photography, issued by Time-Life Books from 1970 on and consisting of about twenty volumes of diverse subject matter. Examples are *The Studio* (1971), defining and explaining studio photography, and *Frontiers of Photography* (1972), which deals with technical innovations as well as experimental photography, holography, and other new developments in "fine art" photography.

In addition to all-around basic volumes, there is a considerable literature of specialized technical volumes, dealing with darkroom techniques, such as developing and enlarging, photographic sensitometry, view camera technique, and the like. Books on these subjects are easily located in the library's card catalog under the heading "Photography," with the appropriate subdivisions. Mention should also be made of the many how-to-do-it books which, however, are strictly geared to the amateur — how to photograph children, animals, landscapes, portraits; how to do phototricks, and the like. Photojournalism is still another popular subject of the how-to-do-it type.

Photography as an Art Form

The aforementioned anthology *Photographers and Photography,* edited by N. Lyons, is a basic and absorbing source collection in which leading photographers from the late nineteenth century to the present express their artistic creeds and reflect on the state of the art from many different angles and points of view. Photographers included are Berenice Abbott, Ansel Adams, Henri Cartier-Bresson, Dorothea Lange, Man Ray, W. Eugene Smith, Edward Steichen, Alfred Stieglitz, Paul Strand, Edward Weston, Minor White, and many others. Biographical notes and a selected bibliography are given on each photographer. The hardcover edition includes some sixty plates, whereas the paperback edition contains only the text.

Three important works explore the history of photography in an exemplary manner. *The History of Photography* (rev. and enl. ed. 1964), by Beaumont Newhall, is the classic text, and is also well illustrated. *The Picture History of Photography* (rev. ed. 1969), by Peter Pollack, stresses the image over the word. *The History of Photography: From the Camera Obscura to the Beginning of the Modern Era* (2d ed. 1969), by Helmut Gernsheim, is particularly helpful for information on the antecedents and early phases of photography.

The interesting relationships between photography and painting have only recently begun to be explored. A pioneer work on the subject is *Painting, Photography, Film* (1969), by L. Moholy-Nagy, first published in 1925 in German as a Bauhaus Book. Two works have laid the groundwork for further investigation: *The Painter and the Photograph: From Delacroix to Warhol* (1972), by Van Deren Coke, an expansion of an eye-opening exhibition with the same title, which was held at the University of New Mexico at Albuquerque in 1964, and *Art and Photography* (1968), by Aaron Scharf.

Pictorial Volumes

Pictorial volumes on photography are abundant, comprising every conceivable theme, aspect, and approach. It is impossible even to begin listing them here. An early example of a well-known photographic volume on a single theme is *The Family of Man.* It was based on an exhibition with this title that was created by the late Edward Steichen, held in 1955 at the Museum of Modern Art, New York, and circulated throughout the world. The photographs, depicting ordinary people from all corners of the earth in their manifold daily lives from birth to burial, "mirror the essential oneness of mankind," the universality of man's aspirations, joys, and sorrows.

The narrow borderline between "documentary" photography and "art" is evident in that volume as it is also in the superb and deeply moving work done under the auspices of the Farm Security Administration during the period from 1935 to 1943 by Walker Evans, Dorothea Lange, Ben Shahn, and others. They photographed the poor — farmers, migrant workers, townspeople — with skill and compassion, creating a memorable photographic record of the human condition and man's dignity. Over the years these photographs, of which the negatives are in the Library of Congress, have been seen in exhibitions and reproduced in books. Examples are a 1962 Museum of Modern Art exhibition, "The Bitter Years," organized by Edward Steichen, and a book, *In This Proud Land* (1973), by Roy E. Stryker and Nancy Wood. This last-named volume reproduces about two hundred photographs selected by Stryker himself, who, as the one-time director of the Farm Security Administration Historical Section, was the inspired guide of the entire photographic project.

A very significant group of pictorial volumes shows close-ups or enlarged details of plants, flowers, vegetables, or other organic forms; the textures and patterns of rocks, soil, water, or man-made objects. Outstanding photographs of this type have been created by Edward Weston. Photomicrography is a further step on the way to photographic abstracton. *Micro-Art: Art Images in a Hidden World* (1970), by Lewis R. Wolberg, shows seemingly "abstract" images of animal, vegetable, and mineral forms as revealed by the microscope.

Especially worthwhile study material for the artist photographer are picture books reproducing the works of the masters of photography. Fine examples are *Alfred Stieglitz: An American Seer* (1973), by Dorothy Norman; *The World of Henri Cartier-Bresson* (1968); *Paul Strand: A Retrospective Monograph* (1972. 2 vols.); and *Edward Weston: Fifty Years* (1973). The latter two titles were issued by *Aperture*. Edward Weston's *Daybooks* (1961-66. 2 vols.) edited by Nancy Newhall, are the journals he kept for many years; they have become a classic of photographic literature and may be read in conjunction with the study of his photographs.

Reference and Research

The Focal Encyclopedia of Photography (1974. 2 vols.) gives authoritative information on the theory and practice of photography. It explains photographic terms, provides biographical and historical entries, and discusses techniques, processes, equipment, and materials as well as photographic themes ranging from nudes to motor car racing. *Dictionary of Contempor-*

ary Photography (1974) L. Stroebel and Hollis N. Todd, is an up-to-date source for definitions of current photographic terms.

The biennial *Photography Market Place* (since 1975) is a popular directory of the where-to-buy-it — where-to-sell-it type, which also lists organizations such as museums, camera clubs, and professional associations, as well as career opportunities including university instruction and photography schools, and grants, prizes, and awards. It has a good section on "Publishers and Publications," which is, in effect, an up-to-date annotated bibliography of pictorial volumes, reference books, and other photographic publications of interest to the photographer.

Photographic Literature (1962) and its sequel *Photographic Literature: 1960-1970* (1972), edited by Albert Boni, are international bibliographic guides listing books, journals, technical reports, magazine articles, on a wide range of subjects from photographic techniques and processes, materials, manufacture, and industrial applications to theory, history, and aesthetics.

The most important resource for scholarly research in the field of photography (and film) is the International Museum of Photography at George Eastman House in Rochester, New York. It has the largest collection of photographs and photographic negatives in the United States and a comprehensive library on the technical, historical, and aesthetic aspects of photography. George Eastman House also publishes a journal, *Image,* which regularly prints articles relating to the materials in the museum's collection.

Periodicals and Yearbooks

Photomagazines and yearbooks are excellent visual sources for study and pleasure. *Aperture* is the leading high-quality photomagazine in the United States. Usually each issue deals with a single subject or individual photographer; most of the recent issues have also been published as hardcover books. *Camera,* a Swiss monthly published in an English-language edition, is the leading foreign magazine. International in scope, it includes both color and black-and-white photography; its articles deal with technical as well as aesthetic subjects.

Camera Work, founded, edited, and published (1903-17) by the photographer Alfred Stieglitz, was an avant-garde journal in its time, important for the artistic and technical development of photography, but even more so for having introduced modern art and the work of controversial young artists from the United States and France to the American public. Leading authors and critics appear in its pages. *Camera Work: A Critical Anthology*

(1973), edited by Jonathan Green, provides an illuminating selection of photographs and articles from this journal. Green, in his introduction "Alfred Stieglitz and Pictorial Photography," critically evaluates Stieglitz's contribution and the role and influence of *Camera Work*.

The *British Journal of Photography Annual* (since 1860), the oldest photography annual still being published, the *German Photographic Annual,* and the *Creative Camera International Yearbook,* are examples of photographic annuals which carefully screen the year's work in photography and print a representative selection of quality photographs and "artists' portfolios." They frequently give technical information on the photographs reproduced. *Photographis,* issued by the editors of the magazine *Graphis,* in an annual concerned with advertising photography only.

CHAPTER 19

Commercial Art

In this publicity-conscious age commercial art has become a vast, rapidly expanding field. The terms "advertising art" and "graphic design," which are often used interchangeably with "commercial art," indicate the principal purpose and media of commercial art.

In the broadest sense commercial art covers the visual aspects of designing, packaging, promoting, and marketing industrial or commercial products. In contrast to most noncommercial art forms and media, commercial artwork is produced under contract and to specifications set by business or industrial clients, usually through advertising agencies. Commercial art is furthermore created with the requirements of mechanical or electronic mass reproduction in mind; it has a fast rate of obsolescence; and it is one of the few art fields that are highly competitive.

The commercial artist is always in search of striking ideas which can be graphically exploited. To him or her the entire library becomes a visual resource, a laboratory of visual ideas. Any kind of image, from prehistoric to pop, can provide visual stimulation and serve to create a fresh, eye-catching design. Avid for novelty, the graphic artist more than any other depends on magazines rather than on books to keep informed about the latest trends in the field.

Periodicals and Annuals

The three leading U.S. commercial art magazines are *Communication Arts,* formerly called *CA Magazine, Art Direction,* and *Print.* The magazine *Industrial Design* frequently includes articles on graphic design subjects. Important though these magazines are, they do not have the quality and prestige of *Graphis,* published bimonthly in Switzerland. Brilliantly produced and sumptuously illustrated, *Graphis* prints a great variety of

articles with brief texts in English, French, and German, dealing with the work of individual graphic artists or studios and with general subjects such as children's book illustration, book jackets, trademarks and logos, posters, and so forth. The coverage is truly international, with emphasis on high-caliber contemporary work; historical material is presented occasionally and from an angle relevant to the present. The German monthly *Novum: Gebrauchsgraphik* ("Graphics for Use") is the counterpart of *Graphis*. It is also trilingual and is the oldest advertising magazine still being published.

The advertising annuals are of particular importance, because they sift the year's production and cull the best current work in readily accessible format. Outstanding is *Graphis Annual,* edited by Walter Herdeg and published since 1951/52 by the same house as *Graphis*. Each volume features a brief introductory essay and nearly 1,000 examples of posters, advertisements, direct mail advertising, booklets, annual reports, magazine and paperback covers,.record albums, book jackets, trademarks and letter-heads, greeting cards, calendars, packaging, film and television graphics. There are indexes of artists, art directors, and advertisers. *Photographis,* an annual published since 1966 and subtitled *International Annual of Advertising, Editorial, and Television Photography,* is a companion to *Graphis Annual* but is limited to the medium of commercial photography. Both these annuals are exemplary in layout, typography, quality of illustration, and production.

These two annuals really preempt the field, although one could mention the British *Modern Publicity,* which is also international in scope and has been around since 1924, although without ever achieving the distinction in format and content of *Graphis Annual* and *Photographis.*

The most important U.S. annual is the *Annual of Advertising, Editorial and Television Art and Design,* the so-called Art Directors Annual, published since 1921. Issued by the Art Directors Club of New York, the pacesetter of U.S. advertising art, it presents a pictorial record of the year's award-winning advertising, editorial, sales promotion, and television art and design. The current volumes are an up-to-date source for the latest design ideas. The back volumes, however, like the ads in old magazines, reflect pictorially and typographically the fads and fashions of past decades — which makes them an excellent visual resource for designs requiring a period flavor of, say, the twenties or thirties.

More specialized are *Graphis Posters,* showing an international cross-section of cultural, political, decorative, and advertising posters, and *Illustrators,* featuring award-winning advertising, book, and magazine illustration selected from the annual national exhibition of the (U.S.) Society of Illustrators.

Although the aforementioned annuals are strictly pictorial, with only brief introductory textual matter, the *Penrose Annual (Penrose Graphic Arts International Annual)*, published in Great Britain since 1895, emphasizes informative articles. Well illustrated and sometimes printed on papers of different tints and textures, the texts focus on the current state of the graphic arts. Recent volumes have covered topics such as design problems in the developing countries, the golden age of comics, Henri van de Velde and book design, the "underground press," display photosetting in the seventies, and the digital computer-controlled scanner for color separation.

Special Subjects

Specialized publications — either pictorial surveys or technical handbooks — exist about most types of commerical art. This is true also of subjects not usually included in the annuals, as, for example, display techniques, textile design, fashion illustration, and the like.

Posters are one of the few commercial art forms that have a considerable historical literature. This is not surprising, since posters have been created by many of the best-known masters of modern art. The subject heading "Posters" in the library's card catalog indicates the titles available in the collection. It should be noted, however, that volumes dealing with the posters of individul artists such as Toulouse-Lautrec, Alphonse Mucha, Picasso, and others are likely to be listed only under the name of the artist and *not* under that subject heading.

A historical survey of the entire field of advertising and commercial art, stressing its pictorial aspects, is *A History of Visual Communication* (1971), by Joseph Müller-Brockmann, which includes important chapters on the influence of the twentieth-century art movements, especially the Bauhaus, on commercial art.

Generally, advertisements and visual designs are protected by copyright law, just like literary material, and may not be copied or reproduced for publication without permission of the copyright owner. However, artwork for which the copyright has expired is in the "public domain," that is, it may be reproduced without restrictions. Commercial artists keep "swipe files" of such "free" material, and publishers have cashed in on this need by publishing collections of artwork that is now in the public domain. Much of it has been published in the Pictorial Archives Series of Dover Publications, of which Clarence P. Hornung's *Handbook of Early Advertising Art* (3d ed. 1956. 2 vols.) is a good example. Volume 1 shows typographical specimens, and volume 2 shows line-cuts of all kinds of objects, from American eagles to antique cars and fire engines, animals, common articles of clothing, trade symbols, and many others.

Techniques

Generally speaking, painting and drawing techniques are the same for commercial and noncommercial artists. However, the preparation of commercial artwork requires additional skills and techniques. Examples of such special techniques are airbrush painting and scratchboard drawing. Layouts, paste-ups, and mechanicals are major steps in the production of commercial designs. Special manuals instruct the student in these and other techniques. Concise definitions of current techniques and the terminology used in the field are found in *Commercial Artist's Handbook* (1973), by John Snyder. Useful titles discussing techniques in detail are *Commercial Art Techniques* (rev. ed. 1974), by S. Ralph Maurello, and his earlier *How to Do Pasteups and Mechanicals* (rev. ed. 1960). *Advertising Agency and Studio Skills* (1970), by Tom Cardamone, has step-by-step instructions of these and other procedures. *Preparing Art for Printing* (1965), by Bernard Stone and Arthur Eckstein, is a clearly written exposition of production requirements, which includes extensive information on color work.

Students often look for a "good" design manual. Design manuals do exist – Armin Hofmann's *Graphic Design Manual* (1965) is probably one of the better ones – but in the view of some experienced teachers and graphic designers a truly good manual is impossible to write. Good design requires creativity; it can therefore not be taught like a step-by-step technique. On the other hand, eye and mind can be trained, and a few excellent books can provide the visual and intellectual stimulation which furthers creative effort. One of these books is *Language of Vision* (1951), by Gyorgy Kepes, who attempts to get at the roots of "visual communication." The other is *Vision in Motion* (1947), by László Moholy-Nagy, a one-time teacher at the Bauhaus. This is a much more profound, even visionary book, poignantly illustrated, in which the author views design as a complex matter integrating technology, social, and economic requirements with the "psychophysical effect of materials, shape, color, volume, and space: thinking in relationships." *Graphic Design* (1973), by Milton Glaser, to name a book of more recent vintage, has neither the depth of a Moholy-Nagy, nor does it offer any recipes, but the author, a well-known graphic designer, tells "where it's at" in an enlightened and enlightening fashion.

On an entirely different plane is an "oldie" dating from the time when design usually meant ornament in the Egyptian, or Grecian, or whatever historic style. It is *The Grammar of Ornament,* by Owen Jones, first published in 1856, the heyday of Victorian eclecticism, and reprinted

as recently as 1972. This large pictorial volume reduces all manner of historic ornament to flat, mostly colored patterns. It is occasionally useful when a two-dimensional historic ornament is needed for a design project.

Typography

Some familiarity with basic typographical resources is essential for the graphic design student. These include manuals for the practising typographer (entered in the library's card catalog under the subject heading "Printing, Practical"), surveys of the history of type, and collections of type faces and type specimens, both historical and contemporary (listed in the card catalog under "Type and Type Founding" and/or "Printing – Specimens").

An Introduction to Typography (2d ed. 1963), by Oliver Simon, covers the essentials of this craft. The standard historical survey is *Printing Types* (3d ed. 1951. 2 vols.), by Daniel B. Updike, presenting a well-researched account of the principal type families and their development. *Four Centuries of Fine Printing* (4th ed. 1960), by the eminent British typographer Stanley Morison, is another important source, containing an authoritative essay on the history of type and well-chosen facsimiles of pages and title pages from mid-fifteenth- to early twentieth-century books. *The Art of the Printed Book: 1455-1955* (1973) contains comparable material but is infinitely superior as a physical volume: the content is excellent, and the book design, typography, and printing are superlative. It was originally the catalog of an exhibition at the Pierpont Morgan Library in New York, which displayed masterpieces of typography from its own collection. The material for the exhibition was selected by the typographer Joseph Blumenthal, who also designed the volume and contributed a knowledgeable essay on the great printers and their works.

Type specimen books are among the most important tools for the graphic designer. Those put out by type founders, presses, typesetters, and others in the printing and publishing industries illustrate the typefaces currently available from the issuing companies. Most useful for the student are specimen books which show complete alphabets and numerals in all available sizes, styles, weights, and widths rather than just a few sample letters.

Type specimen books, no matter how old, never become obsolete in the sense that they lose their value as a design source. An outstanding example is the *Manuale tipografico* (1818) by the famous printer Giambattista Bodoni of Parma, Italy, a work which is still studied for the classical perfection of its letters forms and page layouts.

Excellent type dictionaries and specimen books, compiled by practising typographers or graphic designers, are published commercially. They usually offer a wide range of current as well as historical typefaces and often have informative texts. A good compilation of this kind is *Type and Typography* (rev. ed. 1976), by Ben Rosen. Several volumes of the Dover Pictorial Archives series offer useful collections of historical typefaces in complete alphabets as well as typographical applications, as for example the previously mentioned typographical volume of the *Handbook of Early Advertising Art*, by Clarence Hornung. *A Treasury of Alphabets and Lettering* (1966), by the Swiss typographer Jan Tschichold, and *Lettera* (1954-68. 3 vols.), by Armin Haab, all contain complete alphabets of both typographic and calligraphic letter forms.

Lettering

Fine lettering, or calligraphy, has many uses in book arts and advertising design. The classic manual on lettering with the calligraphic, or square-cut, pen is *Writing and Illuminating, and Lettering* (published in many editions since 1906), by Edward Johnston, who was one of the guiding spirits of the twentieth-century revival of calligraphy. *The Elements of Lettering* (1940), by John Howard Benson and A. G. Carey, is less complete as far as lettering styles and techniques are concerned, but more instructive for the beginner. *Lettering* (1965), by Heinrich Degering, offers an outstanding collection of scripts reproduced from manuscript leaves (and some printed pages), arranged in chronological sequence from the early Middle Ages through the eighteenth century. *A Book of Scripts* (1949), compiled by Alfred Fairbank, may serve as a limited substitute if the former is unavailable.

Early alphabets and writing manuals are astonishingly relevant today; there is really no obsolescence in lettering. An incised inscription on the base of the column of Trajan in Rome, dating from the second century A.D., is still considered the most perfect example of Roman capital letters, as Alexander Nesbitt explains in *The History and Technique of Lettering* (1957). Renaissance artists and theorists, in seeking to discover the ideal proportions of things, turned to letter forms in their investigations. In a book titled *De Divina Proporzione*, first printed in 1509, the author Luca Pacioli (or Paccioli) demonstrated the "divine proportions" (called today the "golden section") on a superbly constructed alphabet of Roman capital letters, which were done on a strict geometric scheme of squares and circles with the appropriate intersecting lines. Stanley Morison, in his *Fra Luca de Pacioli of Borgo S. Sepolcro* (1933), reproduces these beauti-

fully proportioned letters and explains the significance of Pacioli's model. Albrecht Dürer, in turn, studied both Roman and Gothic letter forms in Book 3 of his treatise on measurement (*Unterweisung der Messung*) of 1525. An English translation titled *Of the Just Shaping of Letters* (1917) makes Dürer's contribution readily available.

The handwriting manuals of the Italian Renaissance calligrapher Ludovico degli Arrighi laid the groundwork for modern penmanship. His *Operina* ("Little Work") of 1522 was the earliest manual on the so-called chancery cursive, or italic, writing style. *The First Writing Book* (1954), edited by John Howard Benson, contains an English translation and a facsimile reproduction of the original *La Operina*. The unusual feature of the Benson edition is that the entire volume (except the facsimile, of course), is beautifully handwritten by Benson himself. Arrighi's *Operina,* together with two other sixteenth-century writing manuals by G. A. Tagliente and G. B. Palatino, has also been published under the title *Three Classics of Italian Calligraphy* (1953), introduced by Oscar Ogg.

Part IV. National Schools of Art

CHAPTER 20

The Americas

United States

The Britannica Encyclopedia of American Art (1973), which was discussed in Chapter 4, is a good starting point for information and research on American art. The articles are well and authoritatively written, and the bibliographies (pp. 638-68) give the user a wide choice of references to books, articles, and catalogs through which to pursue the search further. Because of the general availability of this encyclopedia, only a few essential works, or works too new to be included in the bibliographies, are mentioned in this chapter.

A coherent treatment of the entire spectrum of American art — which spans no more than 350 years — is often desired. Several excellent one-volume histories fill this need. *A History of American Art* (2d ed. 1970), by Daniel Mendelowitz, has the best overall coverage. Every work discussed in this readable, attractively produced volume is also illustrated. A brief chapter on the art of the North American Indian sets the stage for a historical account of the arts from the colonial period to the present. Considerable space is devoted to architecture and the applied or decorative arts (the author calls them "household arts") — furniture, interior decoration, ceramics, metalwork, textiles, and so on. A somewhat older, standard introduction is *Art and Life in America* (2d ed. 1960), by Oliver Larkin. The arts are discussed here in relation "to the development of American ideas, particularly the idea of democracy" (foreword). A particularly clearly written, well-balanced text, but less effectively illustrated, is *American Art* (1966), by Samuel M. Green. *American Art* (1976), by John Wilmerding, represents the contribution of the Pelican History of

Art to the American Bicentennial. This volume is less comprehensive than the above-mentioned surveys — architecture and the decorative arts are excluded — and it suffers further from the standard Pelican format, the separation of the illustrations from the text. The text going to be read, nevertheless, and the extensive, well-chosen, and well-organized bibliography is a particularly useful feature.

The most detailed architectural history of the United States is *The Architecture of America: A Social and Cultural History* (1961), by John E. Burchard and Albert Bush-Brown, of which there is also an abridged student edition (1966). Very readable is *Architecture, Ambition, and Americans* (1964), by the noted architectural photographer Wayne Andrews. This book is not intended as an encyclopedic history of American architecture, but is about "architecture as a fine art"; it is a book about "taste." *Architecture in America: A Photographic History* (1960), also by Wayne Andrews, is a pictorial survey of outstanding buildings in excellent black-and-white photographs. From his vast stocks of architectural photographs, Andrews has also compiled several regional volumes, one of which is *Architecture in New England: A Photographic History (1973).* *American Building* (2d ed. 1966-72. 2 vols.), by James M. Fitch, is a standard work. Volume 1 has the self-explanatory title, "The Historical Forces that Shaped It." In volume 2, "The Environmental Forces that Shape It," Fitch develops a "holistic concept" of man and his environment, which architects should recognize. Architecture is seen as the "third environment" which man has "tailored to his specifications." The control of climate, air pollution, lighting, noise, and space, and a democratic aesthetic, are the requirements for a proper architectural environment.

The literature on American sculpture is far from plentiful. *Two Hundred Years of American Sculpture* (1976) is rapidly becoming the standard source on the subject. It is actually the catalog of a comprehensive exhibition held at the Whitney Museum of American Art in conjunction with the Bicentennial. The attractive volume, which is divided into seven sections each having an introductory essay by a specialist, presents American sculpture in a chronological sequence, as well as aboriginal and folk sculpture. There are biographical sketches of the artists, copious illustrations, and ample bibliographical documentation. Dore Ashton's sensitively written and beautifully illustrated *Modern American Sculpture* (1968) was the first attempt to deal critically with the innovations of the contemporary sculptors. *American Sculpture in Process: 1930-1970* (1975), by Wayne Andersen, is a more comprehensive survey of the period, which extends from the early works of Alexander Calder to the minimalists

and process artists. The lengthy bibliography lists books, exhibition cata-
logs, articles, and reviews.

For relevant material on American painting, *American Painting: A Guide to Information Sources* (1974), by Sydney S. Keaveney should be consulted. Major works on the subject are listed with brief but very helpful annotations. A large portion of this guide is given over to entries for individual artists, which list monographs and exhibition catalogs as well as periodical articles.

The quality and variety of American crafts are shown to best advantage in the excellent illustrations of *A Treasury of American Design* (1972. 2 vols.), by Clarence P. Hornung. This book, as stated in the subtitle, is *A Pictorial Survey of Popular Folk Arts Based upon Watercolor Renderings in the "Index of American Design," at the National Gallery of Art.* * The collection assembled by Hornung and reproduced in color and monochrome divides the crafts into six sections: land and sea, home, house and garden, women's world, children's world, and regional styles. Libraries which do not have the present set may have the earlier *Index of American Design* (1950), by Erwin O. Christensen, which covers essentially the same material, but less comprehensively so.

Sources and Resources

American Art: 1700-1960 (1965), by John W. McCoubrey, in the Sources and Documents series, consists of excerpts from important writings by artists and critics from Copley to Pollock. *Readings in American Art: 1900-1975* (rev. ed. 1975), compiled by Barbara Rose, issued as a companion volume to her *American Art since 1900* (rev. ed. 1975), is comparable in concept.

The Archives of American Art, which were founded in 1954 and have been a bureau of the Smithsonian Institution since 1970, are the principal repository for research in American art. The Archives hold several million documents including manuscripts, letters and other personal papers, original works of art such as drawings and sketchbooks, photographs, microfilm, and tapes embracing "not just American art, but the whole range of activities associated with the more general subject of art in America." All of these documents, which are owned partly by the Archives themselves and partly by museums, galleries, private collectors, and others,

*This famous *Index* consists of over 17,000 watercolors depicting every conceivable type of handcrafted object from colonial times to the end of the nineteenth century. The water colors were done by American artists from 1935 to 1941 under the auspices of the Works Project Administration (WPA) during the Depression.

have been recorded on microfilm. Most important for the student is probably the material relating to individual artists. The central repository and main reference center is located in Washington, D.C.; there are regional centers in New York City, Boston, Detroit, and San Francisco. The regional centers maintain complete duplicate sets of the microfilms, which are available for consultation. *Archives of American Art: A Directory of Resources* (1972), by Garnett McCoy, from which the quotation above was taken, lists the collections available for research, arranged alphabetically by the name of artist, firm, or museum; each collection is briefly described. New material is being added continually, however. The *Archives of American Art Journal* lists new acquisitions in every issue and also publishes articles and items of special interest relating to the material in the Archives. Beginning with volume 13 (1973), it issues an annual listing of dissertations and thesis topics on American art.

A multivolume annotated bibliography on American art, titled *The Arts in America* and edited by Bernard Karpel, is being prepared under the auspices of the Archives. At present, however, *American Architecture and Art: A Guide to Information Sources* (1976), by David M. Sokol, and the previously mentioned *American Painting,* by Keaveney, are the only annotated bibliographies on American art available.

A number of important museums throughout the United States collect exclusively or primarily in the area of American art. The listing of museums in the appendix of *The Britannica Encyclopedia of American Art,* along with the brief descriptions given, readily identifies them. Some of these museums issue important publications in their specialty. For example, the catalogs of the annual or biennial juried exhibitions of the Whitney Museum of American Art in New York, which have been held with few interruptions since 1932, faithfully reflect the trends and various art movements in the country since that time. The Amon Carter Museum of Western Art at Fort Worth, Texas, publishes excellent monographs and catalogs on art and artists of the American West.

Periodicals

In addition to the *Archives of American Art Journal,* mentioned above, *American Art Journal* and *American Art Review* are also devoted exclusively to American (U.S.) art. *American Art Journal* prints scholarly articles on a wide range of specialized subjects, while the popular *American Art Review* is limited to the arts before 1950 and features handsome color reproductions.

Canada

Great strides are being made at present to record and document Canadian art. The central resource for Canadian art is the National Gallery of Canada in Ottawa, which owns a major collection of Canadian (and European) art, maintains extensive files on Canadian artists and Canadiana, and sponsors relevant exhibitions, research, and publications. An example is the 1967 exhibition "Three Hundred Years of Canadian Art," which was held at the National Gallery of Canada and presented a good survey of the visual arts in Canada. The catalog, compiled by R. H. Hubbard, is still a useful source. Hubbard's *Development of Canadian Art* (1967), which was based on a lecture series given at the National Gallery, well complements the information provided in the catalog.

Published biographical information on Canadian artists is still scarce. *Early Painters and Engravers in Canada* (1970), by J. Russell Harper, is an important source – though limited to artists born before 1867 – containing bibliographical references in the entries and a full bibliography at the end of the volume. *A Dictionary of Canadian Artists* (begun 1967), by Colin S. MacDonald, promises to be more inclusive, covering also living artists – painters, sculptors, graphic artists, and craftsmen.

The standard work on Canadian painting is *Painting in Canada* (1966), by J. Russell Harper. *Building Canada* (1966), by Alan Gowans, a revised edition of his earlier *Looking at Architecture in Canada,* is an authoritative, well-documented survey of Canadian architecture.

Artscanada is the principal Canadian art journal, dealing with the Canadian art scene as well as general art subjects. It is indexed in *Art Index* and abstracted in *ARTbibliographies Modern.*

Latin America

Historical, ethnic, and stylistic factors have all contributed to the great diversity of Latin American art. To begin with, there are the artistic remains of the indigenous civilizations which perished with the Spanish conquest. Their art, found primarily in Mesoamerica (including Mexico) and Peru, is summarily labeled Pre-Columbian art. Next are the works created by the architects and craftsmen from Spain who settled in the New World and whose art followed the prevailing modes of the mother country. This Spanish colonial art flourished from the mid-sixteenth to the eighteenth century and thereafter declined. Last, we find the traditional arts and crafts produced by the native Indians. Contemporary architects, painters, and sculptors, however, have adopted – with local modifications – the twentieth-century international styles and movements.

One of the few books which deals with all of these different aspects and cultures is *A History of Latin American Art and Architecture* (1969), by Leopoldo Castedo. This book, which is readable and very informative, can of necessity cover so vast and diverse a subject in only the briefest terms.

Three basic volumes take up Pre-Columbian art, each of them with a different emphasis. *Ancient Art of the Americas* (1965), by G. H. S. Bushnell, is the most concise of the three but has the least satisfactory illustrations. *Art and Architecture of Ancient America* (2d ed. 1976), by George Kubler, a volume of the Pelican History of Art, provides solid information but devotes little space to the so-called decorative arts — textiles, ceramics, metalwork — in spite of their admitted importance in Pre-Columbian art. *Medieval American Art* (rev. ed. 1956), by Pál Kelemen, one of the earliest comprehensive surveys of Pre-Columbian art in English, is still useful for its numerous black-and-white illustrations. As pictorial volumes with superior color plates of sculptures, ceramics, gold and other metalwork, mosaics, and textiles, *Treasures of Ancient America* (1964), by Samuel K. Lothrop, and the recent *Pre-Columbian Art of South America* (1976), by Alan Lapiner, are outstanding.

One would expect to find these and other general works on Pre-Columbian art entered in the library's card catalog under the subject heading "Art, Pre-Columbian." But most libraries do not use this heading at all. "Indians — Art" is the most commonly used heading. "Indians of Central America," "Indians of Mexico," and "Indians of South America," with the subhead "Art," and "Mexico — Antiquities" or "Peru — Antiquities" are also useful headings to check.

The arts of the *conquistadores* and subsequent Spanish colonists are authoritatively discussed in *Baroque and Rococo in Latin America* (1951), by Pál Kelemen. *Art and Architecture in Spain and Portugal and Their American Dominions* (1959), by George Kubler and Martin S. Soria, a volume in the Pelican History of Art, makes the relationship between the arts of the Iberian peninsula and those of the colonists very clear.

The books by Frederick J. Dockstader are among the most useful studies of the arts and crafts of the American Indians. They are for the most part based on the unequaled resources of the Museum of the American Indian in New York City and are as a rule liberally illustrated with objects from the museum's collection. Dockstader's *Indian Art in Middle America* (1964) deals with the Indians of Mexico, Guatemala, and other regions of Mesoamerica. His *Indian Art in South America* (1967) brings together works dating from the Pre-Columbian era as well as objects made by native craftsmen in the twentieth century.

The literature on twentieth-century Latin American art is very meager. Gilbert Chase's *Contemporary Art in Latin America* (1970) is a first attempt to present an overview of this area but it does not delve deeply. *Art in Latin American Architecture* (1963), by Paul F. Damaz, is an important but specialized survey concerned with sculpture, paintings, mosaics, and so forth, incorporated into buildings or forming part of larger architectural complexes. *The Emergent Decade: Latin American Painters and Paintings in the 1960's* (1966), by Thomas M. Messer, is a large volume with handsome plates — including photographs of the artists by Cornell Capa — but it is too selective, as it is limited to fewer than fifty painters from a dozen countries.

Of all the Latin American countries Mexico has had the richest artistic tradition and hence the most extensive art literature. *A Guide to Mexican Art: From Its Beginnings to the Present* (1969), by Justino Férnandez, summarizes the different aspects of Mexican art in handbook form. Four broad chapters deal successively with Pre-Columbian art, "New Spain," "modern" (that is, nineteenth century), and "contemporary" art. A bibliography of important relevant English and Spanish publications is appended to each chapter and should be consulted for specialized works.

Europe

France

Although France's role in the evolution of Western art is very considerable, a comprehensive history of French art is yet to be written. In many instances, one must consult specialized works in order to obtain appropriate information on French art of a given period.

The Art of Roman Gaul (1961), by Marcel Pobé, with photographs by Jean Roubier, is a good pictorial survey of Celtic, Roman, and the earliest Christian monuments — mainly architecture and sculpture — which have come down to us from France, the Gaul of antiquity. Medieval France evokes the art of her Romanesque and Gothic cathedrals. The writings of Henri Focillon, Willibald Sauerländer, Jean Bony, and others who have interpreted this art most poignantly have been mentioned in Chapter 9 of this volume. Joan Evans' *Art in Medieval France* (1948) offers a broad cultural and social history of the arts, placing much emphasis on patronage — the church, the orders, the king and the court, the guilds and the citizenry.

Two important volumes of the Pelican History of Art are concerned exclusively with French art. The Renaissance and early baroque are the subject of *Art and Architecture in France: 1500-1700* (rev. ed. 1970). by Sir Anthony Blunt, whereas the late baroque, rococo, and early neo-classicism are discussed in *Art and Architecture of the Eighteenth Century in France* (1972), by Wend Graf Kalnein and Michael Levey. Albert Châtelet, Jacques Thuillier, and Jean Leymarie lucidly trace the development of French painting from 1400 to 1900 in three large, lavishly illustrated volumes published by A. Skira in the Painting, Color, History series: *French Painting: From Fouquet to Poussin* (1963), by Albert Châtelet and Jacques Thuillier; *French Painting: From Le Nain to Fragonard* (1964), by Jacques Thuillier and Albert Châtelet; and *French Painting: The Nineteenth Century* (1962), by Jean Leymarie.

The visual arts from about 1800 to the mid-twentieth century were much influenced by the achievements of French painting. French artists, and artists of other nations active in France, were the creators and champions of the successive styles and movements from neoclassicism and romanticism to cubism and surrealism, which in turn spread all over the Western world. *Painting and Sculpture in Europe: 1780-1880* (1960), by Fritz Novotny, and its sequel, *Painting and Sculpture in Europe: 1880-1940* (1967), by George H. Hamilton, both volumes of the Pelican History of Art, give substantial coverage to these movements and to French painting from David, Ingres, and Delacroix to the impressionists, post-impressionists, and the School of Paris. Additional sources dealing with this period are discussed in Chapter 12.

Germany

The most comprehensive history of German art is *Geschichte der deutschen Kunst* ("History of German Art," 1930-34), by Georg Dehio, and consists of four volumes of a scholarly text and four volumes of black-and-white plates. *History of German Art* (1971), by Gottfried Lindemann, is a concise survey in English, covering in one slim volume the entire range of German art from Carolingian manuscript illumination to the German expressionists and the Bauhaus.

The sixteenth century was the great century of German painting. Its principal masters are the subject of a study by Otto Benesch, titled *German Painting: From Dürer to Holbein* (1966). It is a brilliantly illustrated volume in the Painting, Color, History series.

In the early twentieth century, the Bauhaus (literally, "house of building") briefly catapulted Germany into a leading position in the visual arts. This eminent school of art, architecture, and design, which counted Paul Klee, Wassily Kandinsky, and Ludwig Mies van der Rohe among its teachers, revolutionized the training of artists and architects. Despite its brief existence (1919-32) its influence is still felt today. The artistic and social objectives of the Bauhaus are succinctly stated in *The New Architecture and the Bauhaus* (1935), by its erstwhile director, the architect Walter Gropius. *Bauhaus: 1919-1928* (1938), edited by Herbert Bayer, Walter Gropius, and Ise Gropius, is the catalog of a comprehensive exhibition held at the Museum of Modern Art, New York, which offers a compact, well-illustrated introduction to the teaching concepts and wide-ranging productions of the Bauhaus. The most complete account, which includes also the "New Bauhaus," Chicago, and which contains many important documents in translation and profuse illustrations, is Hans Wingler's monumental *The Bauhaus* (1969).

Sources on the German expressionists and "The Blue Rider" (*Der Blaue Reiter*) group are discussed in Chapter 12.

Great Britain and Ireland

The Pelican History of Art gives particularly full coverage to Britain by devoting five volumes to British art and architecture — examples are *Sculpture in Britain: The Middle Ages* (rev. ed. 1972), by Lawrence Stone, and *Architecture in Britain: 1530-1830* (1969), by John N. Summerson — although strangely enough no volume has yet appeared on nineteenth-century British art. For much of this period T. S. R. Boase's *English Art: 1800-1870* (1959), in the Oxford History of English Art series, is still useful. This important series, intended to comprise eleven volumes, aims at encyclopedic coverage of British art. It is arranged by broad historical periods; each volume treats all the arts within the period covered. Publication began in 1949 with *English Art: 1307-1461,* by the British medievalist Joan Evans. The most recent volume is *English Art: 1714-1800* (1976), by Joseph Burke, in which the author deals with the alternating classical and anticlassical strains as the underlying theme characterizing this period.

Two pictorial volumes, by William Gaunt, provide useful visual material on English painting. They are *The Great Century of British Painting: Hogarth to Turner* (1971) and *The Restless Century: Painting in Britain 1800-1900* (1972). The latter volume begins with the landscape painters Constable and Turner, moves on to the Pre-Raphaelites and Victorians, and ends with the English impressionists Walter Sickert and Wilson Steer. *Pre-Raphaelite Art and Design* (1970), by Raymond Watkinson, offers excellent documentation on the Pre-Raphaelite contribution to the visual arts. In the early twentieth century, vorticism emerged as the British response to cubism. This movement, which was initiated by the painter and writer Wyndham Lewis, has been most thoroughly explored by Richard Cork in *Vorticism and Abstract Art in the First Machine Age* (1976. 2 vols.).

The Yale Center for British Art and British Studies at Yale University is the principal resource for research on British art in this country. Founded in 1968, it houses the rich art collections assembled by Paul Mellon and a large research library. The Center also sponsors major scholarly publications, such as *Hogarth: His Life, Art, and Times* (1971. 2 vols.), by Ronald Paulson, which is the definitive work on this artist.

The brilliant achievements of early Irish art are discussed in a three-volume work by Françoise Henry, the Belgian authority on the subject.

The titles are: *Irish Art in the Early Christian Period* (1965), *Irish Art during the Viking Invasions* (1967), and *Irish Art in the Romanesque Period* (1970).

Italy

More books have been written on the art of Italy than on that of any other country. For· Italy has not only produced an extraordinary number of great artists, but its monuments have for centuries been admired for their perfection and beauty. Artists and writers have traveled to Italy to seek inspiration and enlightenment. An Italian journey, as Boswell, Goethe, Stendhal, and other famous travelers described it, was more than just the the "grand tour" – it was a formative experience.

Bernard Berenson and Heinrich Wölfflin have laid the foundation for our understanding of Italian art, a foundation on which contemporary scholars such as Sydney Freedberg, Creighton Gilbert, Ernst Gombrich, Frederick Hartt, John Pope-Hennessey, Rudolf Wittkower, and others have built. Important works by these authors have been mentioned throughout this volume.

Adolfo Venturi's *Storia dell'arte italiana* ("History of Italian Art," 1901-40. 11 vols.) is the standard history. An English language *Index* (1975. 2 vols.), by Jacqueline Sisson, facilitates the use of this set. *Italian Art* (1963), by André Chastel, is a well-organized handbook replete with facts. Particularly handy is the alphabetical index of artists with their principal works and dates. *The Development of the Italian Schools of Painting* (1923-38. 19 vols.), by Raimond van Marle, is the most comprehensive work on the subject, although it was never completed. Beginning with the sixth century and ending in the sixteenth, it has a comprehensive index (vol. 19) which includes many minor artists and their paintings. Because of its comprehensiveness, Van Marle is still useful, but in view of its date it should be read with caution.

Twelve Hundred Years of Italian Sculpture (1974), with texts by Rossana Bossaglia and others, stands out as the only English-language work encompassing Italian sculpture from the Middle Ages to the present. This large volume is actually a condensed translation of a five-volume set originally published in Italy. The texts, by five Italian art historians, are authoritative and up to date; there are numerous illustrations, many of them in color.

The great unbroken tradition of Italian art lasted from the fourteenth to the seventeenth century – from Giotto to Bernini. Venice, at times, stood somewhat apart. The unique quality of Venetian Gothic is discussed

in an important study, *Gothic Architecture in Venice* (1971), by Edoardo Arslan, illustrated with beautiful and dramatic plates, mainly of the Venetian palaces. In the eighteenth century Venetian painting had a last flowering, which is perceptively discussed in Michael Levey's *Painting in Eighteenth Century Venice (1959).*

In the early twentieth century, futurism, a literary as well as an art movement, placed Italian art once again, though briefly, in the spotlight. The painter Umberto Boccioni and the poet Filippo Tomaso Marinetti were the literary spokesmen for the futurists. Their principal statements, together with other significant writings on futurism, are available in English translation in *Futurist Manifestos* (1973), edited by Umbro Apollonio, a volume in the Documents of 20th-Century Art series. *Futurist Art and Theory* (1968), by Marianne W. Martin, provides a thorough analysis of the concepts and ideology of this movement. *Futurism* (1963), by Raffaele Carrieri, gives a detailed, almost day-to-day account, liberally interspersed with excerpts from futurist writings and lavishly illustrated with large color plates of their work. *Futurism* (1961), by Joshua Taylor, the catalog of an exhibition held at the Museum of Modern Art in New York, contains a valuable assessment of the movement and a useful bibliography. Futurism was followed by *pittura metafisica* ("metaphysical painting"), a movement anticipating surrealism and founded by Giorgio de Chirico and Carlo Carrà. *Metaphysical Art* (1971), edited by Massimo Carrà, is a source collection of writings by these two painters and other adherents of this movement.

The Low Countries

Netherlandish artists from Flanders (now Belgium) and neighboring Holland dominated Northern painting from the late fourteenth to the sixteenth century and again during the seventeenth century, when Rembrandt in Holland and Rubens in Flanders marked the era with their imprint. These important periods have been discussed in Chapters 10 and 11, respectively. In the eighteenth century, the arts of the Low Countries declined. Vincent van Gogh, a solitary figure in the nineteenth century, is usually considered along with the French post-impressionists.

A History of Dutch Life and Art (1959), by J. J. M. Timmers, is a brief but comprehensive survey of Dutch art and architecture from the prehistoric period to the twentieth century. There is no comparable English-language survey of the history of Belgian art.

At the turn of the century Belgian artists and architects developed their own special brand of symbolism and art nouveau. *Symbolism in Belgium* (1972), by Francine C. Legrand, deals authoritatively with the subject. A

good source for Belgian art nouveau and the contributions of Victor Horta and Henri van de Velde is Nikolaus Pevsner's *Sources of Modern Architecture and Design* (1968).

In Holland, Dutch avant-garde artists made the journal *De Stijl* ("Style"), which was published from 1917 to 1931/32, the literary forum for their ideas. *De Stijl* also became the name of the movement associated with Dutch abstract art. The basic work on this movement is *De Stijl: 1917-1931* (1956), by Hans L. C. Jaffé. Under the title *De Stijl: Extracts from the Magazine* (1970), Jaffé has also compiled and edited, in English translation, a source collection of essays from the journal, many of which were written by the painter Piet Mondrian and the architect Theo van Doesburg, the chief theorists of this movement.

Russia

The Art and Architecture of Russia (2d ed. 1975), by George H. Hamilton, a volume in the Pelican History of Art, traces the story of Russian art through a span of "1,000 years, from the Christianization of Russia in 988 to the fall of the Empire in 1917" (foreword). Architecture, sculpture, and painting of European Russia are discussed in exemplary manner. There is a considerable chapter on icon painting, the religious panel painting of the Greek Orthodox church. Icons have also been studied in several specialized works. Particularly useful is *The Meaning of Icons* (1955), by L. Ouspensky and Vladimir Lossky, which deals with both the theological background and the typology of these immutable images. *Art Treasures of Russia* (1967), by Mikhail V. Alpatov, is a fine pictorial volume of Russian architecture, painting, sculpture, and liturgical objects, with a popular text by a recognized Soviet art historian.

The Russian Experiment in Art: 1863-1922 (1962), by Camilla Gray, explores the artistic and social forces leading to constructivism and suprematism, two short-lived movements which represent the Russian entry in twentieth-century abstract art. Several volumes dealing with the international aspects of constructivism have been cited in Chapter 12 of this volume. *Russian Art of the Avant-Garde: Theory and Criticism* (1976), edited by John E. Bowlt, an important volume in the Documents of 20th-Century Art series, offers – in English translation – comprehensive documentation from Russian symbolism at the turn of the century to the beginnings of Soviet realism in the 1930s. There are articles by leading abstract artists – rayonists, suprematists, and constructivists – and a chapter, "The Revolution and Art," reflecting the impact of the Soviet Revolution on the arts.

Spain and Portugal

Spain's national history of art is *Ars Hispaniae: Historia universale del arte hispánico* ("The Art of Spain: General History of Spanish Art," 1947-73. 21 vols.). Numerous large illustrations make it a useful tool also for the non-Spanish reader. José Gudiol, who wrote an important monograph on *Velázquez* (1974), is also the author of *The Arts of Spain* (1964). This is one of the few surveys of Spanish art in English which discusses the arts from the prehistoric cave paintings of Altamira to the twentieth century. *Art and Architecture in Spain and Portugal and Their Dominions: 1500-1800* (1959), by George Kubler and Martin S. Soria, a volume in the Pelican History of Art, is a standard source but is limited to the Iberian Renaissance and baroque. Two large volumes with eye-filling color plates and readable texts tracing the interaction of art and history in Spain are *Treasures of Spain: From Altamira to the Catholic Kings* (1967), by José M. Pita Andrade, and its sequel in point of subject matter, *Treasures of Spain: From Charles V to Goya* (1965), by Alejandro Cirici Pellicer.

A History of Spanish Painting (1930-66. 14 vols. in 20), by Chandler R. Post,* must be mentioned here as the most exhaustive treatment of the subject, but this monumental work stops at the beginning of the Renaissance and thus does not reach the seventeenth century, the century of El Greco, Zurbarán, and Velázquez. *Spanish Painting* (1952. 2 vols.), by Jacques Lassaigne, a comprehensive survey in the Skira Painting, Color, History series, gives this important period its due.

The Art of Portugal: 1500-1800 (1968), by Robert C. Smith, is the basic work in English on the art of that country.

*The last two volumes were edited by H. C. Wethey and published after the author's death.

CHAPTER 22

Oriental Art

"Oriental art" is a loose term for the arts of the vast continent of Asia. Yet "Asia is not one, but many," as Sherman E. Lee notes in the first chapter of his fundamental survey, *A History of Far Eastern Art* (rev. ed., 1973). "It is a collection of peoples, of geographic areas, and, finally of cultures." Consequently, the arts of Asia are extremely diverse. It would be an almost impossible task to cover the entire range of Oriental art with authority in a single volume.

The arts of the ancient Orient, especially Mesopotamia and its adjacent regions, are often studied (along with Egyptian art) in a sequence on the beginnings of Western art and have been so treated in Chapter 8 of this volume. The arts of India, China, and Japan, all of which have a considerable English-language literature of their own, have been grouped together by Sherman Lee in his above-mentioned *History of Far Eastern Art*. The Eurasian steppe and central Asia are a much more neglected area, although recent research and archaeological excavations have brought much new information to light. Karl Jettmar's excellent *Art of the Steppes* (1967) deals with the animal style of the nomadic people from the Scythians in south Russia across the Asian steppes to Mongolia, during the first millenium B.C., whereas Benjamin Rowland, in *The Art of Central Asia* (1974), deals primarily with the art of the Buddhist civilization to the south of this area. Both of these titles are volumes in the Art of the World series. Islamic art, — that is, the art of the Muslims (Moslems) — is usually treated in separate studies.

A pictorial volume introducing a select group of excellently photographed, major architectural monuments in Asia is *Splendors of the East* (1965), edited by Mortimer Wheeler. Each building, or building complex, from the Palace of Darius at Persepolis, Iran, to the Katsura Imperial Villa

at Kyoto, Japan, is also knowledgeably described by the editor and others familiar with these structures.

The specifically Oriental vision of Far Eastern artists, their concepts of man and nature, and the "six canons" of Chinese painting are explained with poetic insight and sensibility by Laurence Binyon in *The Flight of the Dragon* (1911). Binyon, a distinguished scholar, liberally quotes Chinese and Japanese artists, poets, and critics and makes frequent comparisons with Western artists and ideas. This little book is not illustrated, however. The illustrations in James Cahill's *Chinese Painting* (1960) and Terukazu Akiyama's *Japanese Painting* (1961), both of which are volumes in Albert Skira's Treasures of Asia series, may be studied along with the reading of Binyon's lucid text.

The basic bibliographic reference on Oriental art is *The Harvard Outline and Reading Lists for Oriental Art* (3d ed. 1967), by Benjamin Rowland. The bibliographies are "intended for the beginner and as reference lists for the advanced student" (preface). They cover India, China, Japan, and Pre-Islamic Iran (Persia), as well as the secondary areas of Kashmir, Nepal, Tibet, Ceylon (Sri Lanka), Indochina, Indonesia, and Central Asia. Under each of the regions, or countries, works on the architecture, sculpture, painting, and the so-called minor arts (ceramics, metalwork, textile arts, and so forth) are cited. Essential writings on history, religion, and philosophy, so important for background information, are given for the principal areas — India, China, Japan, and Iran. A special section lists the journals devoted exclusively to Oriental art. Islamic art is not included. This bibliography is not annotated — a serious drawback, because no distinction is made between essential and less-important studies. A useful feature, however, are the "outlines" — listings of the principal artistic monuments and the historic periods for each country, which precede the bibliographic section.

Several North American art museums have rich collections of Oriental art, of which only a few truly significant ones can be mentioned here. Leading is probably the Freer Gallery of Art, a unit of the Smithsonian Institution in Washington, D.C., which collects Oriental art almost exclusively.* Its holdings of Chinese bronzes are particularly notable. The Museum of Fine Arts, Boston, has outstanding collections of East Indian art. The Asian Art Museum of San Francisco houses the Avery Brundage collection, celebrated for its Chinese jade carvings. The Clarence Buckingham collection of Japanese prints in the Art Institute of Chicago is famous for its so-called Japanese primitives. The Metropolitan Museum

*It owns also a large collection of the works of James Whistler.

of Art in New York City has distinguished collections of Islamic art, and the Royal Ontario Museum, Toronto, though not strictly an art museum, is noted for its Chinese art treasures. Some of these museums have published all or part of their Oriental art collections. Such publications should be searched in the library's card catalog under the name of the museum, sometimes preceded by the name of the city where the museum is located (for example: "Freer Gallery of Art, Washington, D.C.," but "Chicago. Art Institute.")

The Asia Society deserves special mention for its remarkable exhibition program at its own Asia House Gallery in New York City. Most of the scholarly, well-documented catalogs which the Society has issued in conjunction with these changing loan exhibitions have become standard reference sources for the student of Oriental art. The catalogs have focused on the less-known arts of countries such as Nepal, Thailand, and Tibet and have explored specialized subjects such as the "animal style," Japanese screens, Gandhara sculpture, and Korean ceramics, to give just a few examples of the range of these exhibitions.

Periodicals

The principal English-language journals on Oriental art are *Archives of Asian Art, Ars Orientalis, Artibus Asiae,* and *Oriental Art.* All are scholarly, well illustrated, and highly specialized, dealing with Islamic, Indian, and Far Eastern art; they rarely include Pre-Islamic Near Eastern subjects. *Oriental Art,* published in London and directed to the connoisseur and collector, is perhaps a shade more general, containing somewhat briefer articles than the other journals, current exhibition reviews, and auction sales reports. *Archives of Asian Art,* published annually by the Asia Society, features a lengthy, partly illustrated list of acquisitions of Asian art works by American museums. *Ars Orientalis,* issued jointly by the Freer Gallery of Art and the Department of the History of Art of the University of Michigan, is published every few years in a substantial volume. The articles are often related to objects in the Freer Gallery. *Artibus Asiae,* published by the Institute of Fine Arts of New York University, used to be predominantly in German or French, but in the last decade or so the trend has been reversed and almost all articles are now in English.

Islamic Art

Islamic art is a "complex blend of cultures" (Ernst Grube) produced by

the amalgamation of the late antique and Byzantine tradition with Arab, Iranian (Persian), and Turkish elements. From its seventh-century beginnings and its geographic core in Syria and what is now Saudi Arabia, Islam spread rapidly as far East as Afghanistan, Turkestan, and India, and across the edge of the Mediterranean, Egypt, and North Africa to its westernmost outpost — Spain. Monuments of Islamic art have come down to us from all these regions — from the Taj Mahal at Agra, India, to the Alhambra near Granada, Spain. The periods of Islamic art are identified by Islamic dynasties.

The principal scholarly bibliography of Islamic art is *A Bibliography of the Architecture, Arts and Crafts of Islam* (1961), by K. A. C. Creswell, which includes publications up to 1960. More important for the student is the *Supplement, January 1960-January 1972* (published 1973), which lists the recent literature, including college-level texts and surveys, and even major articles in encyclopedias and journals. References to book reviews are often cited along with the entry for the book itself.

A most concise and at the same time authoritative and well-illustrated survey is *The World of Islam* (1967), by E. J. Grube, in the Landmarks of the World's Art series, which provides a particularly skillful explanation of the complexities of Islamic art. *Islamic Art and Architecture* (1966), by Ernst Kühnel, who has written extensively on the subject, offers somewhat more detailed information. An exceptional pictorial volume is *Design and Color in Islamic Architecture: Afghanistan, Iran, Turkey* (1968), by Sonia Seherr-Thom, with photographs in color by H. C. Seherr-Thom. The plates reproduce magnificent details of the intricate and subtle surface decoration of Mohammedan buildings, many of which combine calligraphic and semistylized natural forms with geometric elements.

In Iran the book arts, especially miniature painting, and the textile arts, especially rug weaving, flourished during the Islamic period. *The Art of Iran* (1965), by André Godard, is one of the surveys which devote a portion of the text and illustrations to the Islamic period. The monumental fourteen-volume *Survey of Persian Art* (1964-67), edited by Arthur U. Pope and Phyllis Ackerman, to which leading scholars have contributed chapters, is, with the exception of the first two volumes, largely concerned with Islamic art. A superior volume with respect to text and illustrations is *Persian Painting* (1961), by Basil Gray, a volume of Skira's Treasures of Asia series, which traces the development of the brilliant and colorful illuminations of Persian legend, romance, and poetry, culminating in Firdausi's Shah-nama (Book of Kings) and the poems of Nizami, of which the most splendid illuminated editions were made during the Mongol and Safavid periods.

India and Southeast Asia

The subcontinent of India (comprising India, Pakistan, and Bangladesh) is the source of one of the world's great civilizations, which in the course of some five thousand years has produced works of art of amazing richness and diversity. Indian art is rooted in the religious and philosophical systems of Buddhism, Hinduism (Brahmanism), and Jainism. Its chief means of expression is the human figure in symbolic pose and gesture. Sculpture, free-standing and in relief, is the glory of Indian art. With the Muslim conquest of a large portion of India, the ways of Islam were brought to India, and Hindu and Islamic traditions gradually interacted. The most brilliant works of Indo-Islamic art and architecture were created during the Mughal (Moghul) period, which was also the first period of secular art in India.

The clearest and most direct explanation of what Indian art is all about is found in *Indian Art* (1958), by K. Bharatha Iyer. The author outlines the fundamental "ideals" of Indian art, the principal symbols including those of the Buddha and the *mudras* (gestures), and the functions of the three principal deities, Brahma, Vishnu, and Siva. There is also a brief sketch of the history of Indian sculpture, architecture, and painting.

This book no more than whets the appetite for broader background knowledge and more scholarly sources. As mythology and religion play a dominant role in Indian art, *Indian Mythology* (1967), by Veronica Ions, may be read for the stories of the Indian gods, the myths of creation, the life of Buddha, and so forth. This popularly written volume is profusely illustrated with representations of the deities in sculptures and paintings. *The Wonder that Was India* (1954), by Arthur L. Basham, is an excellent compendium with a lengthy chapter on religion, along with chapters on the arts, history, state, and society.

Each of the survey histories of Indian art has different merits. *The Art of India* (1962), by Hermann Goetz, a volume in the Art of the World series, presents a coherent narrative of the arts in their religious, historical, and sociological context. It treats all periods of Indian art, from the prehistoric Indus Valley civilization through the Islamic period, with an epilogue on the "modern" period, which discusses India's contact with Europe and the revival of a native art in the late nineteenth and early twentieth centuries. It is well illustrated, has a good bibliography, maps, chronological charts, and a glossary of technical terms. *Five Thousand Years of the Art of India* (1971), by Mario Bussagli and C. Sivaramamurti, is a large volume with an excellent comprehensive text which places the emphasis on art historical contexts. It is richly illustrated in color but lacks a bibliography and charts. Benjamin Rowland's *Art and Architecture of*

India: Buddhist, Hindu, Jain (3d rev. ed. 1967) is another standard source, being a volume of the Pelican History of Art. It omits Indo-Islamic art but includes areas of India's cultural diffusion — Afghanistan, Turkestan, and Kashmir to the northwest, and Ceylon (Sri Lanka), Burma, Siam (Thailand), and Java to the southeast. *The Art of Indian Asia* (2d ed. 1955. 2 vols.), by Heinrich R. Zimmer, which includes the "provincial" styles of Ceylon, Burma, Java, Cambodia, and Thailand, is for the advanced student, since the text, in rather complex language, emphasizes the symbolic and philosophical content of Indian art. But the initial chapter, "The Great Periods of Indian Art," is not at all difficult to understand. In the words of the author, it presents "a brief historical outline of the transformation of Indian art, as well as the key to the symbology of the forms" which can serve as a concise guide to the illustrations. The illustrations, in volume 2, are superlative.* They represent the best visual introduction to the wealth of Indian art (excluding Indo-Islamic).

An older work to be cited in this connection is *History of Indian and Indonesian Art* (1927), by Ananda K. Coomaraswamy. Western readers owe a debt of gratitude to Dr. Coomaraswamy, who was the first scholar to research Indian art in modern terms and whose books have opened the eyes of Westerners to the special beauty and significance of Indian sculpture and painting, an art which in the nineteenth century was still considered to be devoid of any intrinsic artistic qualities.

The arts of Indochina and Indonesia derived much of their inspiration from their contacts with India and, in the eastern regions, also from China. Buddhism and Hinduism, together with the Indian concept of kingship, were the leading influences. *The Art of Southeast Asia* (1967), by Philip S. Rawson, is a concise yet comprehensive and well-written introduction to the art of this area. The author discusses the art of Cambodia, Vietnam, Thailand, Laos, and Burma and of the islands of Java and Bali. Bernard Philippe Groslier's *The Art of Indochina: Including Thailand, Vietnam, Laos and Cambodia* (1962), focuses on the great temples and their sculptures, of which Angkor Vat in Cambodia is a key monument. Angkor is also the subject of several authoritative monographs. *The Civilization of Angkor* (1976), by Madeleine Giteau, with splendid photographs by the author and others, may well be the last book on Angkor to appear in the West for some time to come. Giteau, formerly the curator at the museum of Phnom Penh, discusses religion, history, court ceremony, and provincial life of the Khmer people in relation to the visual arts of the region.

*The quality of the reproductions in the 1955 edition is far superior to that of the 1968 reprint.

Ancient Indonesian Art (1959), by August J. Bernet Kempers, is the standard work on the subject. It contains an introduction tracing the history of the art and an anthology of well-selected plates with informative notes and scholarly bibliographical references. *Indonesia: The Art of an Island Group* (1959), by Frits A. Wagner, a volume in the Art of the World series, is also useful. The word "art" is understood here in a very broad sense to include music, dancing, puppetry, and literature. This comprehensive work has good plates in color, a glossary, a chronological table, maps, and a bibliography.

China

Our knowledge of Chinese art has undergone considerable revision now that the extraordinary bronzes, ceramics, sculptures, and jades excavated in China since the Cultural Revolution have been seen and studied by Western scholars. Some of these exquisite objects were exhibited from 1973 to 1975 in a few select museums in Europe and North America, among them the National Gallery of Art in Washington, D.C. The catalog of this exhibition, called *The Exhibition of Archaeological Finds of the People's Republic of China,* has become widely available.

One of the first books to take these new discoveries into account is *The Arts of China* (1973), by Michael Sullivan, a revised edition of his earlier *A Short History of Chinese Art.* It is a chronological account of the arts as they have evolved from the Stone Age to the present. Names of dynasties form the chapter headings, for Chinese art (like Egyptian and Islamic art) is dated by dynasties, rather than styles. William Willetts, in his *Foundations of Chinese Art* (1965), uses an entirely different approach. Each chapter (except the first, which deals with the Neolithic period) of this large, handsomely illustrated work deals with a specific art form: jade, bronze, lacquer, sculpture, pottery, painting and calligraphy, and, last, architecture. The third basic book on Chinese art, *The Art and Architecture of China* (3d ed. 1968), by Laurence Sickman and Alexander Soper, a volume of the Pelican History of Art, is more limited in coverage; it includes only painting, sculpture, and architecture.

Chinese Painting (1960), by James Cahill, has been mentioned earlier in this chapter for its superb illustrations, about half of which are works in the National Palace Museum in Taipei, Taiwan. The text is also of a high order. It traces the long history of painting expertly, placing just emphasis on the supreme achievements of the Sung painters.

The serious student of Chinese painting needs to be familiar with Osvald Sirén's *Chinese Painting: Leading Masters and Principles* (1956-58. 7 vols.). The "Annotated Lists of Paintings and Reproductions of Paintings

by Chinese Artists" in volume 2, and the "Annotated Lists of Chinese Painters of the Yüan, Ming, and Ch'ing Periods" in volume 7 are an important textual feature of this pioneering work. Together the fifteen hundred or so names form the basis for a dictionary of Chinese painters. Explanations of the selection and classification of the material and the use to be made of these lists are given in the "Introduction to the Lists," volume 2, pages 3 and 4.

In China, calligraphy is considered a "fine art" which is practiced, like painting, with brush and ink on silk or paper. It is the very backbone of painting, Chiang Yee states in his fundamental *Chinese Calligraphy* (3d ed. 1973). Chiang Yee's book is an excellent source for the understanding of this dynamic yet highly disciplined art form. As a Chinese artist and author who has lived in the West, he writes very clearly and simply with a special perception for the needs of Western readers.

The ritual bronze vessels of the Shang and Chou periods are objects very frequently studied in colleges. These bronzes are works of a "unique character" which are "universally admired for their unsurpassed technical skill" and must be considered true works of art, writes Max Loehr in his *Ritual Vessels of Bronze Age China* (1968). This book, which is actually the catalog of an exhibition shown at the Asia House Gallery in New York, has become a standard source on the subject.

An easy way to obtain information on the symbolism of gods, animals and other natural forms, and many objects of Chinese life and art, is to consult *Outlines of Chinese Symbolism and Art Motives* (3d ed. 1941), by C. A. S. Williams. This *Alphabetical Compendium of Antique Legends and Beliefs, as Reflected in the Manners and Customs of the Chinese,* as the subtitle states, contains several hundred definitions and explanations, many of them illustrated with line drawings, of topics ranging from Confucius to pomegranates, from pagodas to unicorns.

The T. L. Yuan Bibliography of Western Writings on Chinese Art and Archaeology (1975), edited by Harrie A. Vanderstappen, must finally be mentioned as the most exhaustive reference guide to sources on Chinese art published between 1920 and 1965 (a few major works published before 1920 have been included). This classified bibliography is divided into two principal sections: "Books" (including book reviews and exhibition catalogs) and "Articles" (and other miscellaneous writings). The entries in each section are divided into broad subject categories — "general," archaeology, architecture, calligraphy, painting, graphics, sculpture, bronzes, ceramics, decorative arts and handicrafts, all of which are further subdivided as required. China-related material from Tibet, Mongolia, Central Asia, Korea, and Japan has been included, and there is an index to authors and collectors.

Korea

Korea is an art-historically much neglected country, even though it has produced important monuments and, due to its geographical position, has played a key role in transmitting Chinese art and culture to Japan. Most histories of Far Eastern art make only passing reference to Korea. The articles on Korea and Korean art in art encyclopedias such as the *Encyclopedia of World Art* may well be the only general sources available in smaller libraries. *The Arts of Korea* (1962), by Evelyn McClune, is a basic survey, written especially for Western readers. Chronologically arranged, it relates the arts of each period to cultural contexts, emphasizing the "interplay of Korea's culture with that of neighboring countries" (preface). *Arts of Korea* (1974), by Chae-wŏn Kim and Lena Kim Lee, is a large, luxuriously produced and superbly illustrated volume, which discusses Buddhist sculpture, the applied arts (mostly tomb finds and ceramics), and painting. It has an authoritative text, notes on the plates, a chronology, and a bibliography divided into works in Oriental and in Western languages.

Japan

Since its publication over two decades ago, *The Pageant of Japanese Art* (1952-54. 6 vols.), issued by the Tokyo National Museum, has been the standard multivolume work on this subject. The six large volumes with their brief authoritative texts and superb plates cover the principal areas of Japanese art — paintings and prints, architecture and garden design, sculpture, metalwork, ceramics, textiles, and lacquer. However, the recent thirty-volume Heibonsha Survey of Japanese Art has become a serious contender as the best multivolume set on Japanese art. Each of the well-designed, medium-sized volumes is written by a leading Japanese art historian, is excellently translated, and is illustrated with color and monochrome plates of high quality. Most of the volumes of the Heibonsha Survey deal with somewhat specialized subjects, but the presentation is usually clear and factual. An important volume in this series is *Japanese Arts and the Tea Ceremony* (1974), by T. Hayashiya and others, adapted by Joseph P. Macadam. It deals comprehensively with a ritual which is at the very core of Japanese aesthetics. Tea houses and gardens, paintings, flower arrangements, and, of course, the tools and vessels used in the tea ceremony itself are discussed in this book.*

**The Book of Tea* (1906), by Kakuzo Okakura, is the classic treatment of the subject.

Another authoritative series, quite similar to the Heibonsha Survey in format, is The Arts of Japan series. An excellent volume in this series is *Ink Painting* (1974), by Takaaki Matsushita, which traces five hundred years of this singular art form, of which Sesshū was the greatest master.

Surveys of Japanese art which follow a chronological sequence often begin with the introduction of Buddhism is Japan during the Asuka period, around A.D. 600. *Japan: Art and Civilization (*1971), by the French scholar Louis-Frédéric, is an informative one-volume survey which relates the arts to Japanese history and social conditions from the prehistoric beginnings to the mid-nineteenth century. It is clearly written and well illustrated with over four hundred illustrations, but it excludes the Meiji period and the present century. *The Art and Architecture of Japan* (2d ed. 1974), by Robert T. Paine and Alexander Soper, in the Pelican History of Art series, is the standard scholarly volume.

The best-known and most popular Japanese art works are prints, or, more exactly, the color woodcut prints of Ukiyo-e ("Pictures of the Floating World"). They started the vogue for Oriental art in the West about one hundred years ago and had a considerable influence, especially on French artists. These influences have been demonstrated in two perceptive exhibitions, "The Great Wave" (1974), mounted by Colta F. Ives at the Metropolitan Museum of Art, and "Japonisme" (1975), by Gabriel P. Weisberg and others, at the Cleveland Museum of Art. Both museums have published excellent, well-illustrated catalogs of these exhibitions.

James A. Michener has been an ardent student of Japanese prints, as his evocative *The Floating World* (1954) so eloquently testifies. Michener's later *Japanese Prints* (1959), written with equal enthusiasm, offers more systematic biographical and stylistic information on the individual print-makers and is lavishly illustrated.

The impact of Zen on the arts of Japan has been the subject of several recent studies. *Zen and the Fine Arts* (1971), by Shin'ichi Hisamatsu, is one of the most comprehensive of these, attempting to trace the influence of Zen on all the arts, from painting and calligraphy to the utensils of the tea ceremony, from architecture and garden design to the costumes of the Nō drama. *Zen Painting and Calligraphy* (1970), by Jan Fontein and M. L. Hickman is the catalog of an exceptional exhibition held at the Museum of Fine Arts, Boston. It presents, in the Introduction, a lucidly written survey of the subject, while the comments on the plates supply the necessary data — including translations of the texts — on each work shown in the exhibition.

CHAPTER 23

Primitive Art, Tribal Art

The arts of the tribal societies of Africa, Oceania, and the American Indian are often grouped together under the summary and somewhat misleading term "primitive art" — misleading, if this term is meant to imply value judgments on the quality of tribal art as compared with the art of other societies and civilizations.

Several books use the term "primitive art" as their very title. Some of these have been mentioned in Chapter 7 and include prehistoric art. Others, dealing only with tribal arts, were written by anthropologists who see the qualities of tribal art in a different light. A typical example is *Primitive Art* (1927), by Franz Boas, a book which was important in its time and is still found in many libraries. It stresses the materials and techniques used by primitive artists while minimizing "social, historical, and psychological factors" (Douglas Fraser). Douglas Fraser, in his *Primitive Art* (1962), tries to avoid such one-sidedness. He is contemporary in his attitude and writes from an art historian's point of view. His book provides an excellent frame of reference for the entire subject of tribal arts. The three main chapters deal with Africa, Asia/Oceania (which includes Australia and New Zealand), and the Americas. The last-named chapter discusses also Pre-Columbian art, since, according to Fraser, "almost all primitive styles in America are influenced directly or indirectly by the high cultures of Mexico and Peru."

Africa

Recent research and a growing consciousness of Black Americans of their artistic heritage have generated an entirely new literature on African art in the last decade or two. These newer volumes place the works of art into their religious and sociological contexts and stress the long tradition,

194

variety, and sophistication of African art, in contrast to some of the earlier writings which focus on its so-called primitivism.

One of the best books on the subject is *African Art* (1971), by Frank Willett. The important first chapter, titled "The Development of the Study of African Art," is more than a mere bibliographic essay tracing the principal earlier writings on the subject; it analyzes the historical concepts and aesthetic attitudes behind these writings and explains the term "primitive" art — a term which recurs in the earlier literature but is now becoming obsolete.

Students primarily concerned with the characteristic arts of individual regions, tribes, or ethnic groups will turn to Elsy Leuzinger's *Africa* (rev. ed. 1967), a volume in the Art of the World series. The first part of this book outlines the religious and socioanthropological background, a knowledge of which is indispensable for the understanding of African art. This is followed by a most informative chapter on the materials and techniques used by African artists and craftsmen. The second part is arranged geographically and discusses the arts of the various regions. *African Sculpture Speaks* (4th ed. 1975), by Ladislas Segy, is another valuable study which discusses the arts of individual tribes.

An eye-filling pictorial volume with superb color plates and brief comments on one characteristic sculpture from each tribe is *African Art* (1968), by Pierre Méauzé. Other titles which are notable for their informative and sensitive texts are: *African Art* (1968), by Michel Leiris and Jacqueline Delange, a volume in the Arts of Mankind series, with sumptuous illustrations, an extensive bibliography, and a useful glossary-index; *The Arts of Black Africa* (1971), by the French poet Jean Laude, who stresses the creativity of the African artist in terms of his environment; and *African Art: Its Background and Traditions* (1968), by the anthropologist René Wassing. This well-illustrated survey deals particularly with West Africa, the region which has produced the most important and best-known monuments of African art.

Specialized studies explore the arts of individual cultures or ethnic groups such as Benin, Ife, Yoruba, Dogon, Ashanti, as well as particular art forms. Sculpture is the principal medium of the African artist, hence the extensive treatment of sculpture in most books on African art. On the other hand, the prehistoric cave paintings of Africa are among the most intriguing facets. of African art. The pioneering discoveries were made in the early twentieth century by the German explorer Leo Frobenius and the French prehistorian Henri Breuil. An example of the scholarly publications which Henri Breuil produced on African rock art is *The White Lady*

of the Brandberg (1966), a thorough, well-illustrated examination of a single South African cave rich in prehistoric remains. *Prehistoric Rock Art of the Federation of Rhodesia & Nyasaland* (1959), by Elizabeth Goodall and others, edited by Roger Summers, is a clearly written description of South African caves, illustrated with colored renderings of the paintings there. *African Rock Art* (1970), by Burchard Brentjes, is a more general, briefer survey.

A Bibliography of African Art (1965), issued by the International African Institute, London, is an important research tool. It is very complete for earlier publications − of which many are in French and German, however. Because of its date it lacks much of the recent English-language material, which limits its usefulness for the undergraduate student.

The quarterly *African Arts,* published by the University of California, Los Angeles, is an excellent source for beautifully illustrated articles on specialized subjects, including the art of obscure African tribes. Many of the articles are written by African authors. The journal covers the visual arts, the performing arts, and literature.

Works of art from Africa were first collected by anthropologists and ethnologists and considered to be ethnographic specimens rather than artistic creations. They were consequently deposited in natural history and ethnological museums, along with tools, potsherds, and similar artifacts. Rich collections of African art are in the Field Museum of Natural History, Chicago, and the American Museum of Natural History, New York, among others. The Museum of African Art in Washington, D.C., and the Museum of Primitive Art in New York (which is now the Department of Primitive Art of the Metropolitan Museum of Art), are important collections which have specialized in African art *as art.* (The Museum of Primitive Art has also collected Pre-Columbian and Oceanian art.) The Museum of Primitive Art in particular has issued valuable publications on the arts of individual cultures and regions, usually in conjunction with its exhibitions. An outstanding example is *Senufo Sculpture* (1964), by Robert Goldwater. The Library of the Museum of Primitive Art has issued several specialized bibliographies, for example *Bibliography of Benin Art* (1968), by Paula Ben-Amos.

Lastly, the Schomburg Center for Research in Black Culture must be mentioned. It is a part of the New York Public Library system and offers the most exhaustive research collections on African and Afro-American culture, including comprehensive materials on the visual arts.

North American Indian

Appreciation of the art of the North American Indian has not benefited so much from the "change in critical perspective" (Hilton Kramer) which,

in recent decades, has accorded Pre-Columbian and African art a status once reserved only for the art of Western civilization. To this day the products of Indian artists and craftsmen are often simply called "artifacts" rather than "art" or "art objects," and are relegated to the attics and basements of museums. In libraries that follow the classification scheme, or arrangement of books, of the Library of Congress, material on the art of the North American Indians is placed not with the arts of other peoples and countries but is wedged between Indian "agriculture" and "botany."

Indian Art in America (3d ed. 1966), by Frederick J. Dockstader, is an excellent survey with an informative general introduction, followed by an anthology of plates in color and in black and white, with brief but helpful comments on each. Equally excellent is Norman Feder's *American Indian Art* (1971), although the volume itself is big and somewhat unwieldy. The first part, too, deals with general matters — origin, materials, techniques of Indian art; the second part discusses the arts of the different "culture areas" — the Plains, Southwest, California, the Pacific Northwest, Eastern woodlands, and the Arctic coast. The illustrations are sumptuous. A somewhat older work, *The Eagle, the Jaguar, and the Serpent: Indian Art of the Americas* (1954), by Miguel Covarrubias, which deals with the United States, Alaska, and Canada, is still useful for its discussion of the aesthetics of Indian art and the descriptions of techniques such as basketry, beadwork, feather mosaic, and others.

Most of the specialized studies deal either with the art of a region or tribe, or with a particular craft. A regional study important for its subject matter as well as its treatment is *Art of the Northwest Coast Indians* (2d ed. 1967), by Robert B. Inverarity. The woodcarvings made by the tribes of the British-Columbian and Alaskan coast are among the outstanding manifestations of American Indian art. Good examples of the many studies dealing with a single craft are *Historic Pottery of the Pueblo Indians* (1974), by Larry Frank and F. H. Harlow; *Southwest Indian Painting* (2d ed. 1973), by Clara L. Tanner; and *Indian Silver: Navajo and Pueblo Jewelers* (1973), by Margery Bedinger.

The forty-eight *Annual Reports* of the American Bureau of Ethnology, dating from 1879/80 to 1930/31, are a veritable mine of authoritative information on the North American Indians, for it was under the auspices of this U.S. government bureau that the basic research on the Indians was conducted. The well-illustrated essays (by various contributors) that are contained in these volumes are often of considerable length and depth. Volume 48 contains an index, which readily identifies articles on American Indian art subjects.

The Eskimos, who qualify as American aborigines but are ethnically

not Indians, have only recently attracted the attention of art historians, although Eskimo art is sometimes included in exhibition catalogs and other general sources on Indian art. *Sculpture of the Eskimo* (1972), by George Swinton, and *Arts of the Eskimo: Prints* (1975), edited by Ernst Roch, deal with two major media employed by Canadian Eskimo artists.

The Museum of the American Indian, Heye Foundation, in New York City, is the largest and most important United States museum devoted exclusively to Indian art of all the Americas and all periods. Among general art museums with outstanding collections of Indian art the Denver Art Museum takes a leading position. Natural history museums, such as the Field Museum of Natural History in Chicago and the National Museum of Natural History of the Smithsonian Institution, Washington, D.C., also have notable collections of American Indian art; so do anthropological and ethnological museums, such as the Peabody Museum of Harvard University and the National Museum of Man in Ottawa, Ontario, Canada.

Oceania

The aforementioned volume, *Primitive Art,* by Douglas Fraser, gives a clear but condensed picture of the multifaceted art of the vast region of Oceania, which extends from the Philippines and the Malayan archipelago in the west to Hawaii in the north and the Easter Islands in the east. *The Art of the South Sea Islands: Including Australia and New Zealand* (1959), by Alfred Bühler and others, in the Art of the World series, provides fuller information, beginning with excellent general chapters, "Principles of Oceanic Art" and "Religious, Social, and Technological Basis of Oceanic Art," before going into the different geographic areas. The bulk of this volume is by Alfred Bühler, a respected Swiss scholar. The section on the Maori art of New Zealand is by T. Barrow, who has written several books on the subject, among them *Maori Wood Sculpture of New Zealand* (1969). The section on the aboriginal art of Australia is by Charles P. Mountford. *Oceanic Art: Myth, Man, and Image in the South Seas* (1971), by Carl A. Schmitz, has a brilliant, highly concentrated but readable text, which deals with the subject in a chronological sequence, rather than by geographic area. The large body of plates in color and monochrome is outstanding in every way. *The Arts of the South Pacific* (1963), by Jean Guiart, in the Arts of Mankind series, is another basic, well-illustrated study. All books cited here have extensive bibliographies referring to the specialized literature on the different regions and styles.

Bibliography

The publications discussed in this book are numbered and listed here in alphabetical order. The form of entry generally corresponds to that established by the Library of Congress, except that periodicals and exhibition catalogs are entered under their titles.

For the convenience of the reader paperbound editions are marked with an asterisk whenever possible and the publisher's name is given if different from the hardcover edition. But for the most up-to-date information the latest *Paperbound Books in Print* should be checked. Many of these titles are also published in British hardcover or paperback editions; usually the American edition is cited. The American publisher's present location is generally given as the place of publication.

The bracketed page number(s) following each entry refer to the text pages in this book where the particular work is mentioned. Each publication is listed under only one entry. Multiple access — by way of authors and coauthors, editors, museums and art organizations, most series, as well as subjects — is provided through the Index.

1. Ackerman, James S. *The Architecture of Michelangelo.* Rev. ed. London: Zwemmer, 1966. 2 vols. (Studies in Architecture). [p. 133]
2. Adam, Leonhard. *Primitive Art.* New York: Barnes & Noble, 1963. [p. 67]
3. Adams, Ansel. *Artificial-Light Photography.* Boston: New York Graphic, c1956. (Basic Photo Series). [p. 158]
4. ————. *Camera and Lens: The Creative Approach.* Rev. ed. Boston: New York Graphic, 1970. (Basic Photo Series). [p. 158]
5. ————. *Natural Light Photography.* Boston: New York Graphic, c1952. (Basic Photo Series). [p. 158]
6. ————. *The Negative: Exposure and Development.* Boston: New York Graphic, c1948. (Basic Photo Series). [p. 158]
7. ————. *The Print: Contact Print and Enlarging.* Boston: New York Graphic, c1950. (Basic Photo Series). [p. 158]

8. *Adams, Henry. *Mont-Saint-Michel and Chartres.* Introd. by Ralph Adams Cram. 1904. Garden City, N.Y.: Doubleday Anchor, 1959. [p. 87]

9. *African Arts.* Los Angeles: Univ. of California, 1967- (Quarterly). [p. 196]

10. *The Age of Neo-classicism.* [Catalogue of] the Fourteenth Exhibition of the Council of Europe [held at] the Royal Academy and the Victoria and Albert Museum, London . . . London: Arts Council of Great Britain, 1972. [pp. 15, 117]

11. Akiyama, Terukazu. *Japanese Painting.* Geneva: Skira. 1961. (Treasures of Asia). [p. 185]

12. Akurgal, Ekrem. *The Art of Hittites.* Photos by Max Hirmer. New York: Abrams, 1962. [p. 71]

13. Albers, Josef. *Interaction of Color.* New Haven: Yale Univ., 1963. Reissued 1975 with revised plate section. [p. 144]

14. Alberti, Leone Battista. *On Painting, and On Sculpture: The Latin Texts of "De pictura" and "De statua."* Edited with Translation, Introduction, and Notes, by Cecil Grayson. London: Phaidon, 1972. [pp. 28, 103]

15. ————. *Ten Books on Architecture.* Translated into English by James Leoni. Ed. by Joseph Rykwert. London: Tiranti, 1955. [p. 134]

16. *Aldred, Cyril. *The Development of Ancient Egyptian Art: From 3200 to 1315 B.C.* London: Academy Editions, 1973. 3 vols. in 1. Paperback ed.: Transatlantic Arts, 1974, in 3 vols. [p. 72]

17. *Alloway, Lawrence. *Topics in American Art since 1945.* New York: W. W. Norton, 1975. [p. 126]

18. Alpatov, Mikhail V. *Art Treasures of Russia.* New York: Abrams, 1967. [p. 182]

19. *American Architects Directory.* 3d ed. New York: Bowker, 1970. [p. 132]

20. *American Art Directory.* New York: Bowker, 1898- (Frequency varies). [p. 46]

21. *American Artist.* New York: 1937- (Monthly). [p. 62]

22. *American Art Journal.* New York: Kennedy Galleries, 1969- (Semiannual). [p. 173]

23. *American Art Review.* Los Angeles: 1973- (Bimonthly). [p. 173]

24. *American Journal of Archaeology.* New York: Archaeological Institute of America, 1885- (Quarterly). [p. 80]

25. *American Sculpture of the Sixties.* Exhibition Selected and Book Catalog Edited by Maurice Tuchman. Los Angeles: Los Angeles County Museum of Art, 1967. [p. 141]

26. Ancona, Paolo d' and E. Aeschlimann. *The Art of Illumination: An Anthology of Manuscripts from the Sixth to the Sixteenth Century.* London: Phaidon, 1969. [p. 90]

27. Andersen, Wayne. *American Sculpture in Process: 1930-1970.* Boston: New York Graphic, 1975. [pp. 141, 171]

28. *Andrews, Wayne. *Architecture, Ambition, and Americans: A Social History of American Architecture.* New York: Free Press, 1964. [p. 171]

29. ————. *Architecture in America: A Photographic History from the Colonial Period to the Present.* New York: Atheneum, 1960. [p. 171]

30. ————. *Architecture in New England: A Photographic History.* Brattleboro, Vt.: Greene, 1973. [p. 171]

31. *Annual of Advertising, Editorial and Television Art and Design.* New York: Art Directors Club, 1921- (Annual). [p. 164]

32. *Antal, Frederick. *Florentine Painting and Its Social Background: The Bourgeois Republic before Cosimo de' Medici's Advent to Power, Fourteenth and Early Fifteenth Centuries.* London: Routledge & K. Paul, 1948. Paperback ed.: Harper & Row, 1975. [p. 90]

33. *Antiques.* New York: 1922- (Monthly). [p. 62]

34. Antreasian, Garo Z. and Clinton Adams. *The Tamarind Book of Lithography: Art and Techniques.* New York: Abrams, 1971. [p. 153]

35. *Aperture.* Millerton, N.Y.: 1952- (Irregular). [p. 161]

36. *Apollinaire, Guillaume. *Apollinaire on Art: Essays and Reviews, 1902-1918.* Ed. by LeRoy C. Breunig. New York: Viking, 1972. (Documents of 20th-Century Art). [p. 29]

37. *————. *The Cubist Painters: Aesthetic Meditations.* 1913. New York: Wittenborn, 1949. Reprinted 1962. (Documents of Modern Art). [p. 122]

38. *Apollo: The Magazine of the Arts:* London: 1925- (Monthly). [p. 62]

39. *Apollonio, Umbro, ed. *Futurist Manifestos.* New York: Viking, 1973. (Documents of 20th-Century Art). [p. 181]

40. *Archaeological Reports.* London: The Hellenic Society and The British School at Athens, 1954- (Annual). [p. 80]

41. *Archaeology.* New York: Archaeological Institute of America, 1948- (Quarterly). [p. 80]

42. *Architectural Design.* London: 1930- (Monthly). [p. 136]

43. *The Architectural Forum.* 1892-1974. (Ceased publication). [p. 136]

44. *Architectural Periodicals Index.* London: Royal Institute of British Architects, British Architectural Library, 1972- (Quarterly, annual cumulations). [p. 137]

45. *Architectural Record.* New York: 1891- (Monthly). Mid-May issue: *Record Houses and Apartments.* 1956- (Annual). [p. 136]

46. *The Architectural Review.* London: 1897- (Monthly). [p. 136]

47. *Archives of American Art Journal.* New York: 1960- (Quarterly). [p. 173]

48. *Archives of Asian Art.* New York: Asia Society, 1966/67- (Annual). [p. 186]

49. Arias, Paolo E. *A History of One Thousand Years of Greek Vase Painting.* Photos by Max Hirmer. New York: Abrams, 1962. [p. 77]

50. Armitage, Edward L. *Stained Glass: History, Technology and Practice.* Newton, Mass.: Branford, 1959. [p. 93]

51. Arnason, H. H. *History of Modern Art: Painting, Sculpture, Architecture.* 2d ed., rev. and enl. New York: Abrams, 1977. Text ed. Prentice-Hall. [p. 115]

52. *Arnheim, Rudolf. *Art and Visual Perception: A Psychology of the Creative Eye, the New Version.* 2d ed. Berkeley: Univ. of California, 1974. [p. 57]

53. *————. *Picasso's Guernica: The Genesis of a Painting.* Berkeley: Univ. of California, 1962. [p. 11]

54. *Ars Hispaniae: Historia universale del arte hispánico.* Madrid: Plus-Ultra, 1947-73. 21 vols. [p. 183]

55. Arslan, Edoardo. *Gothic Architecture in Venice.* London: Phaidon, 1971. [p. 181]

202 BIBLIOGRAPHY

56. *Ars Orientalis: The Arts of Islam and the East.* Washington, D.C.: Freer Gallery of Art, 1954- (Irregular). [p. 186]
57. Artamonov, Mikhail I. *The Splendor of Scythian Art: Treasures from Scythian Tombs.* Introd. by Tamara Talbot Rice. Photos by Werner Forman. New York: Praeger, 1969. [p. 72]
58. *Art + Cinema.* New York: Visual Resources, 1973- (Three issues per year). [p. 52]
59. *ARTbibliographies Modern.* Santa Barbara, Calif.: ABC-Clio Press, 1969- (Semiannual). Continues *LOMA (Literature on Modern Art).* [pp. 8, 39, 64]
60. *The Art Bulletin.* New York: College Art Association of America, 1917- (Quarterly). [p. 62]
61. *Art Design Photo: Annual Bibliography on Modern Art, Graphic Design, and Photography.* Hempstead, England: A. Davis, 1973- (Annual). [p. 39]
62. *Art Direction: The Magazine of Visual Communication.* New York: 1949- (Monthly). [p. 163]
63. *Artforum.* New York: 1962- (Ten issues per year). [pp. 8, 61]
64. *The ARTgallery: The International Magazine of Art and Culture.* Ivoryton, Conn.: 1957- (Bimonthly). Includes *Art Gallery Guide* (Monthly except Summer). [p. 62]
65. *Art History* (A quarterly journal sponsored by the Association of Art Historians of Great Britain). Forthcoming 1977. [p. 63]
66. *Artibus Asiae.* New York: New York Univ., Institute of Fine Arts, 1925- (Quarterly). [p. 186]
67. *Art in America.* New York: 1913- (Bimonthly). [pp. 8, 61]
68. *Art Index.* New York: H. W. Wilson, 1929- (Quarterly; annual cumulations). [pp. 8, 14, 25, 39, 64, 137]
69. *Art International.* Lugano, Switzerland, 1956- (Six issues per year). [pp. 8, 61]
70. *Artist's and Photographer's Market, 1977.* 2d ed. Cincinnati: Writer's Digest, 1976. [p. 47]
71. *Artist's Proof: The Annual of Prints and Printmaking.* 1961-1972. (Ceased publication). [p. 156]
72. *Art Journal* (formerly *College Art Journal*). New York: College Art Association of America, 1941- (Quarterly). [p. 63]
73. *Art News.* New York: 1902- (Ten issues per year). [pp. 8, 61]
74. **Art Nouveau: Art and Design at the Turn of the Century.* [An exhibition.] Ed. by Peter Selz and Mildred Constantine. With Articles by Greta Daniel and others. New York: Museum of Modern Art, 1960. New rev. paperback ed.: New York Graphic, 1975. [p. 120]
75. **Art of the Printed Book: 1455-1955. Masterpieces of Typography through Five Centuries, from the Collections of the Pierpont Morgan Library, New York.* With an Essay by Joseph Blumenthal. Boston: Godine, 1973. [p. 167]
76. *Art Prices Current.* London: 1908- (Annual). [p. 49]
77. *The Art Quarterly.* 1938-1974. Scheduled to resume publication in 1977. [p. 62]
78. *Artscanada.* Toronto: 1943- (Bimonthly). [p. 174]
78a. *The Arts in America: An Anthology of Bibliographies.* Ed. by Bernard Karpel. Published for the Archives of American Art, Smithsonian Institution. Forthcoming 1978. [p. 173]

79. *Arts in Society.* 1958-1976. (Ceased publication). [p. 61]
80. *Arts Magazine* (formerly *Art Digest, Arts Digest*). New York: 1926- (Ten issues per year). [pp. 8, 61]
81. *Arts of the Eskimo: Prints.* Ed. by Ernst Roch. Barre, Mass.: Barre Pub., Dist. Crown, 1975. [p. 198]
82. Ashmole, Bernard. *Architect and Sculptor in Classical Greece.* New York: New York Univ., 1972. (Wrightsman Lectures). [p. 76]
83. Ashton, Dore. *Modern American Sculpture.* New York: Abrams, 1968. [p. 171]
84. *Audiovisual Marketplace: A Multimedia Guide.* New York: Bowker, 1969- (Annual). [p. 51]
85. Auvil, Kenneth W. *Serigraphy: Silk Screen Techniques for the Artist.* Englewood Cliffs, N.J.: Prentice-Hall, 1965. [p. 154]

86. Backes, Magnus and Regine Dölling. *Art of the Dark Ages.* New York: Abrams, 1971. (Panorama of World Art). [p. 83]
87. Baker, John. *English Stained Glass.* Introd. by Herbert Read. Photos by Alfred Lammer. New York: Abrams, 1960. [p. 93]
88. Ball, Hugo. *Flight out of Time: A Dada Diary.* Edited, with an Introduction, Notes, and Bibliography, by John Elderfield. New York: Viking, 1974. (Documents of 20th-Century Art). [p. 123]
89. *Bann, Stephen, ed. *The Tradition of Constructivism.* New York: Viking, 1974. (Documents of 20th-Century Art). [p. 123]
90. Barnes, Albert C. and Violette De Mazia. *The Art of Cézanne.* Merion, Pa.: Barnes Foundation, 1939. [p. 18]
91. *Barr, Alfred H. *Matisse: His Art and His Public.* New York: Museum of Modern Art, 1951. Reprint: Arno, 1966. Paperback ed.: New York Graphic, 1974. [p. 33n.]
92. *————. *What Is Modern Painting?* 5th rev. ed. New York: Museum of Modern Art, Dist. New York Graphic, 1966. [p. 114]
93. Barrow, T. T. *Maori Wood Sculpture of New Zealand.* Wellington, New Zealand: Reed, 1969. [p. 198]
94. Bartsch, Adam von. *Le peintre graveur.* Small-size Reprint of the Würzburg, 1920-1922, edition. Nieuwkoop, Netherlands: De Graaf, 1970. 22 vols. in 4. [pp. 154-155]
95. *Basham, Arthur L. *The Wonder that Was India.* New York: Grove Press, 1954. [p. 188]
96. Bataille, Georges. *Prehistoric Painting: Lascaux, or, The Birth of Art.* Lausanne: Skira, 1955. (The Great Centuries of Painting). [p. 67]
97. *Battcock, Gregory, comp. *The New Art: A Critical Anthology.* Rev. ed. New York: Dutton, 1973. [p. 126]
98. *Baudelaire, Charles. *Art in Paris, 1845-1862: Salons and Other Exhibitions Reviewed.* Transl. and ed. by Jonathan Mayne. London: Phaidon, 1965. [p. 34]
99. *————. *The Painter of Modern Life, and Other Essays.* Transl. and ed. by Jonathan Mayne. London: Phaidon, 1964. [p. 34]
100. *Bauhaus: 1919-1928.* [An exhibition.] Ed. by Herbert Bayer, Walter Gropius, Ise Gropius. New York: Museum of Modern Art, 1938. Reprint: Arno, 1972. Paperback ed.: New York Graphic, 1975. [p. 178]

204 BIBLIOGRAPHY

101. Baum, Julius. *German Cathedrals.* Photos by Helga Schmidt-Glassner. London: Thames and Hudson, 1956. [p. 87]
102. Bazin, Germain. *The History of World Sculpture.* Boston: New York Graphic, 1968. [p. 139]
103. ————. *The Museum Age.* New York: Universe, 1967. [p. 48]
104. Bean, Jacob and Felice Stampfle. *The Eighteenth Century in Italy: Metropolitan Museum of Art and Pierpont Morgan Library.* Boston: New York Graphic, 1971. (Drawings from New York Collections). [p. 146]
105. Beazley, John D. *Attic Black Figure Vase Painters.* Oxford: Clarendon, 1956. [p. 76]
106. ————. *Attic Red Figure Vase Painters.* 2d ed. Oxford: Clarendon, 1963. 3 vols. [p. 76]
107. ————. *The Development of Attic Black Figure.* Berkeley: Univ. of California, 1951. [p. 76]
108. ————. *Paralipomena: Additions to "Attic Black Figure Vase Painters" and to "Attic Red Figure Vase Painters."* 2d ed. Oxford: Clarendon, 1971. [p. 76]
109. ———— and Bernard Ashmole. *Greek Sculpture and Painting to the End of the Hellenistic Period, Historically Arranged.* Cambridge: Cambridge Univ., 1932. Reissued 1966. [p. 75]
110. Becatti, Giovanni. *The Art of Ancient Greece and Rome: From the Rise of Greece to the Fall of Rome.* New York: Abrams, 1967. Text ed. Prentice-Hall. [p. 78]
111. Beckwith, John. *Early Christian and Byzantine Art.* New York: Penguin, 1970. (Pelican History of Art). [p. 83]
112. *————. *Early Medieval Art.* New York: Oxford Univ., 1964. (World of Art). [p. 84]
113. Bedinger, Margery. *Indian Silver: Navajo and Pueblo Jewelers.* Albuquerque: Univ. of New Mexico, 1973. [p. 197]
114. *Ben-Amos, Paula. *Bibliography of Benin Art.* New York: Museum of Primitive Art Library, 1968. (Primitive Art Bibliographies). [p. 196]
115. Benesch, Otto. *The Art of the Renaissance in Northern Europe: Its Relation to the Contemporary Spiritual and Intellectual Movements.* Rev. ed. London: Phaidon, 1965. [p. 104]
116. ————. *German Painting: From Dürer to Holbein.* Geneva: Skira, 1966. (Painting, Color, History). [pp. 106, 178]
117. ————. *Master Drawings in the Albertina: European Drawings from the Fifteenth to the Eighteenth Century.* Boston: New York Graphic, 1967. [p. 147]
118. Benevolo, Leonardo. *History of Modern Architecture.* Cambridge: M.I.T., 1971. 2 vols. [p. 132]
119. Bénézit, Emmanuel. *Dictionnaire critique et documentaire des peintres, sculpteurs et graveurs de tous les temps et de tous les pays . . .* New ed., reset, rev., and corr. Paris: Gründ, 1976. 10 vols. [p. 10]
120. Benson, John H. and A. G. Carey. *The Elements of Lettering.* Newport, R.I.: Stevens, 1940. [p. 168]
121. *Benthall, Jonathan. *Science and Technology in Art Today.* New York: Praeger, 1972. (World of Art). [p. 127]
122. Berenson, Bernard. *The Drawings of the Florentine Painters.* Amplified ed.

Chicago: Univ. of Chicago, 1938. Reissued 1970. 3 vols. [p. 147]

123. *————. *The Italian Painters of the Renaissance*. London: Phaidon, 1967. Paperback ed. in 2 vols. [p. 98]

124. ————. *Italian Pictures of the Renaissance: A List of the Principal Artists and Their Works . . .* Oxford: Clarendon, 1932. [p. 99]

125. ————. *Italian Pictures of the Renaissance: A List of the Principal Artists and Their Works with an Index of Places: Central Italian and North Italian Schools.* 3d ed. London: Phaidon, 1968. 3 vols. [pp. 24, 99]

126. ————. *Italian Pictures of the Renaissance: A List of the Principal Artists and Their Works with an Index of Places: Florentine School.* London: Phaidon, 1963. 2 vols. [pp. 24, 99]

127. ————. *Italian Pictures of the Renaissance: A List of the Principal Artists and Their Works with an Index of Places: Venetian School.* New ed. London: Phaidon, 1957. Reprinted 1971. 2 vols. [pp. 24, 99]

128. Bernet-Kempers, August J. *Ancient Indonesian Art.* Cambridge: Harvard Univ., 1959. [p. 190]

129. Bianchi Bandinelli, Ranuccio. *Rome: The Center of Power: Roman Art 500 B.C. to A.D. 200.* New York: Braziller, 1970. (The Arts of Mankind). [p. 79]

130. ————. *Rome: The Late Empire: Roman Art A.D. 200-400.* New York: Braziller, 1971. (The Arts of Mankind). [p. 79]

131. Bible. Manuscripts, Anglo-Saxon. N.T. Gospels (Lindisfarne Gospels). *Evangeliorum quattuor Codex Lindisfarnensis . . .* Olten, Switzerland: Urs Graf, 1956-60. 2 vols. [p. 91]

132. Bible. Manuscripts, Latin. N.T. Gospels. Book of Durrow. *Evangeliorum quattuor Codex Durmachensis . . .* Olten, Switzerland: Urs Graf, 1960. 2 vols. [p. 91]

133. Bible. Manuscripts, Latin. N.T. Gospels. Book of Kells. *Evangeliorum quattuor Codex Cenannensis . . .* Bern: Urs Graf, 1950-51. 3 vols. [p. 91]

134. *Bibliographic Guide to Art and Architecture.* Boston: Hall, 1975- (Annual). [pp. 40, 42]

135. Bieber, Margarete. *The History of the Greek and Roman Theater.* 2d ed., rev. and enl. Princeton: Princeton Univ., 1961. [p. 76]

136. ————. *The Sculpture of the Hellenistic Age.* Rev. ed. New York: Columbia Univ., 1961. [p. 76]

137. Binyon, Laurence. *The Flight of the Dragon: An Essay on the Theory and Practice of Art in China and Japan, Based on Original Sources.* London: Murray, 1911. Reprinted 1959. (Wisdom of the East). [p. 185]

138. Birren, Faber. *History of Color in Painting: With New Principles of Color Expression.* New York: Van Nostrand Reinhold. 1965. [p. 143]

139. ————. *Principles of Color: A Review of Past Traditions and Modern Theories of Color Harmony.* New York: Van Nostrand Reinhold, 1969. [p. 143]

140. ————, ed. *A Grammar of Color: A Basic Treatise on the Color System of Albert H. Munsell.* New York: Van Nostrand Reinhold, 1969. [p. 144]

141. *Blake, Peter. *The Master Builders.* New York: Knopf, 1960. Paperback ed. (Norton, 1976) has subtitle: *Le Corbusier, Mies van der Rohe, Frank Lloyd Wright.* [p. 131]

142. *The Blaue Reiter Almanac.* Ed. by Wassily Kandinsky and Franz Marc. New

documentary ed. by Klaus Lankheit. New York: Viking, 1974. (Documents of 20th-Century Art). [p. 121]

143. Blunden, Marie and Godfrey Blunden. *Impressionists and Impressionism . . .* Geneva: Skira, 1970. Reissued by Rizzoli, 1976. [p. 119]

144. *Blunt, Anthony. *Art and Architecture in France: 1500-1700.* Rev. ed. New York: Penguin, 1970. (Pelican History of Art). [pp. 111, 177]

145. *————. *Artistic Theory in Italy: 1450-1600.* 2d ed. Oxford: Clarendon, 1957. Reissued 1975. [p. 101]

146. ————. *Nicolas Poussin.* Princeton: Princeton Univ. 1967. 2 vols. (Bollingen Series, A. W. Mellon Lectures in the Fine Arts). [p. 112]

147. ————. *The Paintings of Nicolas Poussin: A Critical Catalogue.* London: Phaidon, 1966. [pp. 13, 112]

148. *Boardman, John. *Athenian Black Figure Vases.* New York: Oxford Univ., 1974. [p. 77]

149. *————. *Athenian Red Figure Vases: The Archaic Period, a Handbook.* London: Thames and Hudson, 1975. (World of Art Library). [p. 77]

150. *————. *Greek Art.* Rev. ed. New York: Oxford Univ., 1973. (World of Art). [p. 58]

151. ————, José Dörig, and Werner Fuchs. *Greek Art and Architecture.* Photos by Max Hirmer. New York: Abrams, 1967. [p. 75]

152. *Boas, Franz. *Primitive Art.* 1927. Reprint: New York: Dover, 1955. [p. 194]

153. Boase, T. S. R. *English Art: 1800-1870.* Oxford: Clarendon, 1959. (Oxford History of English Art, vol. 10). [p. 179]

154. Bodoni, Giambattista. *Manuale tipografico del cavaliere Giambattista Bodoni.* 1818. Reprint: Parma: Ricci, 1964-65. 3 vols. [p. 167]

155. Boëthius, Axel and J. B. Ward-Perkins. *Etruscan and Roman Architecture.* New York: Penguin, 1970. (Pelican History of Art). [p. 79]

156. Boni, Albert, ed. *Photographic Literature: An International Bibliographic Guide to General and Specialized Literature . . .* Dobbs Ferry, N.Y.: Morgan & Morgan, 1962. [p. 161]

157. ————. *Photographic Literature: 1960-1970.* Dobbs Ferry, N.Y.: Morgan & Morgan, 1972. [p. 161]

158. *The Booklist.* Chicago: American Library Association, 1905- (Semimonthly). [p. 51]

159. *The Book of Kells: Reproductions from the Manuscript in Trinity College, Dublin.* With a Study of the Manuscript by Françoise Henry. New York: Knopf, 1974. [p. 91]

160. *Books in Print: An Author-Title-Series Index to the "Publishers' Trade List Annual."* New York: Bowker, 1948- (Annual). [p. 37]

161. Borsook, Eve. *The Mural Painters of Tuscany: From Cimabue to Andrea del Sarto.* London: Phaidon, 1960. [p. 99]

162. Bossaglia, Rossana and others. *1200 Years of Italian Sculpture.* Photos by Bruno Balestrini. New York: Abrams, 1974. [p. 180]

163. *Boston Museum Bulletin.* Boston: 1903- (Semiannual). [p. 63]

164. Bousquet, Jacques. *Mannerism: The Painting and Style of the Late Renaissance.* New York: Braziller, 1964. [p. 108]

165. Bovini, Giuseppe. *Ravenna.* Photos by Leonard von Matt. New York: Abrams, 1973. [p. 93]

166. ————. *Ravenna Mosaics . . .* Boston: New York Graphic, 1956. [p. 93]

167. Bowlt, John, ed. *Russian Art of the Avant-Garde: Theory and Criticism, 1902-1934*. New York: Viking, 1976. (Documents of 20th-Century Art). [p. 182]

168. *Bowra, Cecil M. *The Greek Experience*. Cleveland: World, c1957. Paperback ed.: New American Library. [p. 69]

169. Braham, Allan and Peter Smith. *François Mansart*. London: Zwemmer, 1973. 2 vols. (Studies in Architecture). [p. 133]

170. *Branner, Robert. *Gothic Architecture*. New York: Braziller, 1961. (Great Ages of World Architecture). [p. 86]

171. *————, ed. *Chartres Cathedral*. New York: W. W. Norton, 1969. (Norton Critical Studies in Art History). [p. 88]

172. *Bredius, Abraham. *Rembrandt: The Complete Edition of the Paintings*. 3d ed., rev. by Horst Gerson. London: Phaidon, 1969. [pp. 13, 113]

173. Brentjes, Burchard. *African Rock Art*. New York: Potter, 1970. [pp. 67, 196]

174. Breton, André. *Manifestoes of Surrealism*. Ann Arbor: Univ. of Michigan, 1969. [p. 124]

175. *————. *Surrealism and Painting*. New York: Harper & Row, 1972. [p. 124]

176. Breuil, Henri. *Four Hundred Centuries of Cave Art*. Montignac, France: Centre d'Etudes Préhistoriques, 1952. [p. 66]

177. ————. *The White Lady of the Brandberg*. With the Collaboration of Mary Boyle and E. R. Scherz. Paris: Trianon Press, 1966. (Rock Paintings of Southern Africa). [p. 195]

178. Briganti, Giuliano. *Italian Mannerism*. Princeton: Van Nostrand, 1962. [p. 108]

179. *Brilliant, Richard. *Roman Art: From the Republic to Constantine*. London: Phaidon, 1974. [p. 78]

180. *Brion, Marcel. *Art of the Romantic Era: Romanticism, Classicism, Realism*. New York: Praeger, 1966. (World of Art). [p. 116]

181. ————. *Romantic Art*. New York: McGraw-Hill, 1960. [p. 117]

182. *The Britannica Encyclopedia of American Art*. Chicago: Encyclopedia Britannica, Dist. Simon & Schuster, 1973. [pp. 45, 170]

183. *The British Journal of Aesthetics*. London: British Society of Aesthetics, 1960- (Quarterly). [p. 63]

184. *British Journal of Photography Annual*. London: 1860- (Annual). [p. 162]

185. British Museum. Dept. of Printed Books. *General Catalogue of Printed Books*. Photolithographic ed. to 1955. London: 1959-66. 263 vols. and *Ten Year Supplement 1956-1965*. London: 1968. 50 vols. [p. 41]

186. Brookner, Anita. *The Genius of the Future: Studies in French Art Criticism: Diderot, Stendhal, Baudelaire, Zola, the Brothers Goncourt, Huysmans*. London: Phaidon, 1971. [p. 34n.]

187. Brunner, Felix. *A Handbook of Graphic Reproduction Processes*. New York: Hastings House, 1962. [p. 151]

188. Bühler, Alfred, T. T. Barrow, and Charles P. Mountford. *The Art of the South Sea Islands: Including Australia and New Zealand*. New York: Crown, 1962. (Art of the World). [p. 198]

189. Buonarroti, Michel Angelo. *Complete Poems of Michelangelo*. Translated into Verse with Notes and Introduction by Joseph Tusiani. New York: Humanities Press, 1969. (UNESCO Collection of Representative Works, Italian Series). [p. 102]

190. ————. *Letters.* Transl., ed., and annotated by E. H. Ramsden. Stanford: Stanford Univ., 1963. 2 vols. [p. 102]

191. *Burchard, John E. and Albert Bush-Brown. *The Architecture of America: A Social and Cultural History.* Boston: Little, Brown, 1961. Abridged student ed.: 1966. [p. 171]

192. *Burckhardt, Jacob C. *The Civilization of the Renaissance in Italy.* 1860. Introd. by Benjamin Nelson and Charles Trinkaus. New York: Harper, 1958. 2 vols. [p. 96]

193. Burke, Joseph. *English Art: 1714-1800.* Oxford: Clarendon, 1976. (Oxford History of English Art, vol. 9). [p. 179]

194. *The Burlington Magazine.* London: 1903- (Monthly). [p. 62]

195. *Burnham, Jack. *Beyond Modern Sculpture: The Effects of Science and Technology on the Sculpture of This Century.* New York: Braziller, 1968. [p. 140]

196. *————. *Great Western Salt Works: Essays on the Meaning of Post-Formalist Art.* New York: Braziller, 1974. [p. 126]

197. Busch, Harald and Bernd Lohse. *Pre-Romanesque Art.* Introduction by Louis Grodecki, Commentaries on the Illustrations by Eva-Marie Wagner. New York: Macmillan, 1966. [p. 83]

198. *Bushnell, G. H. S. *Ancient Art of the Americas.* New York: Praeger, 1965. (World of Art). [p. 175]

199. Bussagli, Mario, ed. *Oriental Architecture.* New York: Abrams, 1975. (History of World Architecture). [p. 131]

200. ———— and C. Sivaramamurti. *5000 Years of the Art of India.* New York: Abrams, 1971. [p. 188]

201. *Cabanne, Pierre. *Dialogues with Marcel Duchamp.* New York: Viking, 1971. (Documents of 20th-Century Art). [p. 33]

202. Cahill, James. *Chinese Painting.* Geneva: Skira, 1960. (Treasures of Asia). [pp. 185, 190]

203. Cahn, Joshua B., ed. *What Is an Original Print?* New York: Print Council of America, 1961. [p. 150]

204. *Calas, Nicolas and Elena Calas. *Icons and Images of the Sixties.* New York: Dutton, 1971. [p. 126]

205. *Camera.* Lucerne, Switzerland: 1922- (Monthly). [p. 161]

206. *Camera Work.* 1903-1917. (Ceased publication). Reprint: Kraus, 1969. 6 vols. [p. 161]

207. *Camera Work: A Critical Anthology.* Ed. by Jonathan Green. Millerton, N.Y.: Aperture, 1973. [p. 161]

208. Canaday, John. *Mainstreams of Modern Art.* New York: Holt, 1959. [p. 114]

209. Cardamone, Tom. *Advertising Agency and Studio Skills: A Guide to the Preparation of Art and Mechanicals for Reproduction.* Rev. ed. New York: Watson-Guptill, 1970. [p. 166]

210. Carli, Enzo. *Sienese Painting.* Boston: New York Graphic, 1956. [p. 99]

211. *Carrà, Massimo, comp. *Metaphysical Art.* Translation and Historical Foreword by C. Tisdall. New York: Praeger, 1971. (World of Art). [p. 181]

212. Carrieri, Raffaele. *Futurism.* Milan: Ed. del Milione, 1963. [p. 181]

213. Carter, Howard and A. C. Mace. *The Tomb of Tut-ankh-Amen, Discovered by the Late Earl of Carnarvon and Howard Carter.* 1923-1933. Reprint of the

1954 ed. New York: Cooper Square Pub., 1963. 3 vols. Abridged ed.: Dutton, 1972. [p. 72n.]

214. Cartier-Bresson, Henri. *The World of Henri Cartier-Bresson*. New York: Viking, 1968. [p. 160]

215. *Castedo, Leopoldo. *A History of Latin American Art and Architecture: From Pre-Columbian Times to the Present*. Transl. and ed. by Phyllis Freeman. New York: Praeger, 1969. (World of Art). [p. 175]

216. Castelli-Sonnabend. *Videotapes and Films*. New York: 1974 and supplements. [p. 52]

217. *Castleman, Riva. *Prints of the Twentieth Century: A History*. New York: Museum of Modern Art, Dist. Oxford Univ., 1976. [p. 152]

218. Catholic Church. Liturgy and Ritual. Psalter (Utrecht Psalter). *The Illustrations of the Utrecht Psalter*. Ed. by E. T. Dewald. Princeton: Princeton Univ. 1932. [p. 92]

219. *Catholic Encyclopedia: An International Work of Reference on the Constitution, Doctrine, Discipline, and History of the Catholic Church*. New York: Encyclopedic Press, 1913-1914. 16 vols. [p. 22]

220. *Cellini, Benvenuto. *The Autobiography of Benvenuto Cellini*. Transl. by John A. Symonds. Garden City, N.Y.: Doubleday Anchor, 1960. [p. 103]

221. *Cennini, Cennino. *The Craftsman's Handbook*. New York: Dover, 1954. [p. 143]

222. Cézanne, Paul. *Paul Cézanne: Letters*. Ed. by John Rewald. 4th ed., rev. and enl. New York: Hacker, 1976. [p. 32]

223. ————. *Paul Cézanne Sketchbook Owned by the Art Institute of Chicago*. Introd. by Carl O. Schniewind. New York: Valentin, 1951. 2 vols. [p. 145]

224. *Chaet, Bernard. *The Art of Drawing*. New York: Holt, 1970. [p. 148]

225. Chamberlin, Mary W. *Guide to Art Reference Books*. Chicago: American Library Association, 1959. (New ed. announced for 1977). [p. 38]

226. Chase, Gilbert. *Contemporary Art in Latin America: Painting, Graphic Art, Sculpture, Architecture*. New York: Free Press, 1970. [p. 176]

227. Chassé, Charles. *The Nabis and Their Period*. New York: Praeger, 1969. [p. 119]

228. Chastel, André. *The Age of Humanism: Europe, 1480-1530*. New York: McGraw-Hill, 1964. [p. 15n.]

229. *————. *Italian Art*. New York: Yoseloff, 1963. Paperback ed.: Harper & Row, 1972. [p. 180]

230. Châtelet, Albert and Jacques Thuillier. *French Painting: From Fouquet to Poussin*. Geneva: Skira, 1963. (Painting, Color, History). [p. 106, 177]

231. Chiang Yee. *Chinese Calligraphy: An Introduction to Its Aesthetic and Technique*. 3d ed. Cambridge, Harvard, 1973. [p. 191]

232. Chieffo, Clifford. *Silk-Screen as a Fine Art: A Handbook of Contemporary Silk-Screen Printing*. New York: Van Nostrand Reinhold, 1967. [p. 154]

233. *Childe, V. Gordon. *What Happened in History*. Rev.ed. New York: Penguin, 1954. [p. 69]

234. *Chipp, Herschel B., ed. *Theories of Modern Art: A Source Book by Artists and Critics*. Berkeley: Univ. of California, 1968. (California Studies in the History of Art). [p. 29, 122]

235. Christensen, Erwin O. *The Index of American Design*. Introd. by Holger Cahill. New York: Macmillan, 1950. [p. 172]

236. ————. *Primitive Art.* New York: Crowell, 1955. [p. 67]
237. **Circle: International Survey of Constructive Art.* Ed. by J. L. Martin, Ben Nicholson, N. Gabo. London: Faber & Faber, 1937. Reissued 1971. [p. 123]
238. Cirici Pellicer, Alejandro. *Treasures of Spain: From Charles V to Goya.* Introd. by F. J. Sánchez-Cantón. Geneva: Skira, 1965. (Treasures of the World). [p. 183]
239. Clapp, Jane. *Sculpture Index.* Metuchen, N.J.: Scarecrow, 1970-71. 2 vols. in 3. [p. 139]
240. Clark, Kenneth. *The Drawings of Leonardo da Vinci in the Collection of Her Majesty the Queen at Windsor Castle.* 2d ed., rev. with the assistance of Carlo Pedretti. London: Phaidon, 1968. 3 vols. [p. 146]
241. ————. *Landscape into Art.* Rev. ed. New York: Harper & Row, 1976. [p. 18]
242. *————. *Looking at Pictures.* New York: Holt, 1960. Paperback ed.: Beacon Press, 1968. [p. 17]
243. ————. *The Romantic Rebellion: Romantic versus Classic Art.* New York: Harper & Row, 1973. [p. 117]
244. Clark, T. J. *The Absolute Bourgeois: Artists and Politics in France, 1848-1851.* Boston: New York Graphic, 1973. [p. 117n.]
245. ————. *Image of the People: Gustave Courbet and the Second French Republic, 1848-1851.* Boston: New York Graphic, 1973. [p. 117n.]
246. Clements, Robert J. *Michelangelo's Theory of Art.* New York: New York Univ., 1961. [p. 101]
247. *Coke, Van Deren. *The Painter and the Photograph: From Delacroix to Warhol.* Rev. ed. Albuquerque: Univ. of Mexico, 1972. [p. 159]
248. Collon-Gevaert, Suzanne, Jean Lejeune, and Jacques Stiennon. *A Treasury of Romanesque Art: Metalwork, Illuminations, and Sculpture from the Valley of the Meuse.* London: Phaidon, 1972. [p. 85]
249. **Color of the Middle Ages: A Survey of Book Illumination, Based on Color Facsimiles of Medieval Manuscripts.* Catalog by Carl Nordenfalk. University Art Gallery . . . Pittsburgh, Pa. Pittsburgh: 1976. [p. 91n.]
250. Columbia University. Libraries. Avery Architectural Library. *Catalog of the Avery Memorial Architectural Library.* 2d ed., enl. Boston: G. K. Hall, 1968. 19 vols. 1st supplement, 1972. 4 vols., and 2d supplement, 1975. 4 vols. [p. 42]
251. *Communication Arts* (formerly *CA Magazine*). Palo Alto: 1959- (Bimonthly). [p. 163]
252. *Computers and Their Potential Applications in Museums: A Conference Sponsored by the Metropolitan Museum of Art, 1968.* New York: Arno Press, 1968. [p. 48]
253. *Conant, Kenneth. *Carolingian and Romanesque Architecture: 800-1200.* Rev. ed. New York: Penguin, 1974. (Pelican History of Art). [pp. 84, 86]
254. *The Connoisseur.* London: 1901- (Monthly). [p. 62]
255. *Conrads, Ulrich, ed. *Programs and Manifestoes on Twentieth-Century Architecture.* Cambridge: M.I.T., 1971. [p. 136]
256. Constable, John. *John Constable's Correspondence.* Edited, with an Introduction and Notes, by R. B. Beckett. Ipswich: Suffolk Records Society, 1962-68. 6 vols. [p. 31]

257. ————. *John Constable's Discourses*. Compiled and Annotated by R. B. Beckett. Ipswich: Suffolk Records Society, 1970. [p. 31]

258. ————. *John Constable: Further Documents and Correspondence*. Ipswich: Suffolk Records Society, 1975. [p. 31]

259. *Cook, John W. and Heinrich Klotz. *Conversations with Architects*. New York: Praeger, 1973. [p. 136]

260. *Coomaraswamy, Ananda K. *History of Indian and Indonesian Art*. New York: Weyhe, 1927. Paperback ed.: Dover, 1965. [p. 189]

261. Cork, Richard. *Vorticism and Abstract Art in the First Machine Age*. Berkeley: Univ. of California, 1976. 2 vols. [p. 179]

262. *Corpus Palladianum*. University Park: Pennsylvania State Univ., 1968- (In progress). [p. 133]

263. *Corpus Rubenianum Ludwig Burchard: An Illustrated catalogue raisonné of the Work of Peter Paul Rubens*. London: Phaidon, 1968- (In progress). [pp. 16, 112]

264. *Corpus Vasorum Antiquorum*. 1922- (In progress). [p. 16]

265. *Corpus Vitrearum Medii Aevi*. 1958- (In progress). [p. 94]

266. Courthion, Pierre. *Impressionism*. New York: Abrams, 1972. (The Library of Great Art Movements). [p. 119]

267. ————. *Romanticism*. Lausanne: Skira, 1961. (The Taste of Our Time). [p. 117]

268. ———— and Pierre Cailler, eds. *Portrait of Manet by Himself and His Contemporaries*. New York: Roy, 1960. [p. 34]

269. Covarrubias, Miguel. *The Eagle, the Jaguar, and the Serpent: Indian Art of the Americas: North America, Alaska, Canada, the United States*. New York: Knopf, 1954. Reprinted 1967. [p. 197]

270. *Craft Horizons*. New York: American Crafts Council, 1941- (Bimonthly). [p. 61]

271. *Creative Camera International Year Book*. London: Coo Press, 1975- (Annual). [p. 162]

272. Crespelle, Jean-Paul. *The Fauves*. Boston: New York Graphic, 1962. [p. 121]

273. Creswell, K. A. C. *A Bibliography of the Architecture, Arts, and Crafts of Islam [to] January 1960*. Cairo: American University in Cairo, 1961. *Supplement: January 1960 to January 1972*. Cairo: American Univ. in Cairo, Dist. Oxford Univ., 1973. [p. 187]

274. *Cubism and Abstract Art: Painting, Sculpture, Constructions, Photography, Architecture, Industrial Art, Theatre, Films, Posters, Typography*. [An exhibition.] By Alfred H. Barr. New York: Museum of Modern Art, 1936. Reprint: Arno, 1966. Paperback ed.: New York Graphic, 1974. [p. 122]

275. *The Cubist Epoch*. [An exhibition.] By Douglas Cooper. London: Phaidon, in association with the Los Angeles County Museum and The Metropolitan Museum of Art, 1970. [p. 122]

276. Cummings, Paul, ed. *Dictionary of Contemporary American Artists*. 3d ed. New York: St. Martin's, 1977. [p. 6]

277. *Cumulative Book Index*. New York: H. W. Wilson, 1898- (Monthly; quarterly and annual cumulations). [p. 37]

278. *Cuttler, Charles D. *Northern Painting from Pucelle to Bruegel: Fourteenth, Fifteenth, and Sixteenth Centuries*. New York: Holt, 1968. [p. 105]

279. *Dada, Surrealism, and Their Heritage.* [An exhibition.] By William S. Rubin.
 New York: Museum of Modern Art, Dist. New York Graphic, 1968. [p. 124]
280. Damaz, Paul F. *Art in Latin America Architecture.* Pref. by Oscar Niemeyer.
 New York: Van Nostrand Reinhold, 1963. [p. 176]
281. *Daniel, Howard. *Encyclopedia of Themes and Subjects in Painting: Mytho-
 logical, Biblical, Historical, Literary, Allegorical, and Topical.* Introd. by
 John Berger. New York: Abrams, 1971. Paperback ed.: Transatlantic Arts,
 1974. [p. 20]
282. *Dannenfeldt, Karl H., ed. *The Renaissance: Basic Interpretations.* 2d ed.
 Lexington, Mass.: Heath, 1974. (Problems of European Civilization).
 [p. 96]
283. *Davis-Weyer, Caecilia, comp. *Early Medieval Art: 300-1150.* Englewood Cliffs,
 N.J.: Prentice-Hall, 1971. (Sources and Documents in the History of Art).
 [p. 94]
284. Decker, Hans. *Romanesque Art in Italy.* New York: Abrams, 1959. [p. 86]
285. Degering, Hermann. *Lettering: Modes of Writing in Western Europe from
 Antiquity to the End of the Eighteenth Century.* Pref. by Alfred Fairbank.
 2d ed. New York: Universe, 1965. [p. 168]
286. Dehio, Georg. *Geschichte der deutschen Kunst* . . . 3d ed. Berlin: De Gruyter,
 1930-34. 4 vols. in 8. [p. 178]
287. Dehn, Adolf A. and Lawrence Barrett. *How to Draw and Print Lithographs.*
 New York: American Artists Group, 1950. [p. 153]
288. *Delacroix, Eugène. *The Journal of Eugène Delacroix.* New York: Crown, 1948.
 Paperback ed.: Viking, 1972. [p. 31]
289. *DeLaurier, Nancy. *The Slide Buyer's Guide.* 3d ed. New York: College Art
 Association of America, 1976. [p. 52]
290. Delteil, Loys. *Le peintre-graveur illustré (XIXe et XXe siècles).* Paris, 1906-30.
 31 vols. Reprint: *Le peintre-graveur illustré: The Graphic Work of Nine-
 teenth and Twentieth Century Artists.* New York: Da Capo, 1968-70.
 32 vols. [p. 155]
291. Demargne, Pierre. *The Birth of Greek Art.* New York: Golden Press, 1964.
 (The Arts of Mankind). Published in England as: *Aegean Art: The Origins
 of Greek Art.* [p. 74]
292. Demus, Otto. *Byzantine Mosaic Decoration: Aspects of Monumental Art in
 Byzantium.* London: Paul, Trench & Trubner, 1948. Reissued: New
 Rochelle, N.Y.: Caratzas, 1976. [p. 93]
293. ————. *Romanesque Mural Painting.* Photos by Max Hirmer. New York:
 Abrams, 1970. Reissued 1976. [p. 89]
294. Deschamps, Paul. *French Sculpture of the Romanesque Period: Eleventh
 and Twelfth Centuries.* New York: Harcourt, 1930. Reprint: Hacker,
 1972. [p. 88]
295. De Tolnay, Charles. *Michelangelo.* Princeton: Princeton Univ., 1943-60.
 5 vols. Reprinted 1969-70. [p. 100]
296. Deuchler, Florens. *Gothic Art.* New York: Universe, 1973. (Universe History
 of Art). [p. 85]
297. Dewald, Ernest T. *Italian Painting: 1200-1600.* New York: Holt, 1961.
 [pp. 5, 89, 99]
298. Diehl, Gaston. *The Fauves.* New York: Abrams, 1975. (The Library of Great
 Art Movements). [p. 121]

299. *Dinsmoor, William B. *The Architecture of Ancient Greece: An Account of Its Historic Development.* London: Batsford, 1950. Paperback ed.: W. W. Norton, 1975. [p. 77]

300. Diringer, David. *The Illuminated Book: Its History and Production.* Rev. ed. New York: Praeger, 1967. [p. 90]

301. Doak, Wesley A. and William J. Speed, comps. *International Index to Multi-Media Information: 1970-1972.* Pasadena: Audio-Visual Associates, Dist. Bowker, 1975 [p. 51n.]

302. Doblin, Jay. *Perspective: A New System for Designers.* New York: Whitney Publications, 1956. [p. 149]

303. Dockstader, Frederick J. *Indian Art in America: The Arts and Crafts of the North American Indian.* 3d ed. Boston: New York Graphic, 1966. [p. 197]

304. ————. *Indian Art in Middle America: Pre-Columbian and Contemporary Arts and Crafts of Mexico, Central America, and the Caribbean.* Boston: New York Graphic, 1964. [p. 175]

305. ————. *Indian Art in South America: Pre-Columbian and Contemporary Arts and Crafts.* Boston: New York Graphic, 1967. [p. 175]

306. Dodwell, Charles R. *Painting in Europe: 800-1200.* New York: Penguin, 1971. (Pelican History of Art). [p. 84]

307. Doerner, Max. *The Materials of the Artist and Their Use in Painting.* With Notes on the Techniques of the Old Masters. Rev. ed. New York: Harcourt Brace, 1969. [p. 142]

308. *Dorra, Henri. *Art in Perspective: A Brief History.* New York: Harcourt Brace, 1972. [p. 56]

309. Du Bourguet, Pierre M. *Early Christian Art.* New York: Reynal, 1971. [p. 82]

310. Duchamp, Marcel. *Salt Seller: The Writings of Marcel Duchamp, Marchand du sel.* Ed. by Michel Sanouillet and Elmer Peterson. New York: Oxford Univ., 1973. [p. 33]

311. *Dumbarton Oaks Papers.* Washington, D.C.: Dumbarton Oaks Center for Byzantine Studies, Harvard University, 1941- (Annual). [p. 95]

312. Dupont, Jacques and Cesare Gnudi. *Gothic Painting.* Geneva: Skira, 1954. (The Great Centuries of Painting). [p. 89]

313. *Dürer, Albrecht. *Of the Just Shaping of Letters: From the "Applied Geometry" of Albrecht Dürer, Book 3.* 1917. Reprint: Dover, 1965. [p. 169]

314. ————. *The Writings of Albrecht Dürer.* Transl. and ed. by William Martin Conway. Introd. by Alfred Werner. New York: Philosophical Library, 1958. [p. 107]

315. *Edgerton, Samuel Y. *The Renaissance Rediscovery of Linear Perspective.* New York: Basic Books, 1975. Paperback ed.: Harper & Row, 1976. [p. 100]

316. Ehresmann, Donald L. *Fine Arts: A Bibliographic Guide to Basic Reference Works, Histories, and Handbooks.* Appendix by Julia M. Ehresmann. Littleton, Colo.: Libraries Unlimited, 1975. [pp. 38, 47]

317. *Eisler, Colin T. *New England Museums: Museum of Fine Arts, Boston . . . Fogg Art Museum, Harvard University . . . Wadsworth Antheneum . . . Yale University Art Gallery . . . Sterling and Francine Clark Art Institute . . . Worcester Art Museum.* Brussels: Centre National de Recherches "Primitifs flamands," 1961. (*Les Primitifs flamands*, vol. 4). [p. 105]

318. *Eitner, Lorenz. *Neoclassicism and Romanticism: 1750-1850.* Englewood

Cliffs, N.J.: Prentice-Hall, 1970. 2 vols. (Sources and Documents in the History of Art). [p. 28]

319. *Elsen, Albert E. *Origins of Modern Sculpture: Pioneers and Premises.* New York: Braziller, 1974. [p. 140]

320. *————. *Purposes of Art: An Introduction to the History and Appreciation of Art.* 3d ed. New York: Holt, 1972. [p. 56]

321. *Enciclopedia dell'arte antica, classica e orientale.* Rome: Istituto della Enciclopedia Italiana, 1958-73. 9 vols. including supplement and atlas. [pp. 45, 69]

322. *Encyclopaedia Britannica.* 15th ed. Chicago: Encyclopaedia Britannica, 1974. 30 vols. [p. 43]

323. *Encyclopedia of Modern Architecture.* Ed. by Gerd Hatje. New York: Abrams, 1963. [p. 129]

324. *Encyclopedia of World Art.* New York: McGraw-Hill, 1959-68. 15 vols. [pp. 4, 18, 43]

325. Evans, Arthur J. *The Palace of Minos at Knossos.* London: Macmillan, 1921-35. 4 vols. in 6 and *Index.* London: Macmillan, 1936. Reprint: Biblo & Tannen, 1964. 4 vols. in 7. [p. 74]

326. Evans, Joan. *Art in Medieval France: 987-1498.* London: Oxford Univ., 1948. 3d impression with expanded bibliography, 1969. [p. 177]

327. ————. *English Art: 1307-1461.* Oxford: Clarendon, 1949. (Oxford History of English Art, vol. 5). [p. 179]

328. ————, ed. *The Flowering of the Middle Ages.* New York: McGraw-Hill, 1966. [p. 81]

329. *The Exhibition of Archaeological Finds of the People's Republic of China.* Text Provided by the Organization Committee . . . Washington, D.C.: National Gallery of Art, 1974. [p. 190]

329a. *Fairbank, Alfred. *A Book of Scripts.* 1949. New ed. London: Faber & Faber, 1977. (Forthcoming). [p. 168]

330. *The Family of Man: The Greatest Photographic Exhibition* . . . Created by Edward Steichen for the Museum of Modern Art. New York: Simon & Schuster, 1956. Paperback ed.: New American Library. [p. 159]

331. *Fantastic Art, Dada, Surrealism.* [An exhibition.] Ed. by Alfred H. Barr. Essays by Georges Hugnet. Rev. ed. New York: Museum of Modern Art, 1947. Reprint: Arno, 1968. [p. 124]

332. Feder, Norman. *American Indian Art.* New York: Abrams, 1971. [p. 197]

333. Feininger, Andreas. *Basic Color Photography.* Englewood Cliffs, N.J.: Prentice-Hall, 1965. [p. 158]

334. ————. *The Complete Photographer.* Englewood Cliffs, N.J.: Prentice-Hall, 1965. [p. 158]

335. ————. *The Creative Photographer.* Rev. ed. Englewood Cliffs, N.J.: Prentice-Hall, 1975. [p. 158]

336. *Feminist Art Journal.* New York: 1972- (Quarterly). [p. 62]

337. *Ferguson, George W. *Signs and Symbols in Christian Art.* New York: Oxford Univ., 1954. [p. 23]

338. *Férnandez, Justino. *A Guide to Mexican Art: From Its Beginnings to the Present.* Chicago: Univ. of Chicago, 1969. [p. 176]

339. *Films on Art.* The Arts Council of Great Britain. A Program Organized by The American Federation of Arts in Cooperation with Films Incorporated. New

York: American Federation of Arts, 1975. [p. 52]

340. *Films on Art.* Comp. and ed. by the Canadian Centre for Films on Art for The American Federation of Arts. New York: Watson Guptill in Association with the Canadian Film Institute, 1977 (Forthcoming). [p. 52]

341. *The Fine Arts Market Place.* New York: Bowker, 1973/74- (Biennial). [p. 47]

342. Finlay, Ian. *Celtic Art: An Introduction.* Park Ridge, N.J.: Noyes, 1973. [p. 66]

343. *Fitch, James M. *American Building.* 2d ed., rev. and enl. Boston: Houghton Mifflin, 1966-72. 2 vols. Paperback ed.: Schocken Books, 1973-75. [p. 171]

344. Fitchen, James. *The Construction of Gothic Cathedrals: A Study of Medieval Vault Erection.* Oxford: Clarendon, 1961. [p. 87]

345. *Fleming, John, Hugh Honour, and Nikolaus Pevsner, eds. *The Penguin Dictionary of Architecture.* 2d ed. New York: Penguin, 1972. [p. 129]

346. Fletcher, Banister. *Sir Banister Fletcher's A History of Architecture.* 18th ed., rev. by J. C. Palmes. New York: Scribner's, 1975. Earlier editions have title: *A History of Architecture on the Comparative Method . . .* [p. 129]

347. *The Focal Encyclopedia of Photography.* Englewood Cliffs, N.J.: Prentice-Hall, 1974. 2 vols. One-volume desk ed.: McGraw-Hill, 1969. [p. 160]

348. *Focillon, Henri. *The Art of the West in the Middle Ages.* Edited and Introduced by Jean Bony. 2d ed. London: Phaidon, 1969. 2 vols. [p. 85]

349. ————. *The Life of Forms in Art.* 2d English ed., enl. New York: Wittenborn, 1948. [p. 85]

350. Frank, Larry and Francis H. Harlow. *Historic Pottery of the Pueblo Indians: 1600-1880.* Photos by Bernard Lopez. Boston: New York Graphic, 1974. [p. 197]

351. *Frankfort, Henri. *The Art and Architecture of the Ancient Orient.* 4th rev. impression. New York: Penguin, 1969. (Pelican History of Art). [pp. 69, 70]

352. Frankfort, Henriette A. Groenewegen. *Arrest and Movement: An Essay on Space and Time in the Representational Art of the Ancient Near East.* London: Faber & Faber, 1951. Reprint: Hacker, 1972. [p. 70]

353. ———— and Bernard Ashmole. *Art of the Ancient World: Painting, Pottery, Sculpture, Architecture from Egypt, Mesopotamia, Crete, Greece, and Rome.* New York: Abrams, 1972. (Library of Art History). Text ed. Prentice-Hall. [p. 70]

354. Frankl, Paul. *Gothic Architecture.* New York: Penguin, 1962. (Pelican History of Art). [p. 86]

355. ————. *The Gothic: Literary Sources and Interpretations through Eight Centuries.* Princeton: Princeton Univ., 1960. [pp. 29, 86]

356. Frankl, Paul T. *New Dimensions: The Decorative Arts of Today in Words and Pictures.* New York: Payson & Clarke, 1928. Reprint: Da Capo, 1975. [p. 121]

357. Fraser, Douglas. *Primitive Art.* Garden City, N.Y.: Doubleday, 1962. [pp. 194, 198]

358. ————, comp. *The Many Faces of Primitive Art: A Critical Anthology.* Englewood Cliffs, N.J.: Prentice-Hall, 1966. [p. 19]

359. *Freedberg, Sydney J. *Painting in Italy: 1500-1600.* New York: Penguin, 1971. (Pelican History of Art). Rev. paperback ed.: 1975. [p. 99]

360. *————. *Painting of the High Renaissance in Florence and Rome.* Cambridge: Harvard Univ., 1961. 2 vols. Paperback ed.: Harper & Row, 1972. [p. 99]

361. Freer Gallery of Art. *Dictionary Catalogue of the Library of the Freer Gallery of Art, Smithsonian Institution, Washington, D.C.* Boston: Hall, 1967. 6 vols. [p. 42]

362. *French Painting 1774-1830: The Age of Revolution . . .* [An exhibition.] Detroit: Wayne State Univ., 1975. [p. 116]

363. *Friedlaender, Walter F. *Caravaggio Studies.* Princeton: Princeton Univ., 1955. Reissued 1974. [p. 112]

364. *————. *David to Delacroix.* Cambridge: Harvard Univ., 1952. [p. 116]

365. *————. *Mannerism and Anti-Mannerism in Italian Painting.* 1925. Introd. by Donald Posner. New York: Schocken, 1965. [p. 107]

366. ————. *Nicolas Poussin: A New Approach.* New York: Abrams, 1966. (The Library of Great Painters). [p. 112]

367. Friedländer, Max J. *Early Netherlandish Painting.* Pref. by Erwin Panofsky. Comments and Notes by Nicole Veronee-Verhaegen. Leyden, Netherlands: Sijthoff, 1967-76. 14 vols. in 16 and supplement to vols. 1-13. [pp. 25, 104]

368. *————. *From Van Eyck to Bruegel: Early Netherlandish Painting.* 3d ed. London: Phaidon, 1969. Paperback ed. in 2 vols. [p. 104]

369. *Frisch, Teresa G. *Gothic Art: 1140-ca. 1450.* Englewood Cliffs, N.J.: Prentice-Hall, 1971. (Sources and Documents in the History of Art). [p. 94]

370. *From the Lands of the Scythians: Ancient Treasures from the Museums of the U.S.S.R., 3000 B.C.-100 B.C.* New York: Metropolitan Museum of Art, Dist. New York Graphic, 1976. [p. 71]

371. *"From Today Painting Is Dead!" The Beginnings of Photography.* [Catalogue of an exhibition held at the Victoria & Albert Museum.] London: Arts Council of Great Britain, 1972. [p. 157]

372. *Fry, Edward. *Cubism.* New York: McGraw-Hill, 1966. [p. 122]

373. *Fry, Roger. *Cézanne: A Study of His Development.* London: L. & V. Woolf, 1927. Reprint: Noonday Press, 1958. [p 35]

374. *Futurism.* [An exhibition.] By Joshua Taylor. New York: Museum of Modern Art, 1961. [p. 181]

375. Gantner, Joseph and Marcel Pobé. *The Glory of Romanesque Art.* New York: Vanguard, 1956. British ed. has title: *Romanesque Art in France.* [p. 86]

376. Gardner, Arthur. *Medieval Sculpture in France.* Cambridge: Cambridge Univ., 1931. Reprint: Kraus, 1969. [p. 88]

377. Gardner, Helen. *Gardner's Art through the Ages.* Rev. by Horst de la Croix and Richard G. Tansey. 6th ed. New York: Harcourt Brace, 1975. [pp. 11, 55]

378. *Gauguin, Paul. *The Intimate Journals of Paul Gauguin.* 1936. New York: Liveright, 1970. [p. 32]

379. ————. *Letters to His Wife and Friends.* Ed. by M. Malingue. Cleveland: World, 1949. [p. 32]

380. ————. *Noa Noa: Voyage to Tahiti.* Postscript by Jean Loize. Oxford: Cassirer, 1961. [p. 32]

381. Gaunt, William. *The Great Century of British Painting: Hogarth to Turner.* London: Phaidon, 1971. [p. 179]

382. ————. *Impressionism: A Visual History.* New York: Praeger, 1970. [p. 119]

383. ————. *The Restless Century: Painting in Britain 1800-1900*. London: Phaidon, 1972. [p. 179]
384. ————. *The Surrealists*. New York: Putnam, 1972. [p. 125]
385. *Gazette des Beaux-Arts*. Paris: 1859- (Ten issues a year). [p. 63]
386. *German Photographic Annual*. New York: Hastings House, 1956- (Annual). [p. 162]
387. Gernsheim, Helmut. *The History of Photography: From the Camera Obscura to the Beginning of the Modern Era*. 2d ed. New York: McGraw-Hill, 1969. [p. 159]
388. Gerson, Horst and E. H. ter Kuile. *Art and Architecture in Belgium: 1600-1800*. New York: Penguin, 1960. (Pelican History of Art). [p. 110]
389. *Gesta*. New York: International Center of Medieval Art, The Cloisters, 1963- (Semiannual). [p. 94]
390. Giedion, Sigfried. *Space, Time, and Architecture: The Growth of a New Tradition*. 5th ed. Cambridge: Harvard Univ., 1967. [pp. 127, 131]
391. Giedion-Welcker, Carola. *Contemporary Sculpture: An Evolution in Volume and Space*. 3d ed. New York: Wittenborn, 1961. [p. 140]
392. Gilbert, Creighton. *History of Renaissance Art: Painting, Sculpture, Architecture, throughout Europe*. New York: Abrams, 1973. (Library of Art History). Text ed. Prentice-Hall. [p. 97]
393. Giteau, Madeleine. *The Civilization of Angkor*. New York: Rizzoli, 1976. [p. 189]
394. Glaser, Milton. *Graphic Design*. Woodstock, N.Y.: Overlook Press, 1973. [p. 116]
395. Godard, André. *The Art of Iran*. Ed. by Michael Rogers. New York: Praeger, 1965. [p. 187]
396. Goetz, Hermann. *The Art of India: Five Thousand Years of Indian Art*. New York: Crown, 1962. (Art of the World). [p. 188]
397. Gogh, Vincent van. *The Complete Letters*. With Reproductions of All the Drawings in the Correspondence. Boston: New York Graphic, 1958. 3 vols. [p. 31]
398. *Golding, John. *Cubism: A History and an Analysis, 1907-1914*. Rev. ed. Boston: Boston Book & Art Shop, 1968. Paperback ed.: Harper & Row, 1972. [p. 122]
399. Goldscheider, Ludwig, ed. *Michelangelo: Paintings, Sculptures, Architecture*. Complete (5th) ed. London: Phaidon, 1975. [p. 2]
400. Goldwater, Robert. *Senufo Sculpture from West Africa*. New York: Museum of Primitive Art, 1964. [p. 196]
401. ————. *What Is Modern Sculpture?* New York: Museum of Modern Art, 1969. [p. 140]
402. *———— and M. Treves, eds. *Artists on Art: From the Fourteenth to the Twentieth Century*. 2d ed. New York: Pantheon, 1945. [p. 28]
403. Gombrich, Ernst H. *The Heritage of Apelles: Studies in the Art of the Renaissance*. Ithaca, N.Y.: Cornell Univ., 1976. [p. 100]
404. *————. *Norm and Form: Studies in the Art of the Renaissance*. London: Phaidon, 1966. [p. 100]
405. *————. *The Story of Art*. 12th ed. London: Phaidon, 1972. [pp. 11, 55]
406. *————. *Symbolic Images: Studies in the Art of the Renaissance*. London: Phaidon, 1972. [p. 100]

407. Goncourt, Edmond de and Jules de Goncourt. *French Eighteenth Century Painters.* London: Phaidon, 1948. [p. 111n.]

408. Goodall, Elizabeth. *Prehistoric Rock Art of the Federation of Rhodesia and Nyasaland: Paintings and Descriptions by Elizabeth Goodall* and others. Ed. by Roger Summers. Salisbury, Southern Rhodesia: National Publications Trust, 1959. [p. 196]

409. Gowans, Alan. *Building Canada: An Architectural History.* Rev. and enl. Toronto: Univ. of Toronto, 1966. [p. 174]

410. Grabar, André. *Byzantine Painting: Historical and Critical Study.* Geneva: Skira, 1953. (The Great Centuries of Painting). [p. 89]

411. —————. *Christian Iconography: A Study of its Origins.* Princeton: Princeton Univ. 1968. (The A. W. Mellon Lectures in the Fine Arts, Bollingen Series). [p. 82]

412. —————. *Early Christian Art: From the Rise of Christianity to the Death of Theodosius.* New York: Odyssey, 1969. (The Arts of Mankind). [pp. 79, 82]

413. ————— and Carl Nordenfalk. *Early Medieval Painting: From the Fourth to the Eleventh Century.* Lausanne: Skira, 1957. (The Great Centuries of Painting). [p. 89]

414. ————— and —————. *Romanesque Painting: From the Eleventh to the Thirteenth Century.* Lausanne: Skira, 1958. (The Great Centuries of Painting). [p. 89]

415. *Graham, James W. *The Palaces of Crete.* Princeton: Princeton Univ., 1962. [p. 74]

416. *Graphis: International Journal of Graphic Art and Applied Art.* Zurich: 1944- (Bimonthly). [p. 163]

417. *Graphis Annual: The International Annual of Advertising and Editorial Graphics.* Zurich: Herdeg, 1952/53- (Annual). [p. 164]

418. *Graphis Posters: International Annual of Poster Art.* Zurich: Herdeg, 1973- (Annual). [p. 164]

419. Gray, Basil. *Persian Painting.* Lausanne: Skira, 1961. (Treasures of Asia). [p. 187]

420. *Gray, Camilla. *The Russian Experiment in Art: 1863-1922.* New York: Abrams, 1962. Reissued in reduced format 1970. Paperback ed.: Scribner, 1973. [p. 182]

421. Graziosi, Paolo. *Paleolithic Art.* New York: McGraw-Hill, 1960. [p. 66]

422. *The Great Wave: The Influence of Japanese Woodcuts on French Prints.* [An exhibition.] By Colta F. Ives. New York: Metropolitan Museum of Art, 1974. [p. 193]

423. Green, Samuel M. *American Art: A Historical Survey.* New York: Ronald, 1966. [p. 170]

424. *Greenberg, Clement. *Art and Culture: Critical Essays.* Boston: Beacon, 1961. [p. 126]

425. Groce, George C. and D. H. Wallace. *The New-York Historical Society's Dictionary of Artists in America: 1564-1860.* New Haven: Yale Univ., 1957. [p. 45n.]

426. *Gropius, Walter. *The New Architecture and the Bauhaus.* London: Faber & Faber, 1935. Paperback ed.: M.I.T., 1955.

427. Groslier, Bernard P. *The Art of Indochina: Including Thailand, Vietnam, Laos, and Cambodia.* New York: Crown, 1962. (Art of the World). [p. 189]
428. Grube, Ernst J. *The World of Islam.* New York: McGraw-Hill, 1967. (Landmarks of the World's Art). [p. 187]
429. Gudiol, José. *The Arts of Spain.* London: Thames and Hudson, 1964. (World of Art). [p. 183]
430. ————. *Velázquez: 1599-1660.* New York: Viking, 1974. [p. 183]
431. Guiart, Jean. *The Arts of the South Pacific.* New York: Golden Press, 1963. (The Arts of Mankind). [p. 198]

432. Haab, Armin. *Lettera: A Standard Book of Fine Lettering.* New York: Hastings House, 1954-68. 3 vols. [p. 168]
433. Hale, Robert B. *Drawing Lessons from the Great Masters.* New York: Watson-Guptill, 1964. [p. 148]
434. *Hall, James. *Dictionary of Subjects and Symbols in Art.* Introd. by Kenneth Clark. New York: Harper & Row, 1974. [p. 23]
435. Hamilton, George H. *The Art and Architecture of Russia.* 2d ed. New York: Penguin, 1975. (Pelican History of Art). [p. 182]
436. ————. *Nineteenth and Twentieth Century Art: Painting, Sculpture, Architecture.* New York: Abrams, 1970. (Library of Art History). Text ed. Prentice-Hall. [pp. 58, 115]
437. *————. *Painting and Sculpture in Europe: 1880-1940.* New York: Penguin, 1967. (Pelican History of Art). Rev. paperback ed.: 1972. [pp. 115, 178]
438. Hamlin, Talbot F. *Architecture through the Ages.* New York: Putnam, 1953. [p. 130]
439. Hanfmann, George M. *Classical Sculpture.* Boston: New York Graphic, 1967. (A History of Western Sculpture, vol. 1). [p. 139]
440. Harper, J. Russell. *Early Painters and Engravers in Canada.* Toronto: Univ. of Toronto, 1970. [p. 174]
441. ————. *Painting in Canada: A History.* Toronto: Univ. of Toronto, 1966. [p. 174]
442. Harris, Cyril M., ed. *Dictionary of Architecture and Construction.* New York: McGraw-Hill, 1975. [p. 129]
443. *Harrison, G. B. *The Bible for Students of Literature and Art.* Garden City, N.Y.: Doubleday Anchor, 1964. [p. 20]
444. *Hartt, Frederick. *Art: A History of Painting, Sculpture, and Architecture.* New York: Abrams, 1976. 2 vols. Text ed. Prentice-Hall. [p. 56]
445. ————. *History of Italian Renaissance Art: Painting, Sculpture, Architecture.* New York: Abrams, 1970. Text ed. Prentice-Hall. [p. 98]
446. Harvard University. Fine Arts Library. *Catalogue of the Harvard University Fine Arts Library, The Fogg Art Museum.* Boston: Hall, 1971. 16 vols. and supplement. 1976. 3 vols. [p. 42]
447. Hauser, Arnold. *Mannerism: The Crisis of the Renaissance and the Origin of Modern Art.* New York: Knopf, 1965. 2 vols. [p. 108]
448. *————. *The Social History of Art.* London: Routledge, 1951. 2 vols. Paperback ed.: Vintage Books, 1957 in 4 vols. [p. 56]
449. Hayes, William C. *The Scepter of Egypt: A Background for the Study of the Egyptian Antiquities in the Metropolitan Museum of Art.* Boston: New York Graphic, 1953-59. 2 vols. [p. 73]

450. Hayter, Stanley W. *About Prints*. London: Oxford Univ., 1962. [p. 152]

451. Hegemann, Werner and Elbert Peets. *The American Vitruvius: An Architects' Handbook of Civic Art*. 1922. Reprint: New York: Blom, 1972. [p. 134]

452. Heintze, Helga von. *Roman Art*. New York: Universe, 1971. (Universe History of Art). [p. 78]

453. Held, Julius S. and Donald Posner. *Seventeenth and Eighteenth Century Art: Baroque Painting, Sculpture, Architecture*. New York: Abrams, 1971. (Library of Art History). Text ed. Prentice-Hall. [p. 110]

454. Hempel, Eberhard. *Baroque Art and Architecture in Central Europe: Germany, Austria, Switzerland, Hungary, Czechoslovakia, Poland* . . . New York: Penguin, 1965. (Pelican History of Art). [p. 111]

455. *Henderson, George. *Chartres*. New York: Penguin, 1968. (The Architect and Society). [p. 87]

456. Henry, Françoise. *Irish Art in the Early Christian Period: To 800 A.D.* Ithaca, N.Y.: Cornell Univ., 1965. [p. 179]

457. ————. *Irish Art during the Viking Invasions: 800-1200 A.D.* Ithaca, N.Y.: Cornell Univ., 1967. [p. 179]

458. ————. *Irish Art in the Romanesque Period: 1020-1170 A.D.* Ithaca, N.Y.: Cornell Univ., 1970. [p. 179]

459. *Herbert, Robert L. *Modern Artists on Art: Ten Unabridged Essays*. Englewood Cliffs, N.J.: Prentice-Hall, 1964. [pp. 28, 122]

460. Heydenreich, Ludwig H. and Wolfgang Lotz. *Architecture in Italy: 1400-1600*. New York: Penguin, 1974. (Pelican History of Art). [p. 101]

461. Heyer, Paul. *Architects on Architecture: New Directions in America*. New York: Walker, 1966. [p. 136]

462. *Hibbard, Howard. *Bernini*. New York: Penguin, 1966. [p. 112]

463. ————. *Carlo Maderno and Roman Architecture: 1580-1630*. London: Zwemmer, 1971. (Studies in Architecture). [p. 133]

464. *Hill, Edward. *The Language of Drawing*. Englewood Cliffs, N.J.: Prentice-Hall, 1966. [p. 148]

465. Hind, Arthur M. *Early Italian Engraving: A Critical Catalogue with Complete Reproduction of All the Prints Described*. London: Quaritch, 1938-48. 7 vols. [p. 155]

466. ————. *Engraving in England in the Sixteenth and Seventeenth Centuries: A Descriptive Catalogue with Introductions*. Cambridge: Cambridge Univ., 1952-64. 3 vols. [p. 155]

467. *————. *A History of Engraving and Etching from the Fifteenth Century to the Year 1914*. London: Constable, 1927. Paperback ed.: Dover, 1963. [p. 152]

468. *————. *An Introduction to a History of Woodcut: With a Detailed Survey of Work Done in the Fifteenth Century*. London: Constable, 1935. 2 vols. Paperback ed.: Dover, 1963. [p. 152]

469. Hisamatsu, Shin'ichi. *Zen and the Fine Arts*. Tokyo: Kodansha, 1971. [p. 193]

470. *Hitchcock, Henry R. *Architecture: Nineteenth and Twentieth Centuries*. 3d ed. New York: Penguin, 1968. (Pelican History of Art). [p. 131]

471. Hofmann, Armin. *Graphic Design Manual: Principles and Practice*. New York: Van Nostrand Reinhold, 1965. [p. 166]

472. Hogarth, William. *The Analysis of Beauty*. 1753. Ed. by Joseph Burke. Oxford: Clarendon, 1955. [p. 30]

473. Holländer, Hans. *Early Medieval Art.* New York: Universe, 1974. (Universe History of Art). [p. 83]

474. Hollstein, F. W. H. *Dutch and Flemish Etchings, Engravings, and Woodcuts: ca. 1450-1700.* Amsterdam: Hertzberger, 1949- (In progress). [p. 155]

475. ————. *German Engravings, Etchings, and Woodcuts: ca. 1400-1700.* Amsterdam: Hertzberger, 1954- (In progress). [p. 155]

476. *Holt, Elizabeth G., ed. *A Documentary History of Art.* Garden City, N.Y.: Doubleday Anchor, 1957-58. 2 vols. [p. 28]

477. *————, ed. *From the Classicists to the Impressionists: A Documentary History of Art and Architecture in the Nineteenth Century.* Garden City, N.Y.: Doubleday Anchor, 1966. [p. 28]

478. *Honour, Hugh. *Neo-classicism.* New York: Penguin, 1968. (Style and Civilization). [p. 116]

479. Hornung, Clarence P. *Handbook of Early Advertising Art, Mainly from American Sources.* 3d ed. New York: Dover, 1956. 2 vols. (Pictorial Archives Series). [p. 165, 168]

480. ————. *Treasury of American Design: A Pictorial Survey of Popular Folk Arts Based upon Watercolor Renderings in the "Index of American Design," at the National Gallery of Art.* New York: Abrams, 1972. 2 vols. [p. 172]

481. *The Hours of Catherine of Cleves.* Introduction and Commentaries by John Plummer. New York: Braziller, 1966. [p. 92]

482. Howard, Deborah. *Jacopo Sansovino: Architecture and Patronage in Renaissance Venice.* New Haven: Yale Univ., 1975. [p. 132]

483. Hubbard, Robert H. *The Development of Canadian Art.* Ottawa: National Gallery of Canada, 1967. [p. 174]

484. Hubert, Jean, Jean Porcher, and W. F. Volbach. *The Carolingian Renaissance.* New York: Braziller, 1970. (The Arts of Mankind). [p. 84]

485. ————, ————, and ————. *Europe of the Invasions.* New York: Braziller, 1969. (The Arts of Mankind). British ed. has title: *Europe in the Dark Ages.* [p. 84]

486. Huelsenbeck, Richard. *Memoirs of a Dada Drummer.* Edited, with an Introduction, Notes, and Bibliography, by Hans J. Kleinschmidt. New York: Viking, 1974. (Documents of 20th-Century Art). [p. 123]

487. *Huizinga, Johan. *The Waning of the Middle Ages: A Study of the Forms of Life, Thought, and the Arts in France and the Netherlands in the Fourteenth and Fifteenth Centuries.* 1924. Garden City, N.Y.: Doubleday Anchor, 1954. [p. 103]

488. Hunt, William H. *Pre-Raphaelitism and the Pre-Raphaelite Brotherhood.* New York: Dutton, 1905. 2 vols. [p. 31]

489. Hürlimann, Martin. *English Cathedrals.* Foreword by Geoffrey Grigson. Descriptive Text by Peter Meyer. Rev. ed. New York: Viking, 1961. [p. 87]

490. ————. *French Cathedrals.* Text by Jean Bony. Descriptive Notes by Peter Meyer. Rev. ed. New York: Viking, 1961. [p. 87]

491. Hutter, Irmgard. *Early Christian and Byzantine Art.* Foreword by Otto Demus. New York: Universe, 1971. (Universe History of Art). [p. 83]

492. *Huyghe, René, ed. *Larousse Encyclopedia of Renaissance and Baroque Art.* New York: Prometheus, 1964. Paperback ed.: Hamlyn, 1974. [p. 96]

493. *Illustrators: The Annual of American Illustration.* New York: Society of Illustrators, Dist. Hastings House, 1959- (Annual). [p. 164]

494. *Image: Journal of Photography and Motion Pictures of the Rochester International Museum of Photography at George Eastman House.* Rochester: 1952- (Quarterly). [p. 161]

495. *Industrial Design.* New York: 1954- (Bimonthly). [p. 163]

496. International African Institute. *A Bibliography of African Art.* Compiled by L. J. P. Gaskin under the direction of Guy Atkins. London: The Institute, 1965. [p. 196]

497. *International Art Market: A Monthly Survey of Art Auction Prices.* New York: Art in America, 1961- (Monthly). [p. 49]

498. International Congress of the History of Art, 20th, New York, 1961. *Studies in Western Art.* Princeton, Princeton Univ., 1963. 4 vols. [p. 107]

499. *International Directory of Arts: Internationales Kunst-Adressbuch.* Frankfurt: Verlag Müller, 1952- 2 vols. (Biennial). [p. 47]

500. *International Index to Multi-Media Information.* Pasadena: Audiovisual Associates, 1973- (Quarterly). [p. 51]

501. *Inverarity, Robert B. *Art of the Northwest Coast Indians.* 2d ed. Berkeley: Univ. of California, 1967. [p. 197]

502. Ions, Veronica. *Indian Mythology.* London: Hamlyn, 1967. [p. 188]

503. *Italian Chiaroscuro Woodcuts (Bartsch vol. XII).* Ed. by Caroline Karpinski. University Park: Pennsylvania State Univ., 1971. (Le peintre graveur illustré: Illustrations to Adam Bartsch's *Le peintre graveur,* vols. XII-XXI, vol. 1). [p. 155]

504. Itten, Johannes. *The Art of Color: The Subjective Experience and Objective Rationale of Color.* New York: Van Nostrand Reinhold, 1961. Reissued 1973. [p. 144]

505. *Ivins, William M. *How Prints Look: Photographs with a Commentary.* New York: Metropolitan Museum of Art, 1943. Paperback ed.: Beacon Press, 1958. [p. 152]

506. *————. *Prints and Visual Communication.* Cambridge: Harvard Univ., 1953. Paperback ed.: Da Capo, 1969. [p. 152]

507. Iyer, K. Bharatha. *Indian Art: A Short Introduction.* Bombay: Asia Pub. House, 1958. [p. 188]

508. Jacobson, Egbert. *Basic Color: An Interpretation of the Ostwald Color System.* Chicago: Theobald, 1948. [p. 144]

509. Jacobsthal, Paul. *Early Celtic Art.* Oxford: Clarendon, 1944. 2 vols. Reprinted 1969. [p. 66]

510. Jacobus de Varagine. *The Golden Legend . . .* Translated and Adapted from the Latin by Granger Ryan and Helmut Ripperger. 1941. Reprint: New York: Arno Press, 1969. [p. 22]

511. Jaffé, Hans L. C. *De Stijl, 1917-1931: The Dutch Contribution to Modern Art.* Amsterdam: Meulenhoff, 1956. [p. 182]

512. *————, ed. *De Stijl: Extracts from the Magazine.* London: Thames and Hudson, 1970. (World of Art). [p. 182]

513. Jameson, Anna B. *Legends of the Madonna as Represented in the Fine Arts.* 1890. Reprint: Detroit: Gale, 1972. [p. 20]

514. Janson, Horst W. *History of Art: A Survey of the Major Visual Arts from the*

Dawn of History to the Present Day. 2d ed. New York: Abrams, 1977. Text ed. Prentice-Hall. [pp. 11, 56]

515. ————. *Key Monuments of the History of Art: A Visual Survey.* New York: Abrams, 1962. Text ed. Prentice-Hall. [p. 56]

516. ————. *The Sculpture of Donatello.* 2d ed. Princeton: Princeton Univ., 1963. 2 vols. [p. 100]

517. Jantzen, Hans. *High Gothic: The Classic Cathedrals of Chartres, Reims, Amiens.* New York: Pantheon, 1962. [p. 86]

518. **Japonisme: Japanese Influence on French Art, 1854-1910.* [An exhibition.] By Gabriel P. Weisberg and others. Cleveland: Cleveland Museum of Art, Dist. Kent State Univ., 1975. [p. 193]

519. Jean, Marcel. *The History of Surrealist Painting.* With the collaboration of Arpad Mezei. New York: Grove, 1960. [p. 125]

520. Jeanneret-Gris, Charles Édouard. *Creation Is a Patient Search.* New York: Praeger, 1960. [p. 135]

521. ————. *Le Corbusier: Oeuvre complète. Complete Works: 1910-1965.* Ed. by Willy Boesiger. Zurich: (Publisher varies), Dist. Wittenborn, 1946-66. 7 vols. [p. 135]

522. ————. *Le Corbusier: Last Works.* Ed. by Willy Boesiger. New York: Wittenborn, 1970. Forms vol. 8 of *Oeuvre complète.* [p. 135]

523. *————. *Towards a New Architecture.* 1927. Reissued New York: Praeger, 1970. [p. 135]

524. Jettmar, Karl. *Art of the Steppes.* New York: Crown, 1967. (Art of the World). [p. 58, 184]

525. Johnson, James R. *The Radiance of Chartres: Studies in the Early Stained Glass of the Cathedral.* New York: Random House, 1965. (Columbia University Studies in Art History and Archaeology). [p. 88, 93]

526. Johnston, Edward. *Writing and Illuminating, and Lettering.* Rev. ed. New York: Pitman, 1956. [p. 168]

527. Jones, Owen. *The Grammar of Ornament.* Illustrated by Examples from Various Styles of Ornament. 1856. New York: Van Nostrand Reinhold, 1972. [p. 166]

528. *The Journal of Aesthetics and Art Criticism.* Cleveland: American Society for Aesthetics, 1941- (Quarterly). [p. 63]

529. *Journal of Hellenic Studies.* London: Society for the Promotion of Hellenic Studies, 1880- (Annual). [p. 80]

530. *Journal of the Society of Architectural Historians.* Philadelphia: 1940- (Quarterly). [p. 137]

531. *Journal of the Warburg and Courtauld Institutes.* London: 1937- (Annual). [p. 26]

532. Jullian, Philippe. *Dreamers of Decadence: Symbolist Painters of the 1890s.* New York: Praeger, 1971. [p. 119]

533. ————. *The Symbolists.* London: Phaidon, 1973. [p. 119]

534. Kaftal, George. *Iconography of the Saints in Central and South Italian Schools of Painting.* Florence: Sansoni, 1965. [p. 22]

535. ————. *Iconography of the Saints in Tuscan Painting.* Florence: Sansoni, 1952. [p. 22]

536. Kähler, Heinz. *The Art of Rome and Her Empire.* New York: Crown, 1963. (Art of the World). [p. 78]

537. Kalnein, Wend Graf and Michael Levey. *Art and Architecture of the Eighteenth Century in France.* New York: Penguin, 1972. (Pelican History of Art). [pp. 111, 177]

538. *Kandinsky, Wassily. *Concerning the Spiritual in Art, and Painting in Particular.* 1912. New York: Wittenborn, 1947. Reprinted 1974. (Documents of Modern Art). [p. 32]

539. *Katzenellenbogen, Adolf. *The Sculptural Programs of Chartres Cathedral: Christ, Mary, Ecclesia.* Baltimore: Johns Hopkins Univ., 1959. Paperback ed.: W. W. Norton, 1964. [p. 87]

540. Keaveney, Sydney S. *American Painting: A Guide to Information Sources.* Detroit: Gale, 1974. (Art and Architecture Information Guide Series, vol. 1). [p. 172]

541. *Kelemen, Pál. *Baroque and Rococo in Latin America.* New York: Macmillan, 1951. Paperback ed.: Dover, 1967 in 2 vols. [p. 175]

542. *————. *Medieval American Art: Masterpieces of the New World before Columbus.* 3d rev. ed. New York: Macmillan, 1956. Paperback ed.: Dover, 1969 in 2 vols. [p. 175]

543. Kelley, Kenneth L. and D. B. Judd. *The ISCC-NBS Method of Designating Colors, and A Dictionary of Color Names.* Washington, D.C., U.S. Govt. Print Off., 1955. (National Bureau of Standards). [p. 144]

544. Kepes, Gyorgy. *Language of Vision.* Introductory essays by S. Giedion and S. Hayakawa. Chicago: Theobald, 1951. [pp. 57, 166]

545. ————. *The New Landscape in Art and Science.* Chicago: Theobald, 1956. [p. 127]

546. Keutner, Herbert. *Sculpture: Renaissance to Rococo.* Boston: New York Graphic, 1969. (A History of Western Sculpture, vol. 3). [pp. 100, 139]

547. Kidson, Peter. *The Medieval World.* New York: McGraw-Hill, 1967. (Landmarks of the World's Art). [p. 81]

548. Kim, Chae-wŏn and Lena Kim Lee. *Arts of Korea.* Photos by M. Yamamoto. Tokyo: Kodansha, Dist. Harper & Row, 1974. [p. 192]

549. Kitson, Michael. *The Age of the Baroque.* New York: McGraw-Hill, 1966. (Landmarks of the World's Art). [p. 110]

550. Kitto, H. D. F. *The Greeks.* New Preface by the Author. Chicago: Aldine, 1964. [p. 69]

551. *Kitzinger, Ernst. *Early Medieval Art in the British Museum.* 2d ed. London: The British Museum, 1955. Paperback ed.: Indiana Univ., 1964. [p. 84]

552. ————. *The Mosaics of Monreale.* Palermo: Flaccovio, 1960. [p. 93]

553. *Klee, Paul. *On Modern Art.* 1924. Introd. by Herbert Read. London: Faber & Faber, 1948. [p. 33]

554. ————. *Paul Klee Notebooks.* Ed. Jürg Spiller. New York: Wittenborn, 1961-74. 2 vols. Vol. 1: *The Thinking Eye.* Reprinted 1975. Vol. 2: *The Nature of Nature.* [p. 33]

555. Knobler, Nathan. *The Visual Dialogue: An Introduction to the Appreciation of Art.* 2d ed. New York: Holt, 1971. [p. 57]

556. Kramer, Jack. *Human Anatomy and Figure Drawing: The Integration of Structure and Form.* New York: Van Nostrand Reinhold, 1972. [p. 148]

557. *Kramer, Samuel N., ed. *Mythologies of the Ancient World*. Garden City, N.Y.: Doubleday Anchor, 1961. [p. 69]
558. *Krautheimer, Richard. *Early Christian and Byzantine Architecture*. Rev. ed. New York: Penguin, 1975. (Pelican History of Art). [pp. 83, 86]
559. ———— and Trude Krautheimer-Hess. *Lorenzo Ghiberti*. Princeton: Princeton Univ., 1956. Reprinted 1970 in 2 vols. [p. 100]
560. Kubach, Hans E. *Romanesque Architecture*. New York: Abrams, 1975. (History of World Architecture). [p. 86]
561. Kubler, George. *Art and Architecture of Ancient America: The Mexican Maya and Andean Peoples*. 2d ed. New York: Penguin, 1976. (Pelican History of Art). [p. 175]
562. ———— and Martin S. Soria. *Art and Architecture in Spain and Portugal and Their American Dominions: 1500-1800*. New York: Penguin, 1959. (Pelican History of Art). [pp. 111, 183]
563. Kühnel, Ernst. *Islamic Art and Architecture*. Ithaca, N.Y.: Cornell Univ., 1966. [p. 187]
564. *Künstler, Gustav. *Romanesque Art in Europe*. Boston: New York Graphic, 1968. Paperback ed.: W. W. Norton, 1973. [p. 86]

565. Lalanne, Maxime. *A Treatise on Etching*. Authorized American ed. Boston: Estes and Lauriat, 1885. [p. 153]
566. *Landers Film Review*. Los Angeles: 1956- (Nine issues a year). [p. 51]
567. Landolt, Hanspeter. *German Painting: The Late Middle Ages (1350-1500)*. Geneva: Skira, 1968. (Painting, Color, History). [p. 106]
568. Lange, Kurt. *Egypt: Architecture, Sculpture, Painting in Three Thousand Years*. Photos by Max Hirmer. 4th ed. London: Phaidon, 1968. [p. 73]
569. Lapiner, Alan. *Pre-Columbian Art of South America*. New York: Abrams, 1976. [p. 175]
570. Larkin, Oliver W. *Art and Life in America*. Rev. and enl. New York: Holt, 1960. [p. 170]
571. Lasko, Peter. *Ars Sacra: 800-1200*. New York: Penguin, 1972. (Pelican History of Art). [p. 84]
572. Lassaigne, Jacques. *Spanish Painting*. Geneva: Skira, 1952. 2 vols. (Painting, Color, History). [p. 183]
573. Lassus, Jean. *The Early Christian and Byzantine World*. New York: McGraw-Hill, 1967. (Landmarks of the World's Art). [p. 81]
574. *Laude, Jean. *The Arts of Black Africa*. Berkeley: Univ. of California, 1971. [p. 195]
575. Lavin, Marilyn A. *Piero della Francesca: The Flagellation*. New York: Viking, 1972. (Art in Context). [p. 12]
576. Lawrence, Arnold W. *Greek Architecture*. Rev. ed. New York: Penguin, 1975. (Pelican History of Art). [p. 77]
577. Lee, Sherman E. *A History of Far Eastern Art*. Rev. ed. New York: Abrams, 1973. Text ed. Prentice-Hall. [p. 184]
578. Legrand, Francine C. *Symbolism in Belgium*. Brussels: Laconti, 1972. [p. 181]
579. Leiris, Michel and Jacqueline Delange. *African Art*. New York: Golden Press, 1968. (The Arts of Mankind). [p. 195]
580. *Leonardo da Vinci. *The Literary Works of Leonardo da Vinci*. Compiled and

Edited from the Original Manuscripts by Jean Paul Richter. 3d ed. London: Phaidon, 1970. 2 vols. Paperback ed. has title: *The Notebooks of Leonardo da Vinci*... Dover, 1970. [pp. 30, 102]

581. ————. *The Madrid Codices*. Ed. by Ladislao Reti. New York: McGraw-Hill, 1974. 5 vols. [p. 102]

582. ————. *Treatise on Painting* ... Translated and Annotated by A. Philip McMahon. Introd. by Ludwig H. Heydenreich. Princeton: Princeton Univ., 1956. 2 vols. [p. 102]

583. *Leonardo: International Journal of the Contemporary Artist: Art, Science, Technology*. Elmsford, N.Y.: 1968- (Quarterly). [p. 127]

584. Leroi-Gourhan, André. *Treasures of Prehistoric Art*. New York: Abrams, 1967. [p. 66]

585. *Leslie, C. R. *Memoirs of the Life of John Constable: Composed Chiefly of His Letters*. 1845. London: Phaidon, 1951. Paperback ed.: 1971. [p. 30]

586. Leuzinger, Elsy. *Africa: The Art of the Negro Peoples*. Rev. ed. New York: Greystone, 1967. (Art of the World). Also published as: *The Art of Africa*. [p. 195]

587. Levey, Michael. *Painting in Eighteenth Century Venice*. London: Phaidon, 1959. [p. 181]

588. *————. *Rococo to Revolution: Major Trends in Eighteenth-Century Painting*. New York: Praeger, 1966. (World of Art). [p. 110]

589. Leymarie, Jean. *Fauvism: Biographical and Critical Study*. Geneva: Skira, 1959. (The Taste of Our Time). [p. 121]

590. ————. *French Painting: The Nineteenth Century*. Geneva: Skira, 1962. (Painting, Color, History). [p. 177]

591. ————. *Impressionism: Biographical and Critical Study*. Geneva: Skira, 1955. 2 vols. (The Taste of Our Time). [pp. 6, 118]

592. Licht, Fred. *Sculpture: Nineteenth and Twentieth Centuries*. Boston: New York Graphic, 1967. (A History of Western Sculpture, vol. 4). [p. 140]

593. Lindemann, Gottfried. *History of German Art: Painting, Sculpture, Architecture*. New York: Praeger, 1971. [p. 178]

594. ————. *Prints and Drawings: A Pictorial History*. New York: Praeger, 1970. Reissued by Dutton, 1976. [p. 152]

595. *Lippard, Lucy R., ed. *Dadas on Art*. Englewood Cliffs, N.J.: Prentice-Hall, 1971. [p. 123]

596. *————, ed. *Six Years: The Dematerialization of the Art Object from 1966 to 1972*... New York: Praeger, 1973. [pp. 126, 141]

597. *————, ed. *Surrealists on Art*. Engelwood Cliffs, N.J.: Prentice-Hall, 1970. [p. 124]

598. London Univ. Warburg Institute. *A Bibliography of the Survival of the Classics*. London: Cassel, 1934-38. 2 vols. Reprint: Kraus, 1968. [p. 25]

599. López-Rey, José. *Velázquez: A Catalogue raisonné of His oeuvre with an Introductory Study*. London: Faber & Faber, 1963. [p. 112]

600. ————. *Velázquez' Work and World*. London: Faber & Faber, 1968 [p. 112]

601. *L'Orange, H. P. *Art Forms and Civic Life in the Late Roman Empire*. Princeton: Princeton Univ., 1965. [p. 78]

602. ———— and P. J. Nordhagen. *Mosaics*. London: Methuen, 1966. (Methuen Handbooks of Archaeology). [p. 92]

603. Lothrop, Samuel K. *Treasures of Ancient America: The Arts of the Pre-Columbian Civilizations from Mexico to Peru.* Geneva: Skira, 1964. (Treasures of the World). [p. 175]

604. Louis-Frédéric [pseud]. *Japan: Art and Civilization.* New York: Abrams, 1971. [p. 193]

605. Lövgren, Sven. *The Genesis of Modernism: Seurat, Gauguin, Van Gogh and French Symbolism in the 1880's.* Rev. ed. Bloomington: Univ. of Indiana, 1971. [p. 119]

606. *Lowry, Bates. *Renaissance Architecture.* New York: Braziller, 1962. (Great Ages of World Architecture). [p. 101]

607. *————. *The Visual Experience: An Introduction to Art.* 2d ed. Englewood Cliffs, N.J.: Prentice-Hall, 1975. [p. 57]

608. *Lucas, E. Louise. *Art Books: A Basic Bibliography on the Fine Arts.* Boston: New York Graphic, 1968. [pp. 38, 107, 111]

609. *Ludovico degli Arrighi. *The First Writing Book: An English Translation and Facsimile Text of Arrighi's "Operina," the First Manual of the Chancery Hand.* Introduction and Notes by John Howard Benson. New Haven: Yale Univ., 1954. (Studies in the History of Calligraphy). [p. 169]

610. Lullies, Reinhard. *Greek Sculpture.* Photos by Max Hirmer. Rev. ed. New York: Abrams, 1960. [p. 76]

611. *Lumsden, Ernest S. *The Art of Etching: A Complete . . . Description of Etching, Drypoint, Soft-Ground Etching, Aquatint, and Their Allied Arts, Together with Technical Notes . . .* 1924. New York: Dover, 1962. [p. 153]

612. *Lyons, Nathan, ed. *Photographers on Photography: A Critical Anthology.* Englewood Cliffs, N.J.: Prentice-Hall, 1966. [pp. 157, 159]

613. Macadam, Joseph P. *Japanese Arts and the Tea Ceremony.* By Tatsusaburō Hayashiya and others. Translated and Adapted by Joseph P. Macadam. New York: Weatherhill, 1974. (Heibonsha Survey of Japanese Art). [p. 192]

614. McClinton, Katharine M. *Art Deco: A Guide for Collectors.* New York: Potter, 1972. [p. 121]

615. McClune, Evelyn. *The Arts of Korea: An Illustrated History.* Rutland, Vt.: Tuttle, 1962. [p. 192]

616. *McCoubrey, John W., ed. *American Art: 1700-1960.* Englewood Cliffs, N.J.: Prentice-Hall, 1965. (Sources and Documents in the History of Art). [pp. 28, 172]

617. McCoy, Garnett. *Archives of American Art: A Directory of Resources.* New York: Bowker, 1972. [p. 173]

618. *MacDonald, Colin S. *A Dictionary of Canadian Artists.* Ottawa: Canadian Paperbacks, 1967- (In progress). [p. 174]

619. MacDonald, William L. *The Architecture of the Roman Empire, I: An Introductory Study.* New Haven: Yale Univ., 1965. [p. 79]

620. *————. *Early Christian and Byzantine Architecture.* New York: Braziller, 1962. (Great Ages of World Architecture). [p. 85]

621. *McGraw-Hill Dictionary of Art.* New York: McGraw-Hill, 1969. 5 vols. [pp. 4, 18, 43]

622. *Madsen, Stephan T. *Sources of Art Nouveau.* New York: Wittenborn, 1956. Paperback ed.: Da Capo, 1976. [p. 120]

623. Maison, K. E. *Honoré Daumier: Catalogue raisonné of the Paintings, Water-colours, and Drawings.* Boston: New York Graphic, 1968. 2 vols. [p. 14]

624. Maiuri, Amedeo. *Roman Painting.* Geneva: Skira, 1953. (The Great Centuries of Painting). [p. 79]

625. *Mâle, Émile. *The Gothic Image: Religious Art in France of the Thirteenth Century.* New York: Harper & Row, 1973. [p. 21]

626. *————. *Religious Art: From the Twelfth to the Eighteenth Century.* New York: Pantheon Books, 1949. Paperback ed.: Noonday, 1958. [p. 21]

627. Man, Felix H. *Artists' Lithographs: A World History from Senefelder to the Present Day.* New York: Putnam, 1970. [p. 152]

628. Mander, Carel van. *Dutch and Flemish Painters.* Transl. from the *Schilderboek* and Introd. by Constant Van de Wall. New York: McFarlane, 1936. Reprint: Arno, 1969. [p. 106]

629. Mango, Cyril. *Byzantine Architecture.* New York: Abrams, 1976. (History of World Architecture). [p. 131]

630. *————, ed. *The Art of the Byzantine Empire: 312-1453.* Englewood Cliffs, N.J.: Prentice-Hall, 1972. (Sources and Documents in the History of Art). [pp. 28, 94]

631. *Marcel Duchamp.* [An exhibition.] The Museum of Modern Art and Phila-delphia Museum of Art. Ed. by Anne d'Harnoncourt and Kynaston McShine. Boston: New York Graphic, 1973. [p. 33n]

632. Marinatos, Spyridon. *Crete and Mycenae.* Photos by Max Hirmer. New York: Abrams, 1960. [p. 74]

633. ————. *Excavations at Thera.* Athens, 1968-76. 7 vols. in 8. (Bibliothēkē en Atēnais Archaiologikēs Hetaireias). [p. 74]

634. Marle, Raimond van. *The Development of the Italian Schools of Painting.* The Hague: Nijhoff, 1923-38. 19 vols. Reprint: Hacker, 1970. [pp. 99, 180]

635. Martin, Marianne W. *Futurist Art and Theory: 1909-1915.* Oxford: Clarendon, 1968. [p. 181]

636. *Martindale, Andrew. *Gothic Art: From the Twelfth to Fifteenth Centuries.* New York: Oxford Univ., 1967. (World of Art). [p. 85]

637. Mason, Lauris and Joan Ludman, comps. *Print Reference Sources: A Select Bibliography, Eighteenth to Twentieth Centuries.* Millwood, N.Y.: Kraus-Thomson, 1975. [p. 156]

638. *Master Drawings.* New York: 1963- (Quarterly). [p. 147]

639. Matisse, Henri. *Matisse on Art.* Ed. by Jack Flam. London: Phaidon, 1973. [p. 33]

640. *Matsushita, Takaaki. *Ink Painting.* Translated and Adapted by M. Collcutt. New York: Weatherhill, 1974. (Arts of Japan). [p. 193]

641. Matz, Friedrich. *The Art of Crete and Early Greece: The Prelude to Greek Art.* New York: Crown, 1962. (Art of the World). [p. 74]

642. *Maurello, S. Ralph. *Commercial Art Techniques.* Rev. ed. New York: Amiel, 1974. [p. 166]

643. ————. *How to Do Pasteups and Mechanicals: The Preparation of Art for Reproduction.* Rev. ed. New York: Amiel, 1960. [p. 166]

644. Mayer, Ralph. *The Artist's Handbook of Materials and Techniques.* 3d ed., rev. and enl. New York: Viking, 1970. [p. 142]

645. ————. *A Dictionary of Art Terms and Techniques.* New York: Crowell, 1969. [p. 44]

646. ————. *The Painter's Craft: An Introduction to Artists' Methods and Materials.* 3d ed. New York: Viking, 1975. [p. 142]

647. Mayor, A. Hyatt. *Prints and People: A Social History of Printed Pictures.* New York: Metropolitan Museum of Art, Dist. New York Graphic, 1971. [p. 157]

648. Méauzé, Pierre. *African Art: Sculpture.* Cleveland: World, 1968. [p. 195]

649. Megaw, J. V. S. *Art of the European Iron Age: A Study of the Elusive Image.* New York: Harper & Row, 1970. [p. 66]

650. Meiss, Millard. *French Painting in the Time of Jean de Berry: The Boucicaut Master . . .* London: Phaidon, 1968. [pp. 90, 92]

651. ————. *French Painting in the Time of Jean de Berry: The Late Fourteenth Century and the Patronage of the Duke.* London: Phaidon, 1967. 2 vols. [pp. 90, 92]

652. ————. *French Painting in the Time of Jean de Berry: The Limbourgs and Their Contemporaries . . .* New York: Braziller, 1974. 2 vols. [pp. 90, 92]

653. *————. *Painting in Florence and Siena after the Black Death: The Arts, Religion, and Society in the Mid-Fourteenth Century.* Princeton: Princeton Univ., 1951. Reissued 1976. [p. 89]

654. *Mellaart, James. *Earliest Civilizations of the Near East.* New York: McGraw-Hill, 1965. (Library of Early Civilizations). [p. 66]

655. Mendelowitz, Daniel M. *A Guide to Drawing.* New York: Holt, 1976. [p. 148]

656. *————. *A History of American Art.* 2d ed. New York: Holt, 1970. [p. 170]

657. Messer, Thomas M. *The Emergent Decade: Latin American Painters and Paintings in the 1960's.* Artists' Profiles in Text and Pictures by Cornell Capa. Ithaca, N.Y.: Cornell Univ., 1966. [p. 176]

658. *Metropolitan Museum Journal.* New York: 1968- (Annual). [p. 64]

659. *Metropolitan Museum of Art Bulletin.* New York: 1905-1941. New series: 1942- (Quarterly). [p. 63]

660. Metz, Peter. *The Golden Gospels of Echternach . . .* New York: Praeger, 1957. [p. 92]

661. *Meyer, Ursula, comp. *Conceptual Art.* New York: Dutton, 1972. [p. 126]

662. Michener, James A. *The Floating World.* New York: Random, 1954. [p. 193]

663. ————. *Japanese Prints: From the Early Masters to the Modern.* With Notes on the Prints by Richard Lane. Rutland, Vt.: Tuttle, 1959. [p. 193]

664. Millon, Henry A. *Key Monuments of the History of Architecture.* New York: Abrams, 1964. Text ed. Prentice-Hall. [p. 130]

665. Mills, John W. *The Technique of Sculpture.* New York: Watson-Guptill, 1976. [p. 139]

666. *Modern Publicity.* London: Studio-Vista, 1924- (Annual). [p. 164]

667. *Moholy-Nagy, László. *Painting, Photography, Film.* 1925. Note by Hans M. Wingler. Cambridge: M.I.T., 1969. [p. 159]

668. ————. *Vision in Motion.* Chicago: Theobald, 1947. [p. 166]

669. Moir, Alfred. *The Italian Followers of Caravaggio.* Cambridge: Harvard Univ., 1967. 2 vols. [p. 112]

670. *Mondrian, Piet. *Plastic Art and Pure Plastic Art, 1937, and Other Essays, 1941-1943.* New York: Wittenborn, 1945. (Documents of Modern Art).† [p. 32]

†This essay is also included in *Circle . . .,* no. 237 of this bibliography.

671. Mongan, Agnes and Paul J. Sachs. *Drawings in the Fogg Museum of Art.* 2d ed. Cambridge: Harvard Univ., 1946. 2 vols. [p. 146]

672. Monro, Isabel S. and K. M. Monro. *Index to Reproductions of European Paintings: A Guide to Pictures in More than Three Hundred Books.* New York: Wilson, 1956. [p. 24]

673. Moortgat, Anton. *The Art of Ancient Mesopotamia: The Classical Art of the Near East.* London: Phaidon, 1969. [p. 170]

674. Morassi, Antonio. *A Complete Catalogue of the Paintings of G. B. Tiepolo: Including Pictures by His Pupils and Followers, Wrongly Attributed to Him.* London: Phaidon, 1962. [p. 113]

675. ————. *G. B. Tiepolo: His Life and Work.* London: Phaidon. 1955. [p. 113]

676. Moretti, Mario and G. Maetzke. *The Art of the Etruscans.* Photos by Leonard von Matt. New York: Abrams, 1971. [p. 78]

677. Morison, Stanley. *Four Centuries of Fine Printing: 192 Facsimiles of Pages from Books Printed at Presses Established between 1465 and 1924.* 4th ed. New York: Barnes & Noble, 1960. [p. 167]

678. ————. *Fra Luca de Pacioli of Borgo S. Sepolcro.* New York: Grolier Club, 1933. Reprint: Kraus, 1969. [p. 168]

679. Moskowitz, Ira, ed. *Great Drawings of All Time.* New York: Shorewood, 1962. 4 vols. [p. 146]

680. Motherwell, Robert. *The Dada Painters and Poets: An Anthology . . .* New York: Wittenborn, 1951. (Documents of Modern Art). [p. 123]

681. Mucha, Alphonse M. *Lectures on Art: A Supplement to "The Graphic Work of Alphonse Mucha."* New York: St. Martin's, 1975. [p. 120]

682. Muehsam, Gerd. *French Painters and Paintings from the Fourteenth Century to Post-Impressionism.* New York: Ungar, 1970. [pp. 29, 34]

683. *Müller, Grégoire. *The New Avant-garde: Issues for the Art of the Seventies.* New York: Praeger, 1972. [p. 127]

684. Müller, Hans A. *How I Make Woodcuts and Wood Engravings.* New York: American Artist's Group, 1945. [p. 153]

685. ————. *Woodcuts and Wood Engravings: How I Make Them.* New York: Pynson Printers, 1939. [p. 153]

686. Müller, Theodor. *Sculpture in the Netherlands, Germany, France, and Spain: 1400-1500.* New York: Penguin, 1966. (Pelican History of Art). [p. 106]

687. Müller-Brockmann, Josef. *A History of Visual Communication: From the Dawn of Barter in the Ancient World to the Visualized Conception of Today . . .* New York: Hastings, 1971. [p. 165]

688. Munsell, Albert H. *A Color Notation: An Illustrated System Defining All Colors and Their Relations by Measured Scales of Hue, Value, and Chroma.* Introd. by Royal B. Farnum. 11th ed. Baltimore: Munsell Color Co., 1961. [p. 144]

689. *Murray, Linda. *The High Renaissance.* New York: Praeger, 1967. (World of Art). [p. 98]

690. *————. *The Late Renaissance and Mannerism.* New York: Praeger, 1967. (World of Art). [p. 98]

691. *Murray, Peter. *The Architecture of the Italian Renaissance.* New and enl. ed. London: Thames and Hudson, 1969. Paperback ed.: Schocken, 1966. [p. 101]

692. ————. *Architecture of the Renaissance.* New York: Abrams, 1971. (History of World Architecture). [p. 101]

693. *———— and Linda Murray. *The Art of the Renaissance.* New York: Oxford Univ., 1963. (World of Art). [p. 97]

694. *———— and ————. *A Dictionary of Art and Artists.* New York: Praeger, 1966. 3d paperback ed.: Penguin, 1972. [pp. 4-5]

695. *Museum.* Lausanne, Switzerland: UNESCO, 1948- (Quarterly). [p. 48]

696. *Museum Media: A Biennial Directory and Index of Publications and Audiovisuals Available from United States and Canadian Institutions.* Managing Editor: Paul Wasserman. Detroit: Gale, 1973- (Biennial). [p. 37n.]

697. *Museum News.* Washington, D.C.: American Association of Museums, 1924- (Bimonthly). [p. 48]

698. *Museums of the World: A Directory of 17,500 Museums in 150 Countries . . .* 2d ed., enl. Pullach, Germany: Verlag Dokumentation, Dist. Bowker, 1975. [p. 46]

699. Myers, Bernard S. *The German Expressionists: A Generation in Revolt.* New York: McGraw-Hill, 1963. [p. 121]

700. *Nadeau, Maurice. *The History of Surrealism.* Introd. by Roger Shattuck. New York: Macmillan, 1965. [p. 125]

701. Nash, Ernest. *Pictorial Dictionary of Ancient Rome.* 2d rev. ed. New York: Praeger, 1968. 2 vols. [p. 79]

702. National Information Center for Educational Media. *Indexes . . .* Los Angeles: Univ. of Southern California, 1967- and supplements: *NICEM Update of Nonbook Media.* 1973/74- (Biennial). [pp. 51, 52]

703. *National Sculpture Review.* New York: National Sculpture Society, 1951- (Quarterly). [p. 141]

704. *National Union Catalog: A Cumulative Author List Representing Library of Congress Printed Cards and Titles Reported by Other American Libraries.* Washington, D.C.: Library of Congress, 1956- (Nine monthly issues; quarterly, annual, and five-year cumulations). [p. 40]

705. *National Union Catalog: Pre-1956 Imprints. A Cumulative Author List Representing Library of Congress Printed Cards and Titles Reported by Other American Libraries . . .* London: Mansell, 1968- (In progress). [p. 41]

706. *Neo-Impressionism.* [An exhibition.] By Robert L. Herbert. New York: Solomon R. Guggenheim Museum, 1968. [p. 119]

707. *Nesbitt, Alexander. *The History and Technique of Lettering.* New York: Dover, 1957. [p. 168]

708. *The New Catholic Encyclopedia.* Prepared by an editorial staff of the Catholic University of America. New York: McGraw-Hill, 1967. 15 vols. [p. 22]

709. *New Dictionary of Modern Sculpture.* General Editor: Robert Maillard. New York: Tudor, 1971. [p. 138]

710. *Newhall, Beaumont. *The History of Photography: From 1839 to the Present Day.* Rev. and enl. New York: Museum of Modern Art, Dist. New York Graphic, 1964. [p. 159]

711. *New Serial Titles: A Union List of Serials Commencing Publication after December 31, 1949.* Washington, D.C.: Library of Congress, 1950- (Monthly; quarterly and annual cumulations). [p. 60]

712. New York City. Metropolitan Museum of Art. *A Catalogue of French Paintings.*

By Charles Sterling. Cambridge: Harvard Univ., 1955-56. 3 vols. Vols. 2 and 3 have the title: *French Paintings: A Catalogue of the Collections of the Metropolitan Museum of Art.* By Charles Sterling and Margaretta Salinger. [p. 14]

713. New York City. Metropolitan Museum of Art. Library. *Library Catalog.* Boston: Hall, 1960. 25 vols. and supplements. 1962- (Irregular). [p. 41]

714. New York City. Museum of Modern Art. *Catalog of the Library of the Museum of Modern Art.* Boston: Hall, 1976. 14 vols. [p. 42]

715. New York Public Library. Art and Architecture Division. *Dictionary Catalog of the Art and Architecture Division, The Research Libraries . . .* Boston: Hall, 1975. 30 vols. and supplements: *Bibliographic Guide to Art and Architecture.* 1975- (Annual). [pp. 40, 42]

716. New York Public Library. Prints Division. *Dictionary Catalog of the Prints Division, The Research Libraries . . .* Boston: Hall, 1975. 5 vols. [p. 42n.]

717. *New York School: The First Generation. Paintings of the 1940s and 1950s. A Catalogue of the Exhibition with Statements by the Artists and Critics, and a Bibliography.* Ed. by Maurice Tuchman. Los Angeles: Los Angeles County Museum of Art, 1965. Rev. Paperback ed.: New York Graphic, 1971. [p. 125]

718. *The New York Times Index.* New York: 1851- (Semimonthly; annual cumulations). [p. 8]

719. Nicolaides, Kimon. *The Natural Way to Draw: A Working Plan for Art Study.* Boston: Houghton Mifflin, 1941. Reissued 1976. [p. 148]

720. Noble, Joseph V. *The Techniques of Painted Attic Pottery.* New York: Watson-Guptill, 1965. [p. 77]

721. *Nochlin, Linda. *Realism.* New York: Penguin, 1972. (Style and Civilization). [p. 117]

722. *———, ed. *Impressionism and Post-Impressionism: 1874-1904.* Englewood Cliffs, N.J.: Prentice-Hall, 1966. (Sources and Documents in the History of Art). [p. 28]

723. *———, ed. *Realism and Tradition in Art: 1848-1900.* Englewood Cliffs, N.J.: Prentice-Hall, 1966. (Sources and Documents in the History of Art). [p. 28]

724. Norberg-Schulz, Christian. *Baroque Architecture.* New York: Abrams, 1972. (History of World Architecture). [p. 131]

725. Norman, Dorothy. *Alfred Stieglitz: An American Seer.* New York: Random, 1973. [p. 160]

726. *Novotny, Fritz. *Painting and Sculpture in Europe: 1780-1880.* New York: Penguin, 1960. (Pelican History of Art). [pp. 115, 178]

727. *Novum Gebrauchsgraphik: International Advertising Art* (formerly *Gebrauchsgraphik*). Munich: 1924- (Monthly). [p. 164]

728. Oakeshott, Walter. *The Mosaics of Rome: From the Third to the Fourteenth Centuries.* Boston: New York Graphic, 1967. [p. 93]

729. *The Official Museum Directory: United States and Canada.* Washington, D.C.: American Association of Museums, 1971- (Biennial). [p. 46]

730. Offner, Richard and Klara Steinweg. *A Critical and Historical Corpus of Florentine Painting.* New York: New York Univ. Institute of Fine Arts, Dist. Augustin, 1930- (In progress). [p. 16]

731. *Okakura, Kakuzo. *The Book of Tea*. 1906. Ed. and introd. by Everett F. Bleiler. New York: Dover, 1964. [p. 192n.]

732. *Old Master Drawings: A Quarterly Magazine for Students and Collectors*. 1926-1940. Reprint: Collectors Editions, 1970. 14 vols. [p. 147]

733. *On Understanding Art Museums*. Ed. by Sherman E. Lee. Englewood Cliffs, N.J.: Prentice-Hall, 1975. [p. 48]

734. *Oppositions: A Journal for Ideas and Criticism in Architecture*. Cambridge: M.I.T. for the Institute for Architecture and Urban Studies, 1973- (Quarterly). [p. 137]

735. *Oriental Art: Quarterly Publication Devoted to All Forms of Oriental Art*. London: 1955- (Quarterly). [p. 186]

736. Osten, Gert van der and Horst Vey. *Painting and Sculpture in Germany and the Netherlands: 1500-1600*. New York: Penguin, 1969. (Pelican History of Art). [p. 106]

737. Ostwald, Wilhelm. *The Color Primer: A Basic Treatise on the Color System of Wilhelm Ostwald*. Edited, with a Foreword and Evaluation, by Faber Birren. New York: Van Nostrand Reinhold, 1969. [p. 143]

738. ————. *Colour Science: A Handbook for Advanced Students . . .* London: Winsor & Newton, 1931-33. 2 vols. [p. 144]

739. Ouspensky, Leonid and Vladimir Lossky. *The Meaning of Icons*. Boston: Boston Book and Art, 1955. Reissued 1969. [p. 182]

740. *The Oxford Classical Dictionary . . .* 2d ed. Oxford: Clarendon, 1970. [p. 69]

741. *The Oxford English Dictionary . . .* Oxford: Clarendon, 1933. 13 vols. and supplements. 1972-76. 2 vols. [p. 44]

742. Pach, Walter. *Ingres*. New York: Harper, 1939. Reprint: Hacker, 1973. [p. 31]

743. *Pageant of Japanese Art*. Ed. by staff members of the Tokyo National Museum. Tokyo: Toto Bunka, 1952-54. 6 vols. [p. 192]

744. *Paine, Robert T. and Alexander Soper. *The Art and Architecture of Japan*. 2d ed. New York: Penguin, 1974. (Pelican History of Art). [p. 193]

745. Palladio, Andrea. *The Four Books of Architecture*. 1738. New Introd. by Adolf K. Placzek. New York: Dover, 1965. [p. 134]

746. Pallottino, Massimo. *Etruscan Painting*. Geneva: Skira, 1952. (The Great Centuries of Painting). [p. 78]

747. Panofsky, Erwin. *The Codex Huygens and Leonardo da Vinci's Art Theory: The Pierpont Morgan Library Codex M. A. 1139*. London: Warburg Institute, 1940. (Studies of the Warburg Institute). Reprint: Greenwood, 1970. [pp. 25, 101]

748. *————. *Early Netherlandish Painting: Its Origins and Character*. Cambridge: Harvard Univ., 1954. 2 vols. Paperback ed.: Harper & Row, 1971. [p. 105]

749. *————. *Gothic Architecture and Scholasticism*. Cleveland: Meridian, c1957. [p. 86]

750. *————. *The Life and Art of Albrecht Dürer*. 4th ed. Princeton: Princeton Univ., 1971. [p. 107]

751. *————. *Meaning in the Visual Arts: Papers in and on Art History*. Garden City, N.Y.: Doubleday Anchor, 1955. [pp. 19, 94]

752. *————. *Renaissance and Renascences in Western Art*. Stockholm, Almqvist & Wiksell, 1960. (Gottesman Lectures, Uppsala University). Paperback ed.: Harper & Row, 1969. [p. 97]

753. *Paperbound Books in Print.* New York: Bowker, 1955- (Annual base volume
 and supplements). [p. 38]
754. Parrot, André. *The Arts of Assyria.* New York: Golden Press, 1961. (The Arts
 of Mankind). [p. 71]
755. ————. *Sumer: The Dawn of Art.* New York: Golden Press, 1961. (The
 Arts of Mankind). [pp. 58, 71]
756. Paulson, Ronald. *Hogarth: His Life, Art, and Times.* New Haven: Pub. for
 the Paul Mellon Centre for Studies in British Art (London) by Yale Univ.,
 1971. 2 vols. (Studies in British Art). Abridged paperback ed.: Yale Univ.,
 1974. [pp. 113, 179]
757. ————. *Hogarth's Graphic Works.* With a Commentary. Complete ed. New
 Haven: Yale Univ., 1965. 2 vols. [p. 113]
758. Peck, Stanley R. *Atlas of Human Anatomy for the Artist.* New York: Oxford
 Univ., 1951. [p. 148]
759. *Penrose Graphic Arts International Annual.* New York: Hastings, 1895-
 (Annual). [p. 165]
760. Peterdi, Gabor. *Printmaking: Methods Old and New.* Rev. ed. New York:
 Macmillan, 1971. [p. 153]
761. Pevsner, Nikolaus. "The Architecture of Mannerism." *Readings in Art History.*
 Ed. by Herbert Spencer. 2d ed. New York: Scribner, 1976, vol. 2. [p. 108]
762. ————. *The Buildings of England.* New York: Penguin, 1951-74. 46 vols.
 [p. 47]
763. *————. *An Outline of European Architecture.* 7th ed. Reprinted with rev.
 bibliography. New York: Penguin, 1974. [pp. 101, 130]
764. *————. *Pioneers of Modern Design: From William Morris to Walter Gropius.*
 Rev. ed. New York: Penguin, 1964. [pp. 114, 127]
765. *————. *The Sources of Modern Architecture and Design.* New York:
 Oxford Univ., 1968. (World of Art). [p. 182]
766. ————, John Fleming, and Hugh Honour. *A Dictionary of Architecture*
 Rev. and enl. Woodstock, N.Y.: Overlook 1976. [p. 129]
767. *Phaidon Dictionary of Twentieth Century Art.* London: Phaidon, 1973.
 [pp. 45, 120]
768. Philip, Lotte B. *The Ghent Altarpiece and the Art of Jan van Eyck.* Princeton:
 Princeton Univ., 1971. [p. 13n.]
769. *Philipson, Morris, ed. *Aesthetics Today: Readings.* Cleveland: Meridian, 1961.
 [p. 17n.]
770. *Photographis: International Annual of Advertising, Editorial, and Television
 Photography.* Zurich: Herdeg, 1966- (Annual). [pp. 162, 164]
771. *Photography Market Place.* New York: Bowker, 1975- (Biennial). [p. 161]
772. *Pierce, James S., ed. *From Abacus to Zeus: A Handbook of Art History.*
 Englewood Cliffs, N.J.: Prentice-Hall, 1968. [p. 56]
773. Pigler, Andor. *Barockthemen: Eine Auswahl von Verzeichnissen zur
 Ikonographie des 17. und 18. Jahrhunderts.* 2d enl. ed. Budapest:
 Akadémiai Kiadó, 1974. 3 vols. [p. 24]
774. Pissarro, Camille. *Letters to His Son Lucien.* 3d ed., rev. and enl. Edited, with
 the Assistance of Lucien Pissarro, by John Rewald. Mamaroneck, N.Y.:
 Appel, 1972. [p. 32]
775. Pita Andrade, José Manuel, *Treasures of Spain: From Altamira to the Catholic*

Kings. Introd. by F. J. Sánchez-Cantón. Geneva: Skira, 1967. (Treasures of the World). [p. 183]

776. Plenderleith, Harold J. and A. E. A. Werner. *The Conservation of Antiquities and Works of Art: Treatment, Repair, and Restoration.* 2d ed. London: Oxford Univ., 1971. [p. 48]

777. Plinius Secundus. *The Elder Pliny's Chapters on the History of Art.* Commentary and Historical Introduction by W. Sellers. 1896. Chicago: Ares, 1974. [p. 29]

778. Pobé, Marcel. *The Art of Roman Gaul: A Thousand Years of Celtic Art and Culture.* Photos by Jean Roubier. Toronto: Univ. of Toronto, 1961. [p. 177]

779. Pollack, Peter *The Picture History of Photography: From the Earliest Beginnings to the Present Day.* Rev. and enl. New York: Abrams, 1969. [p. 159]

780. Pollitt, J. J. *Art and Experience in Classical Greece.* London: Cambridge Univ., 1972. [p. 75]

781. *———, ed. *The Art of Greece: 1400-31 B.C.* Englewood Cliffs, N.J.: Prentice-Hall, 1965. (Sources and Documents in the History of Art). [pp. 28, 80]

782. *———, ed. *The Art of Rome: c. 753 B.C.-337 A.D.* Englewood Cliffs, N.J.: Prentice-Hall, 1966. (Sources and Documents in the History of Art). [pp. 28, 80]

783. *Pool, Phoebe. *Impressionism.* New York: Oxford Univ., 1967. (World of Art). [p. 118]

784. Pope, Arthur U. and Phyllis Ackerman, eds. *Survey of Persian Art: From Prehistoric Times to the Present.* London: Oxford Univ., 1938-39. 12 vols. Reissued with corrigenda and addenda 1964-67 in 14 vols. [p. 187]

785. Pope-Hennessy, John. *An Introduction to Italian Sculpture.* Rev. ed. London: Phaidon, 1970-72. 3 vols. Vol. 1: *Italian Gothic Sculpture.* Vol. 2: *Italian Renaissance Sculpture.* Vol. 3: *Italian High Renaissance and Baroque Sculpture.* [pp. 89, 100, 141]

786. ———. *The Portrait in the Renaissance.* Princeton: Princeton Univ., 1967. (A. W. Mellon Lectures in the Fine Arts, Bollingen Series). [p. 100]

787. ———. *Sienese Quattrocento Painting.* London: Phaidon, 1947. [p. 99]

788. Porada, Edith. *The Art of Ancient Iran: Pre-Islamic Cultures . . .* New York: Crown, 1965. (Art of the World). [p. 71]

789. Porter, A. Kingsley. *Romanesque Sculpture of the Pilgrimage Roads.* Boston: Marshall Jones, 1923. 10 vols. Reprint: Hacker, 1966 in 3 vols. [p. 88]

790. Posner, Donald. *Annibale Carracci: A Study in the Reform of Italian Painting around 1590.* London: Phaidon, 1971. 2 vols. (National Gallery of Art: Kress Foundation Studies in the History of European Art). [p. 13]

791. Post, Chandler R. *A History of Spanish Painting.* Cambridge: Harvard Univ., 1930-66. 14 vols. in 20. [p. 183]

792. *Pound, Ezra. *Gaudier-Brzeska: A Memoir.* 1916. New ed. New York: New Directions, 1970. [p. 35]

793. *Powell, Ann. *The Origins of Western Art.* New York: Harcourt Brace, 1973. (Harbrace History of Art). [p. 70]

794. *Powell, Thomas G. E. *Prehistoric Art.* New York: Oxford Univ., 1966. (World of Art). [p. 66]

795. *Praeger Encyclopedia of Art.* New York: Praeger, 1971. 5 vols. [pp. 4, 18, 43]

796. *Previews: Non-Print Software and Hardware News and Reviews.* New York: Bowker, 1972- (Nine issues a year). [p. 51]
797. *Primary Structures: Younger American and British Sculptors.* [An exhibition.] New York: The Jewish Museum, 1966. [p. 126]
798. *Les Primitifs flamands: Corpus de la peinture des anciens Pays-Bas méridionaux au quinzième siècle.* Brussels: Centre National de Recherches "Primitifs flamands," 1951- (In progess). [pp. 16, 105]
799. *Print: America's Graphic Design Magazine.* New York: 1939- (Bimonthly). [p. 163]
800. *The Print Collector's Newsletter.* New York: 1970- (Bimonthly). [p. 156]
801. *Print Review.* New York: Pratt Graphics Center, 1873- (Semiannual). [p. 156]
802. *Progressive Architecture* (formerly *Pencil Points*) Stamford, Conn.: 1920- (Monthly). [p. 136]
803. *Publishers' Trade List Annual.* New York: Bowker, 1904- (Annual). [p. 38]
804. Pucelle, Jean. *The Hours of Jeanne d'Évreux, Queen of France, at The Cloisters, The Metropolitan Museum of Art.* Ed. by J. J. Rorimer. New York: Metropolitan Museum of Art, 1957. [p. 92]
805. Puyvelde, Leo van. *The Flemish Drawings in the Collection of His Majesty the King at Windsor Castle.* London: Phaidon, 1942. [p. 146]

806. Ramsey, Charles G. and Harold R. Sleeper. *Architectural Graphic Standards.* Ed. by Joseph N. Boaz. 6th ed. New York: Wiley, 1970. [p. 129]
807. *Rasmussen, Steen E. *Experiencing Architecture.* 2d ed. Cambridge: M.I.T., 1962. [p. 128]
808. *Rawson, Philip S. *The Art of Southeast Asia: Cambodia, Vietnam, Thailand, Laos, Burma, Java, Bali.* New York: Praeger, 1967. (World of Art). [p. 189]
809. *————. *Drawing.* New York: Oxford Univ., 1969. (The Appreciation of the Arts). [p. 148]
810. Read, Herbert. *Art and Industry: The Principles of Industrial Design.* 5th ed. London: Faber & Faber, 1966. [p. 127]
811. *————. *The Art of Sculpture.* 2d ed. New York: Pantheon, 1961. (A. W. Mellon Lectures in the Fine Arts, Bollingen Series). Paperback ed.: Princeton Univ. [p. 138]
812. *————. *A Concise History of Modern Painting.* 3d ed., enl. and updated. Pref. by Benedict Read. New York: Oxford Univ., 1975. (World of Art). [p. 58]
813. *————. *A Concise History of Modern Sculpture.* New York: Oxford Univ., 1964. (World of Art). [p. 140]
814. *————, ed. *Surrealism.* Contributions by André Breton and others. London: Faber & Faber, 1936. Reissued 1971. [p. 124]
815. Reff, Theodore. *Manet: Olympia.* New York: Viking, c1976. (Art in Context). [p. 12]
816. Reichardt, Jasia. *Cybernetic Serendipity: The Computer and the Arts.* New York: Praeger, 1969. [p. 127]
817. Reinhardt, Ad. *Art-as-Art: The Selected Writings of Ad Reinhardt.* Edited and with an introduction by Barbara Rose. New York: Viking, 1975. (Documents of 20th-Century Art). [p. 29]

818. Rembrandt Hermanszoon van Rijn. *The Drawings of Rembrandt.* Complete ed. by Otto Benesch. Enl. and ed. by Eva Benesch. London: Phaidon, 1973. 6 vols. [p. 147]

819. *Répertoire d'art et d'archéologie: dépouillement des périodiques* . . . Paris: 1910- (Frequency varies). [p. 40]

820. *The Responsive Eye.* [An exhibition.] By William C. Seitz. New York: Museum of Modern Art, 1965. [p. 126]

821. Rewald, John. *The History of Impressionism.* 4th rev. ed. New York: Museum of Modern Art, Dist. New York Graphic, 1973. [pp. 6, 118]

822. ————. *Post-Impressionism: From Van Gogh to Gauguin.* 2d ed. New York: Museum of Modern Art, 1962. (Rev. ed. announced for 1977). [p. 118]

823. *Reynolds, Sir Joshua. *Discourses on Art.* 1797. Ed. by Robert R. Wark. San Marino, Calif.: Huntington Library, 1959. Paperback ed.: Collier-Macmillan, 1966. [p. 30]

824. Rice, David Talbot. *The Art of Byzantium.* Photos by Max Hirmer. New York: Abrams, 1959. [p. 83]

825. *————. *Byzantine Art.* Rev. and expanded. New York: Penguin, 1968. [p. 82]

826. Rich, Jack C. *The Materials and Methods of Sculpture.* New York: Oxford, 1947. [p. 139]

827. Richards, J. M., ed. *Who's Who in Architecture: From 1400 to the Present Day.* London: Weidenfeld & Nicolson, 1977. [p. 132n.]

828. *Richardson, Emiline H. *The Etruscans: Their Art and Civilization.* Chicago: Univ. of Chicago, 1964. [p. 78]

829. *Richter, Gisela M. A. *A Handbook of Greek Art.* 7th ed. London: Phaidon, 1974. [p. 75]

830. ————. *Korai: Archaic Greek Maidens. A Study of the Development of the Kore Type in Greek Sculpture.* London: Phaidon, 1968. [p. 76]

831. ————. *Kouroi: Archaic Greek Youths. A Study of the Development of the Kouros Type in Greek Sculpture.* 3d ed. London: Phaidon, 1970. [p. 76]

832. ————. *The Sculpture and Sculptors of the Greeks.* 4th ed. rev. New Haven: Yale Univ., 1970. [pp. 75, 141]

833. Richter, Hans. *Dada: Art and Anti-Art.* New York: Abrams, 1965. [p. 123]

834. *Rickey, George. *Constructivism: Origins and Evolution.* New York: Braziller, 1967. [p. 123]

835. *RILA: Répertoire international de la littérature de l'art. International Repertory of the Literature of Art.* New York: College Art Association of America, 1975- (Semiannual). [pp. 39, 64]

836. Rilke, Rainer Maria. *Rodin.* London: Grey Walls, 1946. Reprint: Haskell House, 1974. [p. 35]

837. Ring, Grete. *A Century of French Painting: 1400-1500.* London: Phaidon, 1949. [p. 106]

838. *Ripa, Cesare. *Baroque and Rococo Pictorial Imagery: The 1758-60 Hertel Edition of Ripa's "Iconologia"* . . . Introd. by Edward A. Maser. New York: Dover, 1971. [p. 23]

839. *Ritual Vessels of Bronze Age China.* [An exhibition.] By Max Loehr. New York: Asia Society, 1968. [p. 191]

840. Robertson, Martin. *Greek Painting*. Geneva: Skira, 1959. (The Great Centuries of Painting). [p. 76]

841. ————. *A History of Greek Art*. London: Cambridge Univ., 1975. 2 vols. [p. 75]

842. Roeder, Helen. *Saints and Their Attributes: With a Guide to Localities and Patronage*. London: Longmans, 1955. [p. 22]

843. Roethel, Hans K. *The Blue Rider: With a Catalog of the Works by Kandinsky, Klee, Macke, Marc, and Other Blue Rider Artists in the Municipal Gallery, Munich*. New York: Praeger, 1971. [p. 121]

844. *Rogers, Leonard R. *Sculpture*. New York: Oxford, 1969. (The Appreciation of the Arts). [p. 138]

845. *The Romantic Movement: Fifth Exhibition . . . of the Council of Europe* [Shown at the Tate Gallery, London.] London: Arts Council of Great Britain, 1959. [p. 117]

846. *Rose, Barbara. *American Art since 1900*. Rev. and enl. New York: Praeger, 1975. (World of Art). [pp. 58, 172]

847. *————, ed. *Readings in American Art: 1900-1975*. Rev. ed. New York: Praeger, 1975. [p. 172]

848. *Rose, Herbert J. *A Handbook of Greek Mythology: Including Its Extension to Rome*. 6th ed. London: Methuen, 1954. Paperback ed.: Dutton, 1959. [pp. 20, 69]

849. *Rosen, Ben. *Type and Typography: The Designer's Type Book*. Rev. ed. New York: Van Nostrand Reinhold, 1976. [p. 168]

850. Rosenberg, Harold. *Art on the Edge: Creators and Situations*. New York: Macmillan, 1975. [p. 126]

851. *————. *The Tradition of the New*. New York: Horizon, 1959. [p. 126]

852. *Rosenberg, Jacob. *Rembrandt: Life and Work*. 3d ed. London: Phaidon, 1968. [pp. 3, 112]

853. *————, Seymour Slive, and E. H. ter Kuile. *Dutch Art and Architecture: 1600-1800*. New York: Penguin, 1966. (Pelican History of Art). [p. 111]

854. *Rosenblum, Robert. *Cubism and Twentieth-Century Art*. New York: Abrams, 1961. Compact ed. with rev. bibliography, 1976. Paperback ed.: Prentice-Hall, 1976. [p. 122]

855. *————. *Modern Painting and the Northern Romantic Tradition: Friedrich to Rothko*. New York: Harper & Row, 1975. [p. 115]

856. *————. *Transformations in Late Eighteenth Century Art*. Princeton: Princeton Univ., 1967. [p. 116]

857. *Ross, John and Clare Romano. *The Complete Intaglio Print* . . . New York: Free Press, 1974. [p. 153]

858. *———— and ————. *The Complete New Techniques in Printmaking* . . . New York: Free Press, 1974. [p. 153]

859. ———— and ————. *The Complete Printmaker: The Art and Technique of the Relief Print, the Intaglio Print, the Collagraph, the Lithograph, the Screen Print* . . . New York: Free Press, 1972. [p. 153]

860. *———— and ————. *The Complete Relief Print* . . . New York: Free Press, 1974. [p. 153]

861. *———— and ————. *The Complete Screenprint and Lithograph* . . . New York: Free Press, 1974. [p. 153]

862. *Rowland, Benjamin. *The Art and Architecture of India: Buddhist, Hindu, Jain.* 3d rev. ed. New York: Penguin, 1967. (Pelican History of Art). [p. 188]

863. ————. *The Art of Central Asia.* New York: Crown, 1974. (Art of the World). [p. 184]

864. *————. *The Harvard Outline and Reading Lists for Oriental Art.* 3d ed. Cambridge: Harvard Univ., 1967. [p. 185]

865. Rubens, Peter Paul. *Rubens: Paintings and Drawings.* Introd. by R.A.M. Stevenson. London: Phaidon, 1939. [p. 112]

866. Rubin, William S. *Dada and Surrealist Art.* New York: Abrams, 1968. [p. 124]

867. Ruskin, John. *Modern Painters.* 1843-1860. New York: Dutton, 1929-35. 5 vols. (Everyman's Library). [p. 34]

868. ————. *Pre-Raphaelitism: Lectures on Architecture and Painting, Etc., 1851.* New York: Dutton: 1920. (Everyman's Library). [p. 35]

869. ————. *The Seven Lamps of Architecture.* 1849. New York: Dutton, 1932. (Everyman's Library). [p. 35]

870. ————. *The Stones of Venice.* 1851-1853. New York: Dutton, 1921-27. 3 vols. (Everyman's Library). [p. 35]

871. *Saalman, Howard. *Medieval Architecture: European Architecture, 600-1200.* New York: Braziller, 1962. (Great Ages of World Architecture). [p. 86]

872. Salvini, Roberto. *Medieval Sculpture.* Boston: New York Graphic, 1967. (A History of Western Sculpture, vol. 2). [pp. 88, 139]

873. Sandars, Nancy K. *Prehistoric Art in Europe.* New York: Penguin, 1968. (Pelican History of Art). [p. 66]

874. *Sandler, Irving. *The Triumph of American Painting: A History of Abstract Expressionism.* New York: Praeger, 1970. Paperback ed.: Harper & Row, 1976. [p. 125]

875. Sauerländer, Willibald. *Gothic Sculpture in France: 1140-1270.* Photos by Max Hirmer. New York: Abrams, 1972. [pp. 88, 141]

876. Schapiro, Meyer. *Paul Cézanne.* 3d ed. New York: Abrams, 1965. (The Library of Great Painters). [p. 18]

877. ————. *Vincent van Gogh.* New York: Abrams, 1950. (The Library of Great Painters). [p. 18]

878. *Scharf, Aaron. *Art and Photography.* London: Lane, 1968. Paperback ed.: Penguin, 1974. [p. 159]

879. Schider, Fritz. *An Atlas of Anatomy for Artists.* Rev. by M. Auerbach. New Bibliography by Adolf Placzek. 3d American ed. New York: Dover, 1957. [p. 148]

880. Schiller, Gertrud. *Iconography of Christian Art.* Boston: New York Graphic, 1971-72. 2 vols. [p. 21]

881. Schliemann, Heinrich. *Mycenae: A Narrative of Researches and Discoveries at Mycenae and Tyrins.* New ed. 1880. Reprint: New York: Blom, 1967. [p. 73]

882. Schlosser, Julius. *La letteratura artistica: Manuale delle fonti della storia dell'arte moderna.* 3d ed. Appendix by Otto Kurz. Florence: Nuova Italia, 1964. [p. 103]

883. Schmitz, Carl A. *Oceanic Art: Myth, Man, and Image in the South Seas.* New York: Abrams, 1971. [p. 198]

884. Schmutzler, Robert. *Art Nouveau*. New York: Abrams, 1964. [p. 120]
885. Schneede, Uwe M. *Surrealism*. New York: Abrams, 1974. (The Library of
 Great Art Movements). [p. 125]
886. Schönberger, Arno and H. Soehner. *The Rococo Age: Art and Civilization of
 the Eighteenth Century*. New York: McGraw-Hill, 1960. [p. 110]
887. *Scranton, Robert L. *Greek Architecture*. New York: Braziller, 1962. (Great
 Ages of World Architecture). [p. 77]
888. *Scully, Vincent. *Modern Architecture: The Architecture of Democracy*. Rev.
 ed. New York: Braziller, 1974. (Great Ages of World Architecture). [p. 131]
889. *Sculpture International*. 1966-1970. (Ceased publication). [p. 141]
890. *Sculpture of the Twentieth Century*. [An exhibition.] By Andrew C. Ritchie.
 New York: Museum of Modern Art, 1952. [p. 140]
891. *Segy, Ladislas. *African Sculpture Speaks*. 4th ed., enl. New York: Da Capo,
 1975. [p. 195]
892. Seherr-Thom, Sonia. *Design and Color in Islamic Architecture: Afghanistan,
 Iran, Turkey*. Photos by Hans Seherr-Thom. Washington, D.C.: Smithsonian,
 1968. [p. 187]
893. Seitz, William C. *Claude Monet*. New York: Abrams, 1960. (The Library of
 Great Painters). [p. 18]
894. *Selz, Peter. *German Expressionist Painting*. Berkeley: Univ. of California,
 1957. [p. 121]
895. Semenzato, Camillo. *The Rotonda of Andrea Palladio*. University Park:
 Pennsylvania State Univ., 1968. (Corpus Palladianum, vol. 1). [p. 133]
896. *Senefelder, Aloys. *A Complete Course in Lithography*. 1819. New Introd.
 by A. Hyatt Major. New York: Da Capo, 1968. [p. 154]
897. Sérullaz, Maurice. *Great Drawings of the Louvre Museum: The French
 Drawings . . .* New York: Braziller, 1968. [p. 146]
898. *Sewter, A. C. *Baroque and Rococo*. New York: Harcourt Brace, 1972. (Har-
 brace History of Art). [p. 110]
899. Seymour, Charles. *Sculpture in Italy: 1400-1500*. New York: Penguin, 1966.
 (Pelican History of Art). [p. 100]
900. *————, ed. *Michelangelo: The Sistine Chapel Ceiling*. New York: W. W.
 Norton, 1972. (Norton Critical Studies in Art History). [p. 12]
901. Sharp, Dennis. *A Visual History of Twentieth-Century Architecture*. Boston:
 New York Graphic, 1972. [p. 132]
902. *Shearman, John K. G. *Mannerism*. New York: Penguin, 1967. (Style and
 Civilization). [p. 108]
903. *Sickman, Laurence C. S. and Alexander Soper. *The Art and Architecture of
 China*. 3d ed. New York: Penguin, 1968. (Pelican History of Art). [p. 190]
904. *Simon, Oliver. *Introduction to Typography*. Ed. by David Bland. 2d ed.
 London: Faber & Faber, 1963. [p. 167]
905. *Simson, Otto von. *The Gothic Cathedral: Origins of Gothic Architecture and
 the Medieval Concept of Order*. 2d rev. ed. New York: Bollingen Founda-
 tion, 1962. (Bollingen Series). Paperback ed.: Princeton Univ., 1973.
 [p. 86]
906. Sirén, Osvald. *Chinese Painting: Leading Masters and Principles*. London:
 Lund Humphries, 1956-58. 7 vols. Reprint: Hacker, 1974. [p. 190]
907. Sisson, Jacqueline D., ed. *Storia dell'arte italiana: Index*. Nendeln, Liechten-
 stein: Kraus-Thomson, 1975. 2 vols. [p. 180]

908. *Sloane, Joseph C. *French Painting between the Past and the Present: Artists, Critics, and Traditions from 1848 to 1870.* Princeton: Princeton Univ., 1951. Reissued 1973. (Princeton Monographs in Art and Archaeology). [p. 117]

909. *Smart, Alastair. *The Renaissance and Mannerism in Northern Europe and Spain.* New York: Harcourt Brace, 1972. (Harbrace History of Art). [p. 104]

910. *Smith, Earl Baldwin. *Egyptian Architecture as Cultural Expression.* New York: Appleton, 1938. Reprint: American Life Foundation, 1968. [p. 73]

911. Smith, Robert C. *The Art of Portugal: 1500-1800.* New York: Meredith, 1968. [p. 183]

912. Smith, William Stevenson. *Ancient Egypt as Represented in the Museum of Fine Arts, Boston.* 4th rev. ed. Boston: New York Graphic, 1968. [p. 73]

913 ————. *The Art and Architecture of Ancient Egypt.* New York: Penguin, 1958. (Pelican History of Art). [p. 72]

914 ————. *Interconnections in the Ancient Near East: A Study of the Relationships between the Arts of Egypt, the Aegean, and Western Asia.* New Haven: Yale Univ., 1965. [p. 73]

915. Smyth, Craig H. *Mannerism and Maniera.* Locust Valley, N.Y.: Augustin, 1962. [p. 107]

916. Snyder, John. *Commercial Artist's Handbook.* New York: Watson-Guptill, 1973. [p. 166]

916a. Sokol, David M. *American Architecture and Art: A Guide to Information Sources.* Detroit: Gale, 1976. (American Studies Information Guide Series). [p. 173]

917. *Spear, Richard E. *Caravaggio and His Followers.* Rev. ed. New York: Harper & Row, 1975. [p. 112]

918. Special Libraries Association. Picture Division. *Picture Sources: Collections of Prints and Photographs in the U.S. and Canada.* Ann Novotny, Editor. 3d ed. New York: Special Libraries Association, 1975. [p. 54]

919. *Speculum: A Journal of Medieval Studies.* Cambridge: Mediaeval Academy of America, 1926- (Quarterly). [p. 95]

920. *Spencer, Harold, comp. *Readings in Art History.* 2d ed. New York: Scribner, 1976. 2 vols. [p. 108]

921. *Steichen, Edward, ed. *The Bitter Years 1935-1941: Rural America as Seen by the Photographers of the Farm Security Administration.* New York: Museum of Modern Art, 1962. [p. 160]

922. Stein, Gertrude. *Gertrude Stein on Picasso.* Ed. by Edward Burns. New York: Liveright, 1970. [p. 35]

923. *Steinberg, Leo. *Other Criteria: Confrontations with Twentieth-Century Art.* New York: Oxford Univ., 1972. [p. 126]

924. Sterling, Charles. *Still Life Painting from Antiquity to the Present Time.* Rev. ed. New York: Universe, 1959. [p. 18]

925 *Stoddard, Whitney S. *Monastery and Cathedral in France: Medieval Architecture, Sculpture, Stained Glass, Manuscripts, the Art of the Church Treasuries.* Middletown, Conn.: Wesleyan Univ., 1966. Paperback ed. has title: *Art and Architecture in Medieval France . . .* Harper & Row, 1972. [pp. 87, 88]

926. Stone, Bernard and Arthur Eckstein. *Preparing Art for Printing.* New York: Van Nostrand Reinhold, 1965. [p. 166]

927. Stone, Lawrence. *Sculpture in Britain: The Middle Ages.* Rev. ed. New York: Penguin, 1972. (Pelican History of Art). [p. 179]

928. Storrer, William A. *The Architecture of Frank Lloyd Wright: A Complete Catalog.* Cambridge: M.I.T., 1974. [p. 135]

929. Strand, Paul. *Paul Strand: A Retrospective Monograph.* Millerton, N.Y.: Aperture, 1972. 2 vols. [p. 160]

930. *Stroebel, Leslie and Hollis N. Todd. *Dictionary of Contemporary Photography.* Dobbs Ferry, N.Y.: Morgan & Morgan, 1974. [p. 161]

931. Strommenger, Eva. *5000 Years of the Art of Mesopotamia.* Photos by Max Hirmer. New York: Abrams, 1964. [p. 71]

932. *Stryker, Roy E. and Nancy Wood. *In This Proud Land: America 1935-1943 as Seen in the FSA Photographs.* Boston: New York Graphic, 1973. [p. 160]

933. *Stubblebine, James H., ed. *Giotto: The Arena Chapel Frescoes.* New York: W. W. Norton, 1969. (Norton Critical Studies in Art History). [p. 12]

934. *Studio International* (formerly *International Studio*). London: 1893- (Bimonthly). [p. 61]

935. Sturgis, Russell. *A Dictionary of Architecture and Building: Biographical, Historical, and Descriptive.* 1901-2. Reprint: Detroit: Gale, 1966. 3 vols. [p. 129]

936. *Subject Guide to Books in Print.* New York: Bowker, 1955- (Annual). [p. 38]

937. Suger, Abbot of Saint Denis. *Abbot Suger on the Abbey Church of St.-Denis and Its Art Treasures.* Edited, Translated, and Annotated by Erwin Panofsky. Princeton: Princeton Univ., 1946. [p. 94]

938. Sullivan, Michael. *The Arts of China.* New and rev. ed. Berkeley: Univ. of California, 1973. [p. 190]

939. *Summerson, John. *Architecture in Britain: 1530-1830.* 5th rev. ed. New York: Penguin, 1969. Rev. paperback ed.: 1970. (Pelican History of Art). [pp. 111, 179]

940. Swaan, Wim. *The Gothic Cathedral.* With an Historical Introduction: "The Cathedral in Medieval Society." Garden City, N.Y.: Doubleday, 1969. [p. 86]

941. *Swarzenski, Hanns. *Monuments of Romanesque Art: The Art of Church Treasures in North-Western Europe.* 2d ed. Chicago: Univ. of Chicago: 1967. [p. 85]

942. Swinton, George. *Sculpture of the Eskimo.* Boston: New York Graphic, 1972. [p. 198]

943. Tanner, Clara L. *Southwest Indian Painting: A Changing Art.* 2d ed. Tucson: Univ. of Arizona, 1973. [p. 197]

944. Tapié, Victor L. *The Age of Grandeur: Baroque Art and Architecture.* New York: Grove, 1960. [p. 110]

945. *Taylor, Joshua C. *Learning to Look: A Handbook for the Visual Arts.* Chicago: Univ. of Chicago, 1957. [p. 57]

946. Thieme, Ulrich and Felix Becker. *Allgemeines Lexikon der bildenden Künstler*

von der Antike bis zur Gegenwart . . . Leipzig: Seemann, 1907-50. 37 vols. Reprinted 1970-71.† [pp. 10, 44]

947. Thomas, Hugh. *Goya: The Third of May 1808.* New York: Viking, 1973. (Art in Context). [p. 12]

948. *Three Classics of Italian Calligraphy: An Unabridged Re-issue of the Writing Books of Arrighi, Tagliente, and Palatino.* Introd. by Oscar Ogg. New York: Dover, 1953. [p. 169]

949. *Three Hundred Years of Canadian Art: An Exhibition Arranged in Celebration of the Centenary of Confederation.* Catalogue by R. H. Hubbard and J. R. Ostiguy. Ottawa: National Gallery of Canada, 1967. [p. 174]

950. Thuillier, Jacques and Albert Châtelet. *French Painting: From Le Nain to Fragonard.* Geneva: Skira, 1964. (Painting, Color, History). [p. 177]

951. Time-Life Books. *Frontiers of Photography.* New York: Time-Life, 1972. (Life Library of Photography). [p. 158]

952. ————. *The Studio.* New York: Time-Life, 1971. (Life Library of Photography). [p. 158]

953. Timmers, J. J. M. *A History of Dutch Life and Art.* Amsterdam: Elsevier, 1959. [p. 181]

954. Toynbee, Arnold J., ed. *The Crucible of Christianity: Judaism, Hellenism, and the Historical Background to the Christian Faith.* New York: World, 1969. [p. 81]

955. *The Très Riches Heures of Jean, Duke of Berry, Musée Condé, Chantilly.* Introd. and Legends by Jean Longnon and Raymond Cazelles. Pref. by Millard Meiss. New York: Braziller, 1969. [p. 92]

956. Tschichold, Jan. *A Treasury of Alphabets and Lettering: A Source Book of the Best Letter Forms Past and Present* . . . New York: Van Nostrand Reinhold, 1966. [p. 168]

957. *Turner, Richard A. *The Vision of Landscape in Renaissance Italy.* Princeton: Princeton Univ., 1966. [p. 100]

958. *Two Hundred Years of American Sculpture.* [An exhibition.] Essays by Tom Armstrong and others. Boston: Godine, in association with the Whitney Museum of American Art, 1976. [p. 171]

959. *Union List of Serials in Libraries of the United States and Canada.* 3d ed. New York: Wilson, 1965. 5 vols. [p. 60]

960. United Nations Educational, Scientific, and Cultural Organization (UNESCO). *Catalogue of Colour Reproductions of Paintings.* Paris: UNESCO, 1949- (Irregular). Vol. 1: *Paintings prior to 1860.* Vol. 2: *Paintings, 1860 to (date).* [p. 53]

961. U.S. American Bureau of Ethnology. *Annual Reports: 1879/80 to 1930/31.* Washington, D.C.: U.S. Govt. Print. Off., 1880-1932. 48 vols. [p. 197]

962. U.S. National Gallery of Art. Extension Service. *Slide Lectures and Films.* Washington, D.C., U.S. Govt. Print. Off., 1975. [p. 52]

963. Updike, Daniel B. *Printing Types: Their History, Forms, and Use. A Study in Survivals.* 3d ed. Cambridge: Harvard Univ., 1951. [p. 167]

†A 55-volume translation – without text revisions or updated bibliographies – has been announced by International Translations Publishing Company, Detroit, Mich.

964. Vandersleyen, Claude. *Das alte Ägypten* ... Berlin: Propyläen, 1975. (Propyläen Kunstgeschichte). [p. 59]
965. Vasari, Giorgio. *The Lives of the Painters, Sculptors, and Architects.* Edited and with an Introduction, by William Gaunt. Rev. ed. New York: Dutton, 1963. 4 vols. (Everyman's Library). [pp. 96, 102]
966. *———. *Vasari on Technique: Being the Introduction to the Three Arts of Design: Architecture, Sculpture, and Painting, Prefixed to the "Lives..."* Edited with an Introduction and Notes, by G. Baldwin Brown. New York: Dover, 1960. [p. 102n.]
967. Venturi, Adolfo. *Storia dell'arte italiana* ... Milan: Hoepli, 1901-40. 11 vols. Reprint: Kraus, 1967 in 25 vols. [p. 180]
968. Venturi, Lionello. *Modern Painters* ... New York: Scribner, 1947-50. 2 vols. Vol. 2 has the title: *Impressionists and Symbolists* ... Reprint: Cooper Square, 1973. [p. 118]
969. Verheyen, Egon. *The Paintings in the Studiolo of Isabella d'Este at Mantua.* New York: New York Univ., 1971. [p. 100]
970. *Vermeule, Emily T. *Greece in the Bronze Age.* Chicago: Univ. of Chicago, 1964. [p. 74]
971. *Vesalius, Andreas. *The Illustrations from the Works of Andreas Vesalius of Brussels: With Annotations and Translations, a Discussion of the Plates and Their Background, Authorship, and Influence, and a Biographical Sketch of Vesalius.* By J. B. de C. M. Saunders and Charles D. O'Malley. Cleveland: World, 1950. Reprint: Dover, 1973. [p. 149]
972. Vieyra, Maurice. *Hittite Art: 2300-750 B.C.* London: Tiranti, 1955. [p. 71]
973. Vignola, Giacomo Barozzio. *The Five Orders of Architecture: To Which Are Added the Greek Orders.* Ed. and transl. by Arthur Lyman Tuckerman. New York: Comstock, 1891. [p. 134]
974. *Villard de Honnecourt. *The Sketchbook of Villard de Honnecourt.* Ed. by Theodore Bowie. Bloomington: Indiana Univ., 1959. [p. 94]
975. *Vitruvius Britannicus: Or, The British Architect.* 1715-1808. Introd. by John Harris. New York: Blom, 1967-72. 7 vols. in 3 and *Guide to Vitruvius Britannicus* ... by Paul Breman and Denise Addis. 1 vol. [pp. 134, 134n.]
976. *Vitruvius Pollio. *The Ten Books on Architecture.* 1914. New York: Dover, 1960. [p. 134]
977. Volbach, Wolfgang F. *Early Christian Art.* Photos by Max Hirmer. New York: Abrams, 1962. [p. 82]
978. Vollmer, Hans. *Allgemeines Lexikon der bildenden Künstler des XX. Jahrhunderts.* Leipzig: Seemann, 1953-62. 6 vols. [pp. 10, 44n.]

979. Wagner, Frits A. *Indonesia: The Art of an Island Group.* New York: McGraw-Hill, 1959. (Art of the World). [p. 190]
980. Waldberg, Patrick. *Surrealism.* Geneva: Skira, 1962. (The Taste of Our Time). [p. 125]
981. *———. *Surrealism.* New York: McGraw-Hill, 1966. [p. 125]
982. Walker, John A. *Glossary of Art, Architecture, and Design since 1945: Terms and Labels Describing Movements, Styles, and Groups, Derived from the Vocabulary of Artists and Critics.* 2d rev. ed. Hamden, Conn.: Linnet, 1977. [pp. 46, 120, 141]
983. Wallace, Robert. *The World of Rembrandt* ... New York: Time-Life, 1968. (Time-Life Library of Art). [p. 3]

984. Walters Art Gallery, Baltimore. *Arts of the Migration Period in the Walters Art Gallery . . .* By Marvin Chauncey Ross. Introd. and Historical Survey by Philippe Verdier. Baltimore: 1961. [p. 83]

985. Wassing, René S. *African Art: Its Background and Traditions.* New York: Abrams, 1968. [p. 195]

986. Waterhouse, Ellis. *Painting in Britain: 1530-1790.* 3d ed. New York: Penguin, 1969. (Pelican History of Art). [p. 111]

987. Watkinson, Raymond. *Pre-Raphaelite Art and Design.* London: Studio, 1970. [p. 179]

988. *Watrous, James. *The Craft of Old-Master Drawings.* Madison: Univ. of Wisconsin, 1957. Reissued 1967. [p. 148]

989. Watteau, Jean Antoine. *The Complete Paintings of Watteau.* Introd. by John Sunderland. Notes and Catalogue by Ettore Camesasca. New York: Abrams, 1971. (Classics of the World's Great Art). [p. 113]

990. Webb, Geoffrey. *Architecture in Britain: The Middle Ages.* Rev. ed. New York: Penguin, 1965. (Pelican History of Art). [p. 87]

991. *Webster's Third New International Dictionary of the English Language.* Unabridged. Springfield, Mass.: Merriam, 1961. [p. 44]

992. Wedgwood, Cicely V. *The World of Rubens: 1577-1640.* New York: Time, 1967. (Time-Life Library of Art). [p. 112]

993. Weitzmann, Kurt. *Illustrations in Roll and Codex: A Study of the Origin and Method of Text Illustration.* Princeton: Princeton Univ., 1947. Reissued with addenda, 1970. (Studies in Manuscript Illumination). [p. 91]

994. *Weston, Edward. *Daybooks.* Ed. by Nancy Newhall. New York: George Eastman House, 1961-66. 2 vols. Paperback ed.: Aperture, 1973. [p. 160]

995. ―――――. *Edward Weston, Fifty Years: The Definitive Volume of His Photographic Work.* Illustrated Biography by Ben Maddow. Millerton, N.Y.: Aperture, 1973. [p. 160]

996. Wethey, Harold E. *The Paintings of Titian.* Complete ed. London: Phaidon, 1970-75. 3 vols. [p. 13]

997. Wheeler, Sir Mortimer, ed. *Splendors of the East: Temples, Tombs, Palaces, and Fortresses of Asia.* Photos by Ian Graham. New York: Putnam, 1965. [p. 184]

998. Whinney, Margaret. *Christopher Wren.* New York: Praeger, 1971. [p. 133]

999. ―――――. *Sculpture in Britain: 1530-1830.* New York: Penguin, 1964. (Pelican History of Art). [p. 111]

1000. ―――――― and Oliver Millar. *English Art: 1625-1714.* Oxford: Clarendon, 1957. (Oxford History of English Art, vol. 8). [p. 111]

1001. *Whistler, James A. McNeill. *The Gentle Art of Making Enemies.* 1892. Introd. by Alfred Werner. New York: Dover, 1967. [p. 31]

1002. White, Christopher. *Rembrandt as an Etcher: A Study of the Artist at Work.* University Park: Pennsylvania State Univ., 1969. 2 vols. [p. 113]

1003. ―――――― and Karel G. Boon. *Rembrandt's Etchings: An Illustrated Critical Catalogue.* New York: Schram, 1970. 2 vols. [pp. 113, 155]

1004. *White, John. *The Birth and Rebirth of Pictorial Space.* 2d ed. London: Faber & Faber, 1967. Paperback ed.: Harper & Row, 1973. [p. 100]

1005. *White, Minor. *Zone System Manual.* Rev. ed. Dobbs Ferry, N.Y.: Morgan & Morgan, 1972. [p. 158]

1006. *Who's Who in American Art.* New York: Bowker, 1936- (Frequency varies).
 [p. 6]
1007. *Who's Who in Art.* London: Art Trade Press, 1927- (Biennial). [p. 7]
1008. Wildenstein, Georges. *Chardin.* Rev. and enl. ed. by Daniel Wildenstein. Boston:
 New York Graphic, 1969. [p. 12]
1009. *Willett, Frank. *African Art: An Introduction.* New York: Oxford Univ., 1971.
 (World of Art). [p. 195]
1010. Willetts, William. *Foundations of Chinese Art: From Neolithic Pottery to
 Modern Architecture.* New York: McGraw-Hill, 1965. [p. 190]
1011. Williams, Charles A. S. *Outlines of Chinese Symbolism and Art Motives: An
 Alphabetical Compendium of Antique Legends and Beliefs, as Reflected
 in the Manners and Customs of the Chinese.* 3d ed. 1941. Introd. by
 Terence Barrow. Rutland, Vt.: Tuttle, 1974. [p. 191]
1012. Wilmerding, John. *American Art.* New York: Penguin, 1976. (Pelican History
 of Art). [p. 170]
1013. Winckelmann, Johann J. *History of Ancient Art.* 1849-1873. 4 vols. Reprint:
 New York: Ungar, 1969, in 2 vols. [p. 73]
1014. Wingler, Hans. *The Bauhaus: Weimar, Dessau, Berlin, Chicago.* Ed. by Joseph
 Stein. Cambridge: M.I.T., 1969. [p. 178]
1015. Withey, Henry F. and E. R. Withey. *Biographical Dictionary of American
 Architects (Deceased).* Los Angeles: New Age, 1956. Reprint: Hennessey
 & Ingalls, 1970. [p. 132]
1016. *Wittkower, Rudolf. *Architectural Principles in the Age of Humanism.* New
 York: Random, 1965. (Columbia University Studies in Art History and
 Archaeology). Paperback ed.: W. W. Norton, 1971. [p. 101]
1017. *————. *Art and Architecture in Italy: 1600-1750.* 3d ed. New York:
 Penguin, 1973. (Pelican History of Art). [p. 110]
1018. ————. *Gian Lorenzo Bernini: The Sculptor of the Roman Baroque.* 2d
 ed., rev. and enl. London: Phaidon, 1966. [p. 112]
1019. ————. *Palladio and Palladianism.* New York: Braziller, 1974. British ed.
 has title: *Palladio and English Palladianism.* [p. 132]
1020. Witzleben, Elisabeth von. *Stained Glass in French Cathedrals.* New York:
 Reynal, 1968. [p. 93]
1021. Wolberg, Lewis R. *Micro-Art: Art Images in a Hidden World.* Pref. by Brian
 O'Doherty. New York: Abrams, 1970. [p. 160]
1022. Wolf, Walther. *The Origins of Western Art: Egypt, Mesopotamia, the Aegean.*
 New York: Universe, 1971. (Universe History of Art). [p. 70]
1023. *Wölfflin, Heinrich. *Classic Art: An Introduction to the Italian Renaissance.*
 Transl. by P. and L. Murray. 2d ed. London: Phaidon, 1964. [pp. 17, 98]
1024. *————. *Principles of Art History: The Problem of the Development of
 Style in Later Art.* London: Bell, 1932. Paperback ed.: Dover, 1950.
 [p. 109]
1025. ————. *Renaissance and Baroque.* Introd. by Peter Murray. Ithaca, N.Y.:
 Cornell Univ., 1966. [p. 109]
1026. *Womanart.* New York: 1976- (Quarterly). [p. 62]
1027. Woodruff, Helen. *The Index of Christian Art at Princeton University: A Hand-
 book.* Foreword by Charles Rufus Morey. Princeton: Princeton Univ.,
 1942. [p. 25]

1028. Woolley, C. Leonard. *The Development of Sumerian Art*. London: Faber & Faber, 1935. [p. 71]
1029. *————. *Ur of the Chaldees*. 1933. Reprint: New York: W. W. Norton, 1965. [p. 71]
1030. *World Collectors Annuary*. Voorburg, Netherlands: 1950- (Annual). [p. 49]
1031. *Worldwide Art Catalogue Bulletin*. Boston: Worldwide, 1963- (Quarterly). [p. 37n.]
1032. Wright, Frank Lloyd. *An Autobiography*. New York: Duell, 1943. [p. 135]
1033. ————. *Modern Architecture: Being the Kahn Lectures for 1930*. Princeton: Princeton Univ., 1931. [p. 135]
1034. ————. *An Organic Architecture: The Architecture of Democracy. The Sir George Watson Lectures . . . 1939*. London: Lund Humphries, 1939. Reissued M.I.T., 1970. [p. 135]
1035. Würtenberger, Franzsepp. *Mannerism: The European Style of the Sixteenth Century*. New York: Holt, 1963. [p. 108]
1036. *Wycherley, Richard E. *How the Greeks Built Cities*. 2d ed. New York: Macmillan, 1962. Paperback ed.: Doubleday Anchor, 1969. [p. 77]

1037. Yüan, T'ung-li. *The T. L. Yüan Bibliography of Western Writings on Chinese Art and Archaeology*. Ed. by Harrie A. Vanderstappen. London: Mansell, 1975. [p. 191]

1038. Zarnecki, George. *Art of the Medieval World: Architecture, Sculpture, Painting, the Sacred Arts*. New York: Abrams, 1975. (Library of Art History). Text ed. Prentice-Hall. [p. 81]
1039. ————. *Romanesque Art*. New York: Universe, 1971. (Universe History of Art). [p. 84]
1040. *Zen Painting and Calligraphy*. [An exhibition.] By Jan Fontein and Money L. Hickman. Boston: Museum of Fine Art, 1970. [p. 193]
1041. Zigrosser, Carl. *The Book of Fine Prints*. Rev. ed. New York: Crown, 1956. [p. 152]
1042. ———— and Christa M. Gaehde. *A Guide to the Collecting and Care of Original Prints*. Sponsored by the Print Council of America. New York: Crown, 1965. [p. 151]
1043. Zimmer, Heinrich R. *The Art of Indian Asia: Its Mythology and Transformations*. Ed. by Joseph Campbell. 2d ed. New York: Pantheon, 1955. 2 vols. (Bollingen Series). Reprint: Princeton Univ., 1968. [p. 189]
1044. *Zodiac: International Magazine of Contemporary Architecture*. 1957-1972. (Ceased publication). [p. 136]
1045. *Zucker, Paul. *Styles in Painting: A Comparative Study*. New York: Viking, 1950. Paperback ed.: Dover, 1963. [p. 17]

Index

In this index lightface numbers have been used for references to the text; **boldface** numbers refer to the numbered items in the bibliography. Text references precede bibliographic references. Items in the bibliography may be searched under the names of authors, coauthors, editors, museums and art organizations, most series, and under subjects. Titles of works are listed only if the main entry is under the title.

Abstract art, 32, 121-123, 182, **261, 274**
Abstract expressionism, 125, **717, 874**
Abstracts and indexes, 38-40, 64, **44, 59, 61, 68, 239, 277, 301, 672, 702, 718, 819, 835**
Ackerman, J. S., **1**
Ackerman, P., **784**
Adam, L., **2**
Adams, A., 158, **3-7**
Adams, C., **34**
Adams, H., **8**
Addis, D., 134n.
Advertising art. *See* Commercial art
Aegean art, 73-74, **291, 632, 641, 970**
Aeschlimann, E., **26**
Aesthetics, **183, 528, 769**
African art, 194-196, **9, 113, 173, 177, 408, 574, 579, 586, 985, 1009;** bibliography, **114, 496;** museum collections, 196; sculpture, **400, 648, 891**
African Arts, **9**
Afro-American culture, 196
Age of Neo-classicism, **10**
Akiyama, T., **11**
Akurgal, E., **12**
Albers, J., 144, **13**
Alberti, L. B., 28, 101, 103, 134, **14, 15**
Albertina, Vienna. *See* Vienna
Alfred, C., **16**
Alinari (Firm), 54
Allegory, 23
Alloway, L., **17**
Alpatov, M. V., **18**
Alphabets. *See* Lettering and calligraphy; Typography
American Architects Directory, **19**
American art, *See* U.S. art
American Art Directory, **20**
American Artist, **21**
American Art Journal, **22**
American Art Review, **23**
American Assembly, Arden House, 48
American Association of Museums, 48, **697, 729**

American Bureau of Ethnology. *See* U.S. American Bureau of Ethnology
American Crafts Council, 270
American Federation of Arts, **339, 340**
American Indians. *See* Indians
American Institute of Architects (AIA), 132, **19**
American Journal of Archaeology, **24**
American Sculpture of the Sixties, **25**
American Society for Aesthetics, **528**
Americas, the, **198, 269**
Amon Carter Museum of Western Art, Fort Worth. *See* Fort Worth, Tex.
Amos, P. Ben-. *See* Ben-Amos, P.
Anatomy, 148-149, **556, 758, 879**
Ancient art, 69-80, **353, 793, 1022**
Ancient Peoples and Places series, 67
Ancona, P. d'., **26**
Andersen, W., **27**
Andrade, J. M. Pita. *See* Pita Andrade, J. M.
Andrews, W., 54, **28-30**
Angkor, Cambodia, 189, **393**
Animal style, 184, **524**
Annual of Advertising, Editorial, and Television Art and Design, **31**
Antal, F., **32**
Antiques, **33**
Antreasian, G. Z., **34**
Aperture, **35**
Appollinaire, G., **36, 37**
Apollo, **38**
Apollonio, U., **39**
Appreciation of the Arts series, **809, 844**
Archaeological Institute of America, **24, 41**
Archaeological Reports, **40**
Archaeology: periodicals, **24, 40, 41**
Archaeology (periodical), **41**
Architect and Society series, **455**
Architects' monographs, 132, 133
Architectural Design, **42**
Architectural Forum, **43**
Architectural Periodicals Index, **44**
Architectural Record, **45**

Architectural Review, **46**
Architecture, 128-137, **259**, 806, 807;
 baroque, 454,724,944; bibliography,
 134; Byzantine, **558**, **620**, **629**;
 Canada, 409; Carolingian, **253**; China,
 903; Early Christian, **558**, **620**;
 directories, 132, **19**; Egypt, **910**, **913**;
 encyclopedias and dictionaries, 128-
 129, **132**, **323**, **345**, **442**, **766**,
 827, **935**, **1015**; Etruscan, **155**;
 France, **144**, **490**, 517,· **537**, **925**;
 Germany, **101**; Great Britain, **489**,
 762, **939**, **975**, **990**; Gothic, 85-87,
 55, **170**, **344**, **354**, **517**, **749**, **905**;
 Greece, **77**, **82**, **151**, 299, **576**, **887**;
 history, 129-131, **118**, **346**, **390**,
 438, **470**, **664**, **763**, **901**; India;
 862; Islamic, **563**, **892**; Italy, **101**,
 460, **691**, **1017**; Japan; **744**; Latin
 America, **215**; mannerist, **761**; medi-
 eval, **871**; Minoan, **325**, **415**;
 modern, 131-132, 135-136, **118**,
 141, **255**, **390**, **426**, **470**, **765**, **888**,
 901, **1033**; Netherlands, **853**; New
 England, **30**; Oriental, **199**, **997**;
 periodicals, 136-137, 42-46, **530**,
 734, **802**, **1044**; Renaissance, **101**,
 460, **606**, **691**, **692**; Roman, **155**,
 619, **701**; Romanesque, 85-87, **253**,
 560; Russia, **435**; Spain, **562**; theory
 (*See* Theory of architecture); U. S.,
 171, **19**, **28-30**, **191**, **259**, **343**,
 451, **461**; Venice, **55**, **870**
Archives of American Art, 49, 172-173,
 47, 617
Archives of American Art Journal, **47**
Archives of Asian Art, **48**
Arias, P. E., **49**
Armitage, E. L., **50**
Armstrong, T., **958**
Arnason, H. H., **51**
Arnheim, R., **52**, **53**
Arrighi, Ludovico degli. *See* Ludovico
 degli Arrighi
Ars Hispaniae, **54**
Arslan, E., **55**
Ars Orientalis, **56**
Artamonov, M. I., **57**
Art and Architecture Information Guide
 series, **540**
Art + Cinema, **58**
Art and industry, **810**; and photography,
 159, **247**, **667**, **878**; and politics,
 29, **244**, **245**; and technology, 127,
 140, **121**, **195**, **545**, **583**
Art auction catalogs, 48-49
ARTbibliographies Modern, **59**
Art Bulletin, **60**
Art criticism, **186**
Art deco, 120-121, **356**, **614**
Art Design Photo, **61**
Art dictionaries. *See* Encyclopedias and
 dictionaries: art

Art Direction, **62**
Art Directors Club, New York, 164, **31**
Artforum, **63**
ARTgallery Magazine, **64**
Art histories and introductions, 55-59,
 308, 320, 377, 405, 444, 448, 514,
 515, 555, 607, 920, 945
Art History, **65**
Artibus Asiae, **66**
Art in America, **67**
Art in Context series, 12, **575**, **815**, **947**
Art Index, **68**
Art Institute of Chicago. *See* Chicago
Art International, **69**
Artist's and Photographer's Market, **70**
Artists' monographs, 3, **100**, **107**,
 111-113; sketchbooks, 145, **223**
Artist's Proof, **71**
Art Journal, **72**
Art News, **73**
Art nouveau, 120, 182, **74**, **622**, **884**
Art Nouveau (exhibition), **74**
Art of the Printed Book, **75**
Art of the World series, 58, **188**, **396**,
 427, 536, 586, 641, 788, 863, 979
Art prices, **76**, **497**, **1030**
Art Prices Current, **76**
Art Quarterly, **77**
Artscanada, **78**
Art schools, **46**
Arts Council of Great Britain, **10**,
 339, 845
Arts in America, **78a**
Arts in Society, **79**
Arts Magazine, **80**
Arts of Japan series, 193, **640**
Arts of Mankind series, 57-58, **129**,
 130, **291**, **412**, **431**, **484**, **485**, **579**,
 754, **755**
Arts of the Eskimo, **81**
Art theory. *See* Theory of art
Ashmole, B., **82**, **109**, **353**
Ashton, D., **83**
Asia House Gallery, New York. *See*
 New York City
Asian art. *See* Oriental art
Asian Art Museum of San Francisco.
 See San Francisco
Asia Society, 186, **48**, **839**
Association of Art Historians of Great
 Britain, **65**
Assyria: art, **754**
Atkins, G., **496**
Auctions. *See* Art auction catalogs
Audiotapes, **50**
Audiovisual Market Place, **84**
Audiovisual materials, 49-54
Austria: art, **454**
Australia: art, **188**
Auvil, K. W., **85**
Avery Architectural Library. *See*
 Columbia University
A. W. Mellon Lectures in the Fine Arts,

146, 411, 786, 811

Backes, M., 86
Baker, J., 87
Ball, H., 88
Baltimore: Walters Art Gallery, 984
Bandinelli, R. Bianchi. *See* Bianchi Bandinelli, R.
Bann, S., 89
Barnes A. C., 90
Baroque architecture, 454, 724, 944; art, 109-113, 453, 454, 492, 541, 549, 773, 898, 944, 1025; sculpture, 546, 785
Barr, A. H., 91, 92, 274, 331
Barrett, L., 287
Barrow, T. T., 93, 188
Bartsch, A. von, 154-155, 94, 503
Basham, A. L., 95
Basic Photo Series, 3-7
Bataille, G., 96
Battcock, G., 97
Baudelaire, C., 34, 98, 99, 186
Bauhaus, 33, 135, 178, 100, 426, 1014
Bauhaus: 1919-1928, 100
Bauhaus Books series, 159
Baum, J., 101
Bayer, H., 100
Bazin, G., 102, 103
Bean, J., 104
Beazley, J. D., 76-77, 105-109
Becatti, G., 110
Becker, F., 946
Beckett, R. B., 256, 257
Beckwith, J., 111, 112
Bedinger, M., 113
Belgium: art, 388, 578. *See also* Flanders
Ben-Amos, P., 114
Benesch, O., 115-117, 818
Benevolo, L., 118
Bénézit, E., 119
Benson, J. H., 169, 120, 609
Benthall, J., 121
Berenson, B., 147, 180, 122-127
Bernard, E., 32
Bernet Kempers, A. J., 128
Bernini, G. L., 112, 462, 1018
Bianchi Bandinelli, R., 129, 130
Bible, 20, 443; manuscripts, 91, 131-133, 660
Bibliographic Guide to Art and Architecture, 134
Bibliographies, 36-37; African art, 114, 496; architecture, 134, 250; art, 38, 225, 316, 608, 882; Chinese art, 1037; classics, 598; exhibition catalogs, 1031; Islamic art, 273; national, 185, 704, 705; Oriental art, 864; periodicals, 711, 959; photography, 156, 157; prints, 637; serial, 38-40, 59, 61, 68, 134, 819, 835; trade, 37-38, 160, 277, 753, 803, 936; U.S. art, 78a, 540, 916a

Bieber, M., 135, 136
Biegeleisen, J. I., 154
Binyon, L., 137
Birren, F., 138-140, 737
Bitter Years, The, 921
Blake, P., 141
Bland, D., 904
Blaue Reiter Almanac, 142
Blue Rider, 121, 142, 843
Blumenthal, J., 75
Blunden, M., 143
Blunt, A., 144-147
Boardman, J., 148-151
Boas, F., 152
Boase, T. S. R., 153
Boaz, J. N., 806
Boccioni, U., 181
Bodoni, G., 154
Boesiger, W., 521, 522
Böethius, A., 155
Bohemia: art, 454
Bollingen series, 146, 411, 786, 811, 905, 1043
Boni, A., 156, 157
Bony, J., 348, 490
Book arts, 75, 677. *See also* Illuminated manuscripts; Lettering and calligraphy; Typography
Booklist, 158
Book of Durrow, 91, 132
Book of Kells, 91, 133, 159
Book reviews, 61, 62, 64, 187, 191
Books in Print, 160
Books of hours, 92, 481, 804, 955
Boon, K. G., 155, 1003
Borsook, E., 161
Bossaglia, R., 162
Boston Museum Bulletin, 163
Boston: Museum of Fine Arts, 73, 185, 163, 912, 1040
Boucicaut Master, 90, 650
Bousquet, J., 164
Bovini, G., 165, 166
Bowie, T., 974
Bowlt, J. E., 167
Bowra, C. M., 168
Braham, A., 169
Branner, R., 170, 171
Bredius, A., 172
Breman, P., 134n.
Brentjes, B., 173
Bresson, H. Cartier-. *See* Cartier-Bresson, H.
Breton, A., 124, 174, 175
Breuil, H., 66, 195, 176, 177
Breunig, L. C., 36
Bridge, The, 121
Briganti, G., 178
Brilliant, R., 179
Brion, M., 180, 181
Britannica Encyclopedia of American Art, 182
British. *See* Great Britain

British Journal of Aesthetics, **183**
British Journal of Photography Annual,
 184
British Library, 41
British Museum, London. *See* London
British School at Athens, **40**
British Society of Aesthetics, **183**
Brockmann, J. Müller-. *See* Müller-
 Brockmann, J.
Bronze Age, 74, 191, **839, 970**
Brookner, A., **186**
Brown, A. Bush-. *See* Bush-Brown, A.
Brücke, Die. See Bridge, The
Brunner, F. A., **187**
Brzeska, H. Gaudier-. *See* Gaudier-
 Brzeska, H.
Buddhist art, 188-189
Bühler, A., **188**
Buildings of England series, **762**
Buonarroti, Michel Angelo, 2, 28, 30,
 102-103, **1, 189, 190, 246, 295, 399,
 900**
Burchard, J. E., **191**
Burchard, L., **263**
Burckhardt, J., 96, **192**
Burke, J., **193, 472**
Burlington Magazine, **194**
Burma: art, **808**
Burnham, J., **195, 196**
Burns, E., **922**
Busch, H., **197**
Bush-Brown, A., **191**
Bushnell, G. H. S., **198**
Bussagli, M., **199, 200**
Byzantine architecture, **558, 620, 629;**
 art, 82-83, **111, 292, 311, 491,
 573, 630, 824, 825;** painting, **410**

Cabanne, P., **201**
Cage, J., 33
Cahill, J., **202**
Cahn, J. B., **203**
Cailler, P., **268**
Calas, N., **204**
California Studies in the History of
 Art series, **234**
Calligraphy. *See* Lettering and
 calligraphy
Cambodia: art, **393, 427, 808**
Cambridge Ancient History, 75
Camera, **205**
Camera Work, 161, **206, 207**
Camesasca, E., **989**
Campbell, C., 134
Campbell, J., **1043**
Canada: architecture, **409;** art, 173-174,
 198, 78, **483, 618, 949;** painting,
 440, 441
Canaday, J., **208**
Canadian Centre for Films on Art,
 Ottawa. *See* Ottawa
Capa, C., **657**
Caravaggio, 112, **363, 669, 917**

Cardamone, T., **209**
Carey, A. G., **120**
Carli, E., **210**
Carolingian architecture, **253;** art, **484**
Carrà, C., 181
Carrà, M., **211**
Carracci, A., **790**
Carrieri, R., **212**
Carter, H., **213**
Cartier-Bresson, H., **214**
Castedo, L., **215**
Castelli-Sonnabend, **216**
Castleman, R., **217**
Catalogs. *See* Art auction catalogs;
 Catalogue raisonné; Exhibition cata-
 logs; Library catalogs; *Oeuvre* catalog;
 Print catalogs
Catalogue raisonné, 2, 12-13, 154-156
Cathedrals, 86-88, **101, 344, 489, 490,
 517, 905, 940**
Catholic Church, **218**
Catholic Encyclopedia, **219**
Cave art, 66-67, 195-196, **96, 173,
 176, 177, 408**
Cellini, B., 103, **220**
Celtic art, **342, 509, 778**
Cennini, C., **221**
Central Asia: art, **863**
Cézanne, P., 32, 35, **90, 222, 223, 373,
 876**
Chaet, B., **224**
Chamberlin, M., **225**
Chantilly. Musée Condé, **955**
Chardin, J. B. S., **1008**
Chartres Cathedral, 87-88, **8, 171, 455,
 525, 539**
Chase, G., **226**
Chassé, C., **227**
Chastel, A., **228, 229**
Châtelet, A., **230, 950**
Chiang Yee, **231**
Chicago: Art Institute, 185, **223**
Chieffo, C., **232**
Childe, V. G., **233**
China: architecture, **903;** art, 190-191,
 137, 329, 903, 938, 1010; bibliog-
 raphy, **1037;** bronzes, **839;** callig-
 raphy, 191, **231;** painting, **202, 906;**
 symbolism, **1011**
Chipp, H. B., **234**
Chirico, G. de, 181
Christensen, E. O., **235, 236**
Christian art, 81-83, **571, 625, 626;**
 iconography, 20-22, **411, 880;**
 religion, **954**
Cinema. *See* Film
*Circle: International Survey of Con-
 structive Art,* **237**
Cirici Pellicer, A., **238**
Clapp, J., **239**
Clark, K., **240-243**
Clark, T. J., **244, 245**
Classicism, 180, **243, 598.** *See also*
 Neoclassicism

Classics of the World's Great Art series, 989
Clements, R. J., 246
Cleveland Museum of Art, 112, 518
Coke, V. D., 247
College Art Association of America, 62, 60, 72, 835
Collon-Gevaert, S., 248
Color, 143-144, 13, 138-140, 504, 508, 543, 688, 737, 738; photography, 333; reproductions (*See* Painting: color reproductions); woodcut prints, 193
Color of the Middle Ages, 249
Columbia University: Avery Architectural Library, 250; Studies in Art History and Archaeology series, 525, 1016
Commercial art, 163-169, 394, 916; periodicals and annuals, 163-165, 31, 62, 251, 416-418, 493, 666, 727, 759, 770, 799; techniques, 166, 209, 471, 642, 643, 926
Communication Arts, 251
Computerized data bases, 48, 64
Computers, 48, 127, 252, 816
Computers and Their Potential Applications in Museums, 252
Conant, K. J., 253
Conceptual art, 126-127, 661
Connoisseur, 254
Conrads, U., 255
Conservation, 776
Constable, J., 30-31, 256-258, 585
Constantine, M., 74
Constructivism, 122-123, 182, 89, 237, 834
Conway, W. M., 314
Cook, J. W., 259
Coomaraswamy, A. K., 189, 260
Cooper, D., 275
Corbusier, Le. *See* Jeanneret-Gris, C. E.
Cork, R., 261
Corpus, 15-17, 105-106
Corpus Palladianum, 262, 895
Corpus Rubenianum, 263
Corpus Vasorum, 264
Corpus Vitrearum Medii Aevi, 265
Council of Europe exhibitions, 15, 10, 845
Courbet, G., 116, 245
Courtauld Institute. See *Journal of the Warburg and Courtauld Institutes*
Courthion, P., 266-268
Covarrubias, M., 269
Craft Horizons, 270
Creative Camera International Year Book, 271
Crespelle, J.-P., 272
Creswell, K. A. C., 273
Crete. *See* Minoan
Croix, H. de la. *See* de la Croix, H.
Cubism, 28, 121-123, 37, 274, 275, 372, 398, 854

Cubism and Abstract Art, 122, 274
Cubist Epoch, 122, 275
Cummings, P., 276
Cumulative Book Index, 277
Cuttler, C. D., 278
Cybernetic Serendipity, 127

Dada, 123-125, 88, 279, 331, 486, 595, 680, 833, 866
Dada, Surrealism, and Their Heritage, 279
Damaz, P. F., 280
d'Ancona, P. *See* Ancona, P. d'
Daniel, H., 281
Dannenfeldt, K. H., 282
Dark Ages, 86, 485
Daumier, H., 156, 623
Davies, M., 16
da Vinci, Leonardo, *See* Leonardo da Vinci
Davis-Weyer, C., 283
de Chirico, G. *See* Chirico, G. de
Decker, H., 284
de C. M. Saunders, J. B. *See* Saunders, J. B. de C. M.
Degering, H., 285
Dehio, G., 286
Dehn, A., 287
de Honnecourt, Villard. *See* Villard de Honnecourt
Delacroix, E., 31, 34, 288
de la Croix, H., 377
Delange, J., 579
DeLaurier, N., 289
Delteil, L., 290
Demargne, P., 291
De Mazia, V., 90
Demus, O., 292, 293
Denver Art Museum, 198
de Pacioli, L. *See* Pacioli, L. de
Deschamps, P., 294
De Stijl. See *Stijl, De*
De Tolnay, C., 295
Detroit Institute of Arts, 116
Deuchler, F., 296
de Varagine, J. *See* Jacobus de Varagine
Dewald, E. T., 218, 297
d'Harnoncourt, A., 631
Dictionaries. *See* Encyclopedias and dictionaries
Diderot, D., 34, 186
Die Brücke. See Bridge, The
Diehl, G., 298
Dinsmoor, W. B., 299
Directories, 46-47; architecture, 19; art, 20, 70, 341, 499; artists, 1006, 1007; museums, 698, 729; nonprint media, 84, 696; photography, 70, 771
Diringer, D., 300
Dissertations, 63, 173
Doak, W. A., 301
Doblin, J., 302
Dockstader, F. J., 303-305

Documents of Modern Art series, **37, 538, 670, 680**

Documents of 20th-Century Art series, 29, **36, 39, 88, 89, 142, 167, 201, 486, 817**

Dodwell, C. R., **306**

Doerner, M., **307**

Doesburg, T. van, 182

Dölling, R., 86

Donatello, **516**

Dörig, J., **151**

Dorra, H., **308**

Drawing, 145-149, **117, 464, 594, 655, 671, 679, 809, 897**; Italy, **104, 122**; museum collections, 146-147; periodicals, 147, **638, 732**; techniques, 147-148, **224, 433, 556, 719, 988**

Drawings from New York Collections series, 146, **104**

Du Bourguet, P. M., **309**

Duchamp, M., 33, **201, 310, 631**

Dumbarton Oaks Papers, **311**

Dumbarton Oaks Research Library, Washington, D.C. *See* Washington, D.C.

Dupont, J., **312**

Dürer, A., 104, 107, 169, **313, 314, 750**

Dutch. *See* Netherlands

Early Christian architecture, **558, 620**; art, 82-83, **111, 309, 412, 491, 977**

Early Medieval art, 83-84, **112, 197, 283, 473, 551, 573**; painting, **413**

Earthworks, 126-127

Eckstein, A., **926**

Edgerton, S. Y., **315**

Egypt: architecture, **910, 913**; art, 72-73, **16, 449, 568, 912, 913, 964**

Ehresmann, D. L., **316**

Eighteenth century, **104, 193, 407, 453, 537, 587, 588, 856**

Eisler, C. T., **317**

Eitner, L., **318**

Elderfield, J., 88

Electronics and art, 127

Elsen, A. E., **319, 320**

Enciclopedia dell'arte antica, classica e orientale, **321**

Encyclopedia Britannica, **322**

Encyclopedia of Modern Architecture, **323**

Encyclopedia of World Art, **324**

Encyclopedias and dictionaries, **322, 741, 991**; antiquity, **321, 701, 740**; architecture, 128-129, 132, **323, 345, 442, 766, 827, 935, 1015**; art, 4-5, 43-46, **324, 621, 645, 694, 767, 772, 795, 982**; biographical, 9-10, **119, 276, 425, 440, 618, 827, 946, 978, 1015**; iconography, **281, 337, 434**; photography, 160, **347, 930**; Renaissance art, **492**; religious, **219, 708**; sculpture, 138, **709**; U.S. art, **182, 276, 425**

England. *See* Great Britain

Engraving. *See* Prints and printmaking

Eskimo art, 197-198, **81, 942**

Etching, **565, 611**

Etruscan architecture, **155**; art, 77-78, **676, 828**; civilization, **828**; painting, **746**

Europe: painting, **306, 437, 726**; sculpture, **437, 726**

Evans, A. J., 74, **325**

Evans, J., 326-328

Exhibition catalogs; 9, 15; reviews, 8-9

Exhibition of the Archaeological Finds of the People's Republic of China, **329**

Exhibitions, 7-9

Expressionism, 121, **699, 894**

Eyck, J. van, 13n., 16, **768**

Facsimile reproductions, 91-92, 145

Fairbank, A., **329a**

Family of Man, 159, **330**

Fantastic Art, Dada, Surrealism, 124, **331**

Far Eastern art, **577**

Farm Security Administration (FSA), 54, 160, **921, 932**

Fauvism, 121, **272, 298, 589**

Feder, N., **332**

Feininger, A., 158, **333-335**

Feminist Art Journal, **336**

Ferguson, G. W., **337**

Ferguson, W. K., 96

Férnandez, J., **338**

Film, 50, 52, 58, 216, **339, 340, 494, 566**

Films on Art, **339, 340**

Fine Arts Market Place, **341**

Finlay, I., **342**

Fitch, J. M., **343**

Fitchen, J., **344**

Flam, J., **639**

Flanders: drawing, **805**; painting, 104-106; prints, **474**

Fleming, J., **345, 766**

Flemish. *See* Flanders

Fletcher, B., **346**

Florence: drawing, **122**; painting, 32, **126, 360, 653, 730**

Focal Encyclopedia of Photography, **347**

Focillon, H., 85, **348, 349**

Fogg Art Museum. *See* Harvard University

Fontein, J., **1040**

Form analysis, 17-19

Fort Worth, Tex.: Amon Carter Museum of Western Art, 173

France: architecture, 144, **490, 517, 537, 925**; art, 177-178, **98, 99, 144, 244, 245, 326, 375, 518, 537, 625, 925**; drawing, **897**; painting, 90, 106, 230, **362, 364, 407, 590, 650-652, 682, 712, 837, 908, 950**; prints, **290**; sculpture, 88, **294, 376, 875**

Francesca, Piero della. *See* Piero della Francesca

Frank, L., **350**

Frankfort, H., **351**

Frankfort, H. A. Groenewegen-, **352, 353**
Frankl. P., **354, 355**
Frankl. P. T.. **356**
Fraser, D., **357, 358**
Frédéric, Louis. *See* Louis-Frédéric
Freedberg, S. J., **359, 360**
Freeman, P., 215
Freer Gallery of Art, Washington, D.C. *See* Washington, D.C.
French Painting 1774-1830, **362**
Friedlaender, W. F., **363-366**
Friedländer, M. J., 104-105, **367, 368**
Frisch, T. G., **369**
Frobenius, L., 195
From the Lands of the Scythians, **370**
From Today Painting Is Dead, **371**
Fry, E., **372**
Fry, R., 35, **373**
FSA. *See* Farm Security Administration
Fuchs, W., **151**
Futurism, 122, 181, **39, 212, 374, 635**
Futurism (exhibition), **374**

Gabo, N., 122-123, **237**
Gaehde, C. M., **1042**
Gantner, J., **375**
Gardner, A., **376**
Gardner, H., **377**
Gaskin, L. J. P., **496**
Gaudier-Brzeska, H., 35, **792**
Gauguin, P., 32, 119, **378-380, 605**
Gaunt, W., **381-384, 965**
Gazette des Beaux-Arts, **385**
German expressionists, 121, **699, 894**
German Photographic Annual, **386**
Germany: architecture, **101;** art, 178-179, **286, 454, 593, 699;** painting, 106, **116, 567, 736, 894;** prints, **475;** sculpture, 106, **736**
Gernsheim, H., **387**
Gerson, H., **172, 388**
Gesta, **389**
Gevaert, S. Collon-. *See* Collon-Gevaert, S.
Ghiberti, L., **559**
Giedion, S., **390**
Giedion-Welcker, C., **391**
Gilbert, C., **392**
Giotto, **933**
Giteau, M., **393**
Glaser, M., **394**
Glass, stained. *See* Stained glass
Gleizes, A., 28, **122**
Gnudi, C., **312**
Godard, A., **395**
Goetz, H., **396**
Gogh, V. van, 31-32, 119, **397, 605, 877**
Golden Gospels of Echternach, 92, **660**
Golden Legend, 21-22
Golding, J., **398**
Goldscheider, L., **399**
Goldwater, R., **400-402**
Gombrich, E. H., 17n., **403-406**

Goncourt Brothers, **186, 407**
Goodall, E., **408**
Gospels. *See* Bible
Gothic architecture, 85-87, **55, 170, 344, 354, 517, 749, 905;** art, 84-95, **296, 355, 369, 625, 636;** painting, 89-90, **312;** sculpture, 88-89, **539, 875**
Gottesman Lectures, Uppsala University, **752**
Gourhan, A. Leroi-. *See* Leroi-Gourhan
Gowans, A., **409**
Goya, F., **155, 947**
Grabar, A., **410-414**
Graham, J. W., **415**
Graphic arts. *See* Drawing; Prints and printmaking
Graphic design. *See* Commercial art
Graphis, **416**
Graphis Annual, **417**
Graphis Posters, **418**
Gray, B., **419**
Gray, C., **420**
Grayson, C., **14**
Graziosi, P., **421**
Great Ages of World Architecture series, 85, 130, **170, 606, 620, 871, 887, 888**
Great Britain: architecture, **489, 762, 939, 975, 990;** art, 179, **153, 193, 327, 1000;** painting, 179, **381, 383, 986;** prints, **466;** sculpture, **927, 999**
Great Centuries of Painting series, 89, 96, **112, 410, 413, 414, 624, 746, 840**
Great Wave, The, **422**
Greece: architecture, 77, 82, **151, 299, 576, 887;** art, 73-77, 80, **109, 110, 151, 780, 781, 829, 841, 1013;** city planning, **1036;** civilization, 168, 550; painting, 76-77, **49, 105-109, 148, 149, 840;** sculpture, 75-76, **82, 109, 136, 439, 610, 830-832**
Green, J., **207**
Green, S. M., **423**
Greenberg, C., **424**
Groce, G. C., **425**
Groenewegen-Frankfort, H. A. *See* Frankfort, H. A. Groenewegen-
Gropius, W., 135, 178, **100, 426**
Groslier, B. P., **427**
Grube, E., **428**
Gudiol J., **429, 430**
Gudiol i Ricart, J. *See* Gudiol, J.
Guggenheim Museum, New York. *See* New York City
Guiart, J., **431**
Guys, C., **34**

Haab, A., **432**
Hale, R. B., **433**
Hall, J., **434**
Hamilton, G. H., **435-437**
Hamlin, T. F., **438**

Hanfmann, G. M., **439**
Harbrace History of Art series, 59, 739, 898, 909
Harlow, F. H., **350**
Harnoncourt, A. d'. *See* d'Harnoncourt, A.
Harper, J. R., **440, 441**
Harris, C. M., **442**
Harrison, G. B., **443**
Hartt, F., **444, 445**
Harvard University: Fine Arts Library, **446**; Fogg Art Museum, 146
Hatje, G., **323**
Hauser, A., **447, 448**
Hayashiya, T., **613**
Hayes, W. C., **449**
Hayter, S. W., **450**
Hegemann, W., **451**
Heibonsha Survey of Japanese Art series, 192, **613**
Heintze, H. von, **452**
Held, J. S., **453**
Hempel, E., **454**
Henderson, G., **455**
Hennessy, J. Pope-. *See* Pope-Hennessy, J.
Henry, F., 159, **456-458**
Herbert, R. L., **459, 706**
Heydenreich, L. H., **460**
Heyer, P., **461**
Hibbard, H., **462, 463**
Hiberno-Saxon. *See* Ireland
Hickman, M. L., **1040**
Hill, E., **464**
Hind, A. M., **465-468**
Hirmer, M., 71, **12, 49, 151, 293, 568, 632, 824, 875, 931, 977**
Hisamatsu, S., **469**
Historic American Buildings Survey, 54
History of Western Sculpture series, 139, **439, 546, 592, 872**
History of World Architecture series, 131, **199, 560, 629, 692, 724**
Hitchcock, H. R., 131, **470**
Hittite art, 71, **12, 972**
Hofmann, A., **471**
Hogarth, W., 30, **472, 756, 757**
Holländer, H., **473**
Hollstein, F. W. H., **474, 475**
Holography, 158
Holt, E. G., **476, 477**
Honnecourt, Villard de. *See* Villard de Honnecourt
Honour, H., 345, **478, 766**
Hornung, C. P., **479, 480**
Horta, V., 182
Hours of Catherine of Cleves, **481**
Houses, **45**
Howard, D., **482**
Hubbard, R. H., **483, 949**
Hubert, J., **484, 485**
Huelsenbeck, R., **486**
Huizinga, J., **487**

Humanism, **228**
Hungary: art, **454**
Hunt, W. H., 31, **488**
Hürlimann, M., **489, 490**
Hutter, I., **491**
Huyghe, R., **492**
Hyatt Mayor, A. *See* Mayor, A. Hyatt

ICOM. *See* International Council of Museums
Iconography, 19-26, **337, 411, 434, 534, 535, 773, 838, 880**
Icons, 182, **739**
Illuminated manuscripts, 90-92, **26, 249, 300, 650-652, 993**; facsimiles, 91-92, **131-133, 159, 218, 481, 660, 955**
Illustrators, **493**
Image, **494**
Impressionism, 117-119, **143, 266, 382, 591, 722, 783, 821**
Index of American Design, 172, 172n., **235, 480**
Index of Christian Art, 25, **1027**
Indexes. *See* Abstracts and indexes
India: architecture, **862**; art, 188-189, **200, 260, 396, 507, 862, 1043**; civilization, **95**
Indians of Central America, **304**; of Mexico, **304**; of North America, 196-198, **113, 303, 332, 350, 501, 943, 961**; of South America, **305**
Indochina: art, **427, 808**
Indonesia: art, 189-190, **128, 260, 979**
Industrial design, **495, 810**
Industrial Design (periodical), **495**
Ingres, J. A. D., 31, **742**
Ink painting, **640**
Institute for Architecture and Urban Studies, New York. *See* New York City
Institute of Contemporary Arts, London. *See* London
Institute of Fine Arts, New York University. *See* New York University
International African Institute, London. *See* London
International Art Market, **497**
International Center of Medieval Art, The Cloisters. *See* New York City
International Congress of the History of Art, **498**
International Council of Museums (ICOM), 48
International Directory of Arts, **499**
International Gothic, 90, 104
International Index to Multi-Media Information, **301, 500**
International Museum of Photography, Rochester. *See* Rochester, N.Y.
International Repertory of the Literature of Art. See *RILA*
International Surrealist Exhibition, London, 124

Inter-Society Color Council (ISCC), 144, 543

Inverarity, R., **501**

Ions, V., **502**

Iran. *See* Persia

Ireland: art, 91-92, 179-180, **456-458**

Iron Age, **649**

Isabella d'Este, **969**

Islamic architecture, **563**, 892; art, 185-186, **428**, **563**; bibliography, 273; periodicals, 56

Italian Chiaroscuro Woodcuts, **503**

Italy: architecture, 101, **460, 691, 1017**; art, 180-181, **145**, 229, 284, 967, **1017**; civilization, **192**; drawing, **104**, 122; painting, 89-90, 98-100, **123-127**, 161, 178, 297, 359, 360, 365, 534, 535, 634, 669, 957, 969; prints, 465, **503**; Renaissance, 97-103, **192**, 359, 360, 445, **1023**; sculpture, 89, 100, 162, 785, **899** (*See also under* Florence, Siena, Tuscany, Venice)

Itten, J., **504**

Ives, C. F., **422**

Ivins, W. M., **505, 506**

Iyer, K. B., **507**

Jacobson, E., **508**

Jacobsthal, P., **509**

Jacobus de Varagine, **510**

Jaffé, H. L. C., **511, 512**

Jameson, A. B., **513**

Janson, H. W., **514-516**

Jantzen, H., **517**

Japan: architecture, **744**; art, 192-193, **137**, 518, 604, 613, 731, 743, **744**; painting, **11**, 640; prints, 193, **422**, 518, **662, 663**

Japonisme, **518**

Jean, Duke of Berry, **650-652, 955**

Jean, M., **519**

Jeanneret-Gris, C. E., 132, 135, **141**, **520-523**

Jettmar, K., **524**

Jewelry, **113**

Jewish Museum, New York. *See* New York City

Johnson, J. R., **525**

Johnston, E., **526**

Jones, O., **527**

Journal of Aesthetics and Art Criticism, **528**

Journal of Hellenic Studies, **529**

Journal of the Society of Architectural Historians, **530**

Journal of the Warburg and Courtauld Institutes, **531**

Judd, D. B., **543**

Jugendstil, 120

Jullian, P., **532, 533**

Kaftal, G., **534, 535**

Kähler, H., **536**

Kalnein, W. G., **537**

Kandinsky, W., 32, 121, **142, 538, 843**

Karpel, B., 123, **98a**

Karpinski, C., **503**

Katzenellenbogen, A., **539**

Keaveney, S. S., **540**

Kelemen, P., **541, 542**

Kelley, K. L., **543**

Kempers, A. J. Bernet-. *See* Bernet-Kempers, A. J.

Kepes, G., **544, 545**

Keutner, H., **546**

Khmer, **393**

Kidder Smith, G. E. *See* Smith, G. E. Kidder

Kidson, P., **547**

Kim, C., **548**

Kitson, M., **549**

Kitto, H. D. F., **550**

Kitzinger, E., **511, 552**

Klee, P., 33, **553, 554, 843**

Kleinschmidt, H. J., **486**

Klotz, H., **259**

Knobler, N., **555**

Korea: art, 192, **548, 615**

Kramer, J., **556**

Kramer, S. N., **557**

Krautheimer, R., **558, 559**

Kubach, H. E., **560**

Kubler, G., **561, 562**

Kühnel, E., **563**

Kuile, E. H. ter. *See* ter Kuile, E. H.

Künstler, G., **564**

Lalanne, M., **565**

Landers Film Reviews, **566**

Landmarks of the World's Art series, 58, **428, 547, 549**

Landolt, H., **567**

Landscape painting, 18, 31, **241, 957**

Lange, K., **568**

Lankheit, K., **142**

Laos: art, **427, 808**

Lapiner, A., **569**

Larkin, O. W., **570**

Larousse Encyclopedia of Renaissance and Baroque Art, **492**

Lascaux, France, **96**

Lasko, P., **571**

Lassaigne, J., **572**

Lassus, J., **573**

Latin America: architecture, 54, **215**; art, 54, 174-175, **215, 226, 280, 541**; painting, **657**

Laude, J., **574**

Lavin, M. A., **575**

Lawrence, A. W., **576**

Le Corbusier. *See* Jeanneret-Gris, C. E.

Lee, L. K., **548**

Lee, S. E., **577, 733**

Legrand, F. C., **578**

Leiris, M., **579**

Lejeune, J., **248**

Leonardo (periodical), 127, **583**
Leonardo da Vinci, 30, 101, 102, **240,** **580-582, 747**
Leroi-Gourhan, A., **584**
Leslie, C. R., **585**
Lettering and calligraphy, 168-169, 191, **120, 231, 285, 313, 329a, 432, 526,** **609, 707, 948, 956, 1040**
Leuzinger, E., **586**
Levey, M., **537, 587, 588**
Lewis, W., 179
Leymarie, J., **589-591**
Library catalogs, 40-41, **185, 704, 705;** art, 41-43, **361, 446, 713-716**
Library of Art History series, 58, **353,** **392, 436, 453, 1038**
Library of Congress, 54, 156, 160, **704,** **705, 711**
Library of Great Art Movements series, **266, 298, 885**
Library of Great Painters series, **366,** **876, 877, 893**
Licht, F., **592**
Life Library of Photography series, 158, **951, 952**
Limbourg Brothers, 90, **652**
Lindemann, G., **593, 594**
Lindisfarne Gospels, 91, **131**
Lippard, L. R., **595-597**
Lithography, **34, 287, 627, 861, 896**
Loehr, M., **839**
Lohse, B., **197**
LOMA, **59**
London: British Museum, 84, **185, 551;** Institute of Contemporary Arts, 127; International African Institute, 496; National Gallery, 16; Royal Academy, 10; Tate Gallery, 845; University: Warburg Institute, 25-26, **531, 598,** **747;** Victoria and Albert Museum, **10**
López-Rey, J., **599, 600**
L'Orange, H. P., **601, 602**
Los Angeles County Museum of Art, 71, **25, 275, 370, 717**
Lossky, V., **739**
Lothrop, S. K., **603**
Lotz, W., **460**
Louis-Frédéric, **604**
Louvre, Paris. *See* Paris
Lövgren, S., **605**
Low Countries: art, 181-182. *See also* Belgium; Flanders; Netherlands
Lowry, B., **606, 607**
Luca de Pacioli. *See* Pacioli, L. de
Lucas, E. L., **608**
Ludman, J., **637**
Ludovico degli Arrighi, 169, **609, 948**
Lullies, R., **610**
Lumsden, E., **611**
Lyons, N., **612**

Macadam, J. P., **613**
McClinton, K. M., **614**

McClune, E., **615**
McCoubrey, J. W., **616**
McCoy, G., **617**
MacDonald, C. S., **618**
MacDonald, W. L., **619, 620**
Mace, A. C., **213**
McGraw-Hill Dictionary of Art, **621**
Macke, A., **843**
McMahon, A. P., **582**
McShine, K., **631**
Maddow, B., **995**
Maderno, C., **463**
Madsen, S. T., **622**
Maetzke, G., **676**
Magazines. *See* Periodicals
Maillard, R., **709**
Maison, K. E., **623**
Maiuri, A., **624**
Makers of Contemporary Architecture series, 133
Mâle, E., 21, **625, 626**
Malingue, M., **379**
Man, F. H., **627**
Mander, C. van, 106, **628**
Manet, E., 34, **268, 815**
Mango, C., **629, 630**
Mannerism, 107-108, **164, 178, 365,** **447, 690, 761, 902, 909, 915, 1035**
Mansart, F., **169**
Manuscript illumination. *See* Illuminated manuscripts
Maori sculpture, 93
Marc, F., **121, 142, 843**
Marcel Duchamp, **631**
Marinatos, S., **632, 633**
Marinetti, F. T., 181
Marle, R. van, **634**
Martin, J. L., **237**
Martin, M. W., **635**
Martindale, A., **636**
Mary, Virgin, **513**
Maser, E. A., **838**
Masks, 19
Mason, L., **637**
Master Drawings, **638**
Masters of World Architecture series, 133
Matisse, H., 33, **91, 639**
Matsushita, T., **640**
Matt, L. von, **676**
Matz, F., **641**
Maurello, S. R., **642, 643**
Mayer, R., **644-646**
Mayne, J., 98, 99
Mayor, A. Hyatt, **647**
Méauzé, P., **648**
Mediaeval Academy of America, **919**
Medieval architecture, **871;** art, 81-95, **326, 348, 547, 571, 925, 1038;** art periodicals, 94-95, **311, 389, 919;** civilization, **328, 487;** painting, 89-90, **306;** sculpture, 88-89, 376, 872, 927
Megaw, J. V. S., **649**
Meiss, M., **650-653**

Mellaart, J., **654**
Mendelowitz, D., **655, 656**
Mesopotamia: art, 70-71, **673, 931.**
 See also Near East, Ancient
Messer, T. M., **657**
Metaphysical art, **211**
Metropolitan Museum Journal, **658**
Metropolitan Museum of Art, New York.
 See New York City
Metropolitan Museum of Art Bulletin,
 659
Metz, P., **660**
Metzinger, J., 28, 122
Mexico: art, 175, 176, **338, 561, 603**
Meyer, P., **489, 490**
Meyer, U., **661**
Michelangelo. *See* Buonarroti, Michel
 Angelo
Michener, J. A., **662, 663**
Microfilm and microfiche, 50
Middle Ages. *See* Medieval
Middle East. *See* Near East
Mies van der Rohe, L., **141**
Migration period: art, 83-84, **485, 984**
Millar, O., **1000**
Millon, H. A., **664**
Mills, J. W., **665**
Miniature painting. *See* Illuminated
 manuscripts
Minimal art, 126-127
Minoan architecture, **325, 415;** art, 74,
 325, 632, 641
Mint, The, **108**
Modern architecture, 131-132, 135-136,
 118, 141, 255, 390, 426, 470, 765,
 888, 901, 1033; art, 29, 114-127, **51,**
 208, 234, 459; art bibliography, **59,**
 61; design, **764;** painting, **92, 812,**
 855, 968; prints, **217;** sculpture,
 140-141, 83, 319, 391, 401, 592,
 709, 797, 813, 890
Modern Publicity, **666**
Moholy-Nagy, L., **667, 668**
Moir, A., **669**
Mondrian, P., 32, 182, **670**
Monet, C., 5-6, **893**
Mongan, A., **671**
Monographs. *See* Architects' monographs;
 Artists' monographs
Monro, I. S., **672**
Mont-Saint-Michel, France, 8
Moortgat, A., **673**
Morassi, A., **674, 675**
Moretti, M., **676**
Morey, C. R., 25
Morgan Library, New York. *See* New
 York City: Pierpont Morgan Library
Morison, S., **677, 678**
Mosaics, 18-19, 92-93, **165, 166, 292,**
 552, 602, 728
Mosan art, 248
Moskowitz, I., **679**
Motherwell, R., **680**

Motion pictures. *See* Film
Mountford, C. P., **188**
Mucha, A. M., 120, **681**
Muehsam, G., **682**
Müller, G., **683**
Müller, H. A., **684, 685**
Müller, T., **686**
Müller-Brockmann, J., **687**
Munsell (A. H.) color system, 143-144,
 140, 688
Mural painting, 79, 89-90, **161, 293,**
 624
Murray, L., **689, 690, 693, 694**
Murray, P., **691-694**
Museology, 47-48, **103, 695, 697, 733**
Museum (periodical) **695**
Museum Computer Network, 48
Museum Media, **696**
Museum News, **697**
Museum of Fine Arts, Boston. *See*
 Boston
Museum of Modern Art, New York. *See*
 New York City
Museum of Primitive Art, New York.
 See New York City
Museum of the American Indian, New
 York. *See* New York City
Museum publications, 14-15; bulletins,
 63-64, **163, 658, 659**
Museums, **103, 698, 729;** directories,
 698, 729
Museums of the World, **698**
Mycenae, 73-74, **881;** art, **632, 641, 970**
Myers, B. S., **699**
Mythology, **502, 557, 848**

Nabis, **227**
Nadeau, M., **700**
Nagy, L. Moholy-. *See* Moholy-Nagy, L.
Nash, E., **701**
National Bureau of Standards (NBS), **543**
National Gallery, London. *See* London
National Gallery of Art, Washington,
 D.C. *See* Washington, D.C.
National Gallery of Art. Kress Founda-
 tion Studies in the History of Euro-
 pean art, **790**
National Gallery of Canada, Ottawa. *See*
 Ottawa
National Information Center for Educa-
 tional Media (NICEM), **702**
National Palace Museum, Tai Pei. *See*
 Tai Pei, Taiwan
National Sculpture Review, **703**
National Sculpture Society, **703**
National Union Catalog, **704, 705**
Near East, Ancient, 70-72, **351, 352,**
 654, 673, 914
Neoclassicism, 116-117, **10, 318, 478**
Neo-impressionism, **706**
Neolithic art, **654**
Nesbitt, A., **707**
Netherlands: architecture, **853;** art,

103-106, **511, 628, 736, 853, 953;**
painting, 104-106, **317, 367, 368,
748, 798;** prints, 474; sculpture, 736
New Catholic Encyclopedia, 708
New Dictionary of Modern Sculpture, 709
Newhall, B., **710**
Newhall, N., **994**
New Serial Titles, **711**
New York City: Asia House Gallery, 186,
839; Guggenheim (Solomon R.)
Museum, **706;** Institute for Archi-
tecture and Urban Studies, **737;**
International Center of Medieval Art,
The Cloisters, **389;** Jewish Museum,
797; Metropolitan Museum of Art,
252, **658, 659;** Metropolitan Museum
of Art collections, 73, 185, **104, 449,
712, 804;** Metropolitan Museum of
Art exhibitions, **275, 370, 422;**
Metropolitan Museum of Art Library,
713; Museum of Modern Art exhibi-
tions, 74, **100, 274, 279, 330, 331,
374, 631, 820, 890, 921;** Museum of
Modern Art Library, **714;** Museum of
Primitive Art, 196, **114, 400;** Museum
of the American Indian, 175, 198;
Pierpont Morgan Library, **75, 104,
747;** Whitney Museum of American
Art, 173, **958**
New-York Historical Society, **425**
New York Public Library, 196, **134,
715, 716**
New York School, 125, **717**
New York Times Index, 718
New York University: Institute of Fine
Arts, **66, 730**
New Zealand: art, **93, 188**
NICEM, 702
Nicholas of Verdun, 85
Nicholson, B., **237**
Nicolaides, K., **719**
Nineteenth Century, 114-119, **98, 99,
153, 290, 364, 383, 436, 477, 590,
592, 908**
Noble, J. V., **720**
Nochlin, L., **721-723**
Nonprint materials, 49-54, **301, 702;**
directories, 84, **696;** periodicals, **58,
158, 500, 566, 796**
Norberg-Schulz, C., **724**
Nordenfalk, C., **249, 413, 414**
Nordhagen, P. J., **602**
Norman, D., **725**
North American Indians. *See* Indians
of North America
Northern Renaissance, 103-107, **115,
278, 909**
Norton Critical Studies in Art History
series, 11-12, **171, 900, 933**
Novotny, F., **726**
Novum Gebrauchsgraphik, **727**

Oakeshott, W., **728**

Oceania: art, 198, **188, 431, 883**
Oeuvre catalog, 2, 13
Official Museum Directory, 729
Offner, R., **730**
Ogg, O., **948**
Okakura, K., **731**
Old Master Drawings, 732
O'Malley, C. D., **971**
On Understanding Art Museums, 733
Oppositions, 734
Optical ("Op") art, 126-127, **820**
Orders (Architecture), 135, **973**
Orient, Ancient. *See* Near East, Ancient
Oriental architecture, **199, 997;** art,
184-193; art bibliography, **864;**
museum collections, 185-186; period-
icals, 186, **48, 56, 66, 735**
Ornament, 527
Osten G. van der, **736**
Ostwald (W.) color system, 143-144,
737, 738
Ottawa: Canadian Centre for Films on
Art, **340;** National Gallery of Canada,
174, **483, 949**
Ouspensky, L., **739**
Oxford Classical Dictionary, **740**
Oxford English Dictionary, **741**
Oxford History of English Art series,
179, **153, 193, 327, 1000**

Pach, W., **742**
Pacioli, L. de, 168, **678**
Pageant of Japanese Art, **743**
Paine, R. T., **744**
Painter and the Photograph, The, 159
Painting, **1045;** Byzantine, **410;** Canada,
440, 441; China, **202, 906;** color
reproductions, 53, **960;** Early Med-
ieval, **413;** Etruscan, **746;** Europe,
306, 437, 726; Flanders, 104-106;
Florence, **32, 126, 360, 653, 730;**
France, 90, 106, **230, 362, 364, 407,
590, 650-652, 682, 712, 837, 908,
950;** Germany, 106, **116, 567, 736,
894;** Gothic, 89-90, **312;** Great
Britain, 179, **381, 383, 986;** Greece,
76-77, **49, 105-109, 148, 149, 840;**
Italy, 89-90, 98-100, **123-127, 161,
178, 297, 359, 360, 365, 534, 535,
634, 669, 957, 969;** Japan, **11, 640;**
landscape, **241, 957;** Latin America,
657; medieval, 89-90, **306;** modern,
92, 812, 855, 968; mural, 79, 89-90,
161, 293, 624; Netherlands, 104-106,
317, 367, 368, 748, 798; Persia, 187,
419; portrait, **786;** Renaissance,
98-100, **123-127, 786;** Roman, **624;**
Romanesque, 89-90, **293, 414;** Siena,
210, 653, 787; Spain, **572, 791;** still
life, **924;** techniques, 142-144, **221,
307, 644, 646;** Tuscany, **161, 535;**
U.S., **540, 717, 874;** Venice, **127, 587**
Painting, Color, History series, **116, 230,**

567, 572, 590, 950
Palatino, G. B., 948
Paleolithic art, 421, 584
Palladianism, 134, 1019
Palladio, A., 133, 134, 262, 745, 895, 1019
Pallottino, M., 746
Palmes, J. C., 346
Panofsky, E., 96, 104, 105, 747-752, 937
Panorama of World Art series, 86
Paperbound Books in Print, 753
Paris: Louvre, 897
Parrot, A., 754, 755
Paulson, R., 756, 757
Pausanias, 80
Peck, S. R., 758
Peets, E., 451
Peintre-graveur, 154, 94
Pelican History of Art series, 57, 86, 179, 111, 144, 155, 253, 306, 351, 388, 435, 437, 454, 460, 470, 537, 558, 561, 562, 571, 576, 686, 726, 736, 744, 853, 862, 873, 899, 903, 913, 927, 939, 986, 990, 999, 1012, 1017
Pellicer, A. Cirici. *See* Cirici Pellicer, A.
Penguin Dictionary of Architecture, 345
Penrose Annual, 759
Perception, 52
Periodical indexes. *See* Abstracts and indexes
Periodicals: aesthetics, 183, 528; African art, 9; antiquity, 80, 24, 40, 41, 529; architecture, 136-137, 42-46, 530, 734, 802, 1044; art, 60-64, 21, 33, 38, 60, 63-65, 67, 69, 72, 73, 76, 77, 79, 80, 163, 194, 254, 270, 336, 385, 531, 583, 658, 659, 934, 1026; art prices, 76, 497, 1030; bibliography, 711, 959; Canada, 78; commercial art, 163-165, 31, 62, 251, 416-418, 493, 666, 727, 759, 770, 799; drawing, 147, 638, 732; industrial design, 495; medieval art and civilization, 94-95, 311, 389, 919; museology, 695, 697; nonprint media, 58, 158, 500, 566, 796; Oriental art, 186, 48, 56, 66, 735; photography, 161-162, 35, 184, 205, 206, 271, 386, 494, 770; prints and print-making, 156, 71, 800, 801; sculpture, 141, 703, 889; U.S. art, 173, 22, 23, 47
Perkins, J. B. Ward-. *See* Ward-Perkins, J. B.
Persia: art, 71, 187, 395, 784, 788; painting, 187, 419
Perspective, 100, 302, 315, 1004
Peru: art, 561, 603
Peterdi, G., 760
Peterson, E., 310
Pevsner, A., 122-123
Pevsner, N., 345, 761-766
Phaidon Dictionary of Twentieth Century Art, 767

Philadelphia Museum of Art, 631
Philip, L. B., 768
Philipson, M., 769
Photographis, 770
Photographs and pictures, 53-54, 918
Photography, 157-162, 330, 371, 612, 921, 951; bibliography, 156, 157; directories, 70, 771; encyclopedias and dictionaries, 160, 347, 930; history, 159, 387, 710, 779; manuals, 157-158, 3-7, 333-335, 952, 1005; periodicals and yearbooks, 161-162, 35, 184, 205, 206, 271, 386, 494, 770; pictorial volumes, 159-160; 214, 725, 929, 932, 995, 1021
Photography and painting, 159, 247, 667, 878
Photography Market Place, 771
Photomicrography, 160, 1021
Photorealism, 126-127
Picasso, P., 35, 121, 53, 922
Pictorial Archives series, 165, 168, 479
Pictures and photographs, 53-54, 918
Pierce, J. S., 772
Piero della Francesca, 28, 575
Pierpont Morgan Library, New York. *See* New York City
Pigler, A., 773
Pissarro, C., 32, 774
Pita Andrade, J. M., 775
Pittsburgh: University Art Gallery, 249
Placzek, A. K., 134, 879
Plenderleith, H. J., 776
Plinius Secundus, 29, 80, 777
Pliny. *See* Plinius Secundus
Plummer, J., 481
Pobé, M., 778
Poland: art, 454
Pollack, P., 779
Pollitt, J. J., 780-782
Pompeii, 79
Pool, P., 783
Pop art, 126-127
Pope, A. U., 784
Pope-Hennessy, J., 785-787
Porada, E., 788
Porcher, J., 484, 485
Porter, A. Kingsley, 789
Portrait painting, 786
Portugal: art, 562, 911
Posner, D., 453, 790
Post, C. R., 791
Posters, 165, 418
Post-impressionism, 117-119, 722, 822
Pound, E., 792
Poussin, N., 146, 147, 366
Powell, A., 793
Powell, T. G. E., 794
Praeger Encyclopedia of Art, 795
Pratt Graphics Center, 801
Pre-Columbian art, 175, 198, 542, 561, 569, 603
Prehistoric art, 65-68, 96, 176, 408, 421.

584, 794, 873
Pre-Raphaelitism, 31, 35, 488, 868, 987
Previews, 796
Primary sources, 27-35, 79-80, 94, 102-103, 106, 133-136, 143, 172-173
Primary Structures, 797
Primitifs flamands, Les, 317, 798,
Primitive art, 67-68, 194-198, **2, 152, 236, 357, 358**
Primitive Art Bibliographies series, 196, **114**
Princeton Monographs in Art and Archaeology series, **908**
Print, 799
Print catalogs, 154-156, **94, 290, 465, 466, 474, 475, 503;** bibliography, 637
Print Collector's Newsletter, 800
Print Council of America, 150, **203, 1042**
Print Review, 801
Prints and printmaking, 150-156, **81, 187, 203, 450, 505, 1042;** bibliography, **637;** collections, 156; France, **290;** Great Britain, **466;** history, 151-152, **217, 467, 468, 506, 594, 647, 1041;** Italy, **465, 503;** Japan, **422, 662, 663;** periodicals, 156, **71, 800, 801;** techniques, 153-154, **34, 85, 232, 287, 565, 611, 684, 685, 760, 857-861**
Progressive Architecture, 802
Propyläen Kunstgeschichte series, 59, **964**
Proto-Renaissance, 89, 98
Psychology of art, **52**
Publishers' Trade List Annual, 803
Pucelle, J., **804**
Puyvelde, L. van, **805**

Ramsden, E. H., **190**
Ramsey, C. G., **806**
Rasmussen, S. E., **807**
Ravenna, Italy, 93, **165, 166**
Rawson, P. S., **808, 809**
Read, H., 98, **810-814**
Realism, 116-117, **180, 721, 723**
Record Houses and Apartments of the Year, 45
Reff, T., **815**
Reichart, J., **816**
Reinhardt, A., **817**
Religious art. *See* Christian art
Rembrandt, 3, 147, **172, 818, 852, 1002, 1003**
Renaissance, 96-107, **282;** architecture, 101, **460, 606, 691, 692;** art, 96-107, **392, 403, 404, 406, 492, 693, 752, 1025;** Italy, 97-103, **192, 359, 360, 445, 689-691;** Northern *(See* Northern Renaissance); painting, 98-100, **123-127, 786;** sculpture, 100, **546, 785;** theory of art, 101, **14, 15, 145**
Répertoire d'art et d'archéologie, 819
Responsive Eye, The, 820

Reti, L., **581**
Rewald, J., 118, **222, 774, 821, 822**
Rey, J. López-. *See* López-Rey, J.
Reynolds, J., 30, **823**
RIBA, 44
Rice, D. Talbot, **824, 825**
Rich, J. C., **826**
Richards, J. M., **827**
Richardson, E. H., **828**
Richter, G. M. A., **829-832**
Richter, H., **833**
Richter, J. P., **580**
Rickey, G., **834**
RILA, 835
Rilke, R. M., **836**
Ring, G., **837**
Ripa, C., **838**
Ripperger, H., **510**
Ritchie, A. C., **890**
Ritual Vessels of Bronze Age China, 839
Robertson, M., **840, 841**
Robison, A., 156
Roch, E., **81**
Rochester, N.Y.: International Museum of Photography, 161, **494**
Rock art. *See* Cave art
Rock Paintings of Southern Africa series, 177
Rococo art, 109-113, **886, 898;** sculpture, 546
Rodin, A., 35, **836**
Roeder, H., **842**
Roethel, H. K., **843**
Rogers, L. R., **844**
Rohe, L. Mies van der. *See* Mies van der Rohe, L.
Roman architecture, **155, 619, 701;** art, 77-80, **110, 129, 130, 179, 452, 536, 601, 782;** painting, **624;** sculpture, 439
Romanesque architecture, 85-87, **253, 560;** art, 84-95, **248, 284, 375, 564, 941, 1039;** painting, 89-90, **293, 414;** sculpture, 88-89, **294, 789**
Romano, C., **857-861**
Romanticism, 116-117, **180, 181, 243, 267, 318, 845, 855**
Romantic Movement, The, 845
Rorimer, J. J., **804**
Rose, B., **817, 846, 847**
Rose, H. J. **848**
Rosen, B., **849**
Rosenberg, H., **850, 851**
Rosenberg, J., **852, 853**
Rosenblum, R., **854-856**
Ross, J., **857-861**
Ross, M. C., **984**
Roubier, J., **778**
Rowland, B., **862-864**
Royal Academy, London. *See* London
Royal Institute of British Architects

(RIBA), **44**
Royal Ontario Museum, Toronto. *See* Toronto
Rubens, P. P., 112, **263, 865, 992**
Rubin, W. S., **279, 866**
Ruskin, J., 31, 34-35, **867-870**
Russia: architecture, **435**; art, 182, **18, 167, 420, 435**
Ryan, G., **510**
Rykwert, J., **15**

Saalman, H., **871**
Sachs, P. J., **671**
Saints, 21-23, **510, 534, 535, 842**
Salinger, M., **712**
Salon (exhibition), 34, 98
Salvini, R., **872**
Sandars, N. K., **873**
Sandler, I., **874**
San Francisco: Asia Art Museum of San Francisco, 185
Sanouillet, M., **310**
Sansovino, J., **482**
Santorini. *See* Thera
Sauerländer, W., **875**
Saunders, J. B. de C. M., **971**
Schapiro, M,, 17n., **876, 877**
Scharf, A., **878**
Schider, J., **879**
Schiller, G., **880**
Schliemann, H., 73, **881**
Schlosser, J., **882**
Schmitz, C. A., **883**
Schmutzler, R., **884**
Schneede, U. M., **885**
Schomburg Center for Research in Black Culture, 196
Schönberger, A., **886**
Schulz, C. Norberg-. *See* Norberg-Schulz, C.
Scranton, R. L., **887**
Screen printing. *See* Serigraphy
Scully, V., **888**
Sculpture, 138-141, **239, 811, 844;** Africa, **400, 648, 891;** classical, **439;** encyclopedias and dictionaries, 138, **709;** France, 88, **294, 376, 875;** Germany, **736;** Gothic, 88-89, **539, 875;** Great Britain, **927, 999;** Greece, 75-76, **82, 109, 136, 439, 610, 830-832;** history, 139-141, **102, 546, 686;** Italy, 89, 100, **162, 785, 899;** Maori, **93;** medieval, 88-89, **376, 872, 927;** modern, 140-141; **83, 319, 391, 401, 592, 709, 797, 813, 890;** Netherlands, **736;** periodicals, 141, **703, 889;** Renaissance, 100, **546, 785;** Roman, **439;** Romanesque, 88-89, **294, 789;** techniques, 139, **665, 826;** U.S., 171, **25, 27, 83, 958**
Sculpture International, **889**
Sculpture of the Twentieth Century, **890**
Scythians: art, 71-72, **57, 370**

Segy, L., **891**
Seherr-Thom, S., **892**
Seitz, W. C., **820, 893**
Selz, P., 74, **894**
Semenzato, C., **895**
Senefelder, A., **896**
Serials. *See* Periodicals
Series, 57-59
Serigraphy, 154, **85, 232, 861**
Sérullaz, M., **897**
Seurat, G., 119, **605**
Sewter, A. C., **898**
Seymour, C., **899, 900**
Sharp, D., **901**
Shearman, J., **902**
Sickman, L. C. S., **903**
Sieber, R., **19**
Siena: painting, **210, 653, 787**
Silk screen printing. *See* Serigraphy
Simon, O., **904**
Simson, O. von, **905**
Sirén, O., **906**
Sisson, J., **907**
Sivaramamurti, C., **200**
Sleeper, H. R., **806**
Slides, 52, **289**
Slive, S., **853**
Sloane, J. C., **908**
Smart, A., **909**
Smith, E. B., **910**
Smith, G. E. Kidder, **54**
Smith, P., **169**
Smith, R. C., **911**
Smith, W. S., **912-914**
Smithsonian Institution. *See* Archives of American Art; Washington, D.C.: Freer Gallery of Art
Smyth, C. H., **915**
Snyder, J., **916**
Society of Architectural Historians, **530**
Society of Illustrators, **493**
Soehner, R. H., **886**
Sokol, D. M., **916a**
Sonnabend. *See* Castelli-Sonnabend
Soper, A., **744, 903**
Soria, M. S., **562**
Sotheby Parke-Bernet, 49
Sources and Documents in the History of Art series, 28, **283, 318, 369, 616, 630, 722, 723, 781, 782**
South America. *See* Latin America
Southeast Asia: art, 189, **427, 808**
South Sea Islands: art, 198, **188, 431, 883**
Soviet Union. *See* Russia
Spain: architecture, **562;** art, 182-183, **54, 238, 429, 562, 775;** painting, **572, 791**
Spear, R. E., **917**
Special Libraries Association, **918**
Speculum, **919**
Speed, W. J., **301**
Spencer, H., **920**
Spiller, J., **553**

Stained glass, 93-94, **50**, **87**, **265**, **525**, **1020**
Stampfle, F., **104**
Steichen, E., **330**, **921**
Stein, G., 35, **922**
Steinberg, L., **923**
Steinweg, K., **730**
Stendhal, 186
Sterling, C., **712**, **924**
Stevenson, R. A. M., **865**
Stieglitz, A., 161, 162, **725**
Stiennon, J., 248
Stijl, De, 122, 182, **511**, **512**
Still life painting, 18, **924**
Stoddard, W. S., **925**
Stone, B., **926**
Stone, I., 31n.
Stone, L., **927**
Storrer, W. A., **928**
Strand, P., **929**
Stroebel, L., **930**
Strommenger, E., **931**
Stryker, R. E., **932**
Stubblebine, J. H., **933**
Studies in Architecture series, 133, **1**, **169**, **463**
Studies in British Art series, **756**
Studies in Manuscript Illumination series, **993**
Studies in the History of Calligraphy series, **609**
Studies of the Warburg Institute series, 25-26, **747**
Studio International, **934**
Sturgis, R., **935**
Style, 17, 17n., **109**, **349**, **1024**, **1045**
Style and Civilization series, **478**, **721**, **902**
Stylistic analysis, 17-19
Subject Guide to Books in Print, **936**
Suger, abbot of St.-Denis, 94, **937**
Sullivan, M., **938**
Sumer: art, **755**, **1028**, **1029**
Summers, R., 408
Summerson, J., **939**
Sunderland, J., **989**
Suprematism, 182
Surrealism, 123-125, **174**, **175**, **279**, **331**, **384**, **519**, **597**, **700**, 814, **866**, **885**, **980**, **981**
Swaan, W., **940**
Swarzenski, H., **941**
Swinton, G., **942**
Switzerland: art, **454**
Symbolism, 23, **337**, **434**, **1011**
Symbolism (post-impressionist), 117-119, **532**, **533**, **578**, **605**

Tagliente, G. A., **948**
Tai Pei, Taiwan: National Palace Museum, 190
Talbot Rice, D. *See* Rice, D. Talbot
Tamarind Workshop, 153, **34**

Tanner, C. L., **943**
Tansey, R. G., **377**
Tapié, V., **944**
Taste of Our Time series, **267**, **589**, **591**, **980**
Tate Gallery, London. *See* London
Taylor, J. C., **374**, **945**
Tea ceremony, 192, **613**, **731**
Technology and art. *See* Art and technology
ter Kuile, E. H., **388**, **853**
Text/fiche, 50
Thailand: art, **427**, **808**
Theater, **135**
Theory of architecture, **15**, **255**, **745**, **869**, **1016**; of art, 101, **14**, **137**, **145**, **234**, **246**, **349**, **472**, **538**, **580-582**, **670**, **747**, **823**, **966**
Thera, Greece, 74, **633**
Thieme, U., **946**
Thom, S. Seherr-. *See* Seherr-Thom, S.
Thomas, H., **947**
Three Classics of Italian Calligraphy, **948**
Three Hundred Years of Canadian Art, **949**
Thuillier, J., **230**, **950**
Tiepolo, G. B., 113, **674**, **675**
Time-Life Books, **951**, **952**
Time-Life Library of Art series, **983**, **992**
Timmers, J. J. M., **953**
Titian (Tiziano Vecellio), 4-5, **996**
Todd, H. N., **930**
Tokyo National Museum, **743**
Tolnay, C. de. *See* De Tolnay, C.
Topographical Guides, 47
Toronto: Royal Ontario Museum, 186
Toynbee, A., **954**
Treasures of Asia series, **11**, **202**, **419**
Treasures of the World series, **238**, **603**, **775**
Très riches heures, 90, 92, **955**
Treves, M., **402**
Tribal art, 194-198
Tschichold, J., **956**
Tuchman, M., **25**, **717**
Tuckerman, A. L., **973**
Turner, J. M. W., 34
Turner, R. A., **957**
Tuscany: painting, **161**, **535**
Tusiani, J., 189
Tut-ankh-Amen, 72, 72n., **213**
Twentieth-century architecture, **255**, **901**; art, 119-127, **17**, **51**, **97**, **121**, **167**, **196**, **204**, **226**, **280**, **424**, **436**, **511**, **596**, **683**, **767**, **846**, **847**, **850**, **851**, **854**, **922**; prints, **217**; sculpture, 140-141, **25**, **27**, **83**, **195**, **391**, **592**, **797**, **890**
Two Hundred Years of American Sculpture, **958**
Typography, 167-168, **75**, **154**, **677**, **849**, **904**, **963**

Ukiyo-e, 193

UNESCO, 48, **695, 960**
Union List of Serials, **959**
United Kingdom. *See* Great Britain
Universe History of Art series, 58-59, **296, 452, 473, 491, 1022, 1039**
University Prints, Winchester, Mass., 53
Updike, D. B., **963**
Ur, Sumer, 71, **1029**
U.S. American Bureau of Ethnology, 197, **961**
U.S. architecture, 171, **19, 28-30, 191, 259, 343, 451, 461;** art, 170-173, **17, 423, 570, 616, 617, 656, 846, 847, 1012;** art bibliography, 173, **78a, 540, 916a;** art encyclopedias and dictionaries, **183, 276, 425;** art periodicals, 173, **22, 23, 47;** folk art, **235, 480;** painting, **540, 717, 874;** sculpture, 171, **25, 27, 83, 958**
U.S.: Library of Congress. *See* Library of Congress; National Bureau of Standards. *See* National Bureau of Standards; National Gallery of Art. *See* Washington, D.C.
Utrecht Psalter, 92, **218**

Van der Osten, G. *See* Osten, G. van der
Van der Rohe, L. Mies. *See* Mies van der Rohe, L.
Vandersleyen, C., **964**
Vanderstappen, H. A., **1037**
Van de Velde, H. *See* Velde, H. van de
Van Doesburg, T. *See* Doesburg, T. van
Van Gogh, V. *See* Gogh, V. van
Van Mander, C. *See* Mander, C. van
Van Marle, R. *See* Marle, R. van
Van Puyvelde, L. *See* Puyvelde, L. van
Varagine, J. de. *See* Jacobus de Varagine
Vasari, G., 96, 102, 102n., 107, **965, 966**
Vase painting, 76-77, **49, 105-109, 148, 149, 264, 720**
Velázquez, D., **430, 599, 600**
Velde, H. van de, 182
Venice, 180-181; architecture, **55, 870;** painting, **127, 587**
Venturi, A., **907, 967**
Venturi, L., **968**
Verbeek, J., 155
Verdier, P., **984**
Verheyen, E., **969**
Vermeule, E. T., **970**
Vesalius, A., **971**
Vey, H., **736**
Victoria and Albert Museum, London. *See* London
Video art, 50, **216**
Vienna: Albertina, **117**
Vietnam: art, **427, 808**
Vieyra, M., **972**
Vignola, G., 134, **973**
Villard de Honnecourt, 94, **974**
Vinci, Leonardo da. *See* Leonardo da Vinci

Visual communication, **506, 544, 668, 687;** perception, **52**
Vitruvius Britannicus, **975**
Vitruvius Pollio, 133-134, **976**
Volbach, W. F., **484, 485, 977**
Vollmer, H., **978**
von Bartsch, A. *See* Bartsch, A. von
von Heintze, H. *See* Heintze, H. von
von Matt, L. *See* Matt, L. von
von Simson, O. *See* Simson, O. von
von Witzleben, E. *See* Witzleben, E. von
Voragine, J. de. *See* Jacobus de Varagine
Vorticism 122, 179, **261**

Wagner, F. A., **979**
Waldberg, P., **980, 981**
Walker, J. A., **982**
Wallace, D. H., **425**
Wallace, R., **983**
Walters Art Gallery, Baltimore. *See* Baltimore
Warburg Institute, London. *See* London: University
Ward-Perkins, J. B., **155**
Ware, I., 134
Wark, R. R., **823**
Washington, D.C.: Dumbarton Oaks Research Library and Collection. 94-95; Freer Gallery of Art, 185, **56, 361;** Library of Congress (*See* Library of Congress); National Gallery of Art, **329, 480, 962**
Wassing, R., **985**
Waterhouse, E., **986**
Watkinson, R., **987**
Watrous, J., **988**
Watteau, J. A., 113, **989**
Webb, G., **990**
Webster's Third New International Dictionary, **991**
Wedgwood, C. V., **992**
Weisberg, G. P., **518**
Weitzmann, K., **993**
Welcker, C. Giedion-. *See* Giedion-Welcker, C.
Werner, A. E. A., **776**
Weston, E., **994, 995**
Wethey, H. E., 183n., **996**
Weyer, C. Davis-. *See* Davis-Weyer, C.
Wheeler, M., **997**
Whinney, M., **998-1000**
Whistler, J., 31, 35, 185n., **1001**
White, C., **1002, 1003**
White, J., **1004**
White, M., **1005**
Whitney Museum of American Art, New York. *See* New York City
Who's Who in American Art, **1006**
Who's Who in Art, **1007**
Wildenstein, D., **1008**
Wildenstein, G., **1008**
Willett, F., **1009**

Willetts, W., **1010**
Williams, C. A. S., **1011**
Wilmerding, J., **1012**
Winckelmann, J. J., 73 73n., **1013**
Windsor Castle, 146, **240**, 805
Wingler, H., **1014**
Withey, H. F., **1015**
Wittkower, R., **1016-1019**
Witzleben, E. von, **1020**
Wolberg, L. R., **1021**
Wolf, W., **1022**
Wölfflin, H., 98, 109-110, 180, **1023-1025**
Womanart, **1026**
Wood, N., **932**
Woodcut, 468, 503, 684, **685**
Woodruff, H., **1027**
Woolley, C. L., 71, **1028, 1029**
World Collectors Annuary, **1030**
World of Art series, 58, **112, 121, 149, 150, 180, 198, 211, 215**, 429, 588, 636, 689, 690, 693, 765, 783, 794,

812, 813, 846, **1009**
Worldwide Art Catalogue Bulletin, **1031**
Wren, C., 133, **998**
Wright, F. L., 135, **141, 928, 1032-1034**
Wrightsman Lectures, 82
Würtenberger, F., **1035**
Wycherley, R. E., **1036**

Yale Center for British Art and British Studies, 179
Yee, Chiang. *See* Chiang Yee
Yüan, T. L., **1037**

Zarnecki, G., **1038, 1039**
Zen, 193, 469, **1040**
Zen Painting and Calligraphy, **1040**
Zigrosser, C., **1041, 1042**
Zimmer, H. R., **1043**
Zodiac, **1044**
Zola, E., 34, 186
Zucker, P., **1045**